Pictures Showing What Happens on
Each Page of Thomas Pynchon's
Novel *Gravity's Rainbow*

ZAK SMITH

Pictures Showing What Happens on Each Page of Thomas Pynchon's Novel *Gravity's Rainbow*

Introduction by Steve Erickson

Tin House Books

Pictures of What Happens on Each Page of Thomas Pynchon's Novel Gravity's Rainbow, 2004.
Ink on paper with acrylic and mixed media. 755 parts, 5.5 x 4.5 inches each.
Collection Walker Art Center, Minneapolis, MN. Gift of Jeff I. Ross.

Published by Tin House Books, Portland, Oregon, and New York, New York
Distributed to the trade by Publishers Group West,
1700 Fourth St., Berkeley, CA 94710, www.pgw.com

Hardcover ISBN-13: 978-0-9773127-8-8
ISBN-10: 0-9773127-8-X

Paperback ISBN-13: 978-0-9773127-9-5
ISBN-10: 0-9773127-9-8

Second Printing, 2007

Printed in China by Print Vision

Design by Laura Shaw Design, Inc.

www.tinhouse.com

INTRODUCTION

The one time we met, thirteen years ago, he gave me an Amy Fisher comic book. For those not old enough to remember, Fisher was the infamous "Long Island Lolita," as the tabloids would have it—a teenager whose affair with the considerably more senior Joey Buttafuoco resulted in an attempt to kill his inconvenient wife, who in her inconvenient fashion survived. In the early nineties it was a big story. Even those of us who lived on the West Coast were caught up in it. On one side of the comic book was an Amy Fisher cover; then you flipped it over and there was the Buttafuoco cover, half the magazine telling her side of the story and half telling his.

The comic book was the only thing about the meeting that was Pynchonesque. There was no secret handshake, no blindfolded drive deep into the woods at midnight. If there's anyone who seems not captivated by the mystique of Thomas Pynchon, it's Pynchon.

The author of the earlier novels *V.* and *The Crying of Lot 49*, in 1973's *Gravity's Rainbow* Pynchon distilled the Einsteinian double-helix of time and space into a word. It was not unlike the Word we've always been told was there

in the Beginning—but the word is . . . what? Several thousand years of Judeo-Christianity say God; Pynchon the lunatic god of modern American literature says something else, though which of the hundreds of thousands of words that fill *Gravity's Rainbow* he never tells. It's only one of the novel's infinite secrets. Pynchon isn't above the old trick of spelling god backward, so perhaps the Word is the dog—a red setter—that goes up in flames with the rest of Gottfried's memories in the novel's final paragraphs, as the rocket he rides is "betrayed to Gravity." Maybe the Word is Slothrop, the name of the novel's central figure, or maybe it's the "blackout" on page three or the more portentous "Void" on page 578 (a "delicious and screaming collapse"), or the "pussy" that the World War II soldiers sing about on page 305. Whatever is the pynchon-god's Word, like splitting an atom the Word is split in *Gravity's Rainbow*, along with the libido. The result is that screaming across the sky that's Doom, the death rattle of the modern age, the umbilical whiplash of Nuclear Time or Cosmic Time (Pynchon refers to not the nuclear but the Cosmic Bomb), the ejaculation of a psychedelic penis. Of course *Gravity's Rainbow* is as much about Freud's calculations as Einstein's. Sometimes they cancel each other out. Sometimes they conspire, crosswiring geographic and temporal coordinates with foggy latitudes and longitudes that disappear into the Sargasso Sea of the psyche.

Greil Marcus once wrote that the Sex Pistols divided in half the pop history that only the Beatles had divided before. *Gravity's Rainbow* fractured literature, which previously had

been fractured only by *Ulysses* and which no book has so fractured since. Pynchon's novel transcends assessment: whatever you think of it, whatever you can even *begin* to think of it, you can't resist it, it's inexorable, the event horizon of contemporary literature. The only novel of the last fifty years in its league is *One Hundred Years of Solitude*. The power of *Gravity's Rainbow*, particularly for other novelists, is that even as the reading of a single randomly selected page—say that one with the Void, 578, which all by itself seems to swallow up not only surrounding pages but surrounding books, whole surrounding oeuvres—can put one meekly and immutably in his or her place, it also races the blood recklessly to the erogenous zone of one's dreams. In the last half of the twentieth century, it's the great American novel of possibilities. Perhaps if you smashed together the dozen best novels of Philip K. Dick you would have something that approaches it—a pulpy low-culture version of *Gravity's Rainbow*, it's tempting to say, except that not the least of Pynchon's revolutions is how he obliterated the distinctions of low and high culture, at least for anyone paying attention. (Some didn't.) Novelists who have felt the influence of *Gravity's Rainbow* hope that all of their collective work might bridge just half the sky that Pynchon's rainbow covers.

To any rational person, Zak Smith's aspiration to illustrate *Gravity's Rainbow* must appear doomed to failure, but true Pynchonians believe that aspirations doomed to failure are the only ones worth aspiring to. So doomed, Smith is liber-

ated by having nothing to lose, and as seen here his illustrations pulse with neither doom nor failure but with that same sense of possibility that the novel represents to other novelists. Smith's rendition of page 578 does indeed appear to be a universe devouring everything around it, but who can be certain? He has claimed that his intent was to translate the novel at its most literal, but in the novel's paradoxical fashion, that winds up resulting in a translation of the novel at its most metaphoric. If the epigram to the novel's third section, on page 279, is Dorothy's line to Toto about not being in Kansas anymore—which, since the publication of *Gravity's Rainbow*, has become quoted to the point of cliché—Smith duly gives us the Cowardly Lion, the Tin Man, and the Scarecrow (almost edging Dorothy out of the frame altogether), which in one way is rather obvious, of course, but in another way does not simply replicate the galaxy of pop references that dominate the Pynchonian Infinite but implies their secret language. As when Dorothy steps through her doorway into Oz in the movie, it's also one of the rare times that Smith's *Pictures Showing What Happens on Each Page of Thomas Pynchon's Novel Gravity's Rainbow* bursts into color. And in the end there's something slightly counter-intuitive about Smith's vision of such an epic, told (or displayed) (or composed) as it is not in wide-screen, bombed-out cityscapes but 760 pages of mostly close-ups, less *Blade Runner* and more *The Passion of Joan of Arc*.

Just as the only way to read the novel is to buckle yourself in and roar through it—those who try to *decipher* the fucking

thing, like those who try to decipher *Ulysses*, couldn't miss the point more—so the only way to make a visual representation of it is to surrender to the inkblots of whatever Rorschach the novel inspires. Dazzling and virtuosic in its own right, with dashes of everyone from Basquiat to the early eighties punk Italian comix artist Tanino Liberatore, Zak Smith's *Pictures Showing What Happens on Each Page of Thomas Pynchon's Novel* Gravity's Rainbow is ultimately his own version of the story. It coheres among all the alternate-universe *Gravity's Rainbow*s that fill a library comprising the novel's every single reading by every single reader who's ever read it. There's not one *Gravity's Rainbow* but thousands. I don't doubt the Amy Fisher comic is one of them; there's the Void right there, at the Freeport Motor Inn on page four. No one who understands *Gravity's Rainbow*—to the extent anyone does, even its author—can doubt that Pynchon would have it any other way.

—STEVE ERICKSON

FOREWORD

So . . . what the fuck?

So why does a guy best known for portraits of half-naked punk-porn chicks decide one day to sit down and illustrate every single page of a relentlessly difficult classic of twentieth-century literature?

Last year a newspaper wanted an article out of me on roughly that topic. If there was a punk-porn/Pynchon connection I didn't know what it was but I told the guy I'd give it a shot and hung up the phone. I did know there was a go-go dancing, fire-eating, tattooed anarchist lying on my bed, and I knew she was busy reading *Vineland* out loud—and that was about it.

A few days later, I went to Los Angeles and met lots of pornographers. The first pornographer had the muted post horn from Pynchon's *The Crying of Lot 49* tattooed on his arm. He told me to read Steve Erickson.

The second pornographer told me about a third pornographer who I *had* to talk to because he was like the *original* punk pornographer and he was doing it before *anybody* so I asked what's this guy's name and he said, "Benny Profane."

I called Benny:

"Benny Profane, you're named after a character in *V.* and you make dirty movies. Can you please explain to me the secret connection between Thomas Pynchon and punk-porn?"

Benny said nobody'd ever recognized his stage name and said some stuff about hmmm . . . maybe, the concept of preterition and girls with chipped teeth and stuff. I mailed him a disk of all the *Gravity's Rainbow* pictures I'd done; he mailed me some porno movies.

Benny then says he's a big fan and it'd mean a lot to him if he could maybe use the *Gravity's Rainbow* pictures in a movie he's doing for *Hustler*. I say no problem and I say it'd mean a lot to me if I could fuck some girls in the movie he's doing for *Hustler*.

Six months later I have a vigorous second career as a porn actor and Steve Erickson is writing the introduction to my book.

THE PYNCHONISH STYLE OF THOUGHT

Now I suspect Pynchon fans will find all that thoroughly gratifying and not just because it ends with one of them getting to have sex a lot. It's gratifying because it pretty much validates the real-world utility of the Pynchonish style of thought: go off looking for the answer to some maybe-meaningless question, collect and connect the obscure clues, find out

that the world is weirder and wider than you'd imagined and so are you.

Or, to put it another way: *Pay attention to everything interesting because everything is connected.*

People often call this style of thinking "paranoid," but that word connotes something pathetic rather than something that might be creative or useful. *Gravity's Rainbow* in particular seems to have been written by someone who began with no other project than to observe, write essays about, and know the history of nearly everything that interested him in the one-eyed hope that, in the end, it would all be connected—the hope that after 760 pages some thread connecting warfare, behaviorism, and bad limericks would emerge and that this thread would be relevant, if not to the entire world, then at least to the life of the author.

Painters do that, too. The one who lived near the mountain painted the mountain, the one who liked bullfights painted the bullfight, the one who watched the light pass through the greasy glass and hit the orange peel on the kitchen counter painted the light passing through the greasy glass and hitting the orange peel on the kitchen counter—not because they *knew* that looking closely at these things would tell them something but because they *hoped* it would.

In *Gravity's Rainbow*, this style of thought extends all the way down to the language—all those long, detailed, poetic, discursive, intricate, elusive sentences. Sentences that demand to be examined inch by inch and always *do* much more than they *say*.

So, like a lot of people, I sat down one summer and read 760 pages and the style of thought contained in those pages inspired a powerful shock of recognition and the shock bounced around my head for years afterward like a ball of fireflies. *Unlike* most of those people I had both an urge to catch as many of those fireflies as I could and a job that turned this activity into a pleasant and fascinating way to spend my working hours instead of a cranky, dorky, and borderline-psychotic waste of spare time.

But that's a little deceptive—I didn't really do "spare time" during the *GR* project. People often ask how long it took—I worked on it during nine months of fourteen-hour days and seven-day weeks. I threw away tons of drawings. I did a few other pieces during that time but mostly it was *Gravity's Rainbow* all day every day. Some days, looking up the Mendoza rifle on the Internet at three in the morning or trying to figure out a new and interesting way to draw two people having a conversation in a room for the twentieth time, it seemed like the stupidest art idea on Earth. I initially tried to draw every page in order, but after a while I pretty much went after any image I could get excited about and then went through at the end and filled in the gaps. I could only pushpin about a third of the pictures to my bedroom wall at any given time and so I was constantly hanging and rehanging the pictures. My wall looks like a termite city.

People ask about my "obsession" with *Gravity's Rainbow*, but I wouldn't say I was obsessed—I was just doing the thing the way it needed to be done. The book is, above all, com-

plex and gorgeous; the pictures had to be complex and gorgeous. Would you be looking at this book if it had been done any other way?

The book was in my head as much as some Bible scene or bunch of grapes or Peruvian factory-worker plight was in the head of some other artist, and I decided to deal with my subject in the hope that, once dealt with, it would make sense, and so I dealt with my subject, as all artists do, with the only style I have, and my style is nothing if not thorough.

. . . which makes these illustrations a little complicated.

WHAT THIS BOOK IS AND IS NOT

Page 49: ". . . the sight of your blood spurting from the flaccid stub of artery . . ."

. . . and there I am in the drawing, the blood spurting from what's left of a skinny, tattooed arm. Because when I read that sentence (or one of the very few others in which Pynchon uses second person) I think of me—just as when you read it you probably think of you. So in trying to be *thorough* as well as *faithful* to my understanding of the words, I very occasionally ended up making pictures that simply wouldn't do if I'd actually been *hired* to illustrate this book. Instead of drawing some sort of WWII-era British everyman or -woman mutilated for that picture, I chose to be faithful to what I saw in my head when I read that sentence rather than to what some art director would've demanded.

That having been said, I am conventional and sober-minded enough that when Pynchon writes, say, "ambulance," I see an ambulance in my head, not a washrag. I might even go look up a 1940s German ambulance to make sure I get it right. So don't worry, this book is not some hippie word-association game.

On the third hand—"Silver and black. Curvewarped reflections of stars flowing across, down the full length of, round and round in meridians exact as the meridians of acupuncture" (page 699). OK, dude, *you* draw that. Sometimes—maybe half the time—Pynchon's language *requires* interpretation, which is one of the reasons it was fun to draw (How can I make a thing that looks like a benzene molecule *and* a snake at the same time? How can I make an angel in the sky that you're not sure you're actually seeing?), and one of the reasons it might be fun for you to compare notes with me as you read, and one of the reasons that any attempt to make a *definitive* set of illustrations for *Gravity's Rainbow* would be doomed from the start.

That's why there are no words opposite the pictures in this book. There is nothing official about what I saw when I read. What you're holding right now is just my end of a three-way conversation about a book between you, me, and the guy who wrote it.

—ZAK SMITH

ARTIST'S NOTE

The illustrations follow the original 1973 edition of Thomas Pynchon's *Gravity's Rainbow* published by Viking Press.

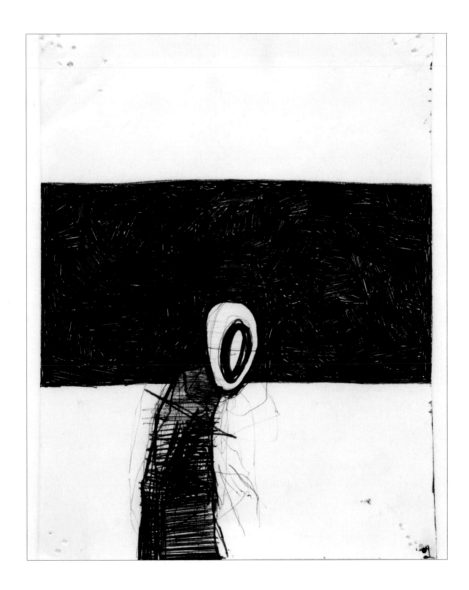

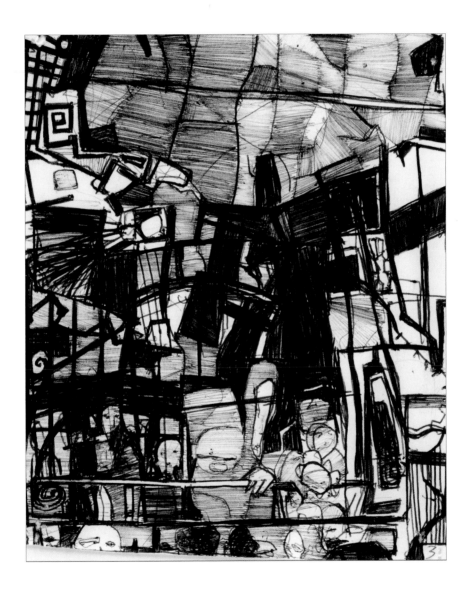

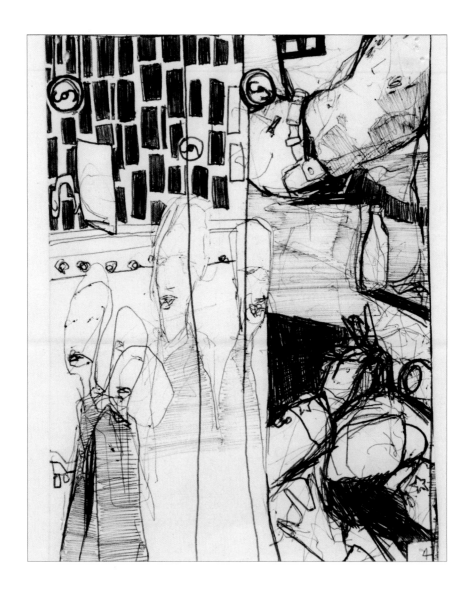

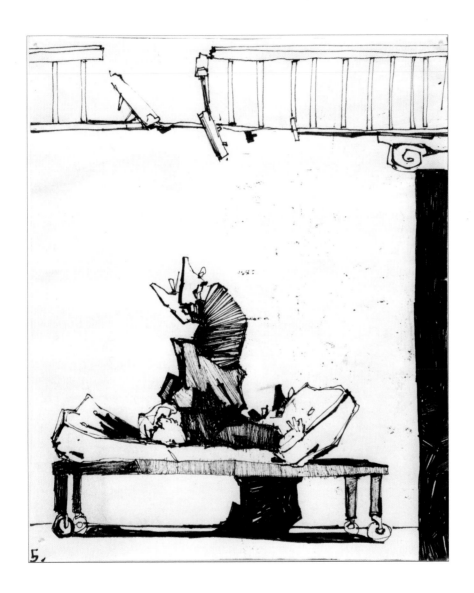

5.

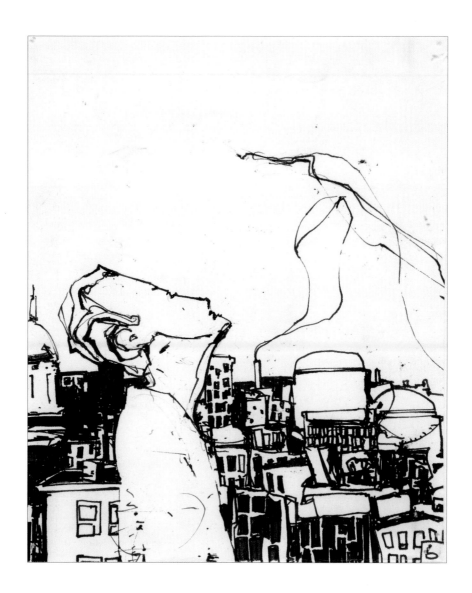

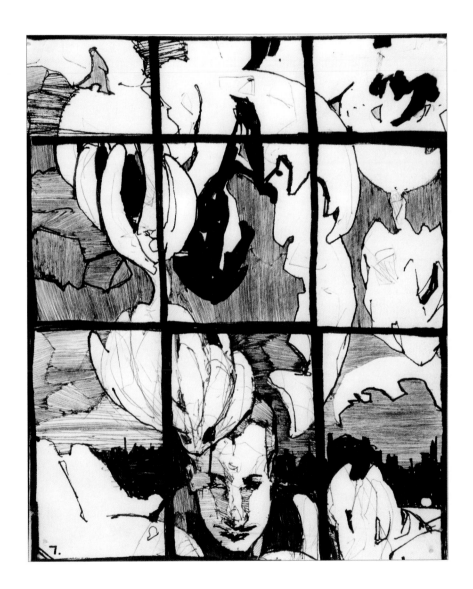

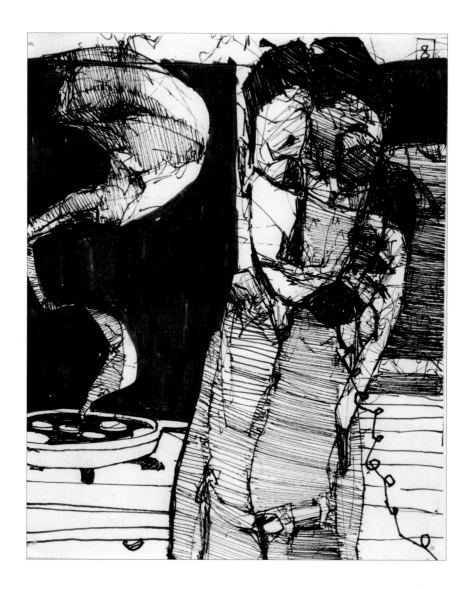

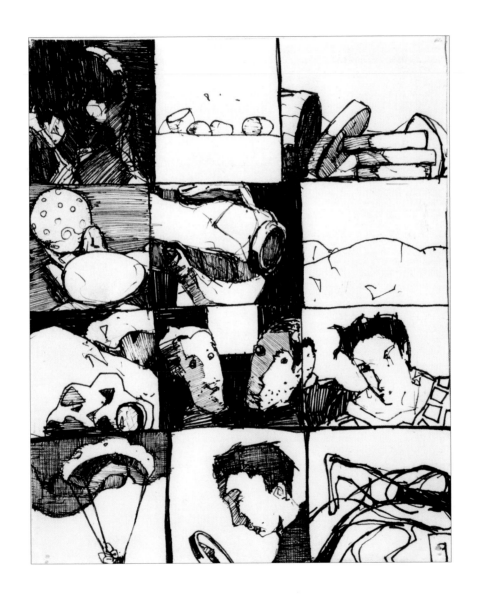

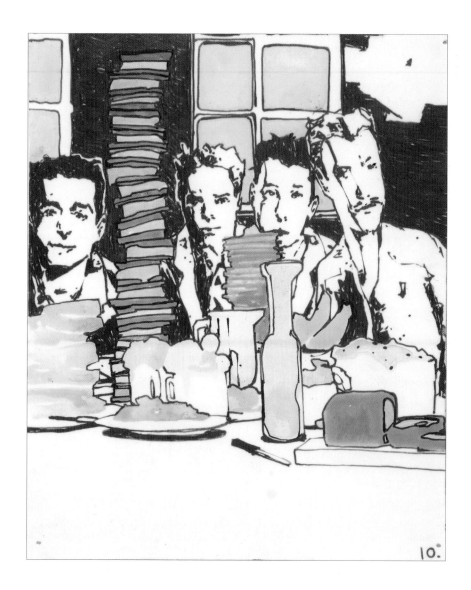

10.

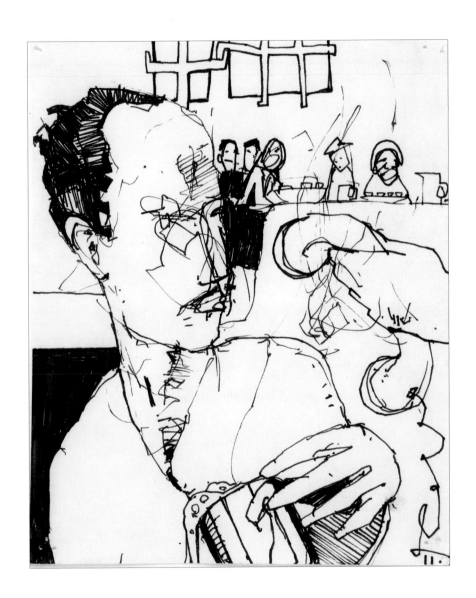

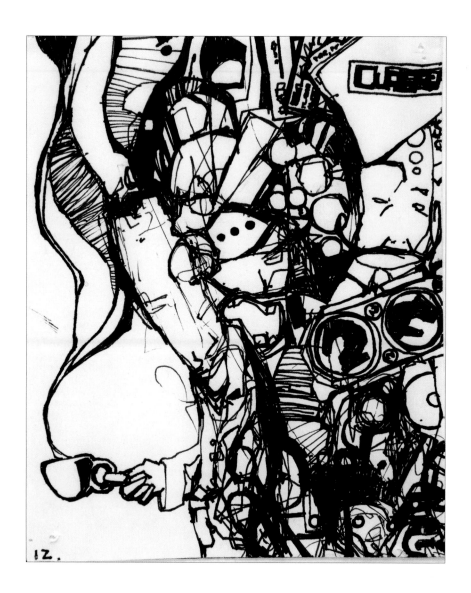

12.

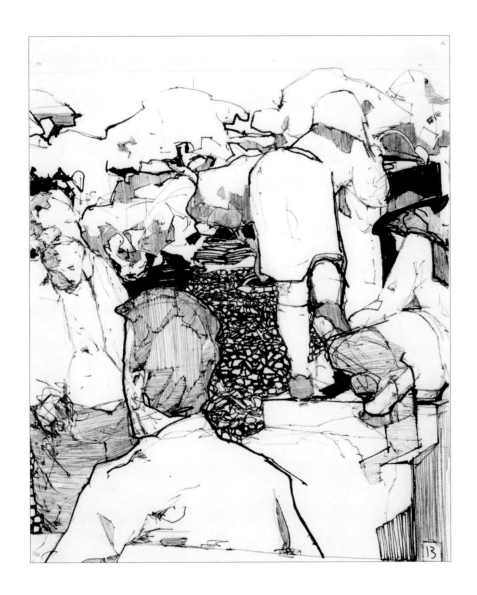

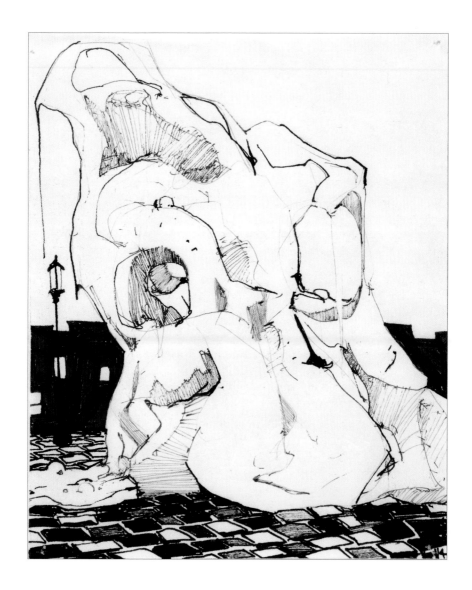

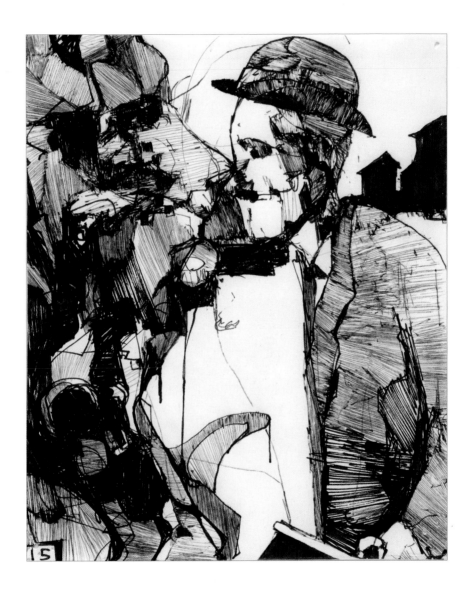

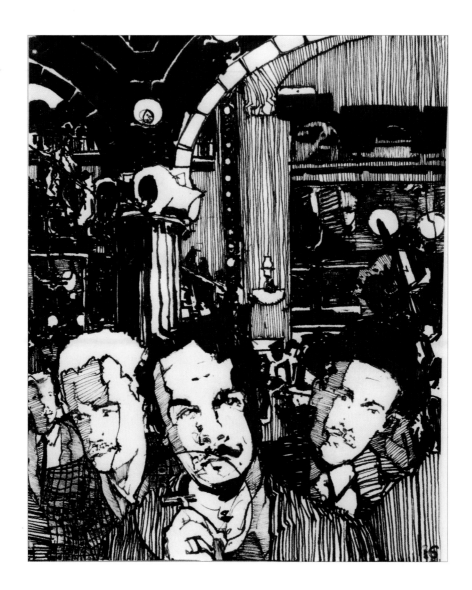

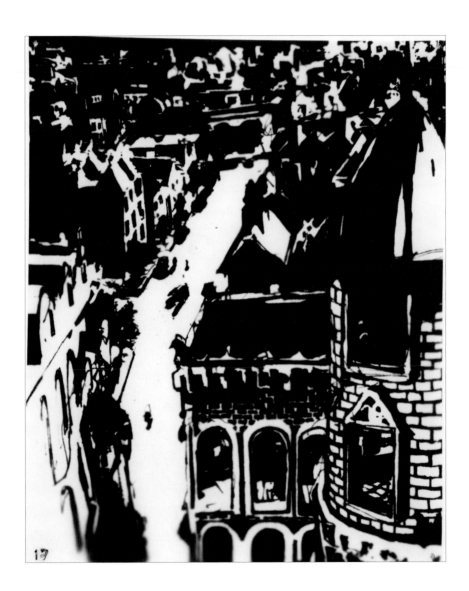

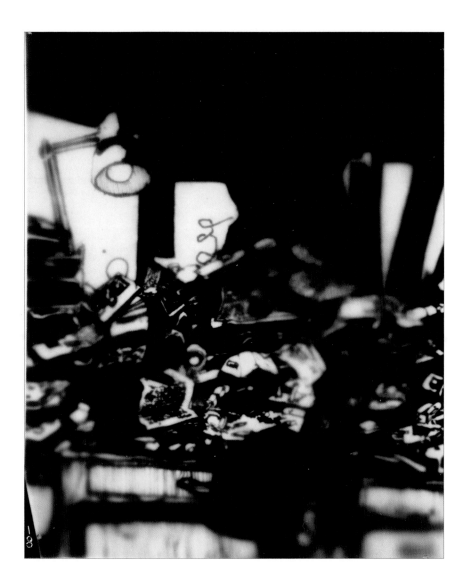

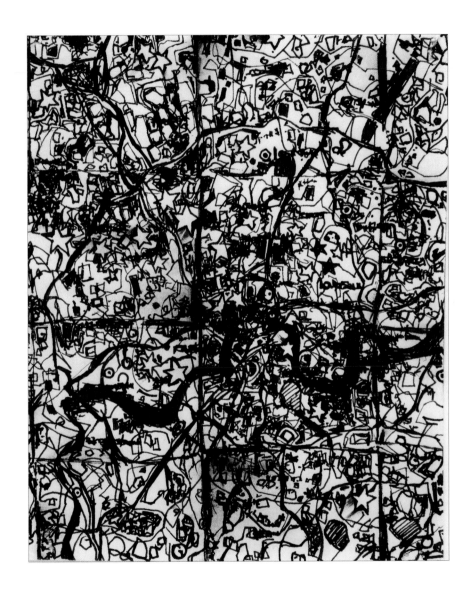

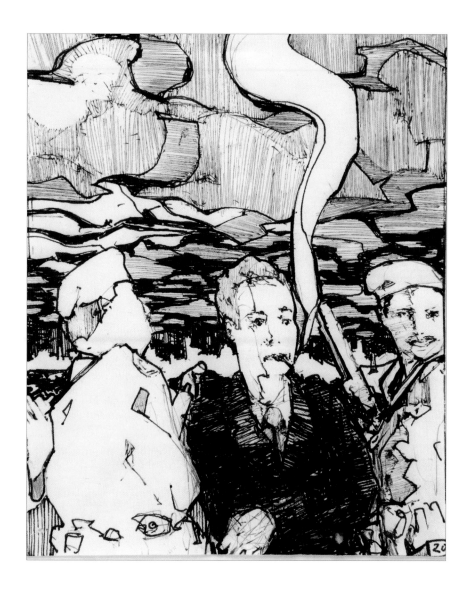

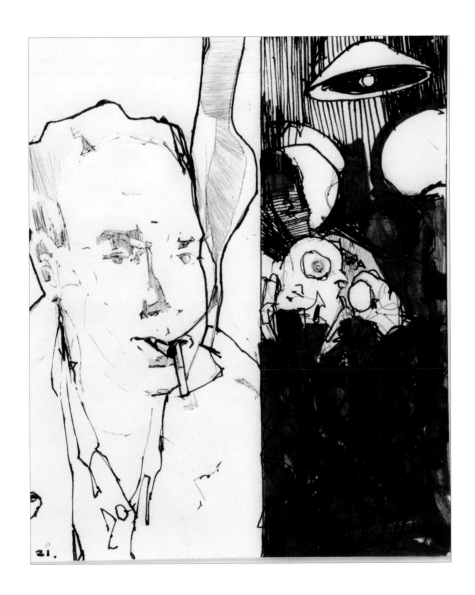

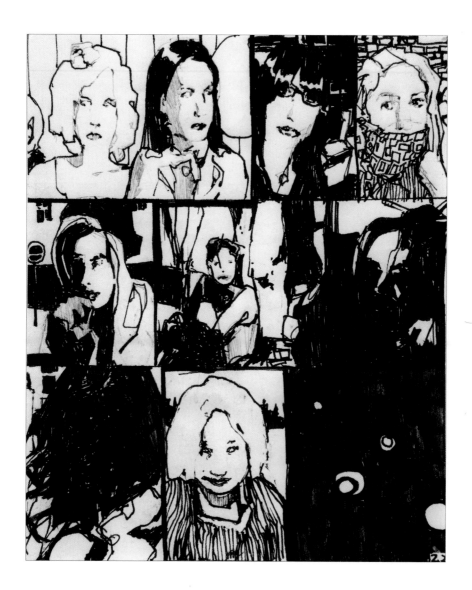

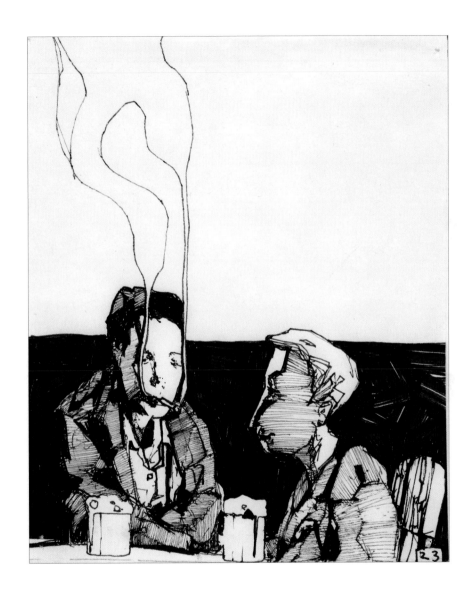

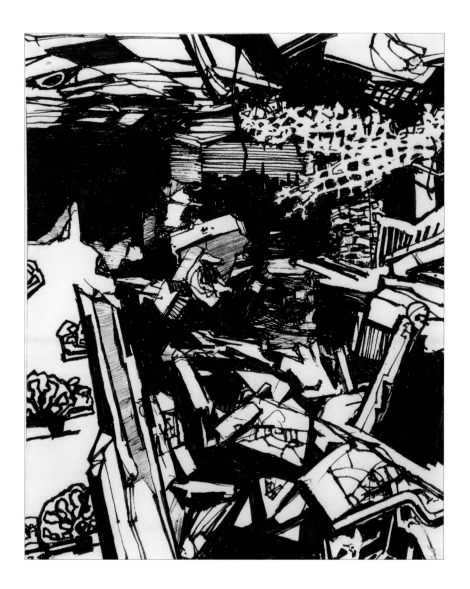

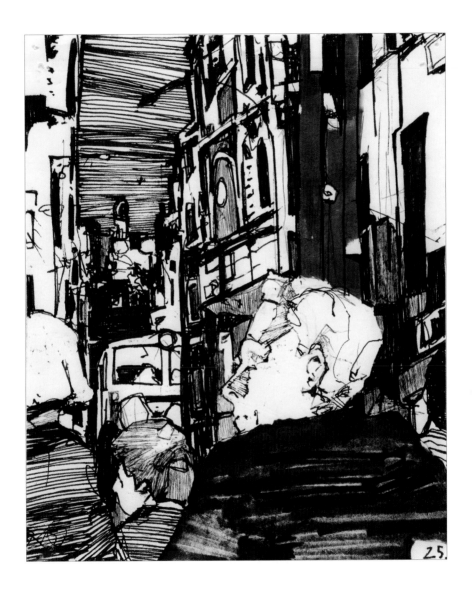

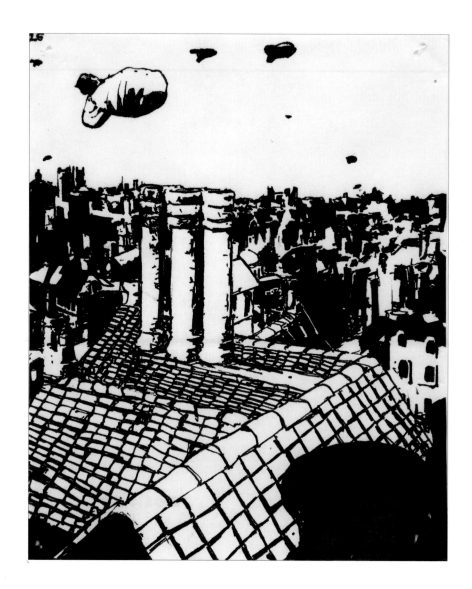

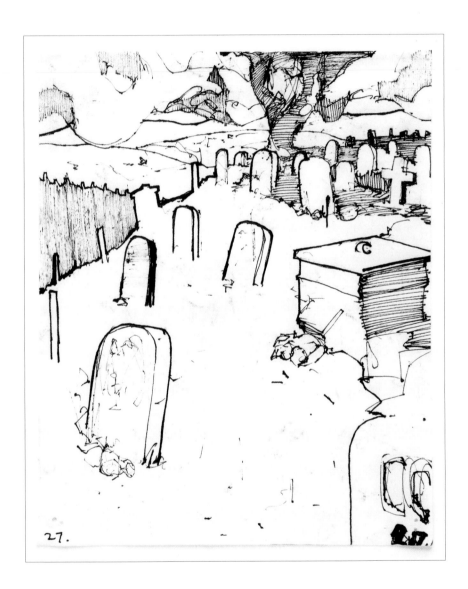

27.

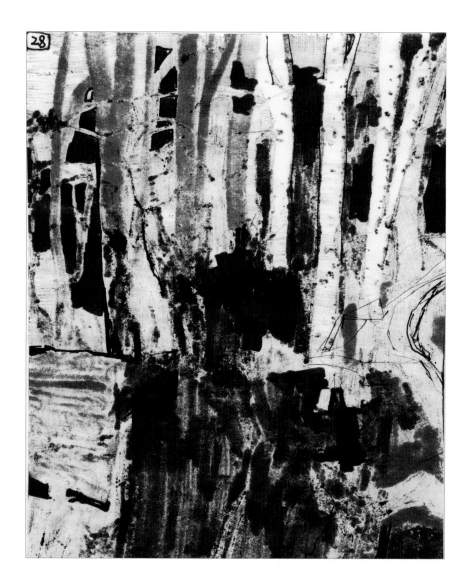

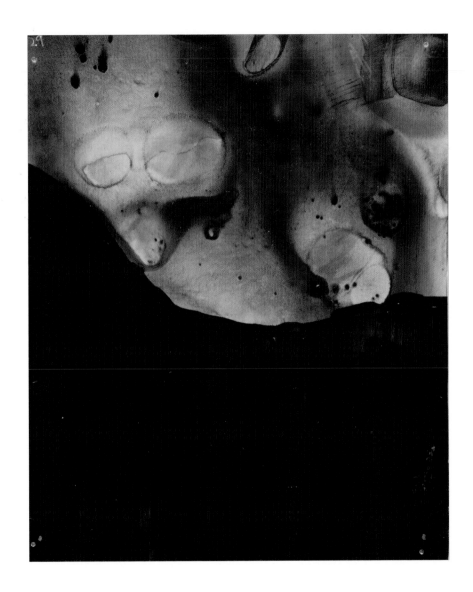

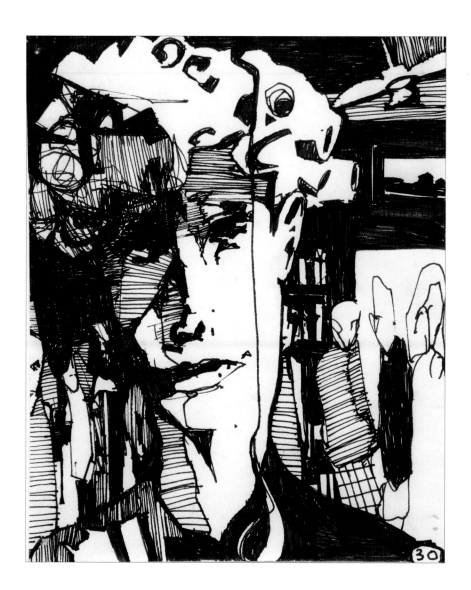

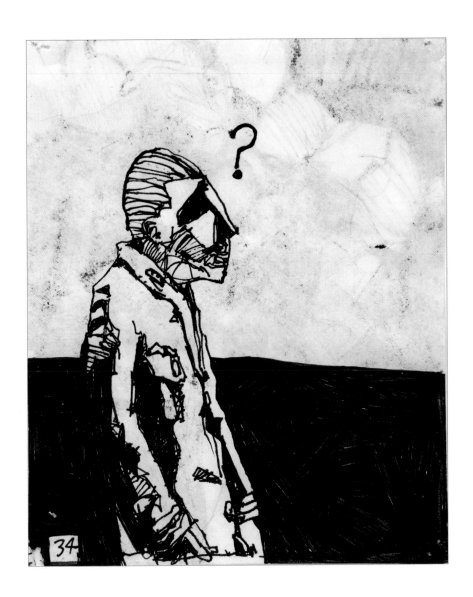

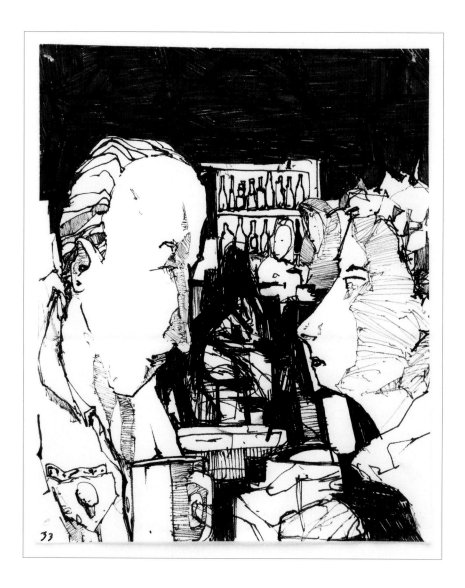

GERMAN — III

(illegible) — I

CHINESE — IIII II

(illegible) — I

Skull — IIII IIII I

(illegible) — IIII

(illegible) — II

(illegible) — IIII I

(illegible) — III

death — IIII IIII IIII III

(illegible) — IIII

(illegible) — I

(illegible) — IIII III

(illegible) — IIII I

32.

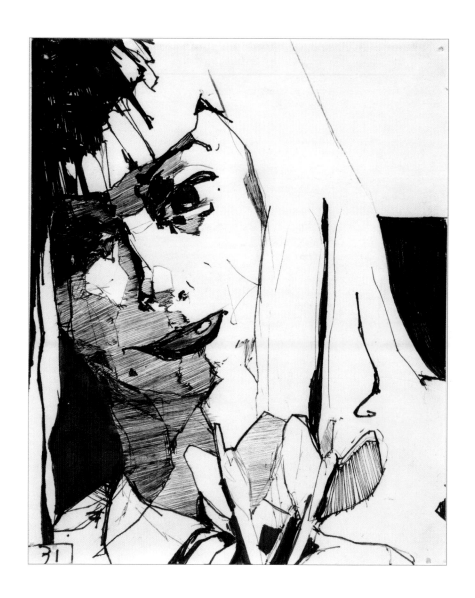

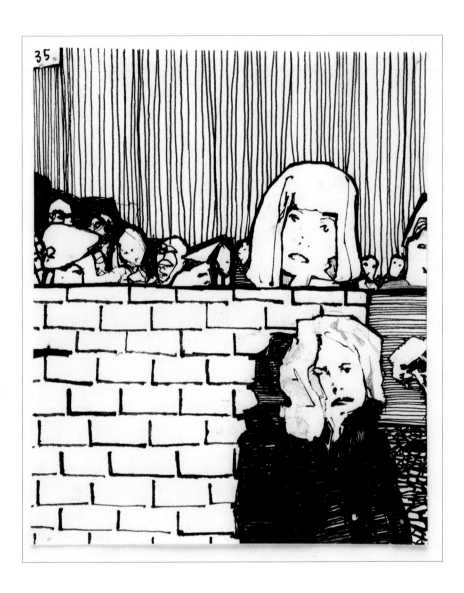

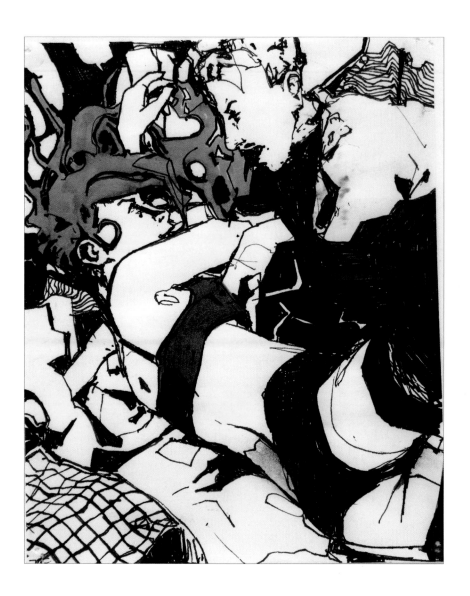

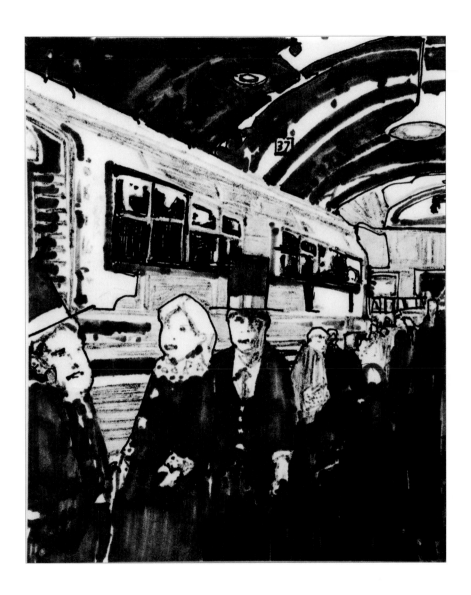

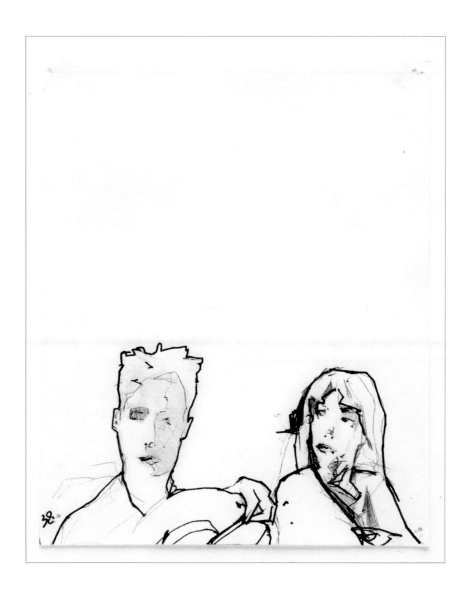

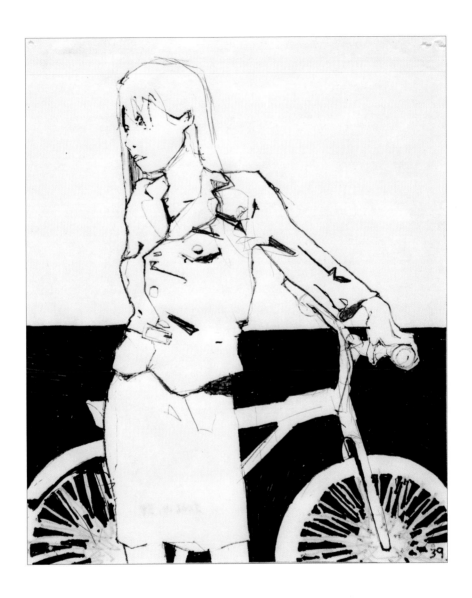

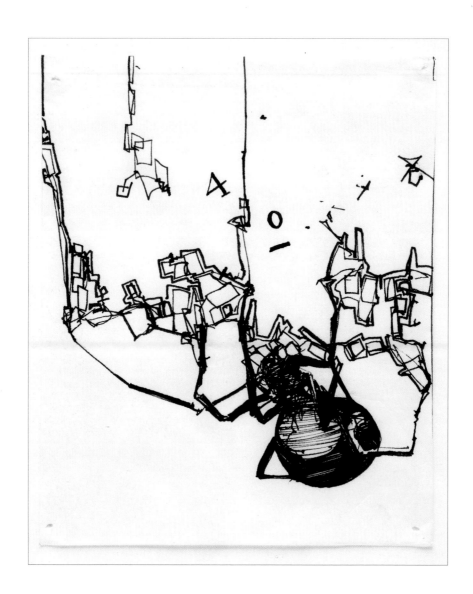

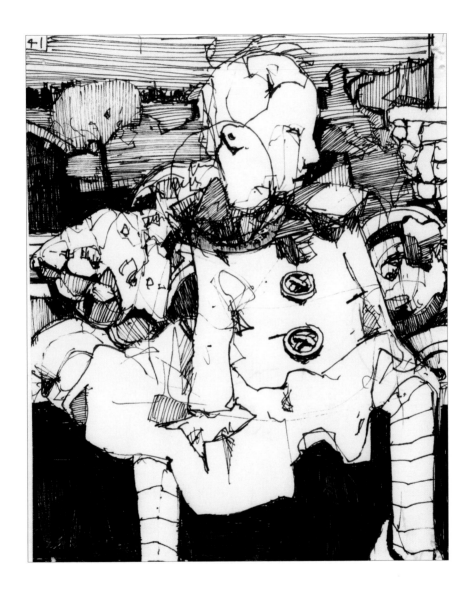

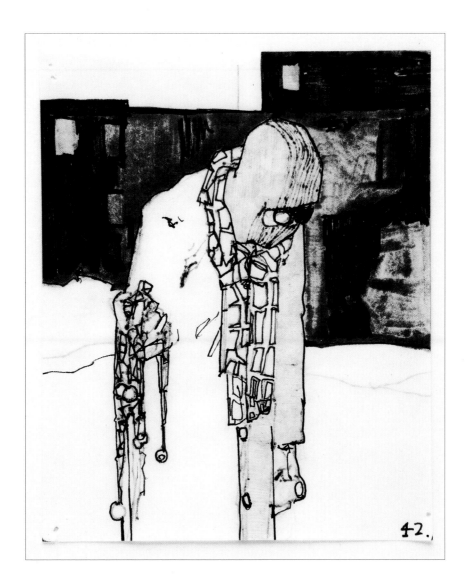

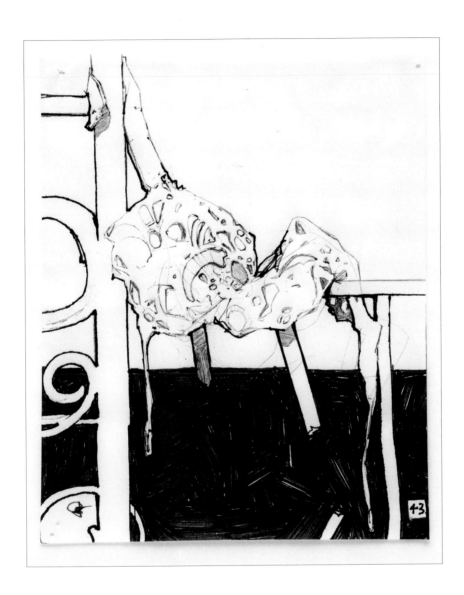

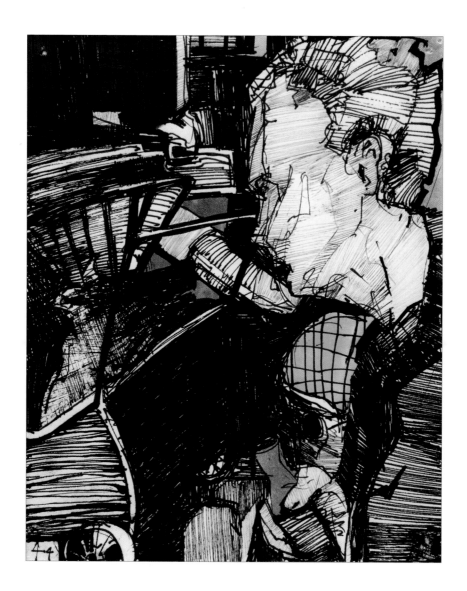

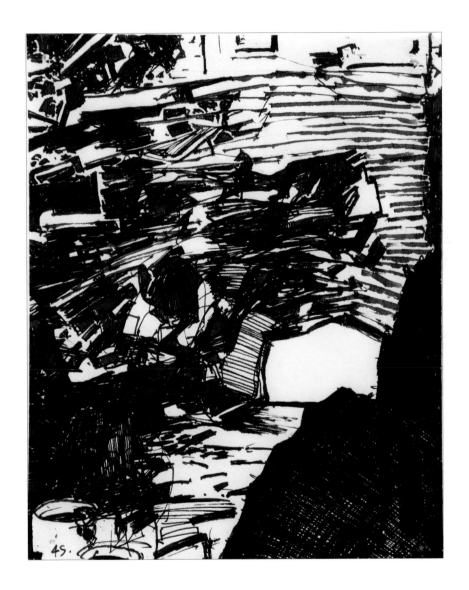

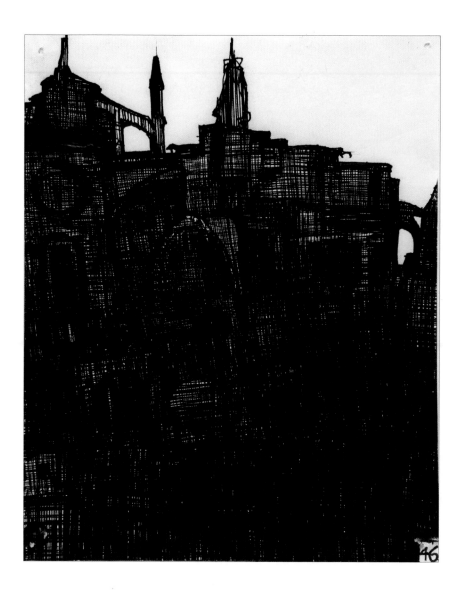

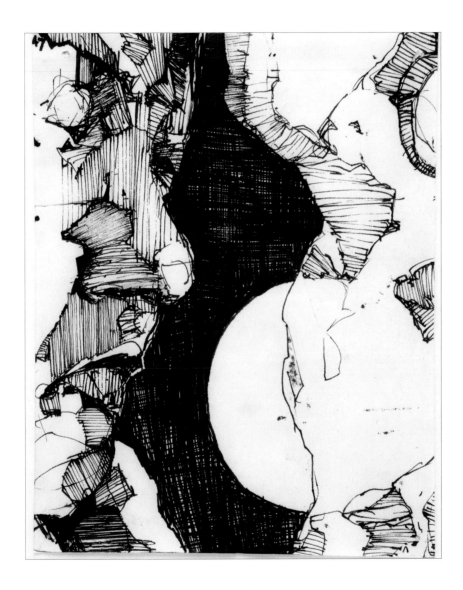

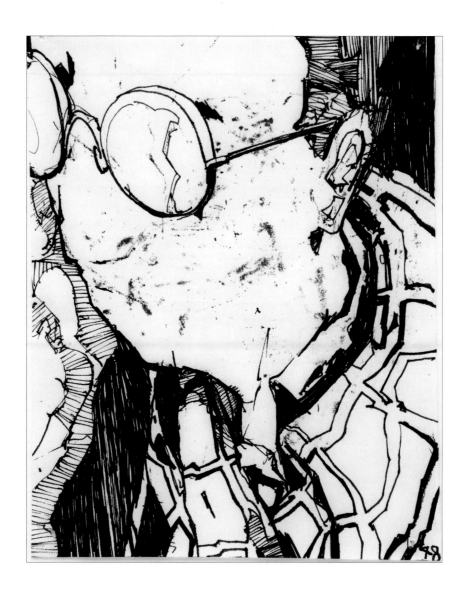

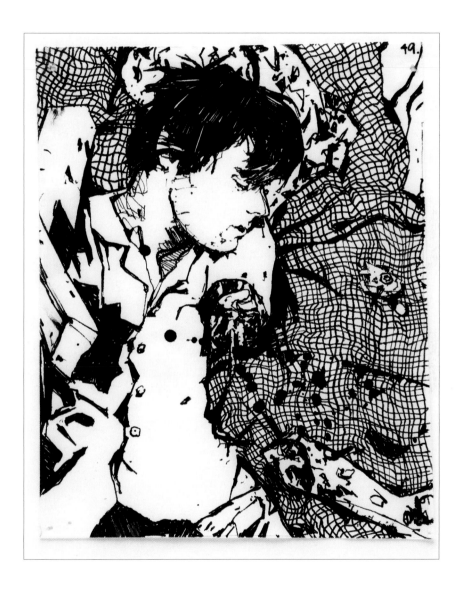

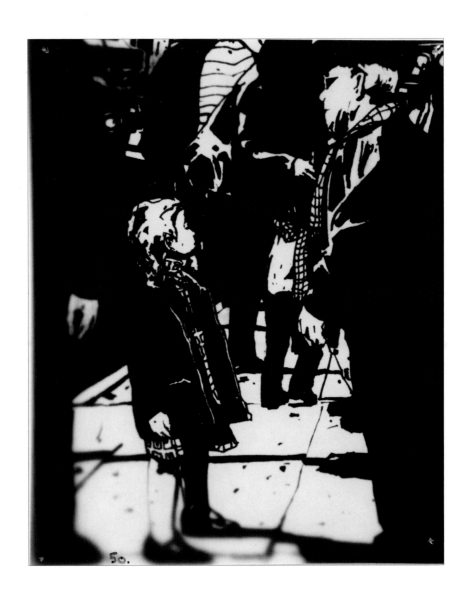

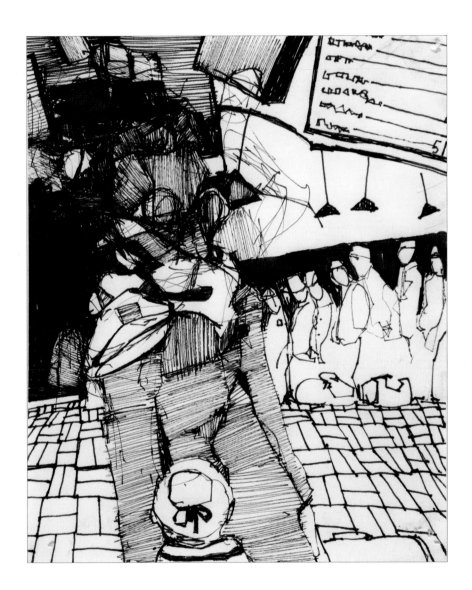

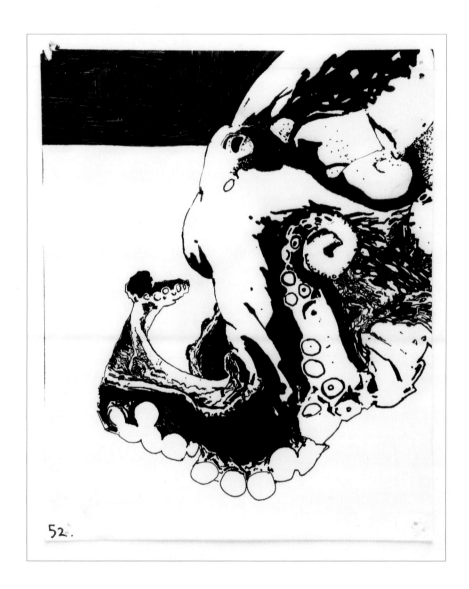

52.

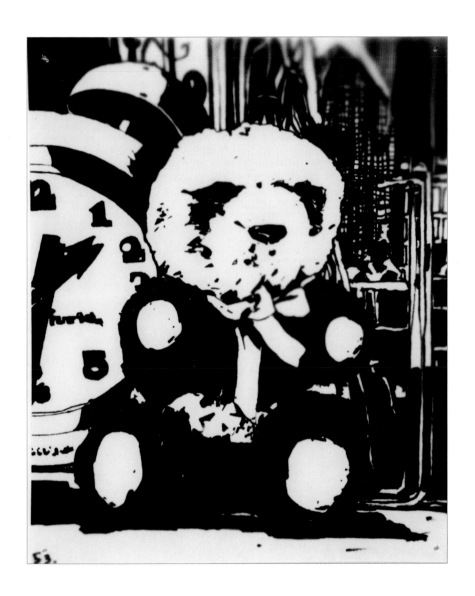

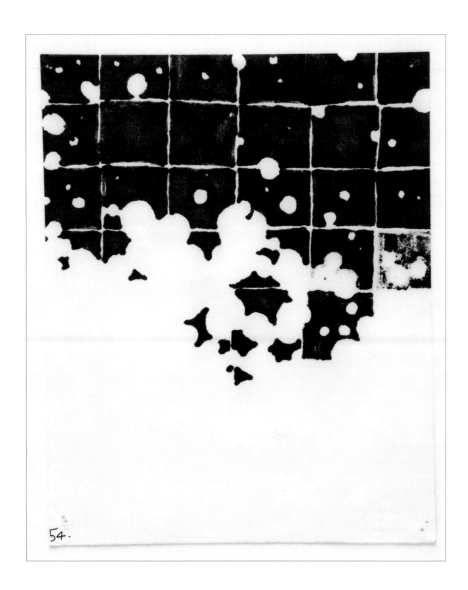

54.

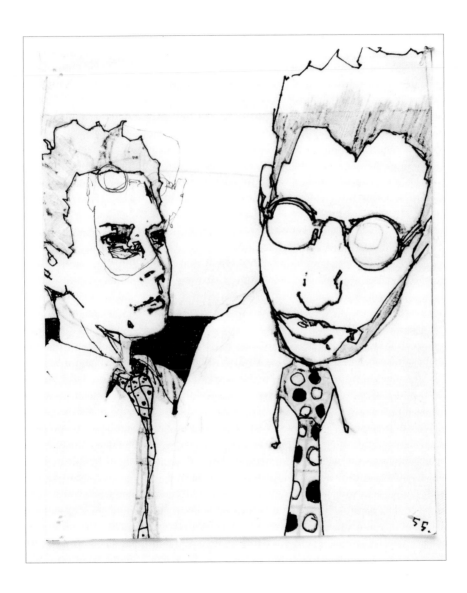

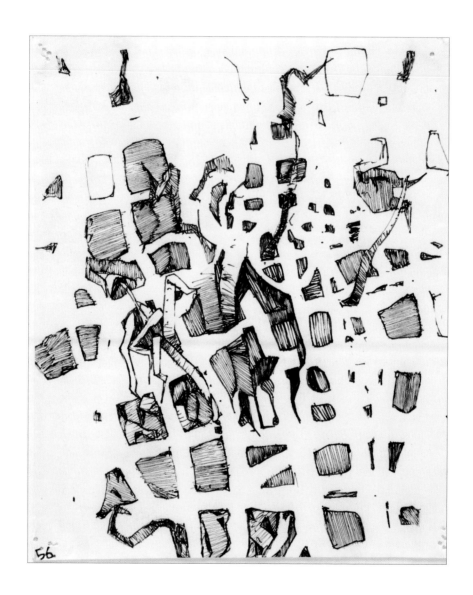

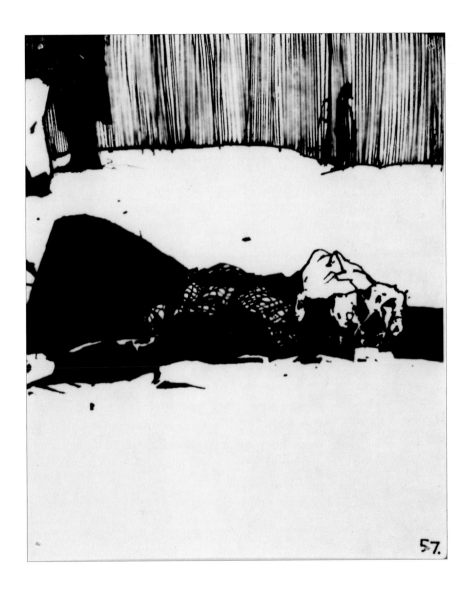

57.

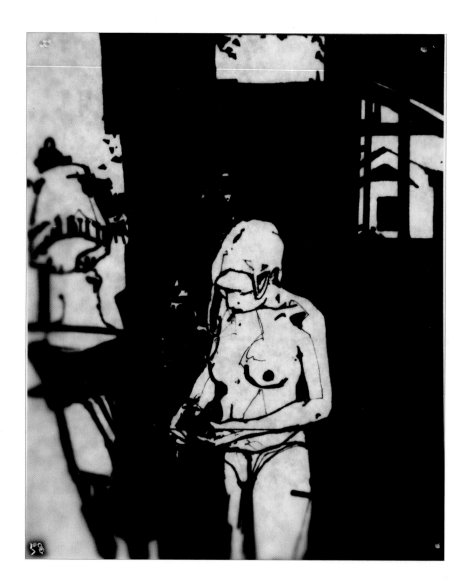

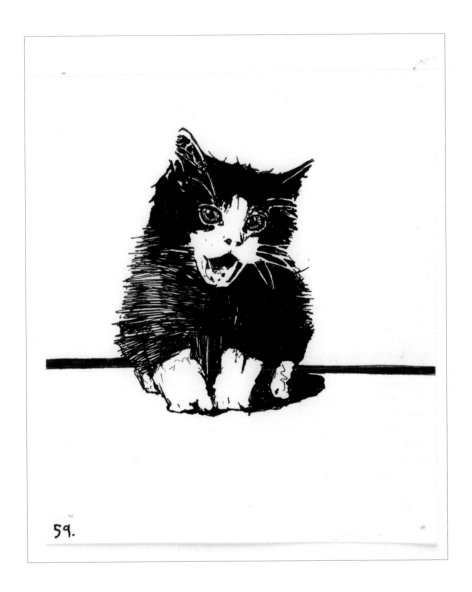

59.

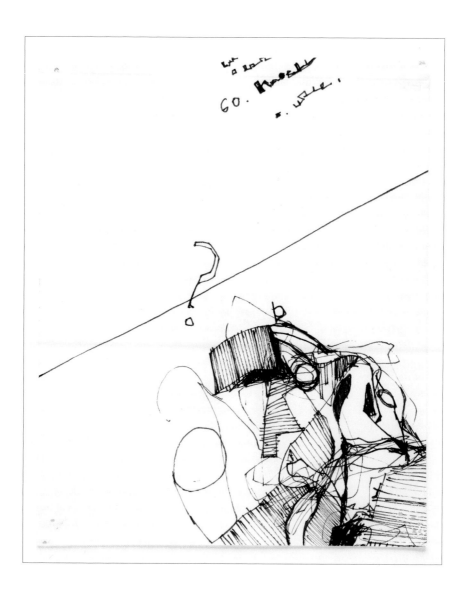

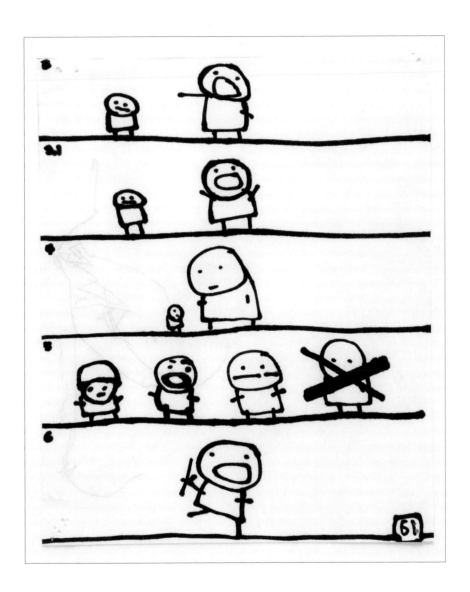

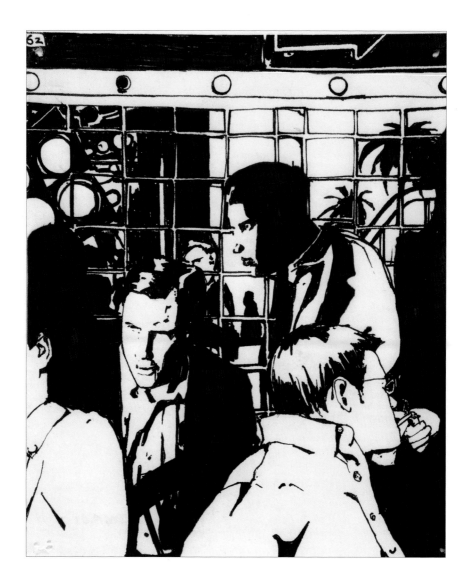

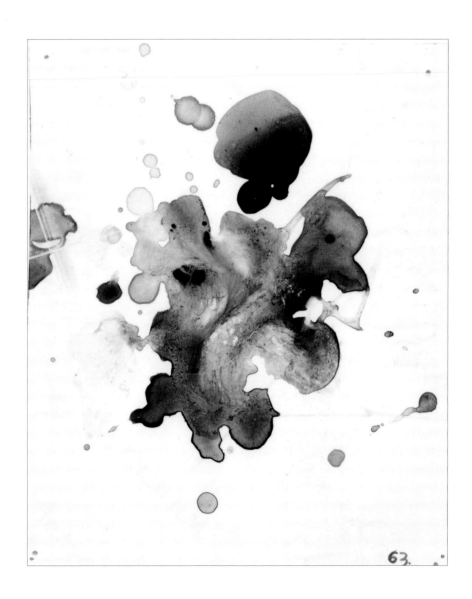

63.

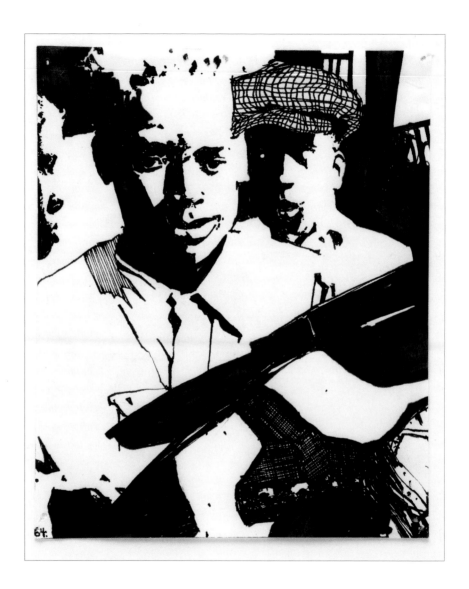

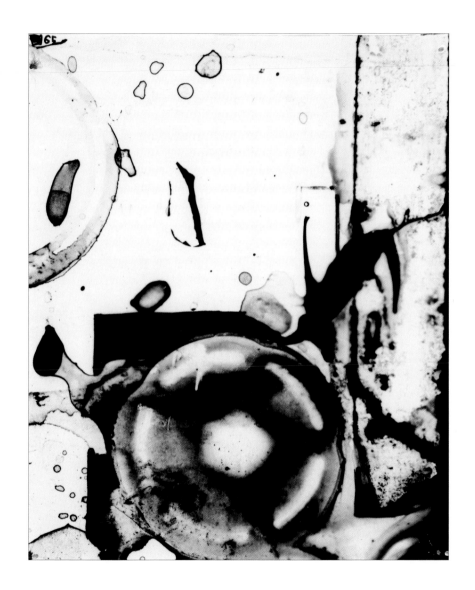

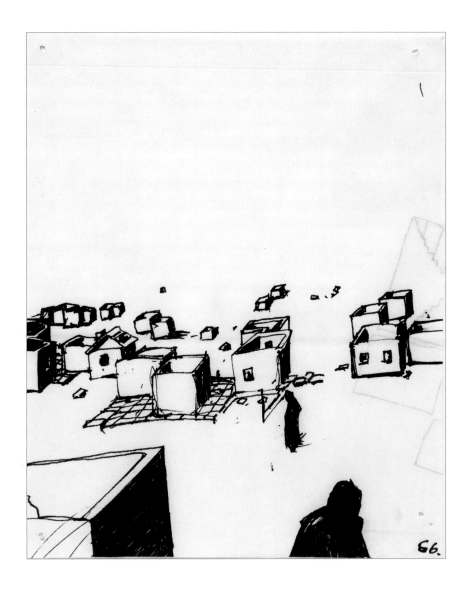

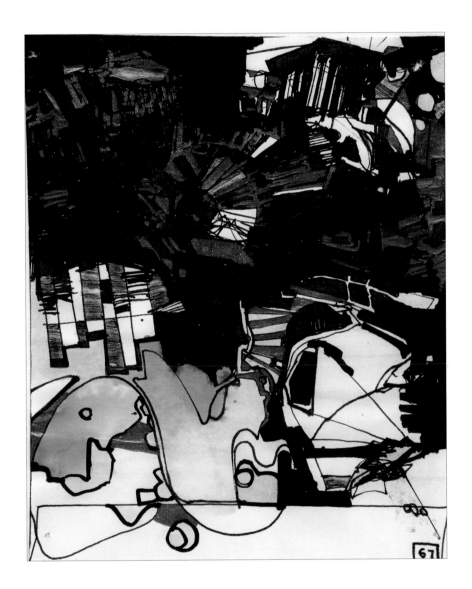

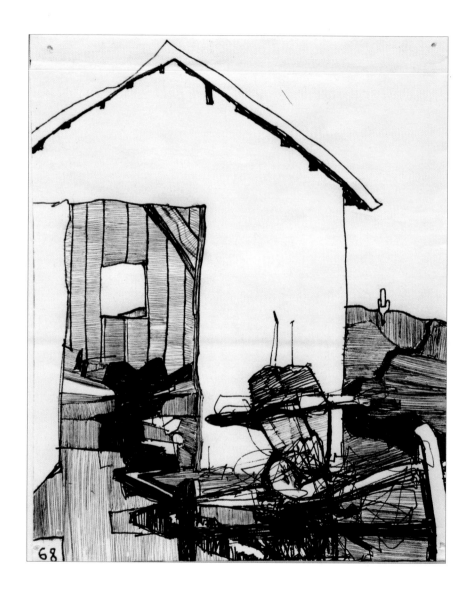

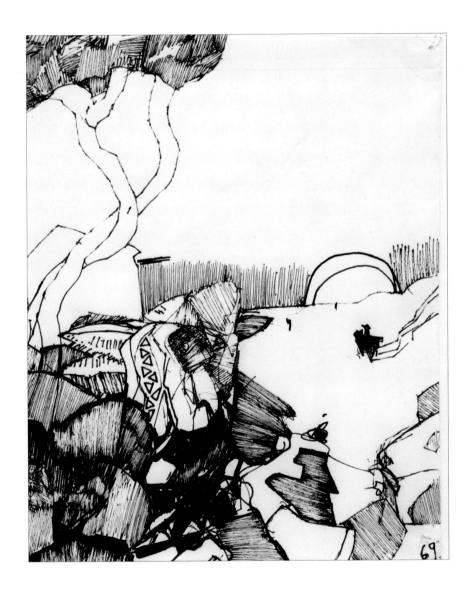

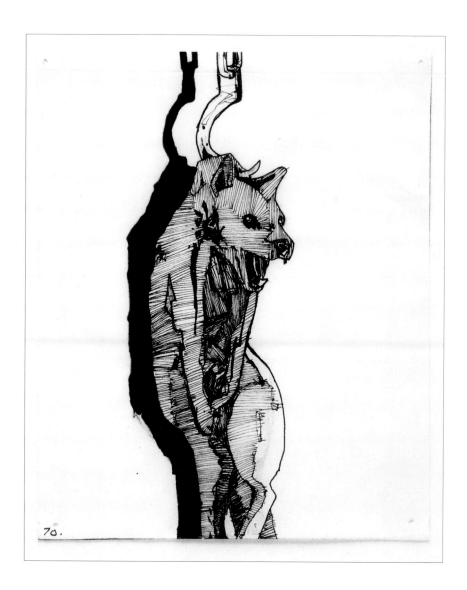

70.

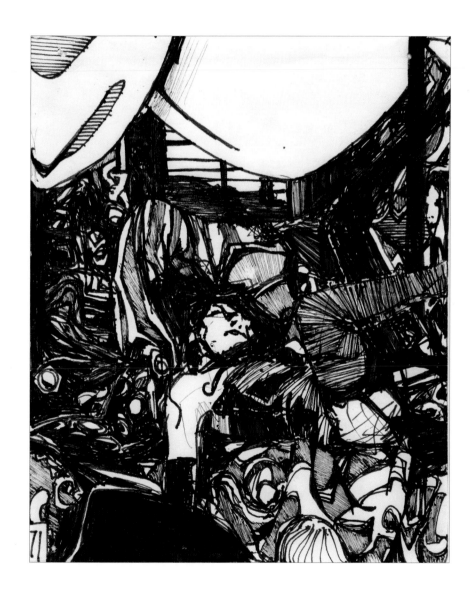

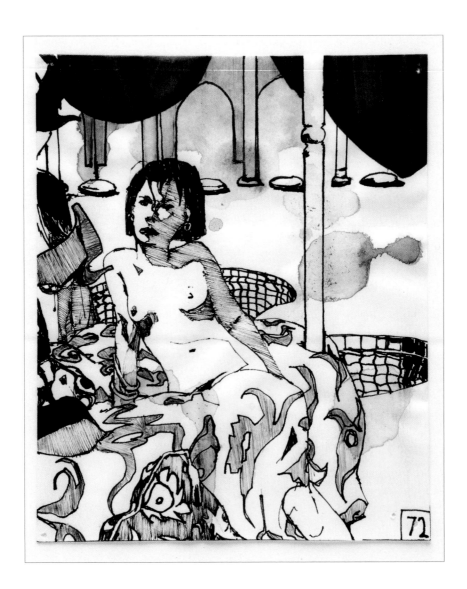

72

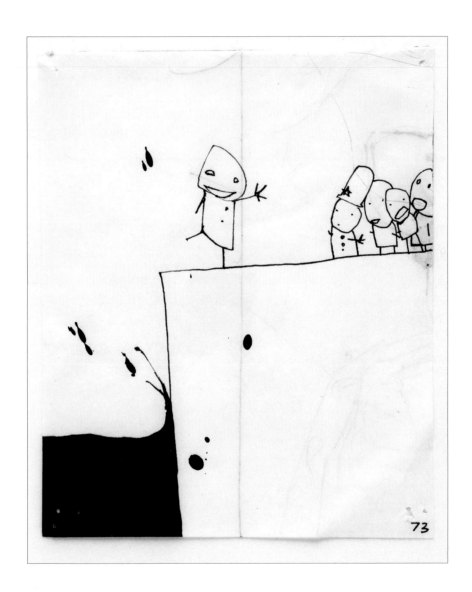

73

74

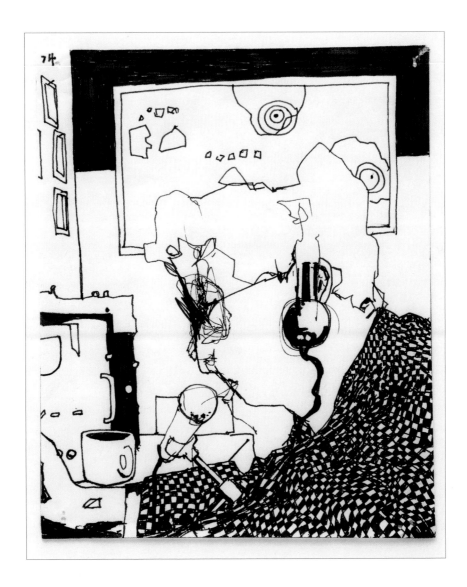

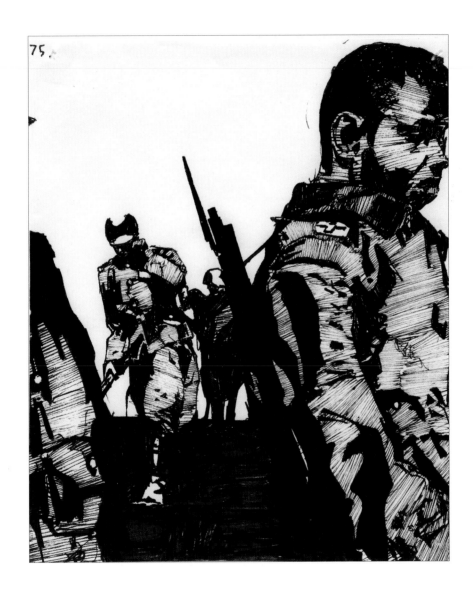

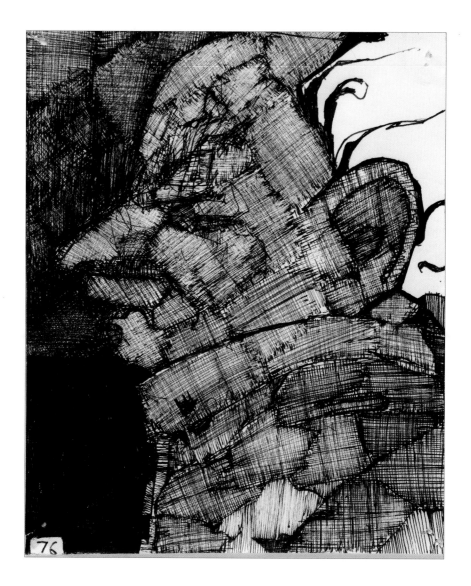

76

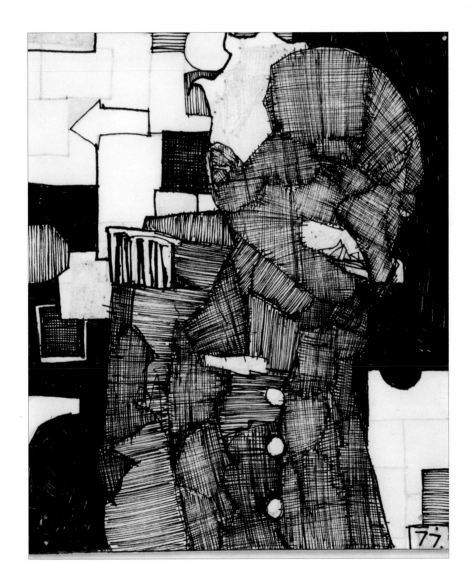

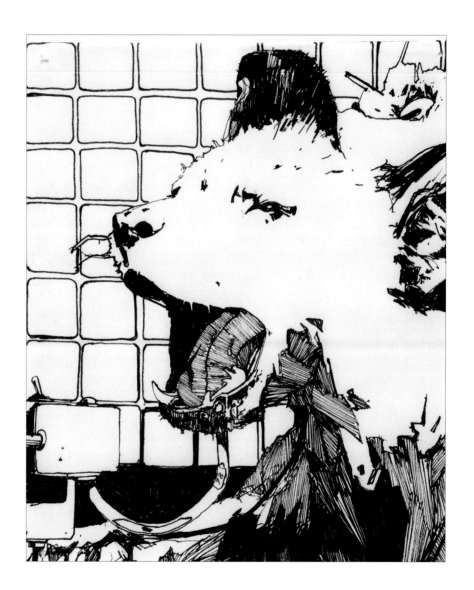

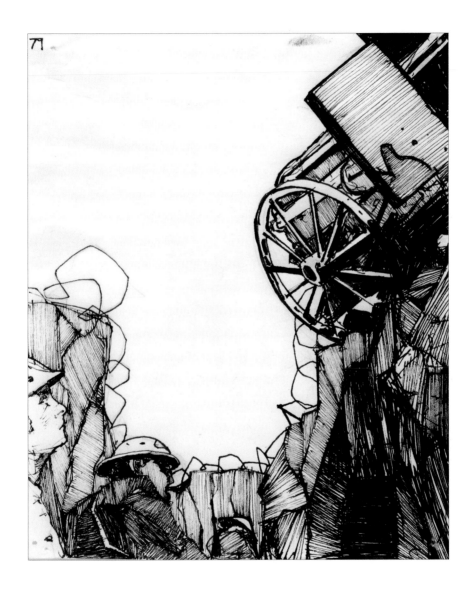

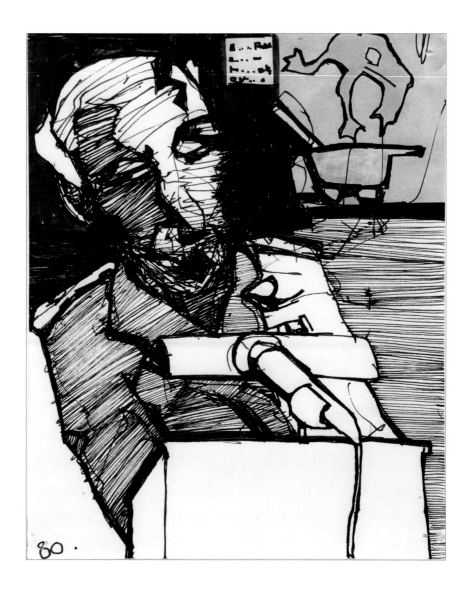

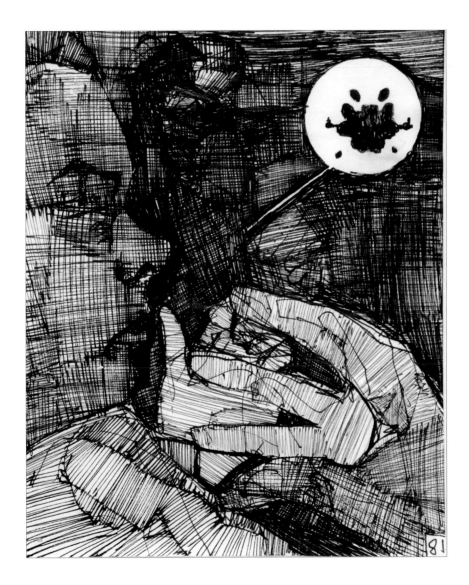

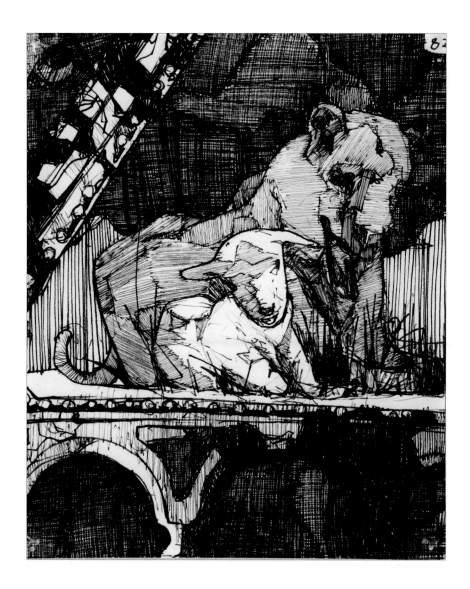

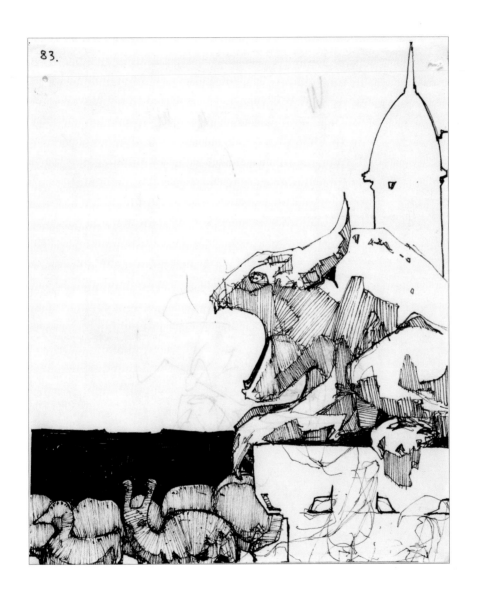

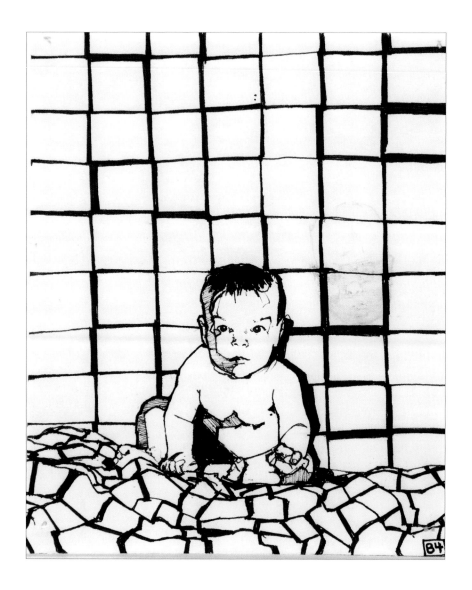

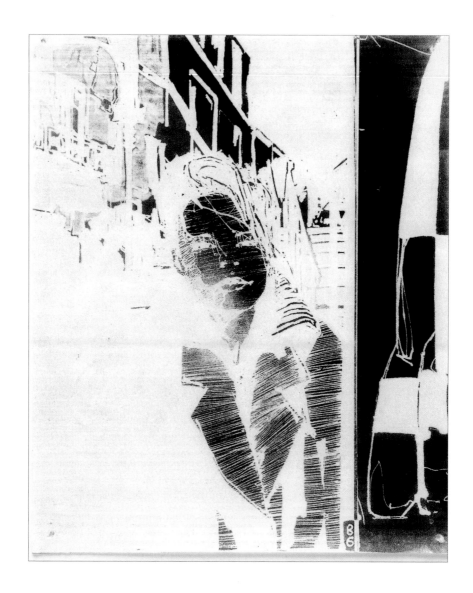

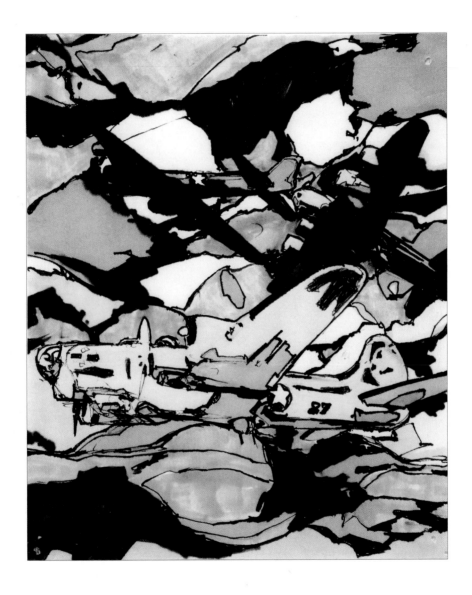

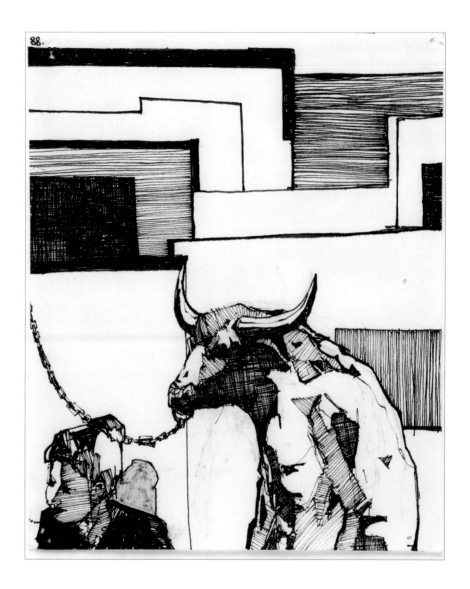

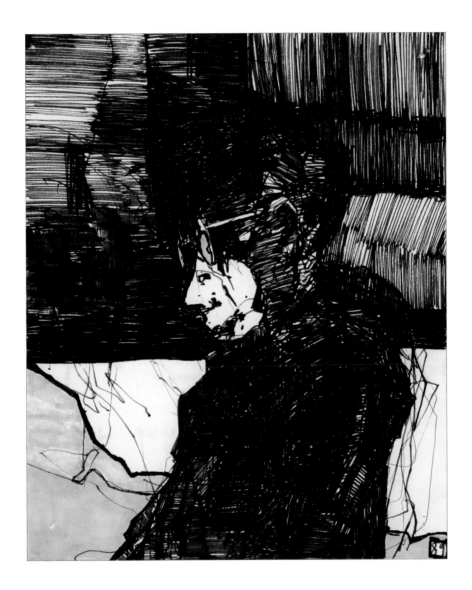

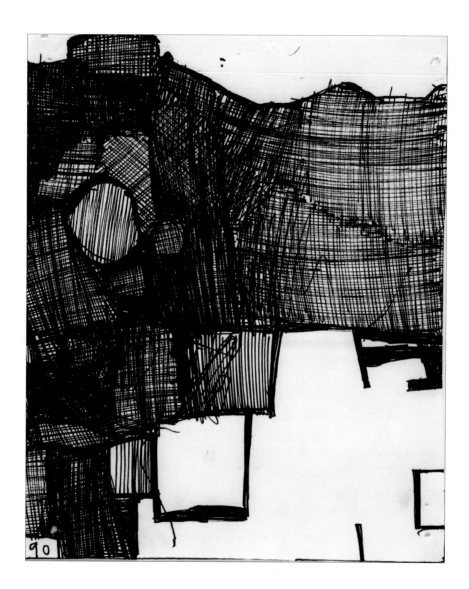

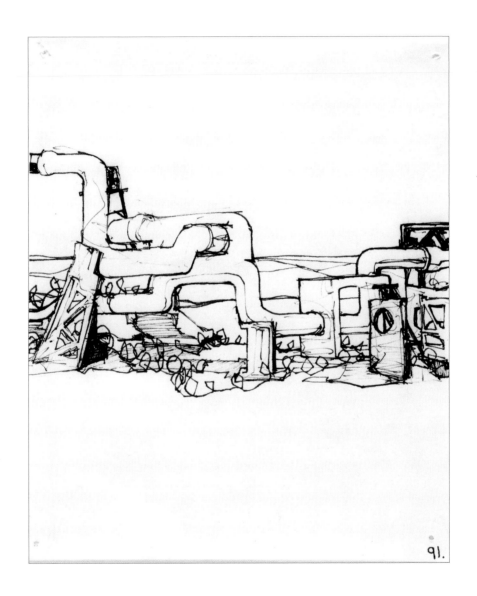

91.

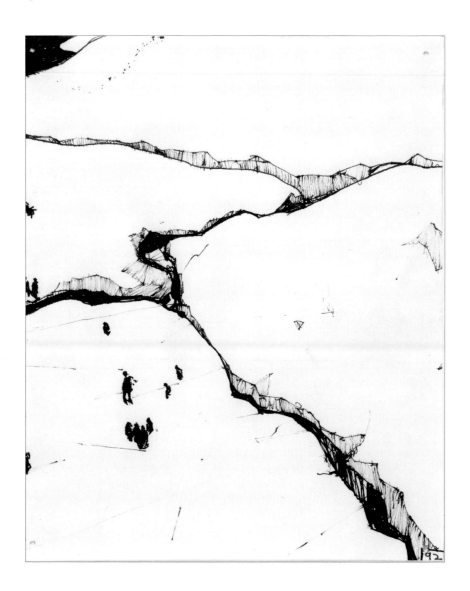

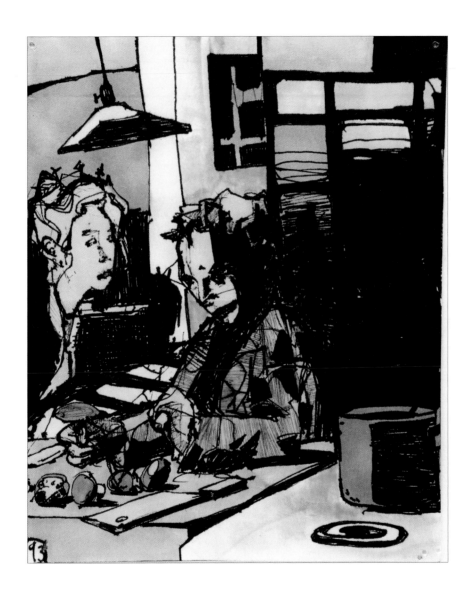

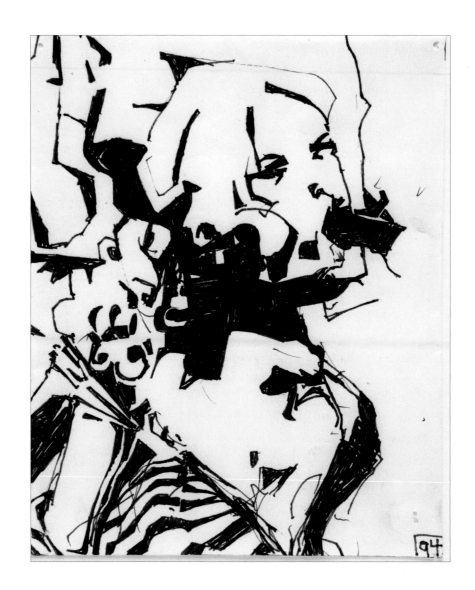

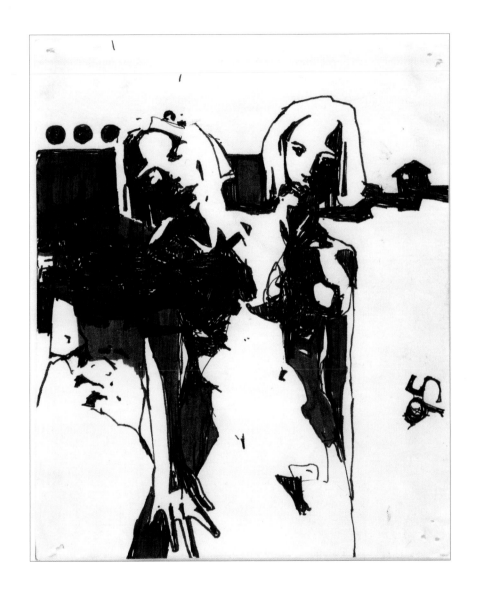

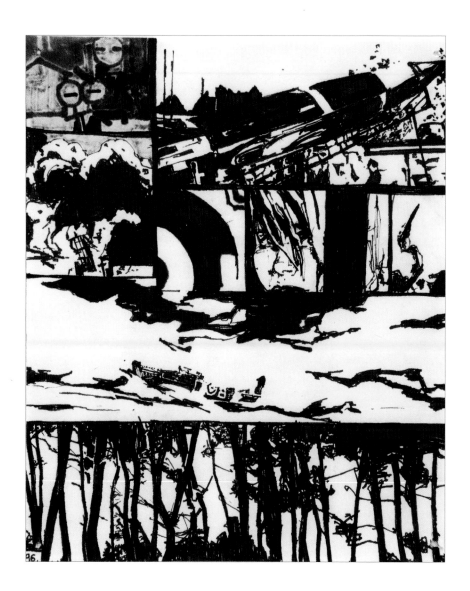

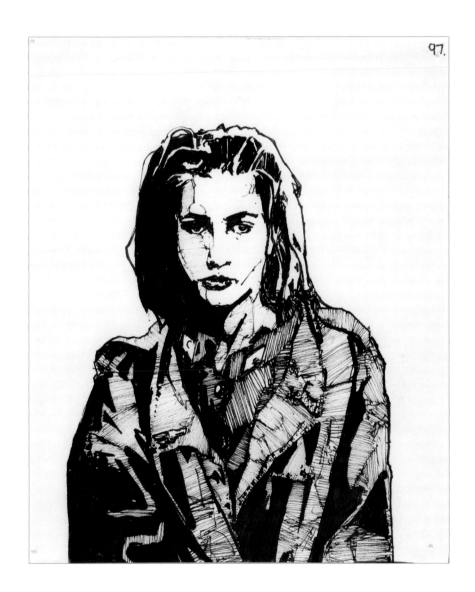

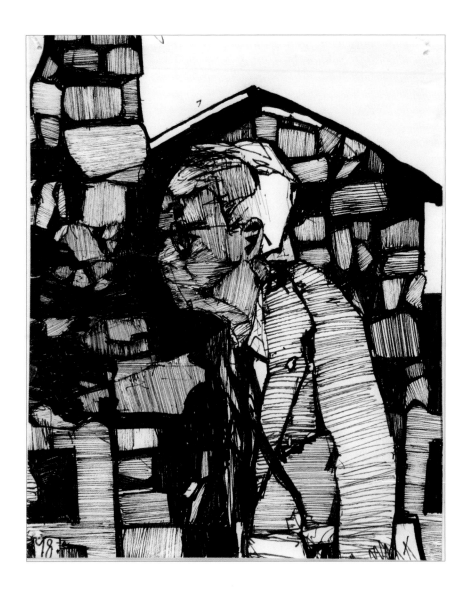

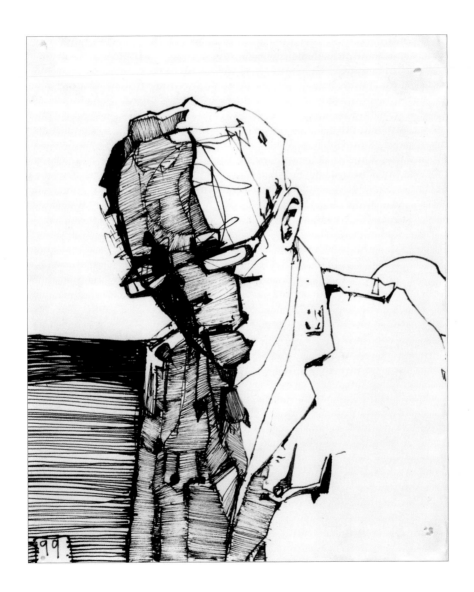

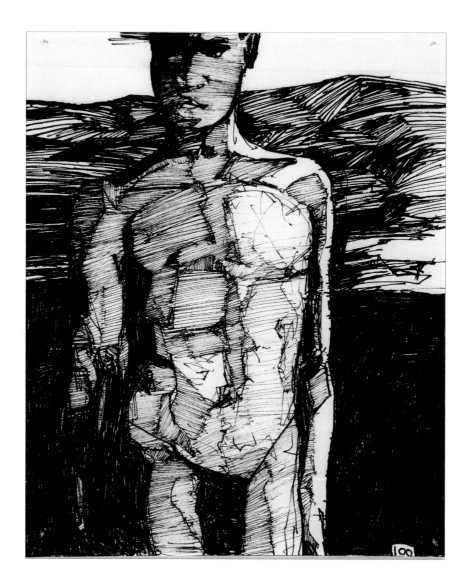

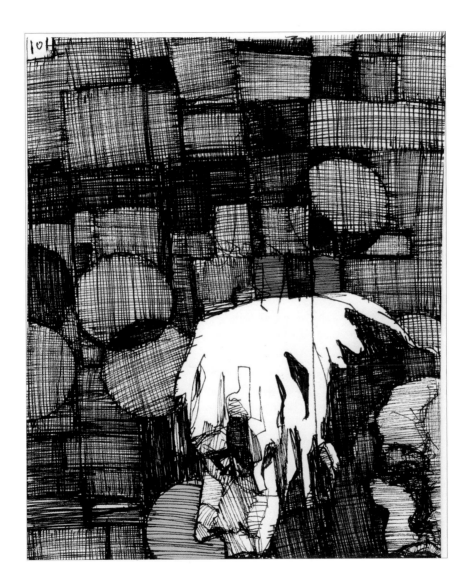

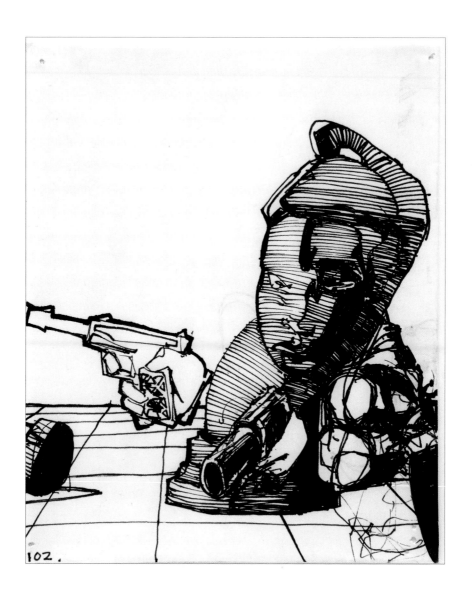

102.

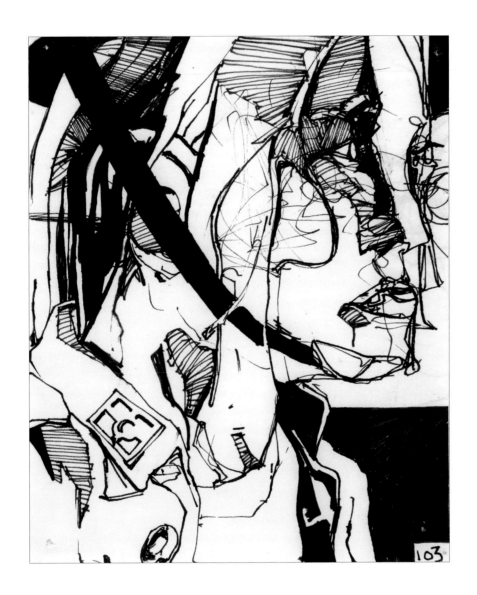

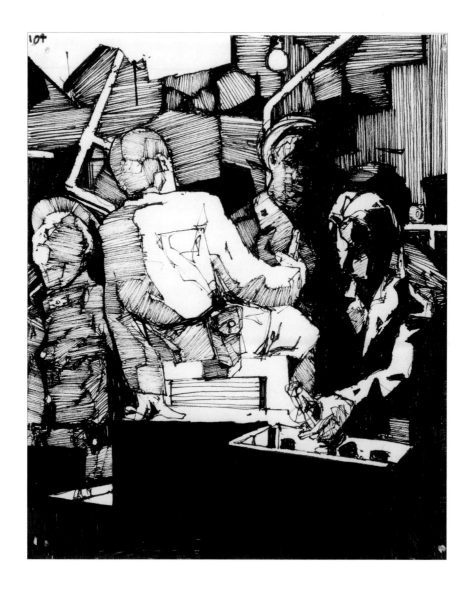

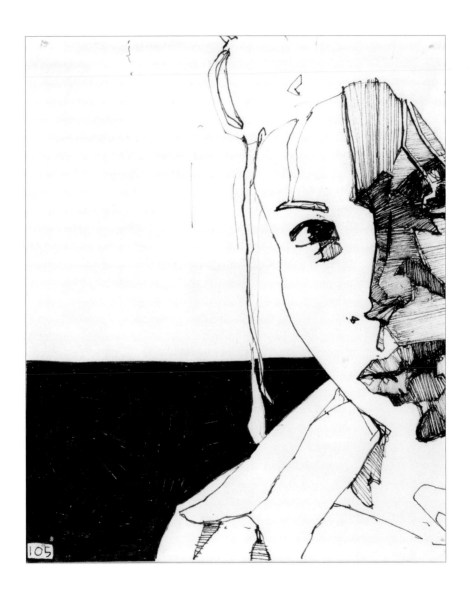

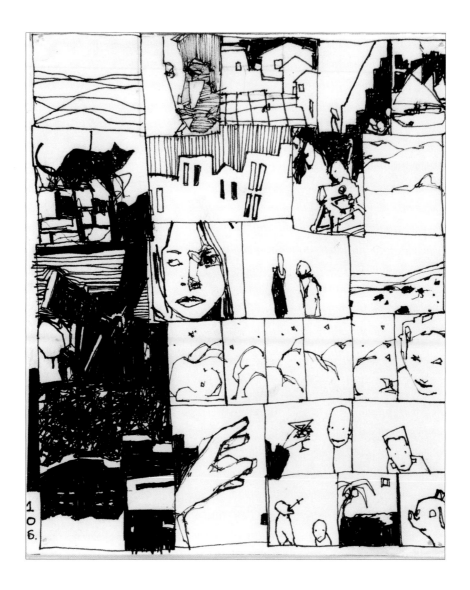

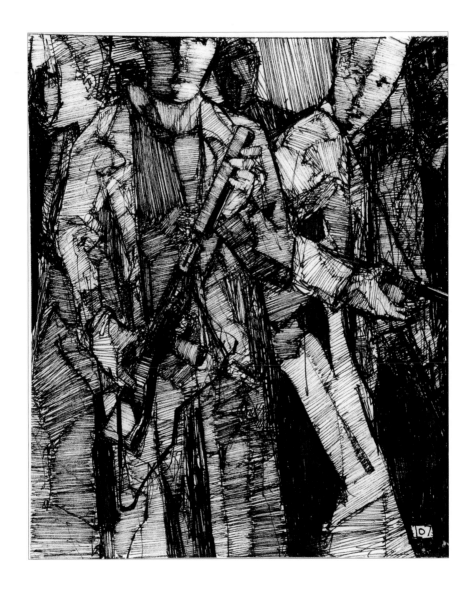

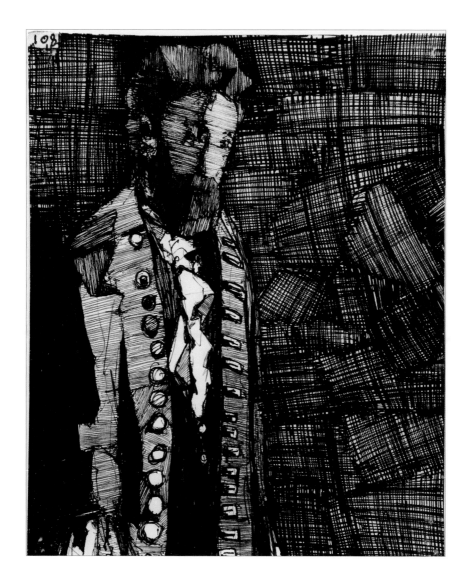

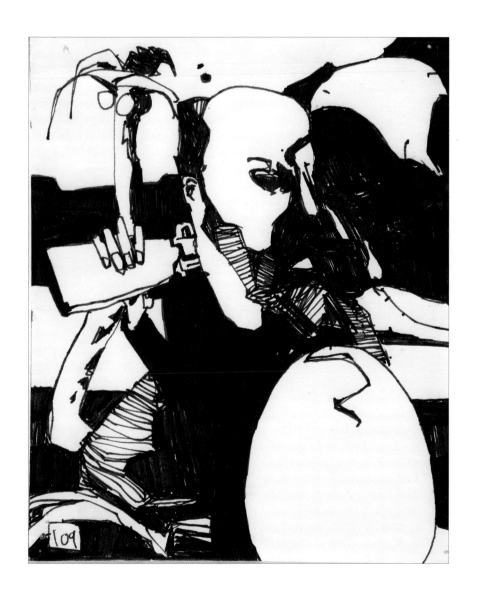

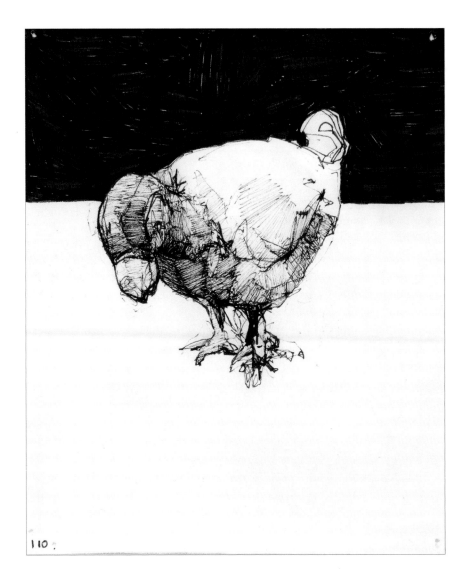

110 :

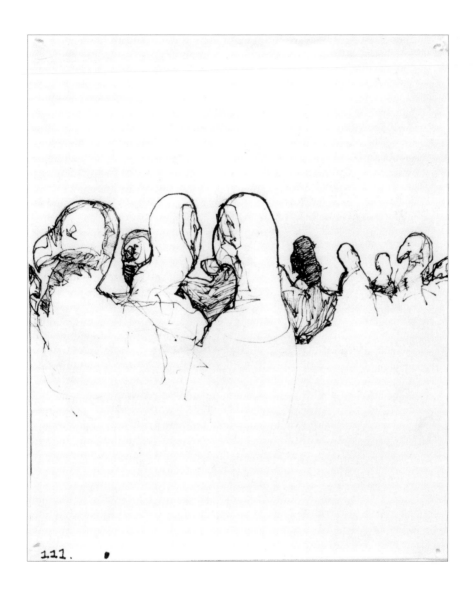

111.

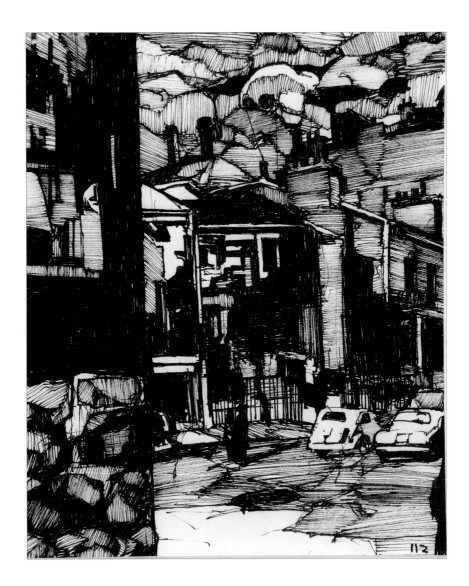

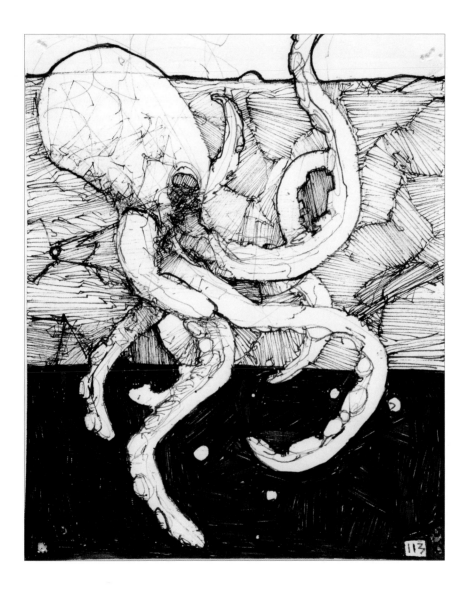

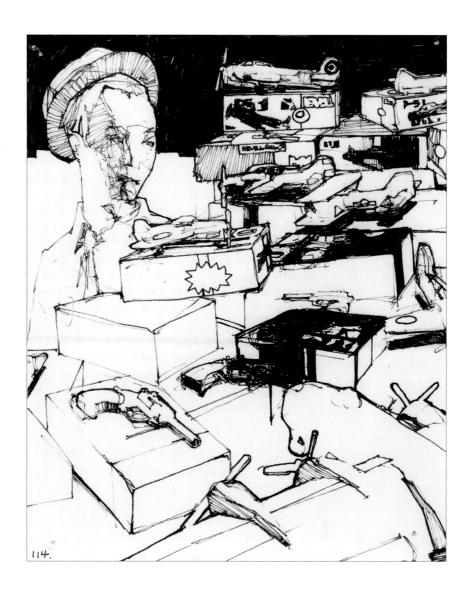

114.

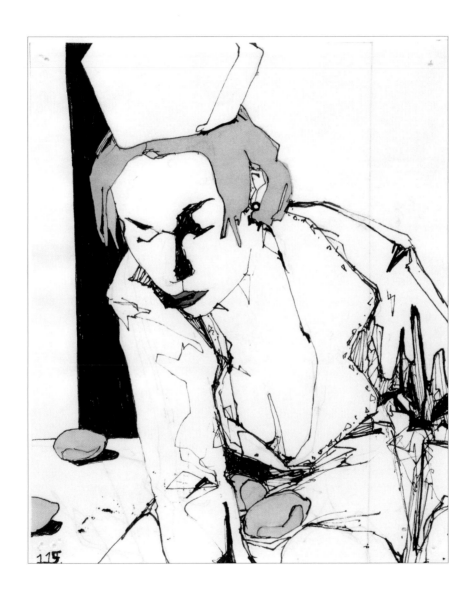

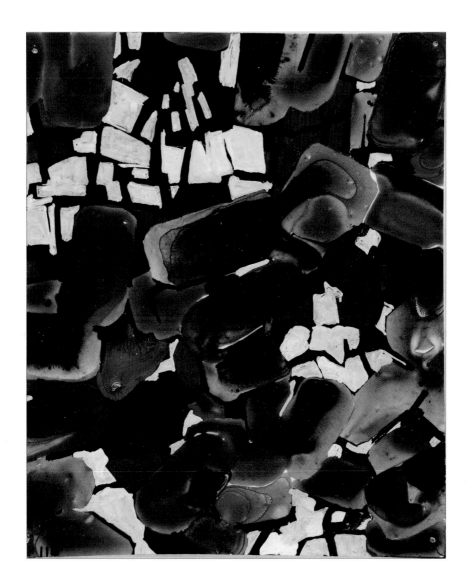

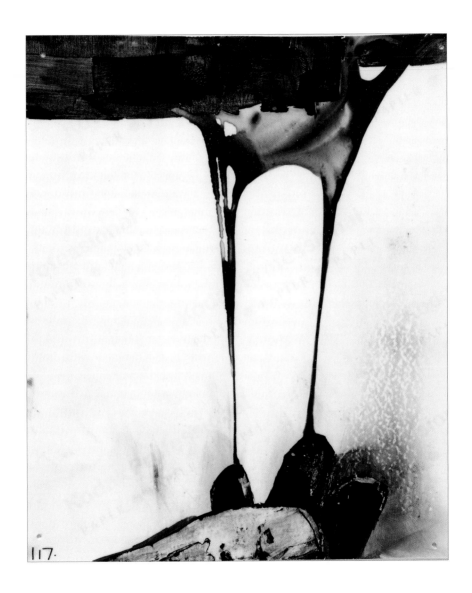

117.

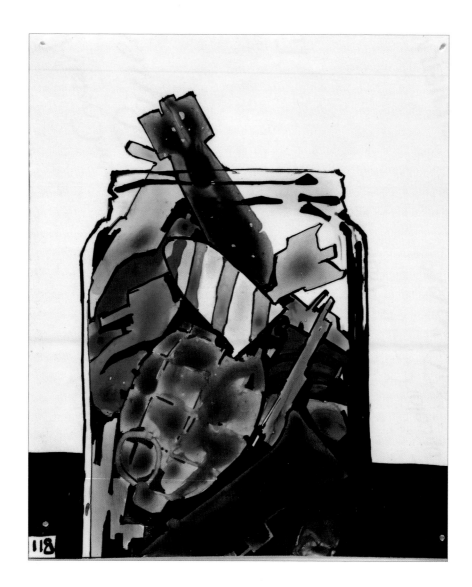

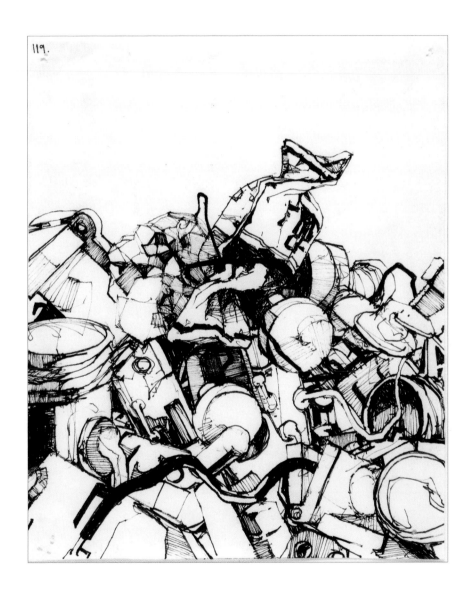

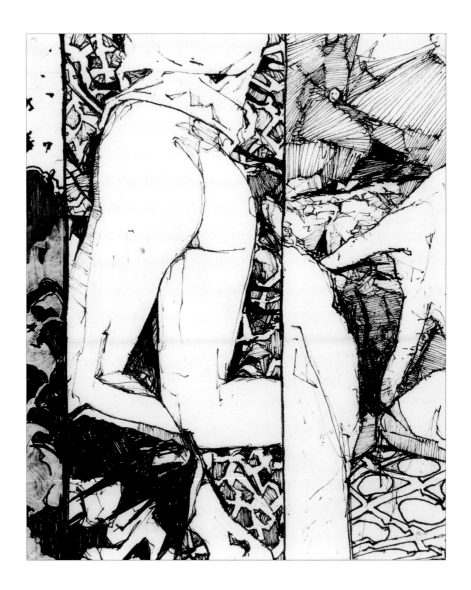

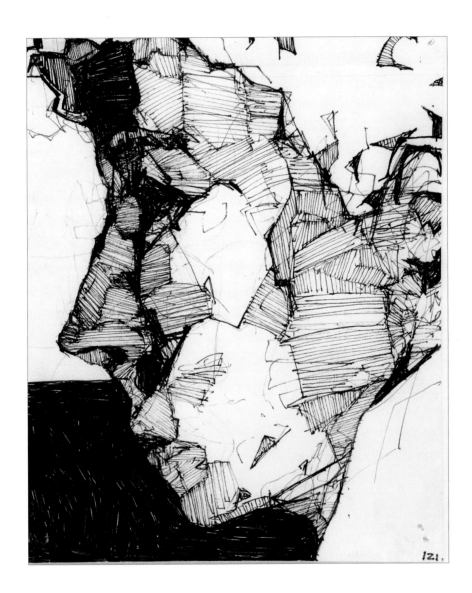

121.

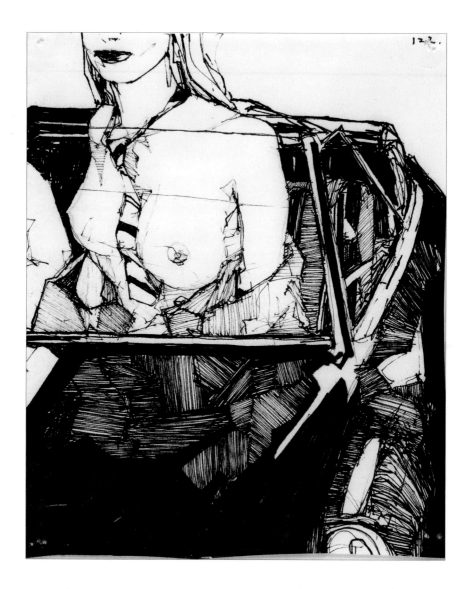

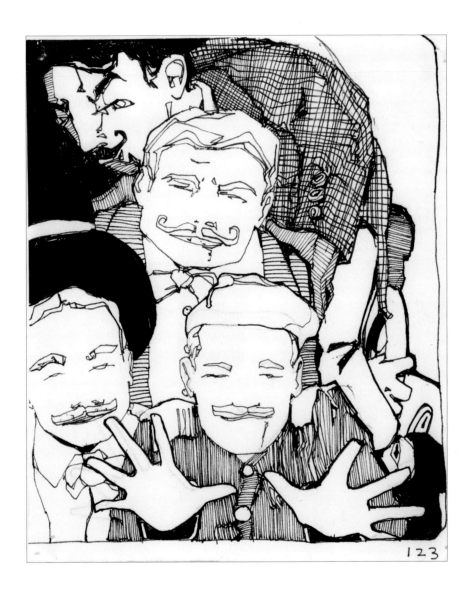

123

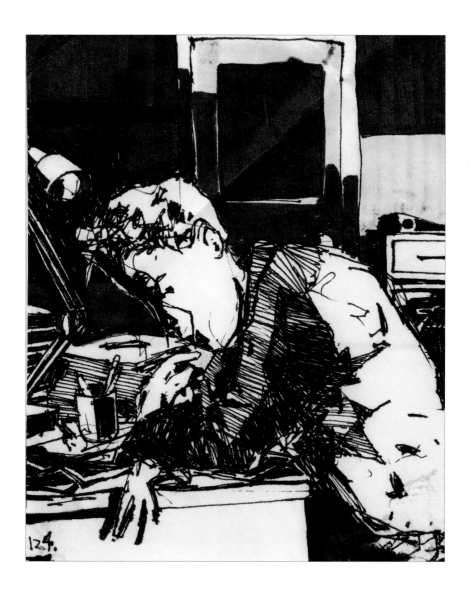

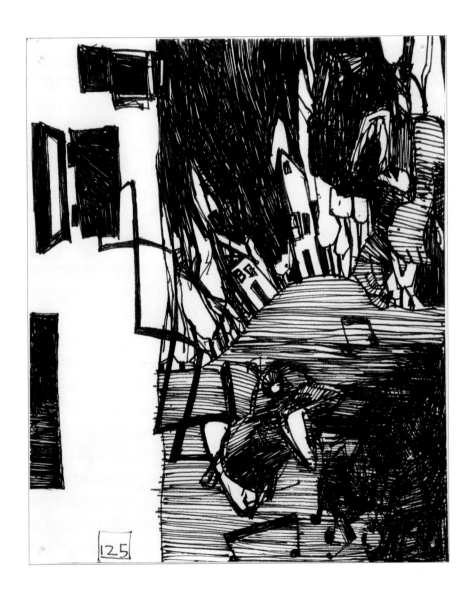

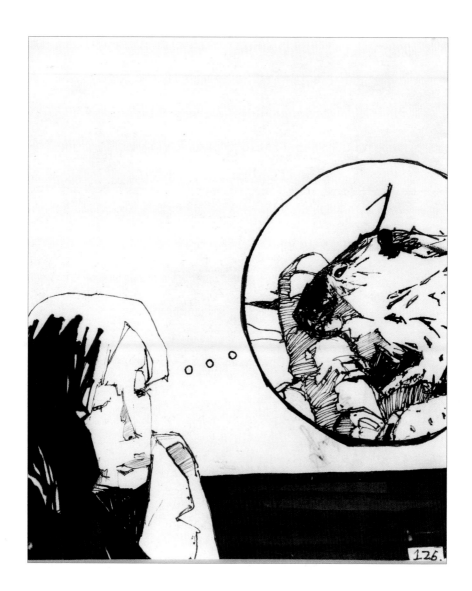

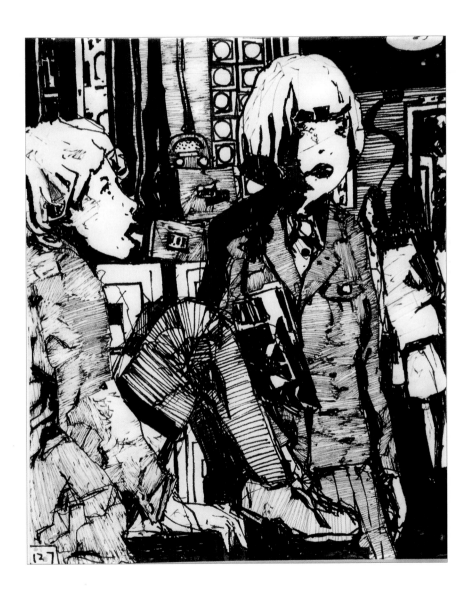

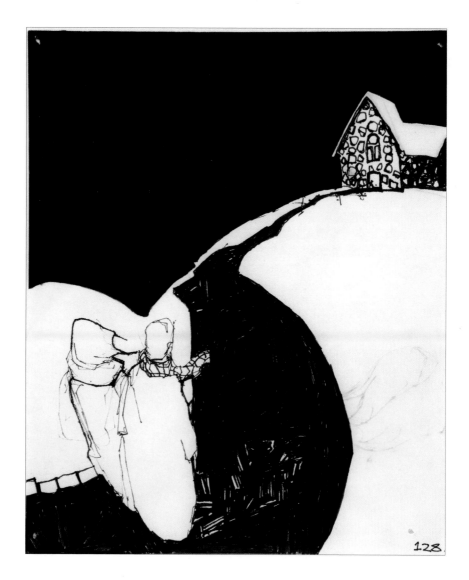

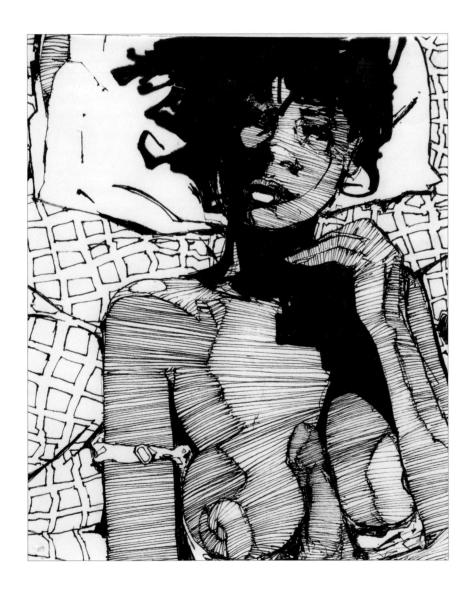

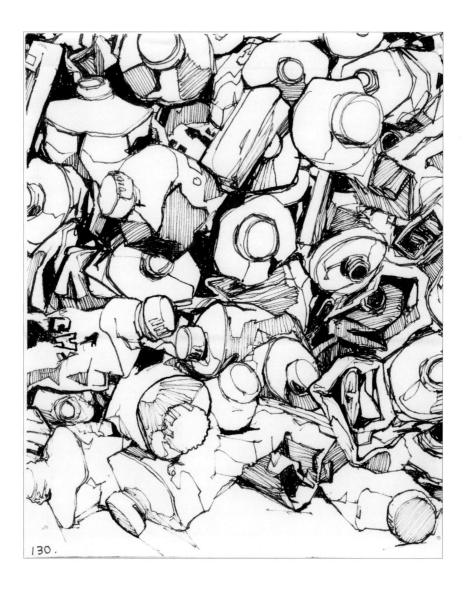

130.

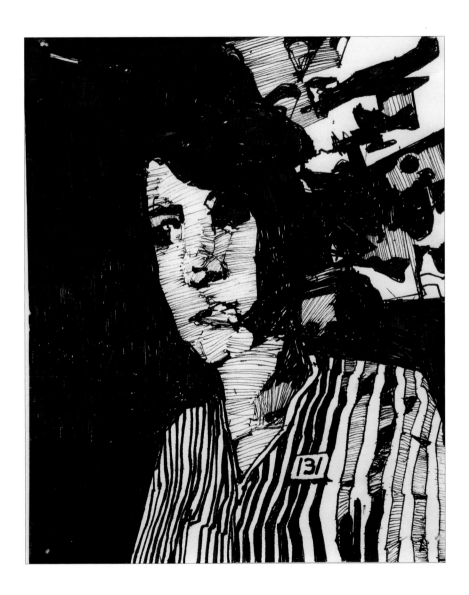

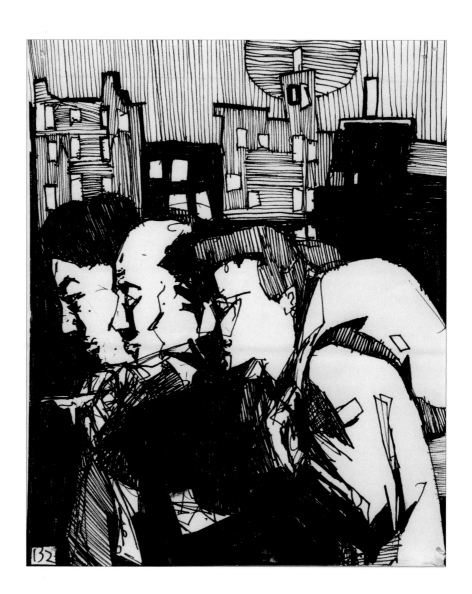

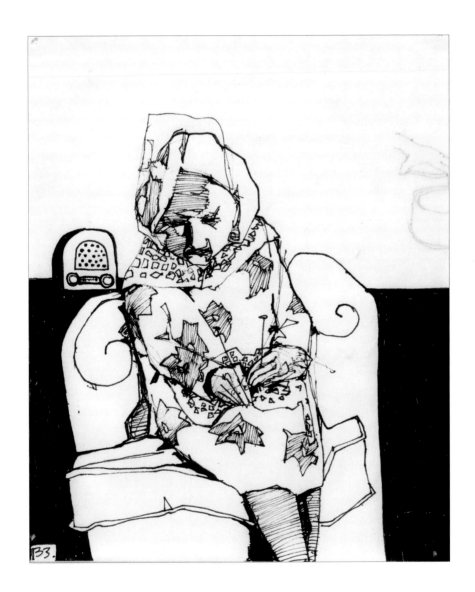

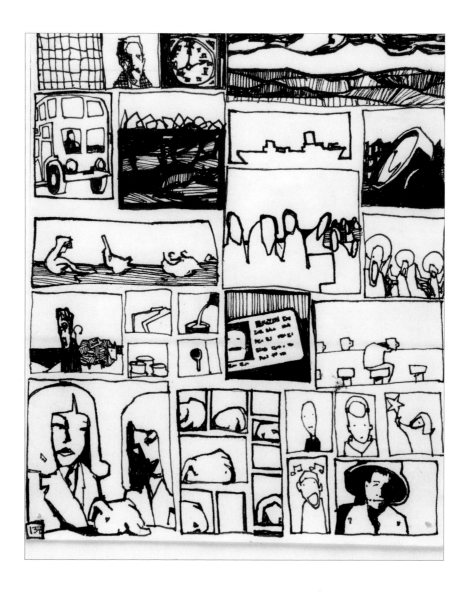

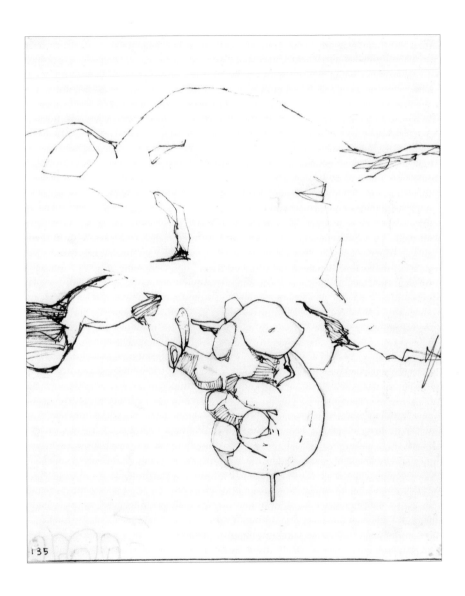

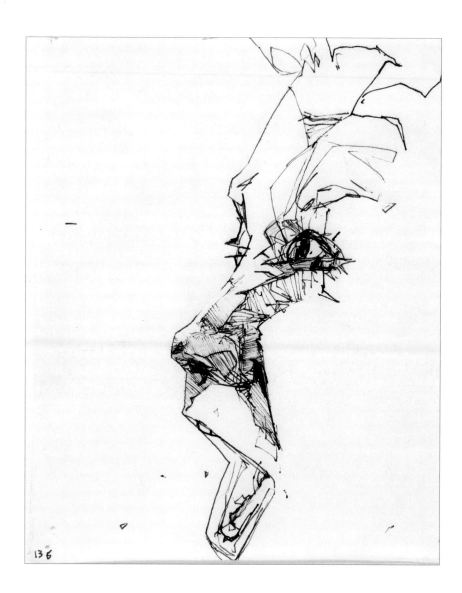

136

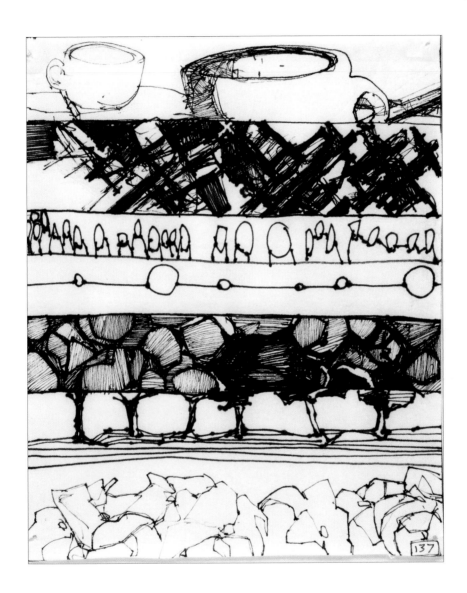

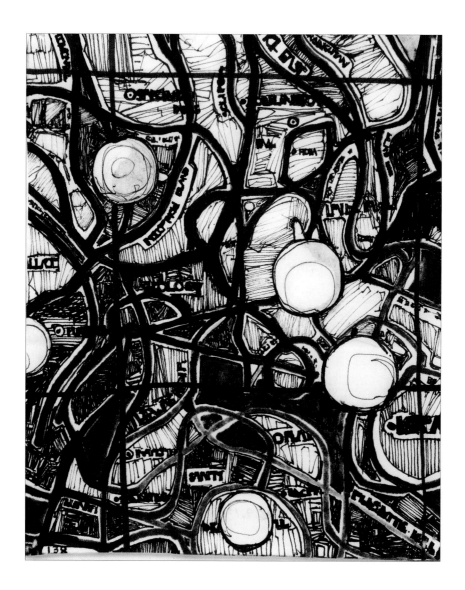

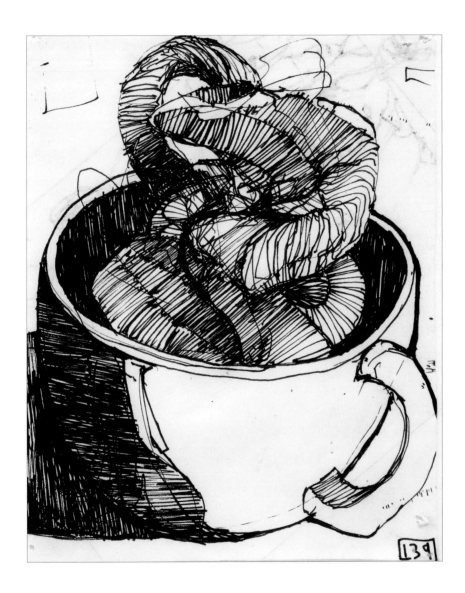

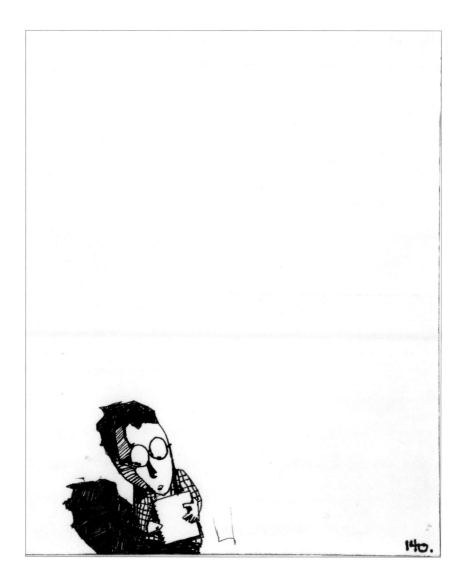

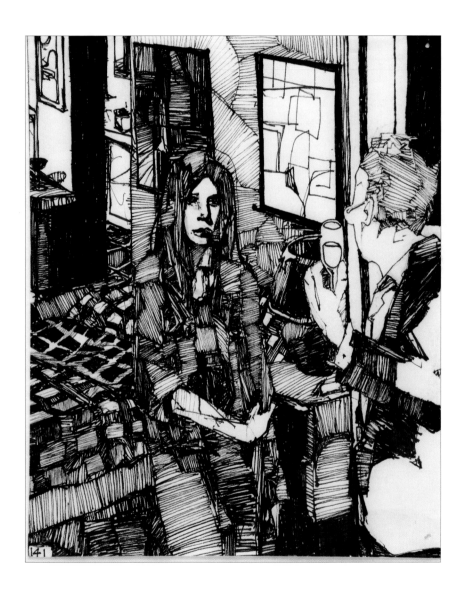

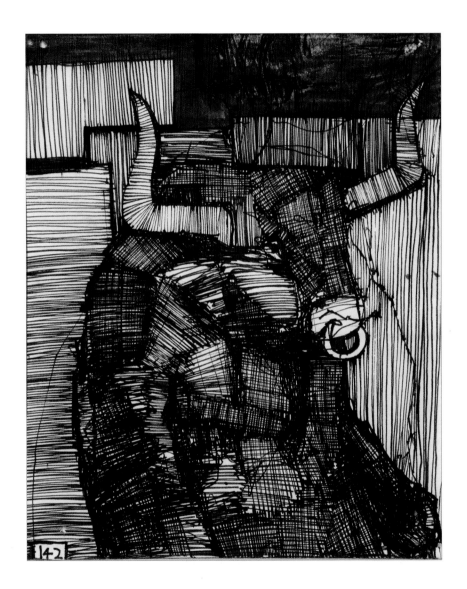

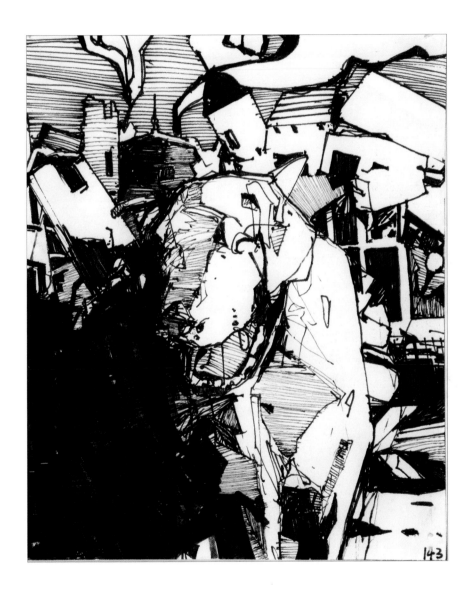

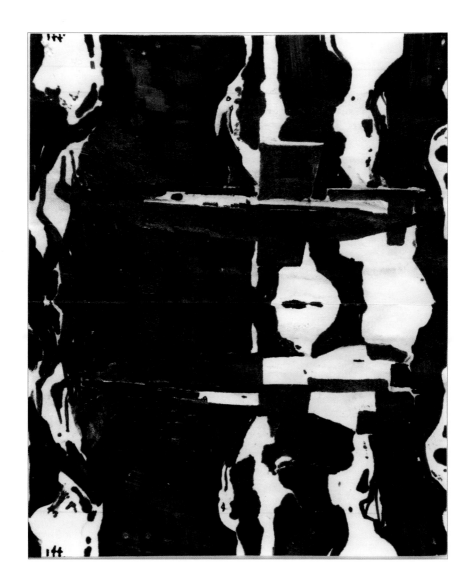

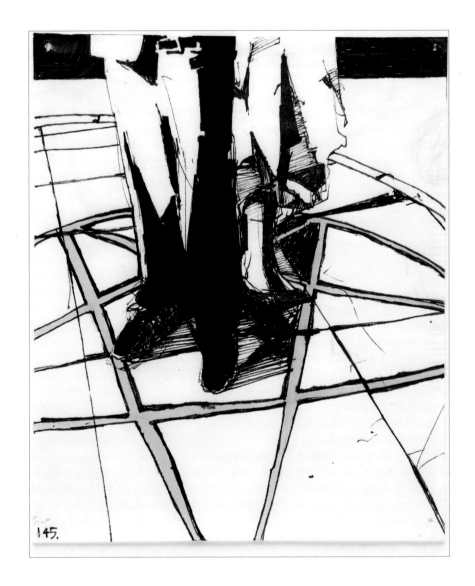

145.

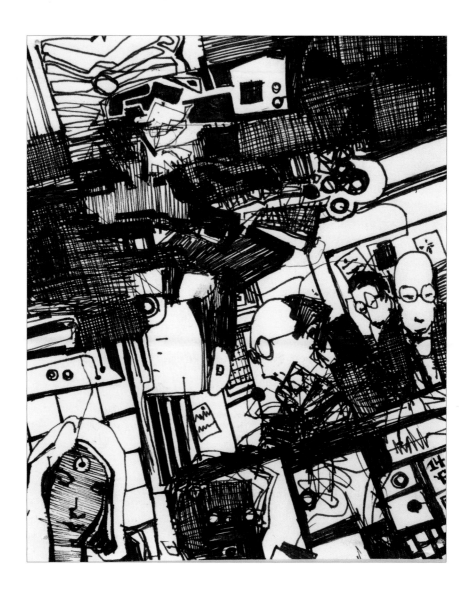

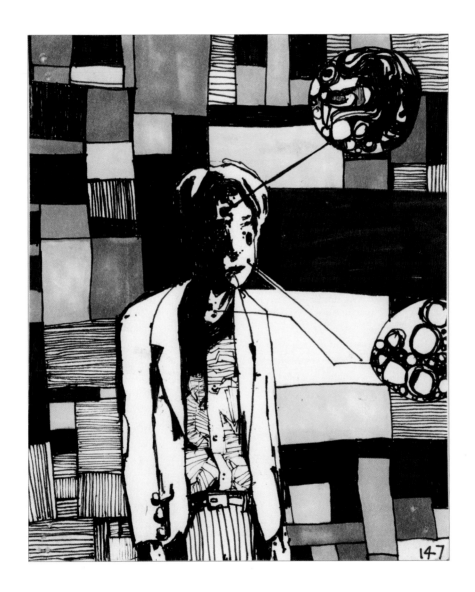

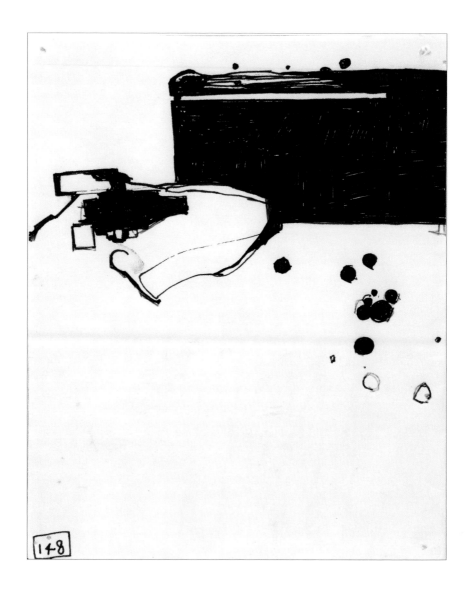

148

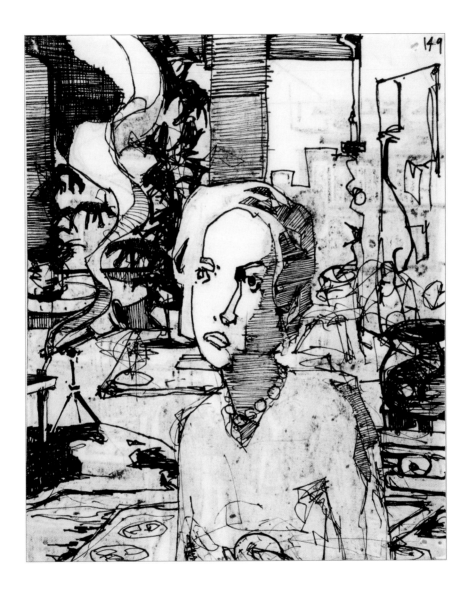

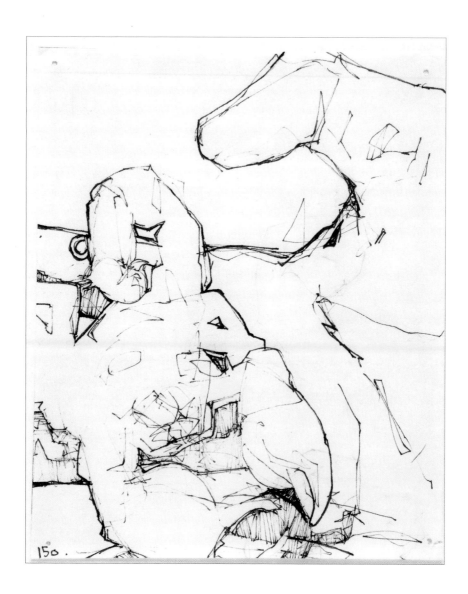

150.

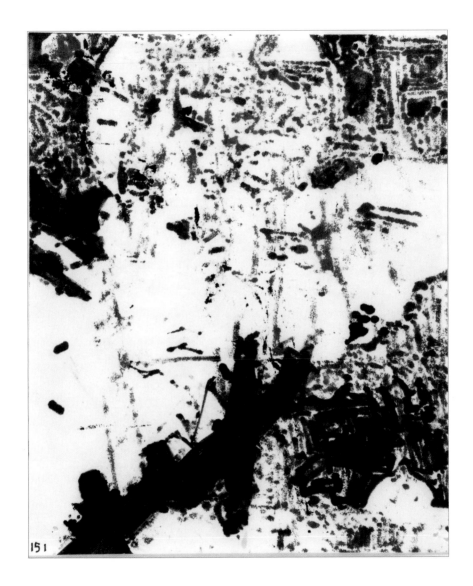

151

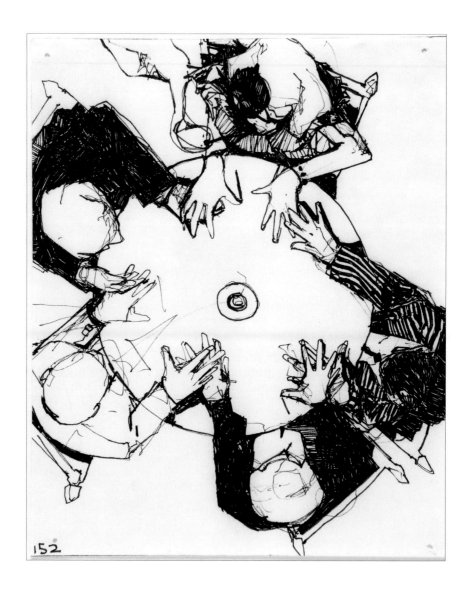

152

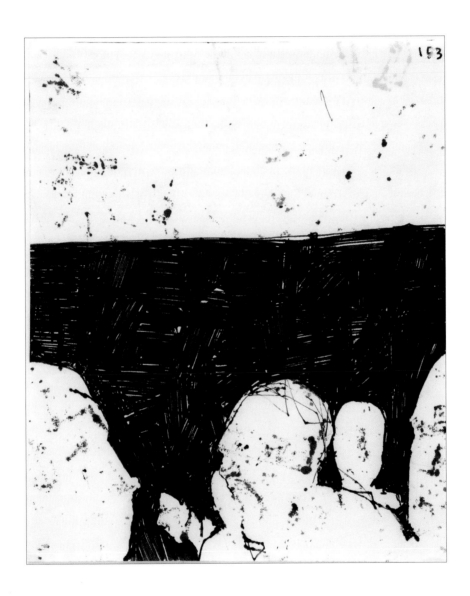

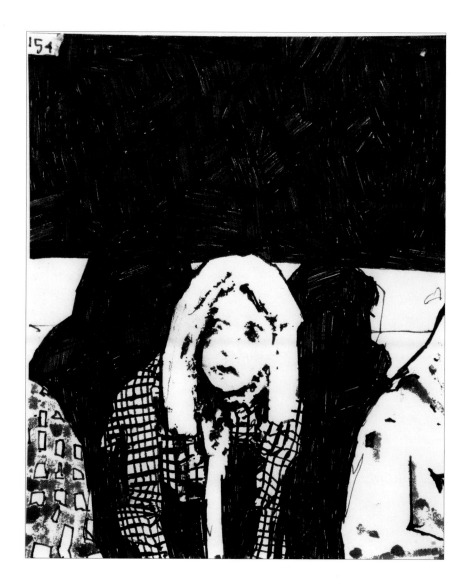

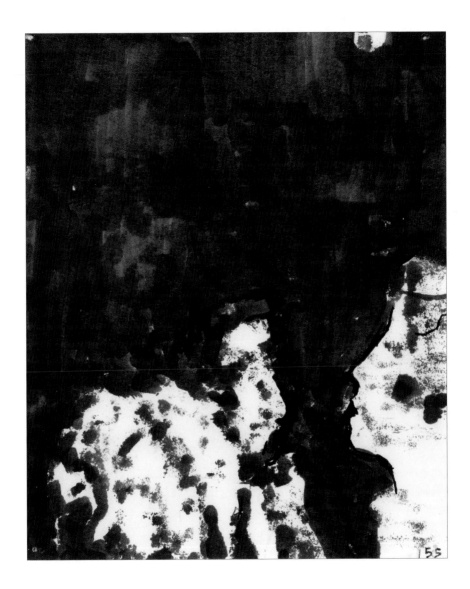

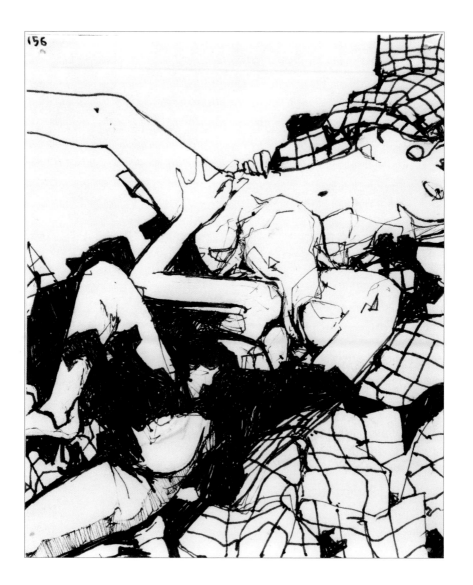

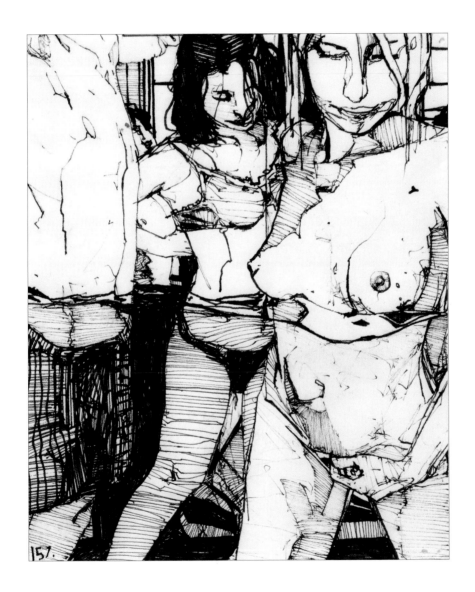

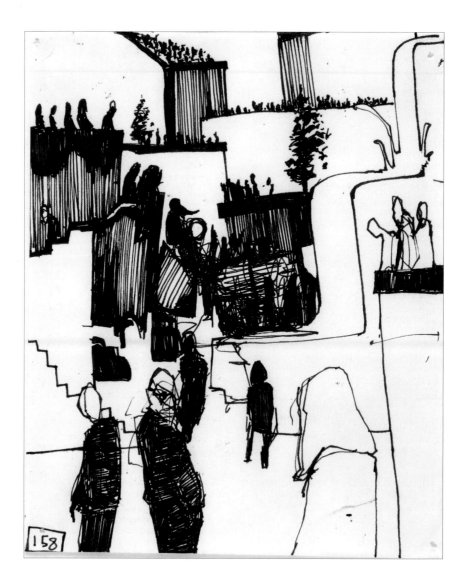

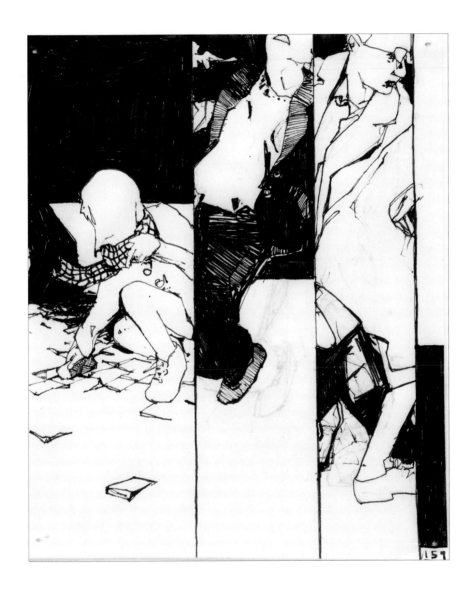

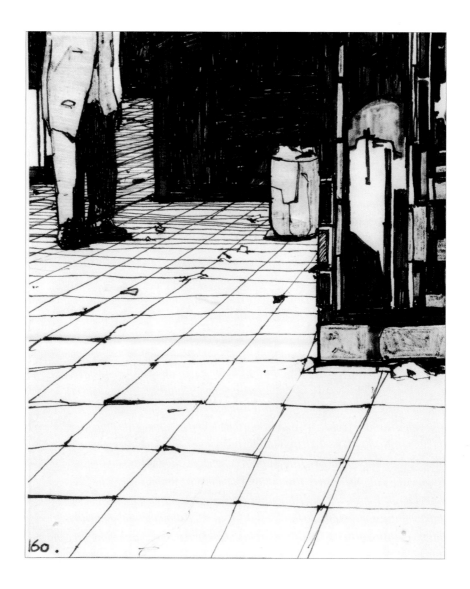

160.

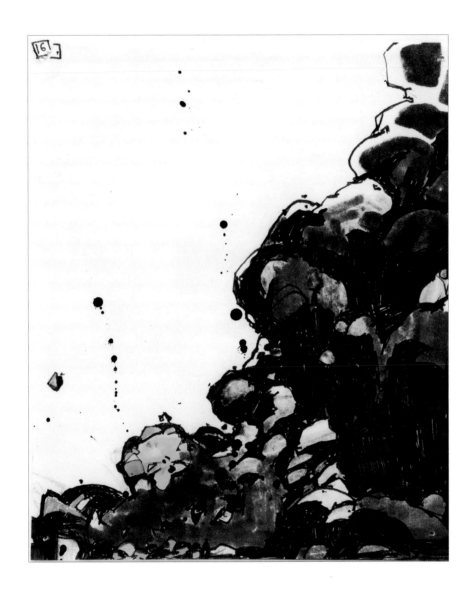

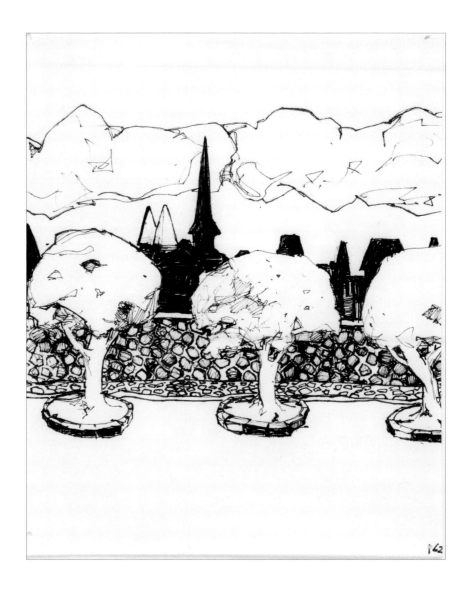

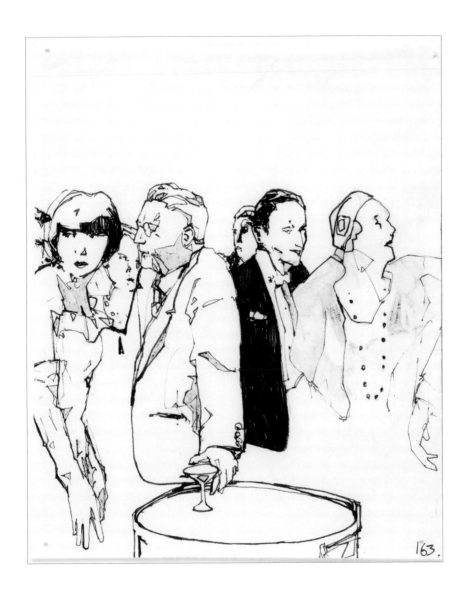

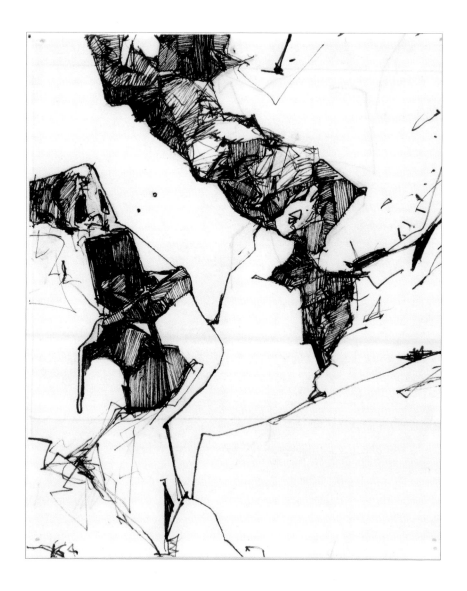

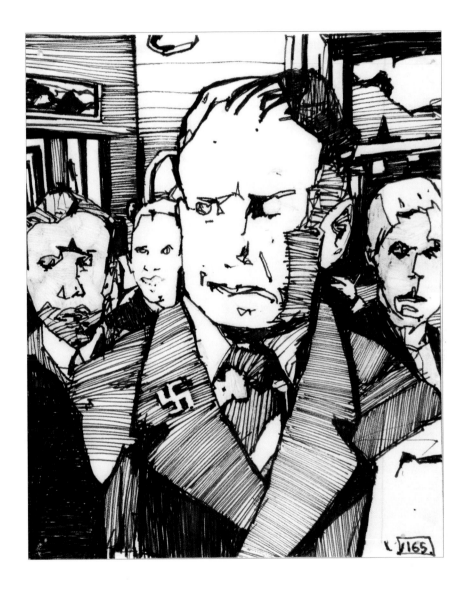

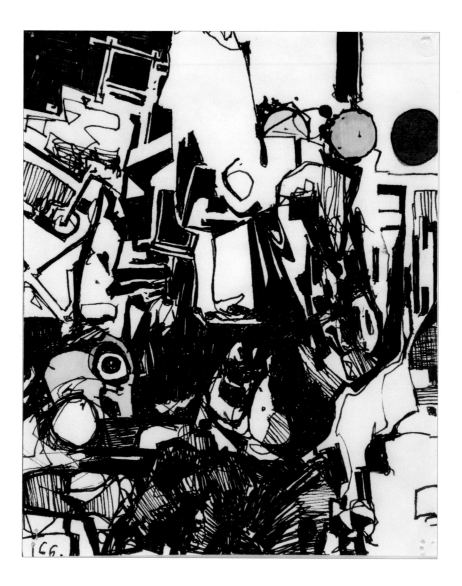

167.

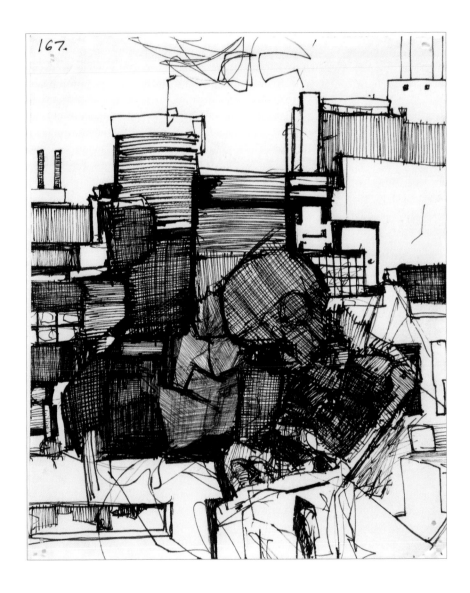

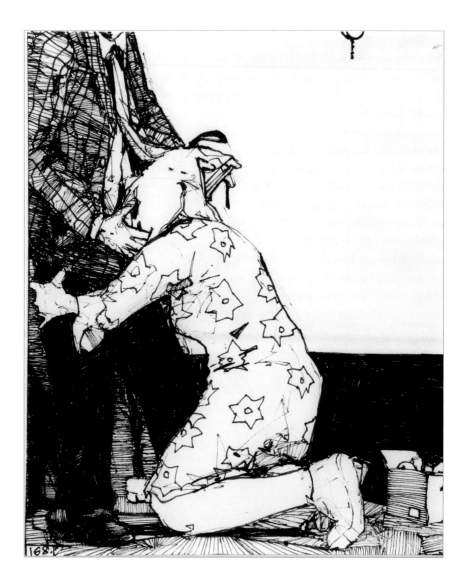

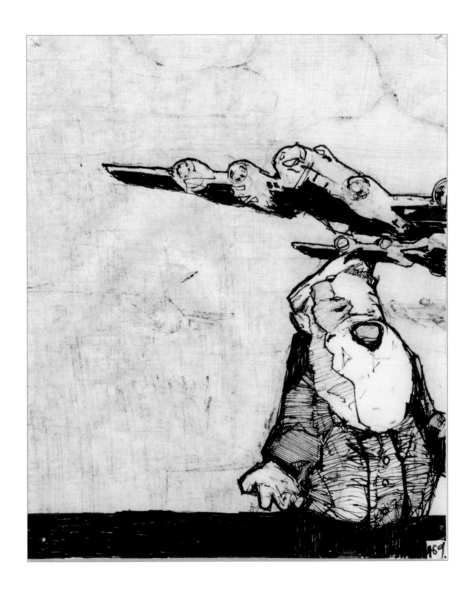

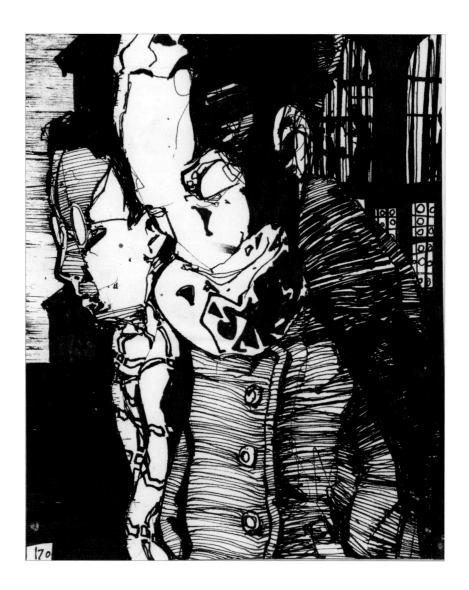

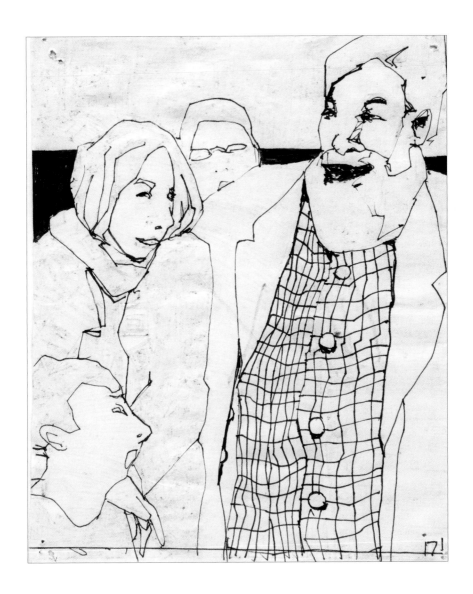

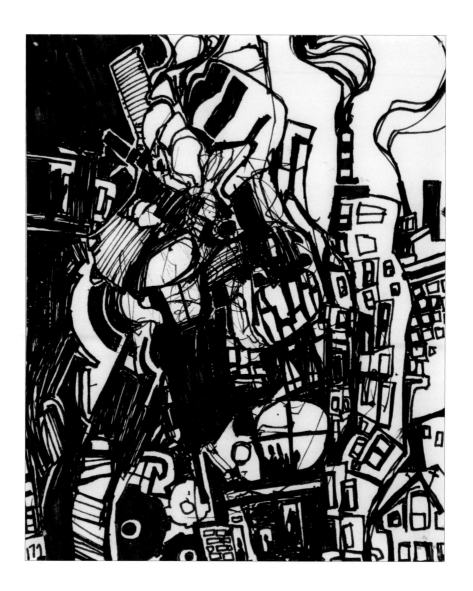

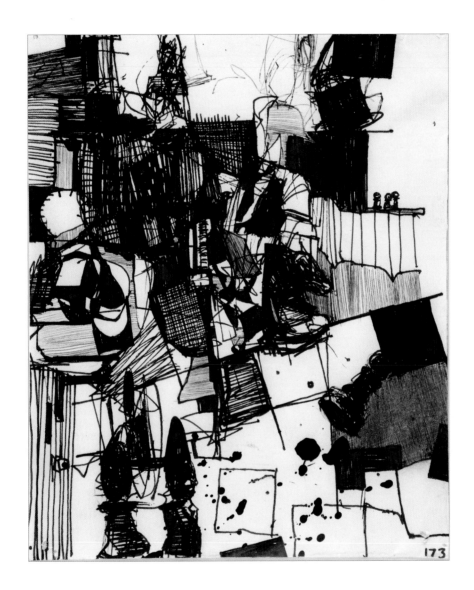

173

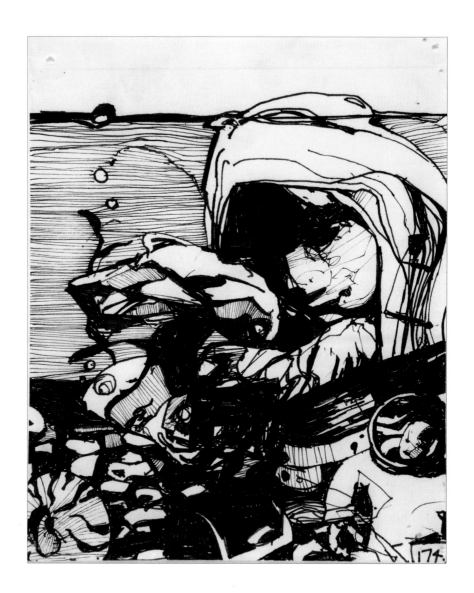

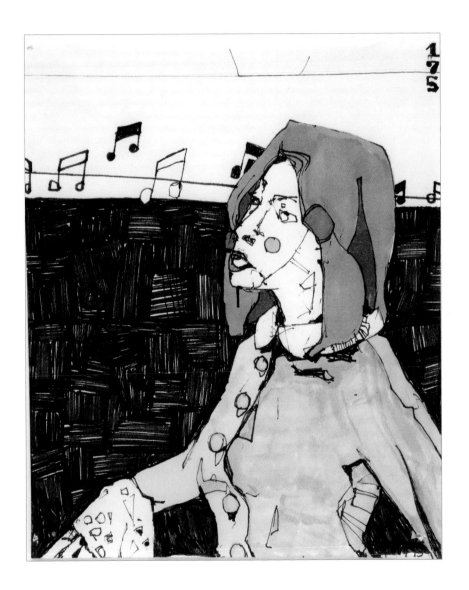

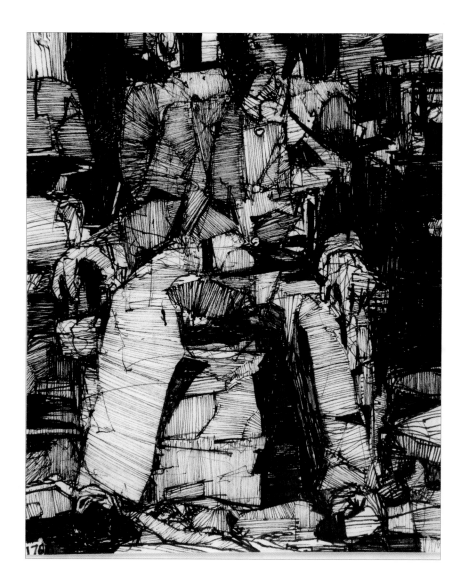

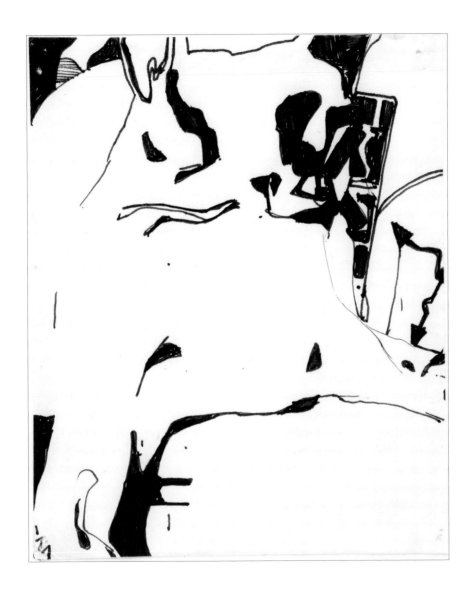

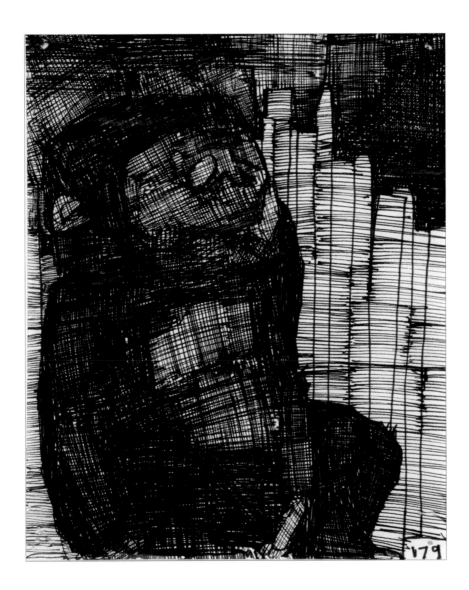

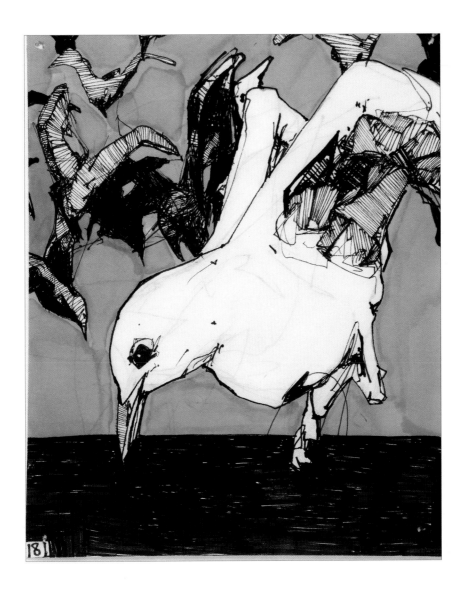

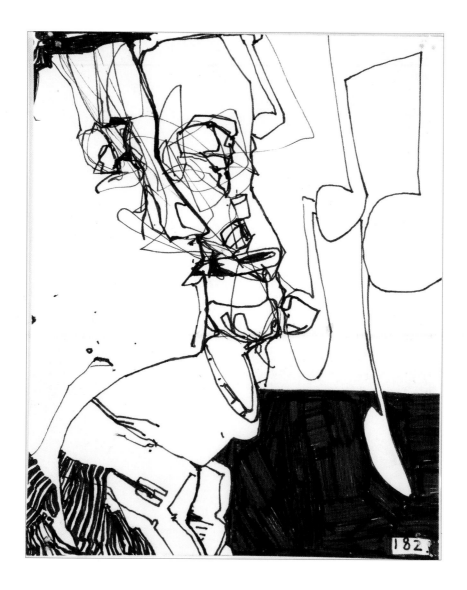

: 182 :

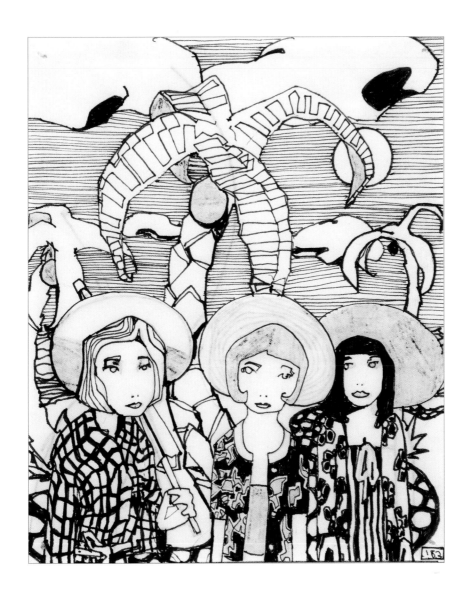

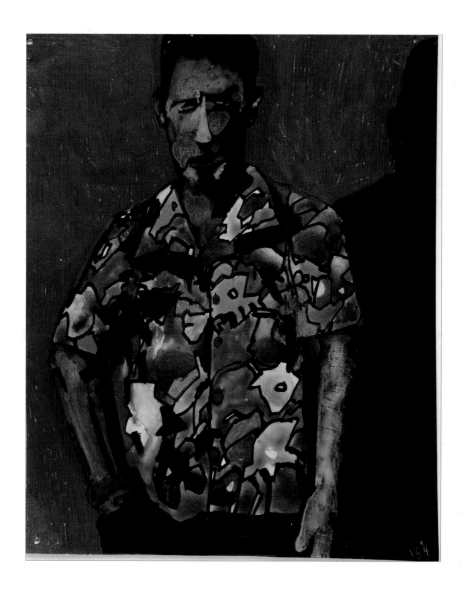

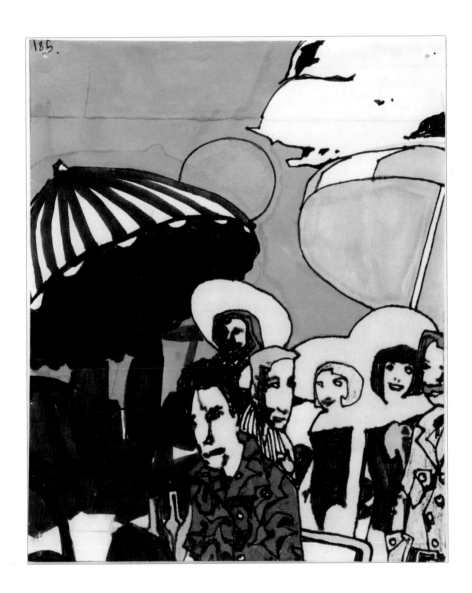

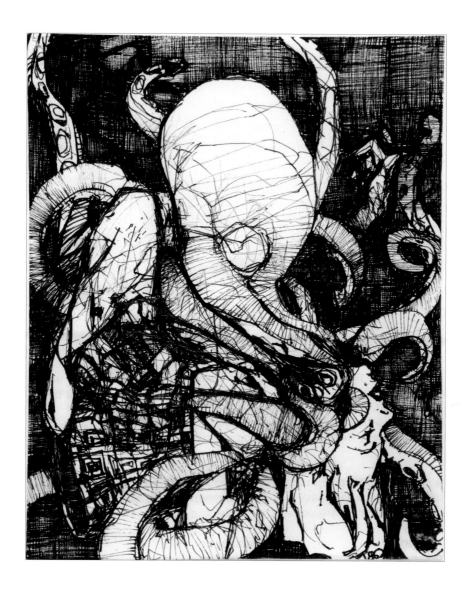

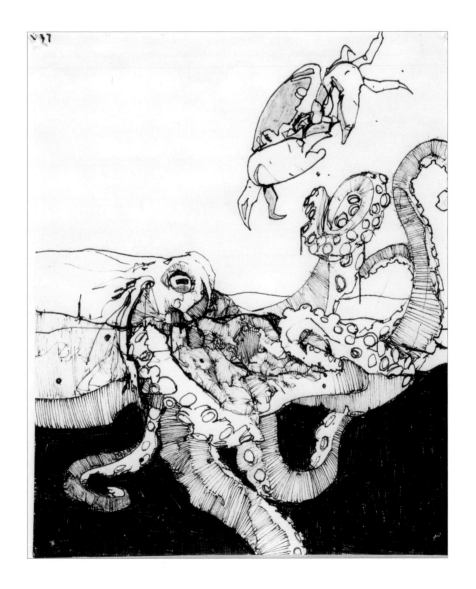

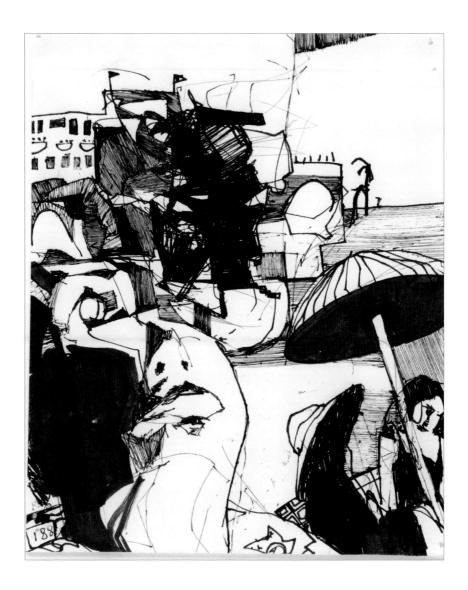

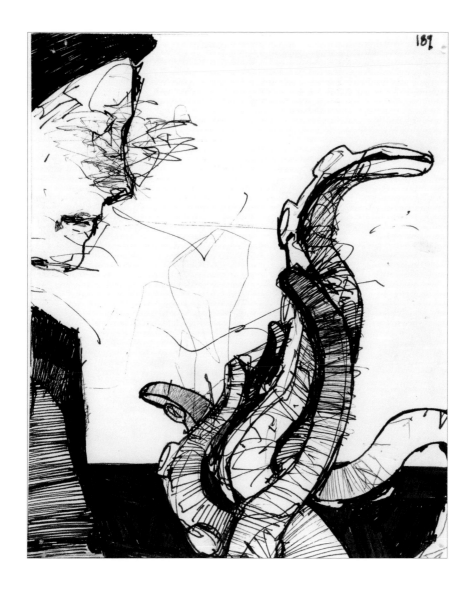

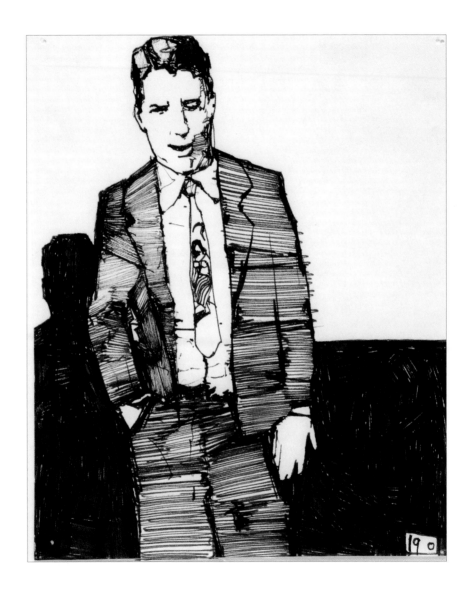

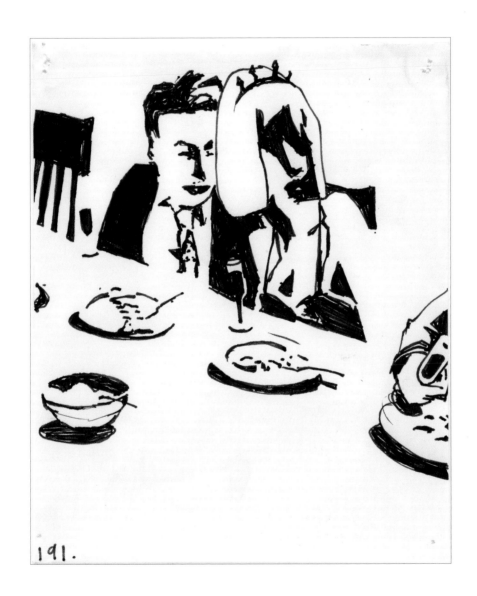

191.

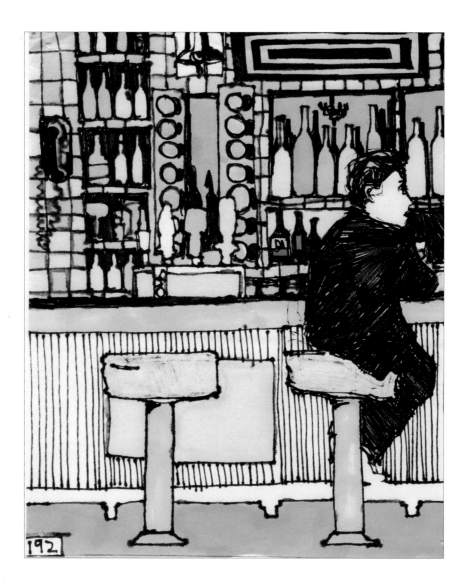

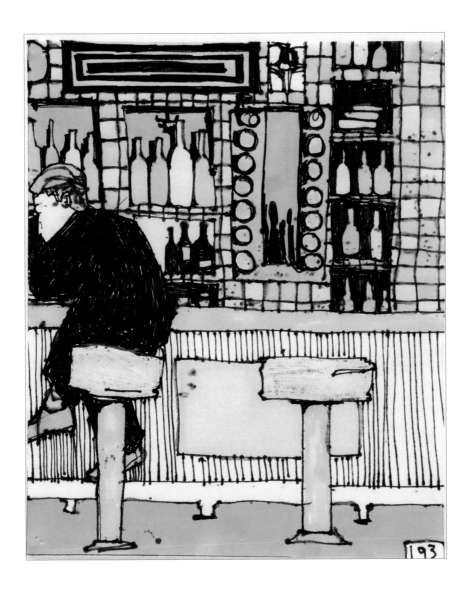

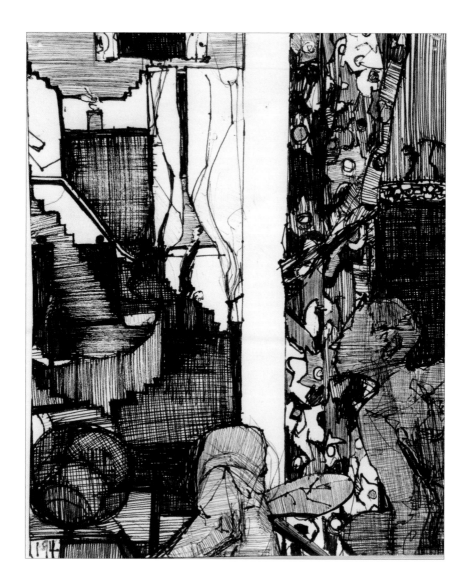

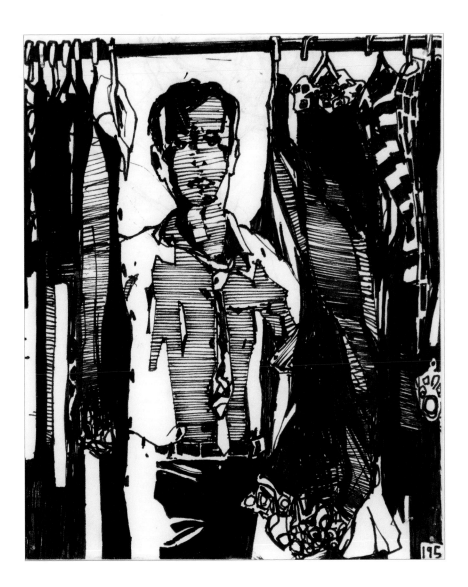

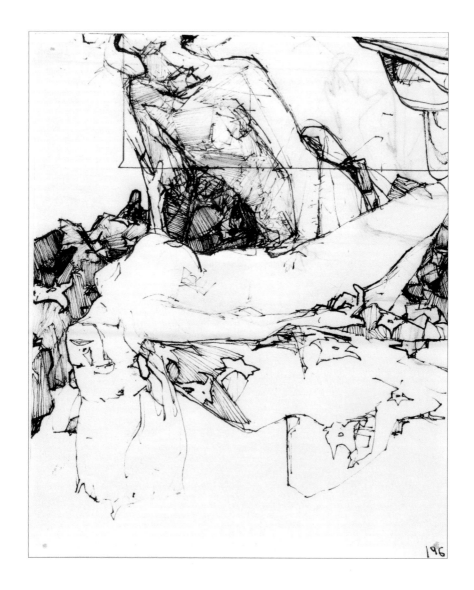

196

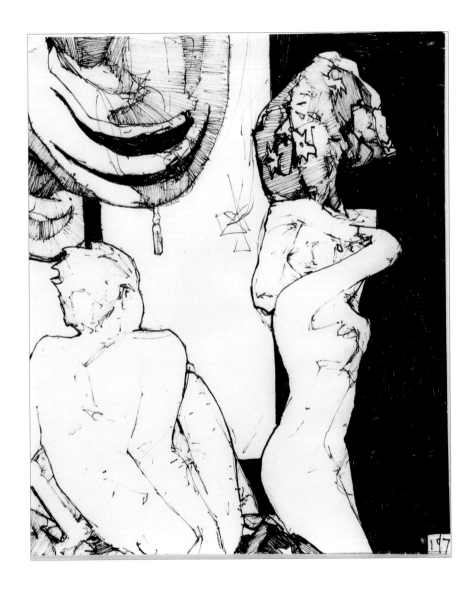

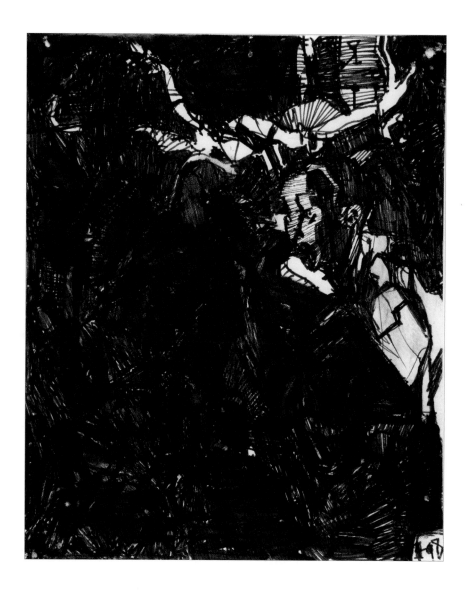

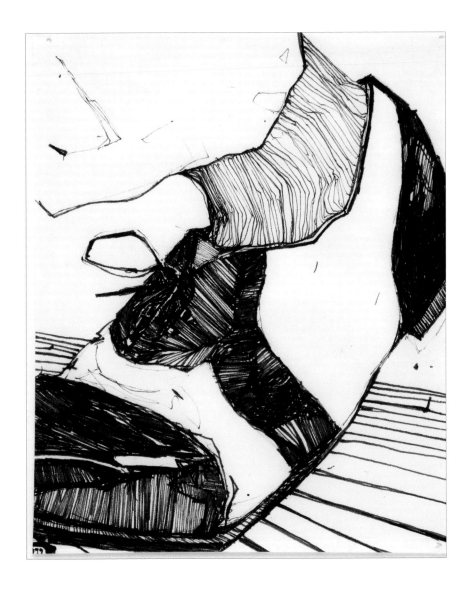

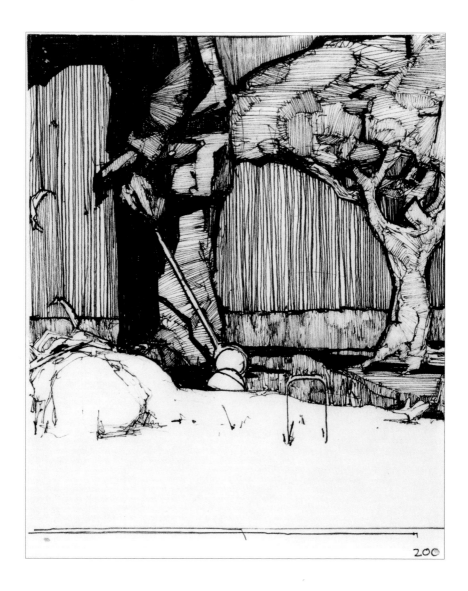

200

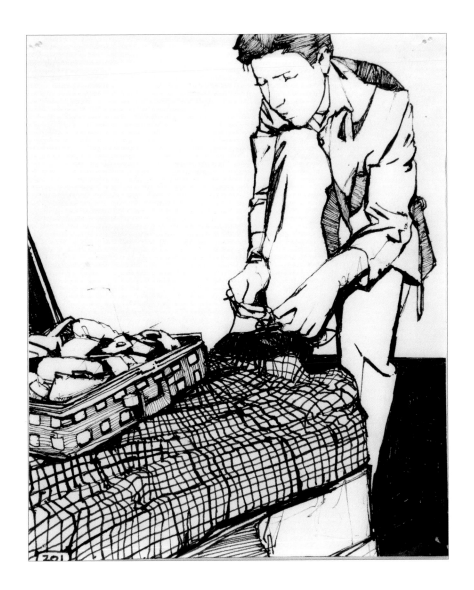

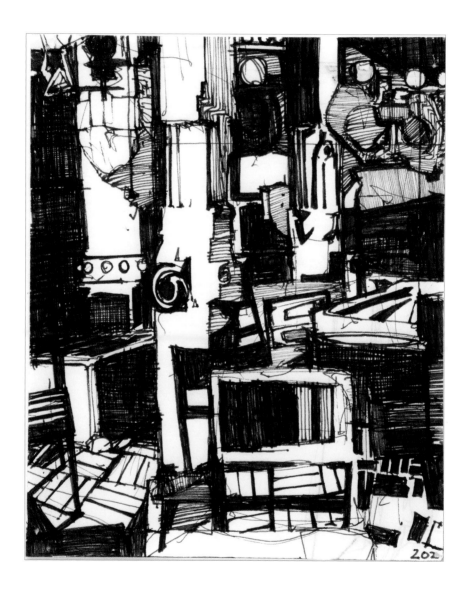

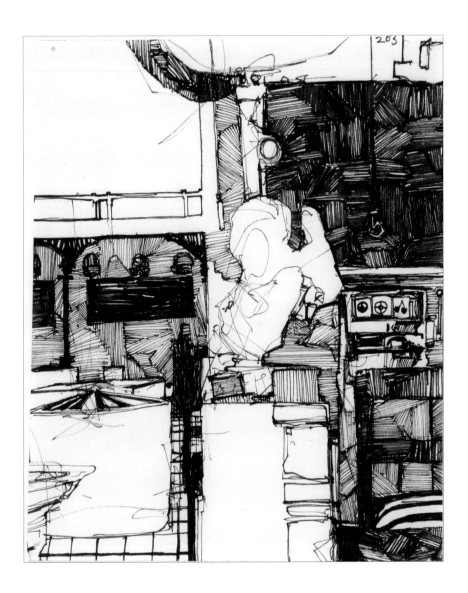

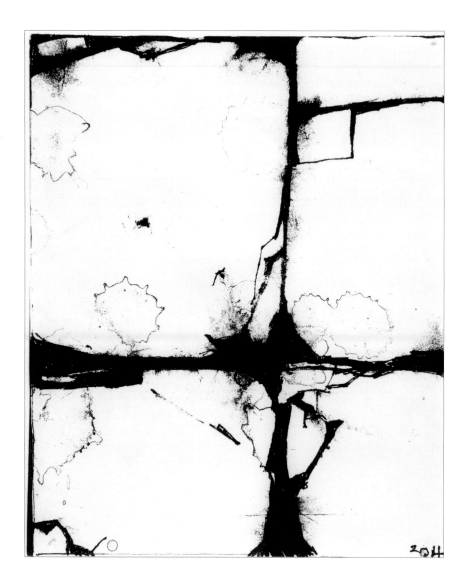

205

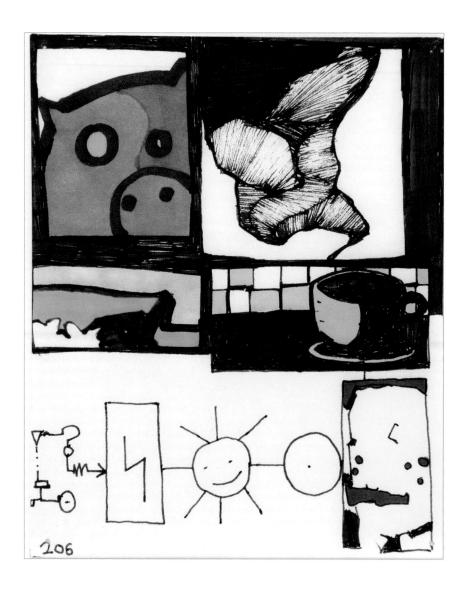

206

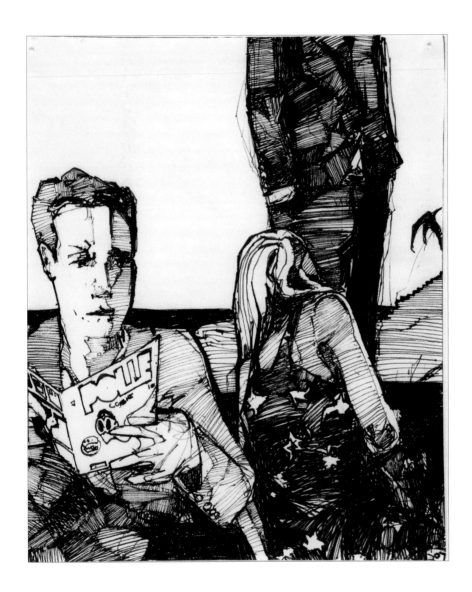

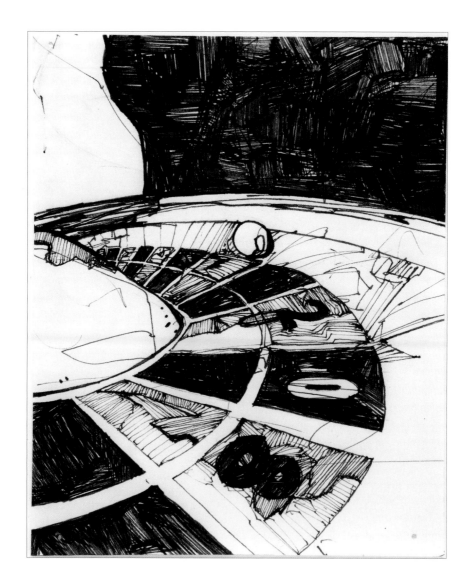

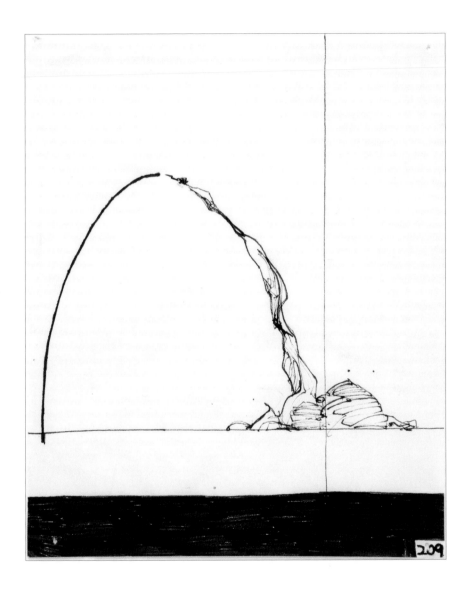

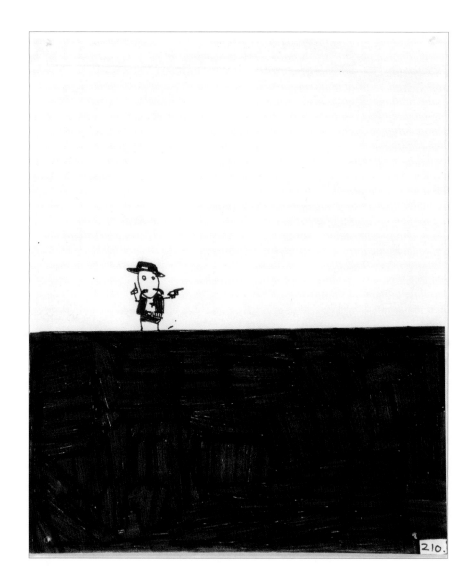

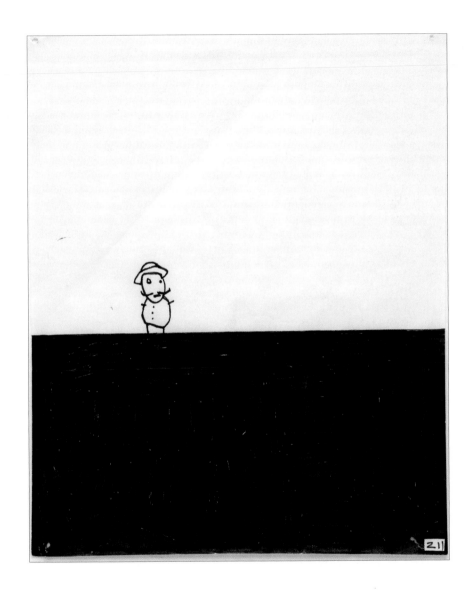

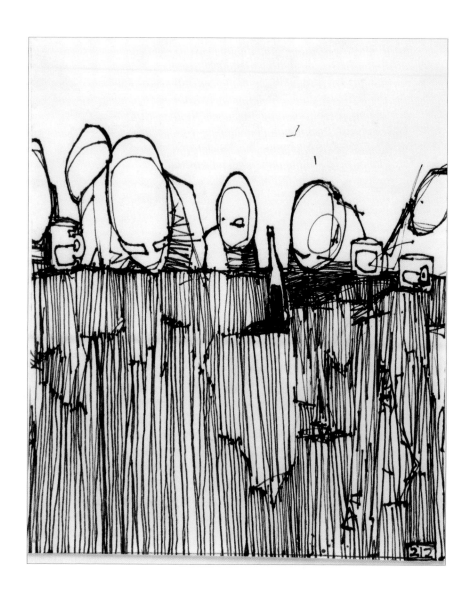

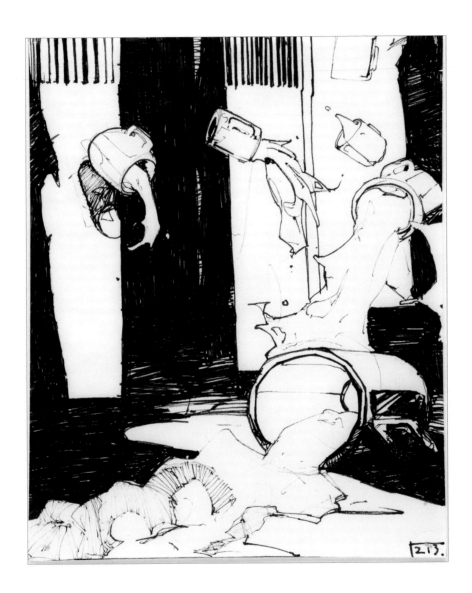

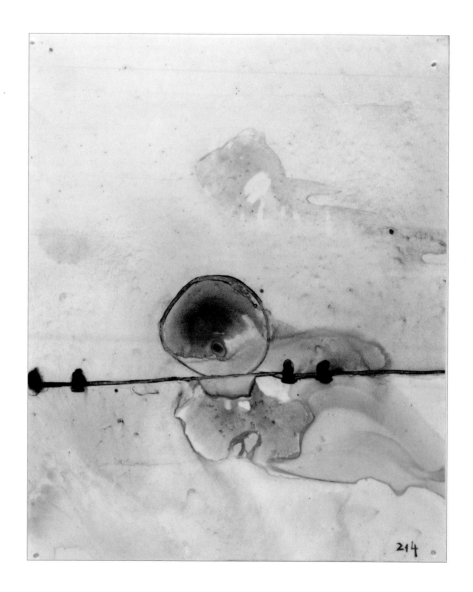

214

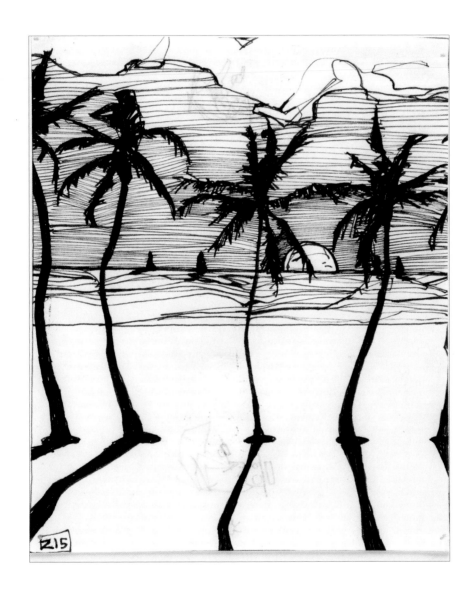

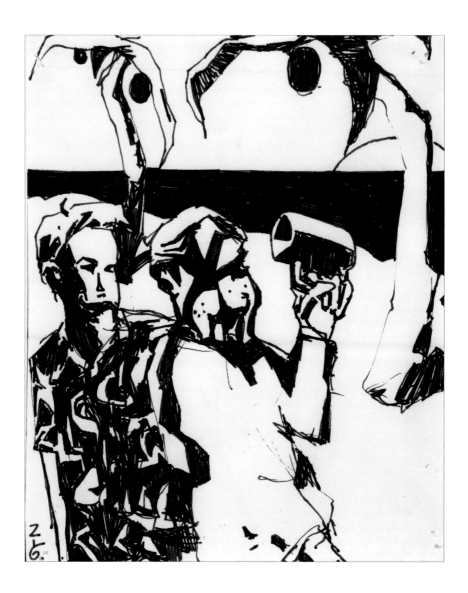

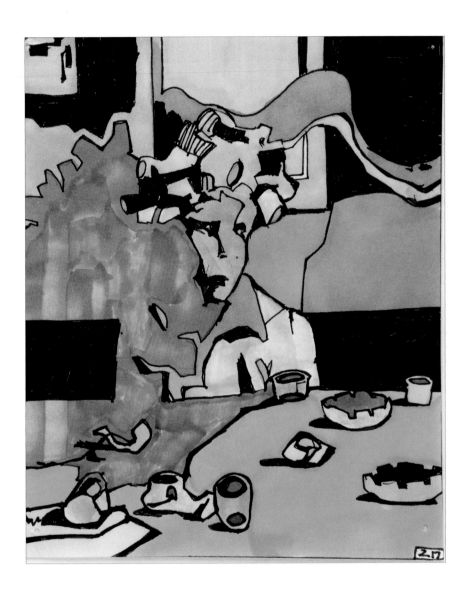

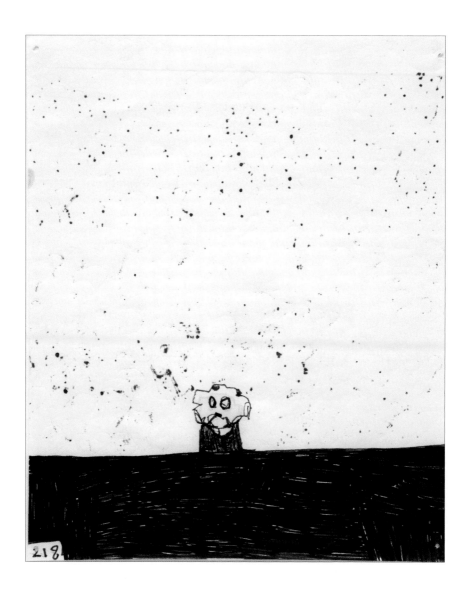

218

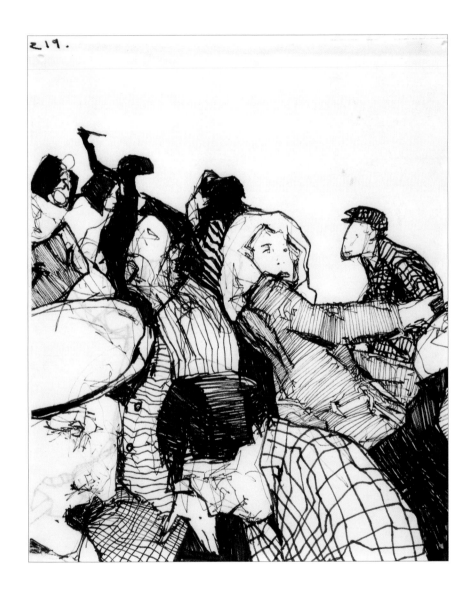

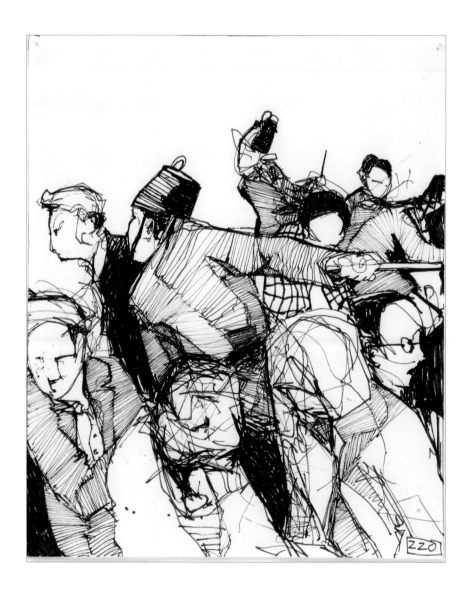

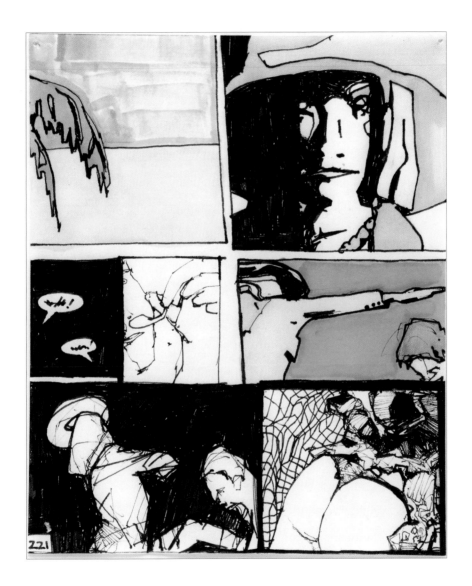

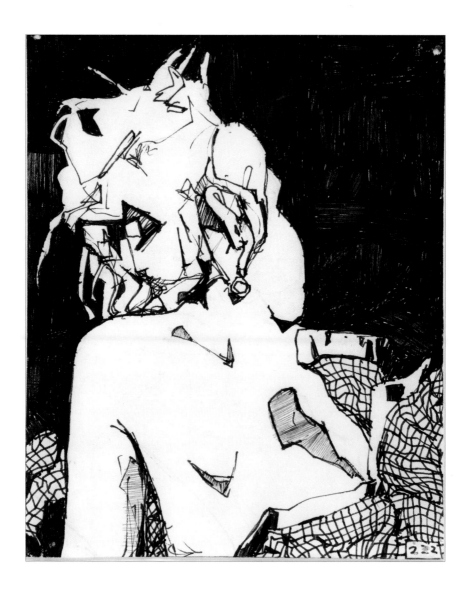

: 222 :

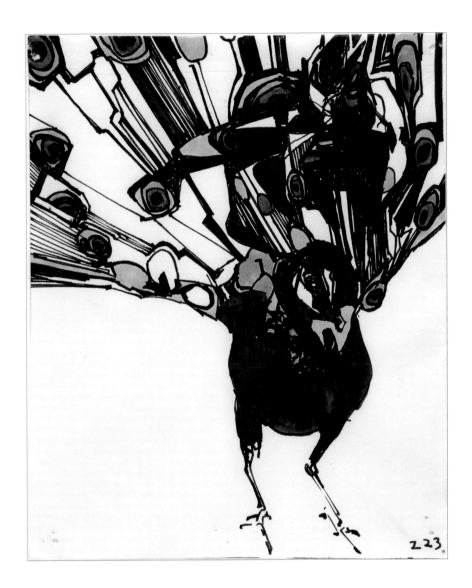

223

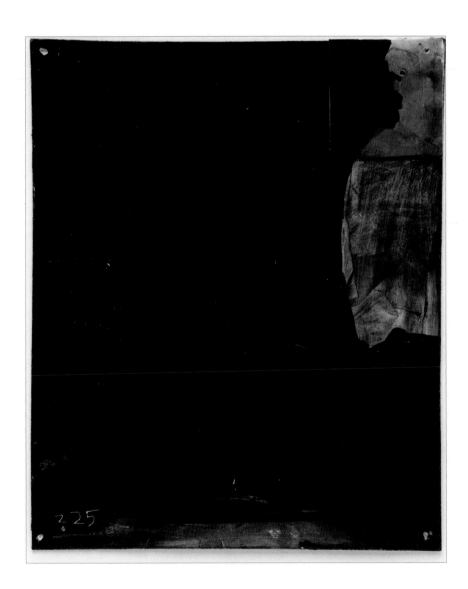

225

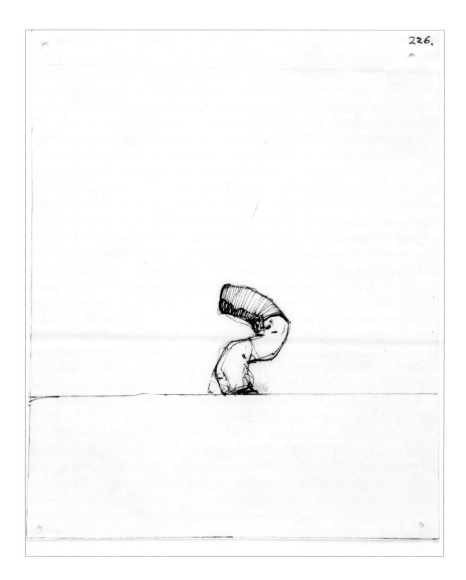

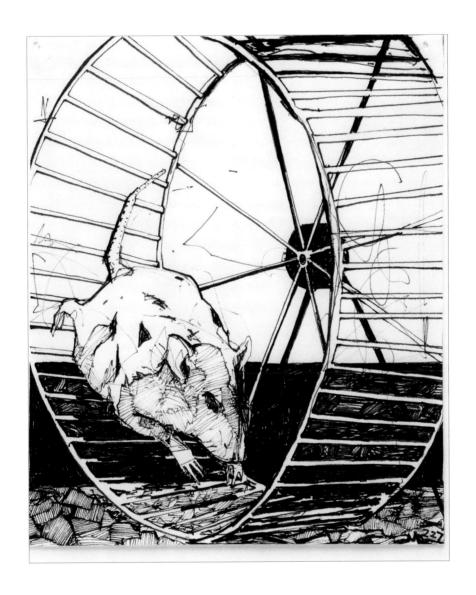

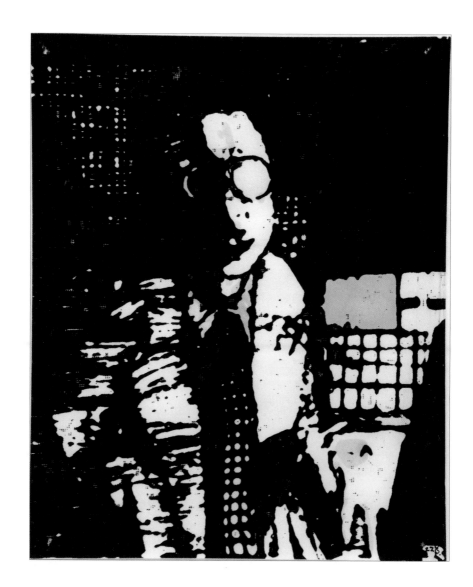

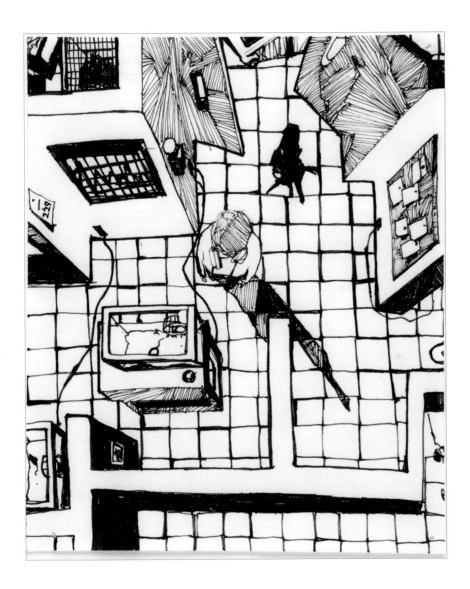

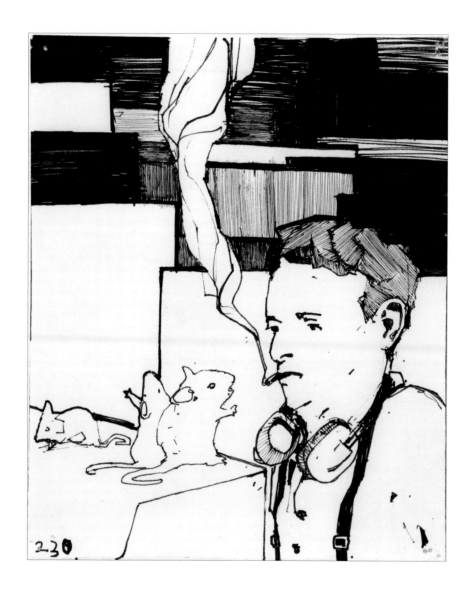

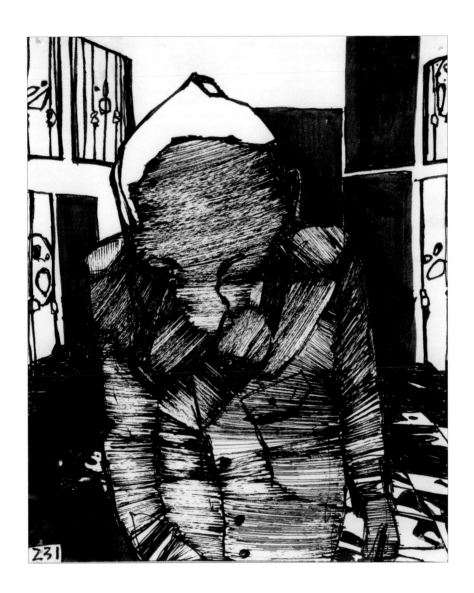

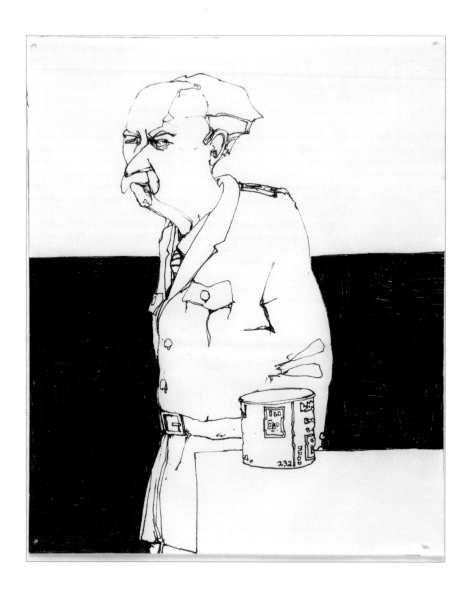

233.

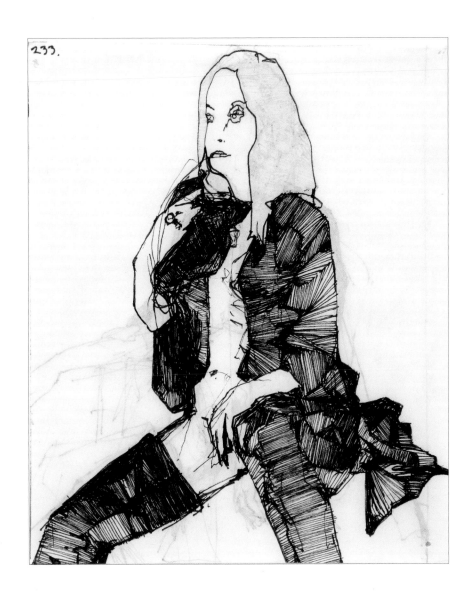

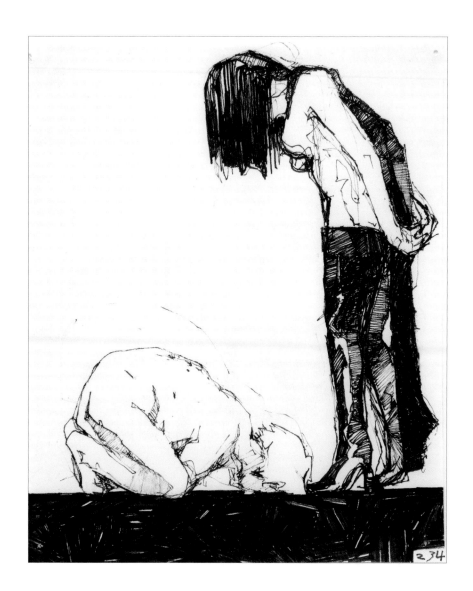

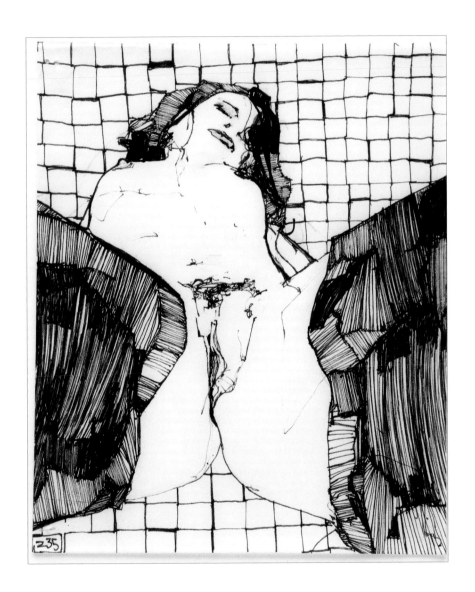

236

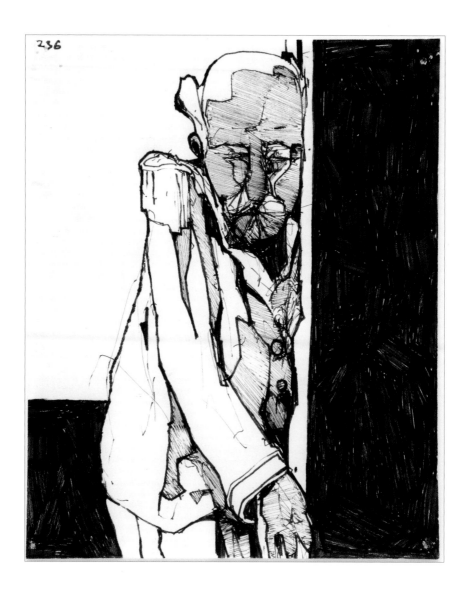

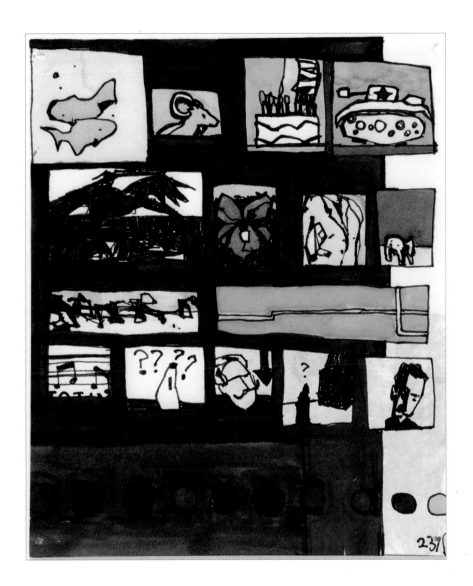

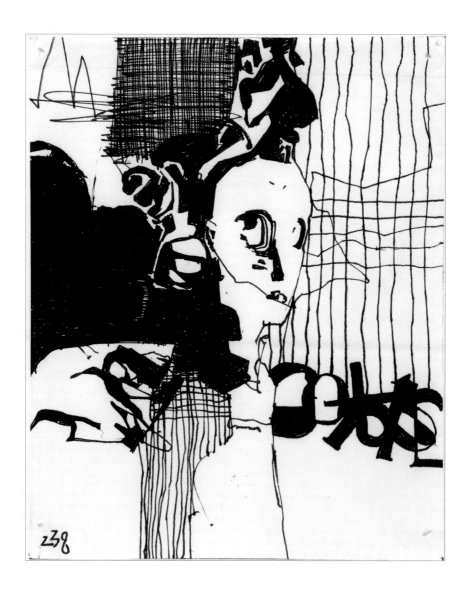

238

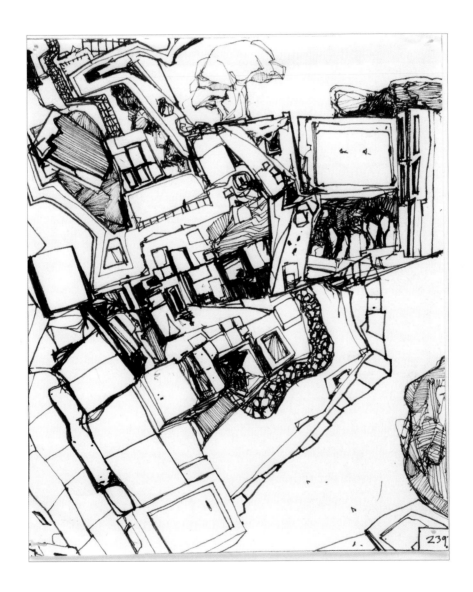

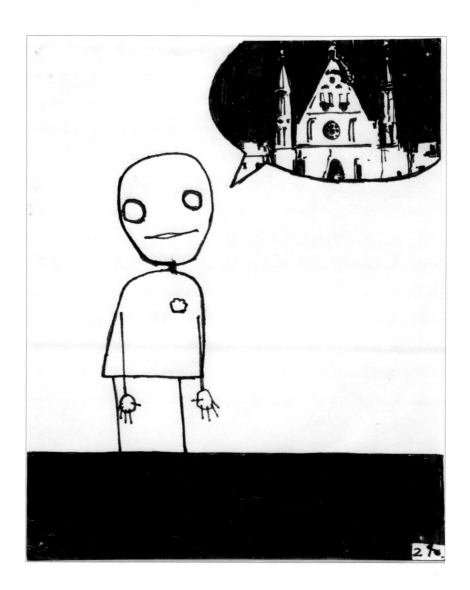

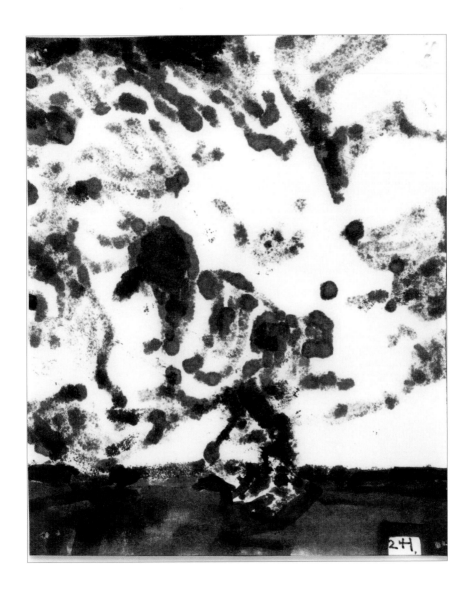

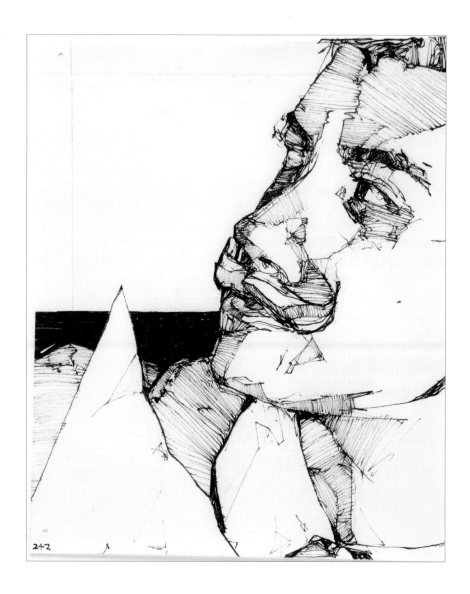

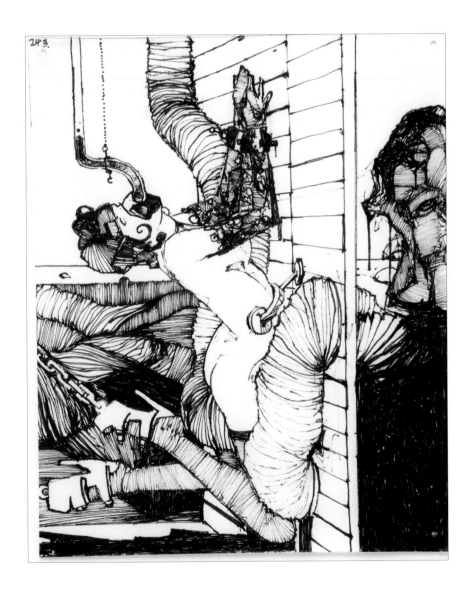

243.

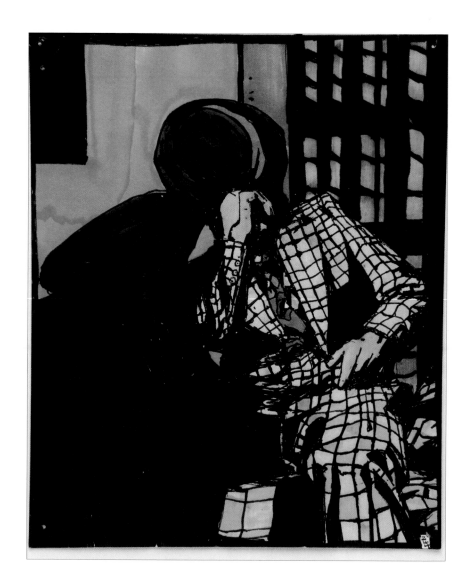

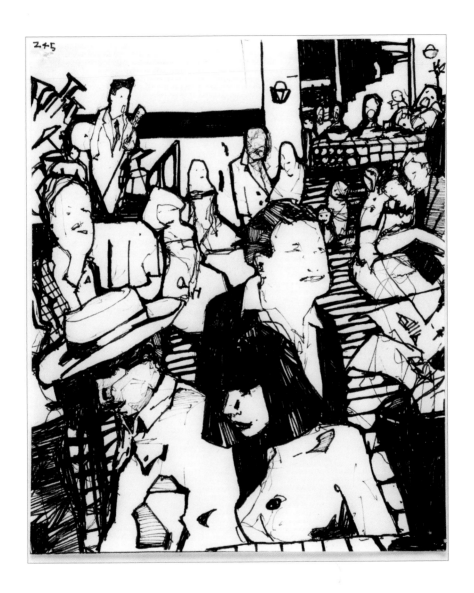

246.

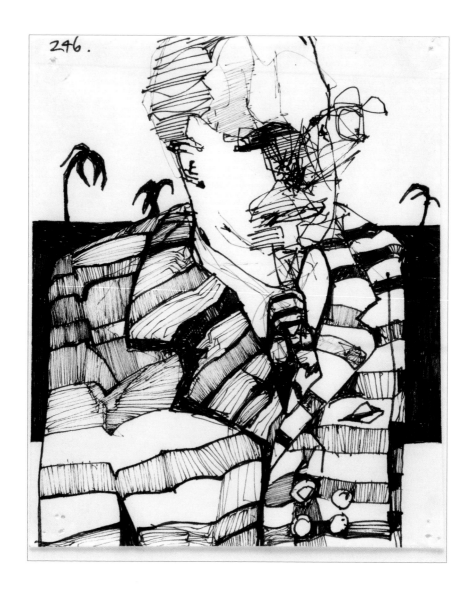

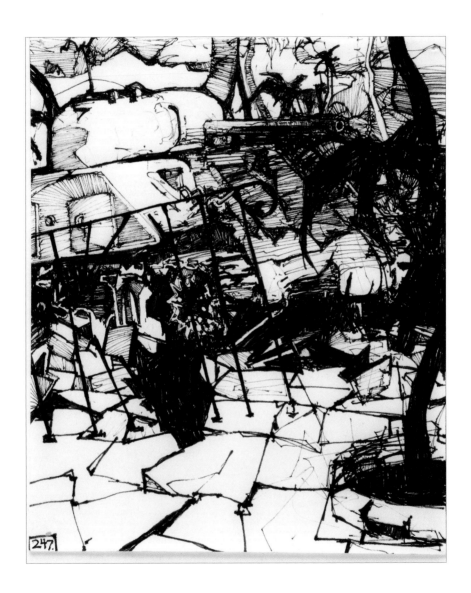

247.

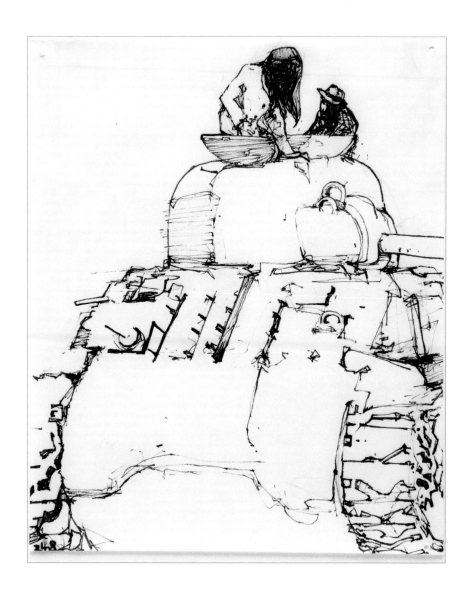

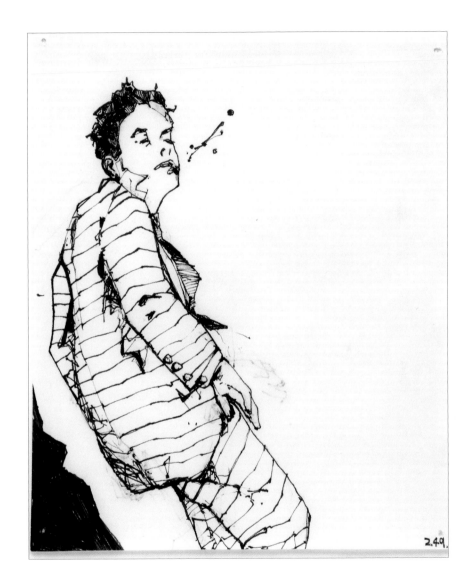

2.49.

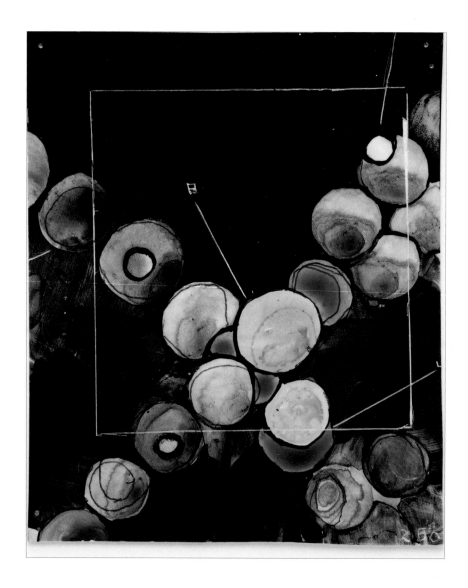

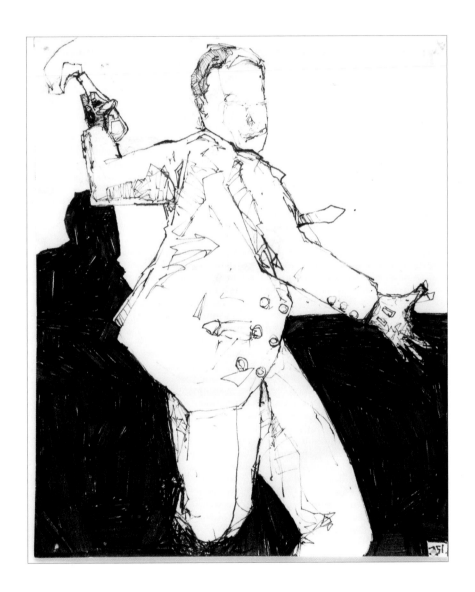

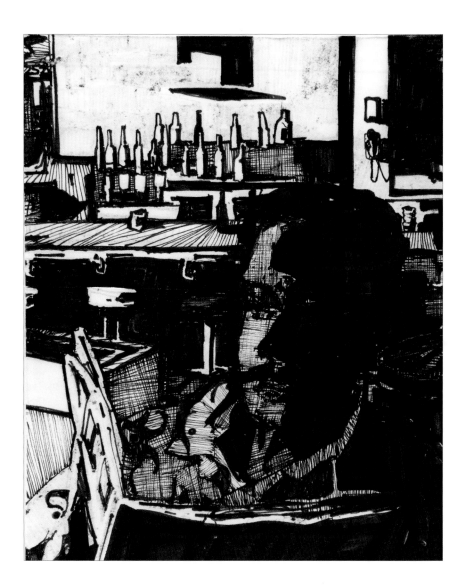

253.

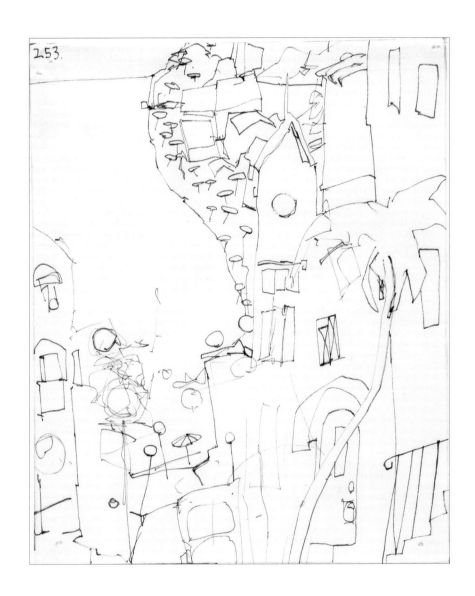

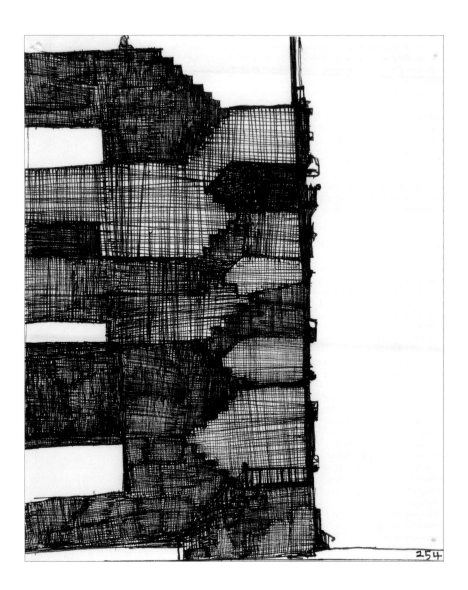

254

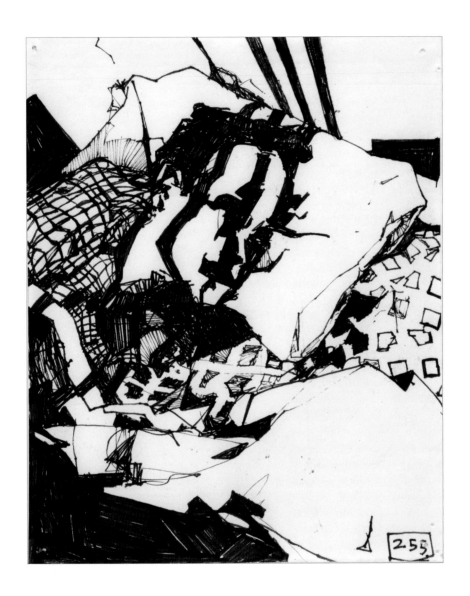

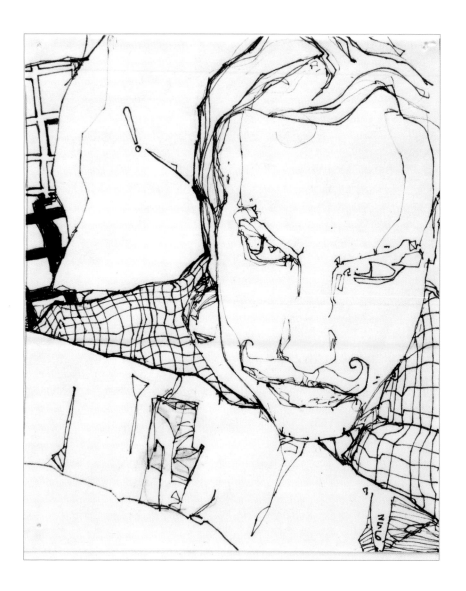

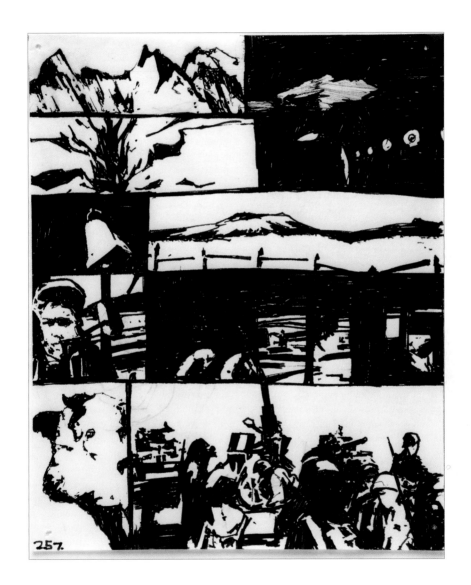

257.

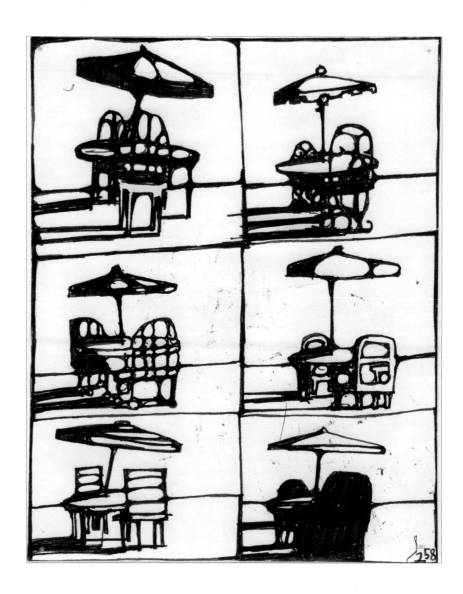

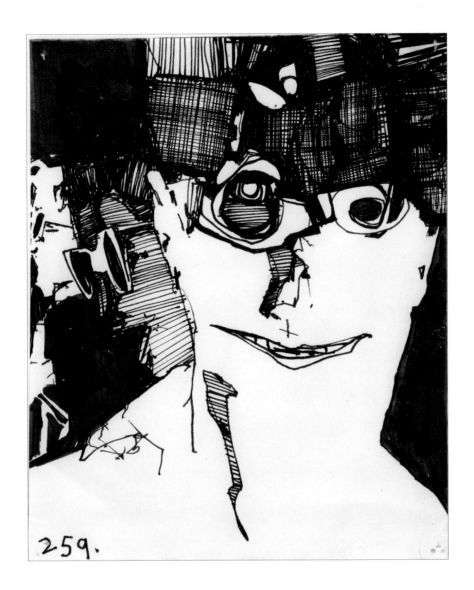

259.

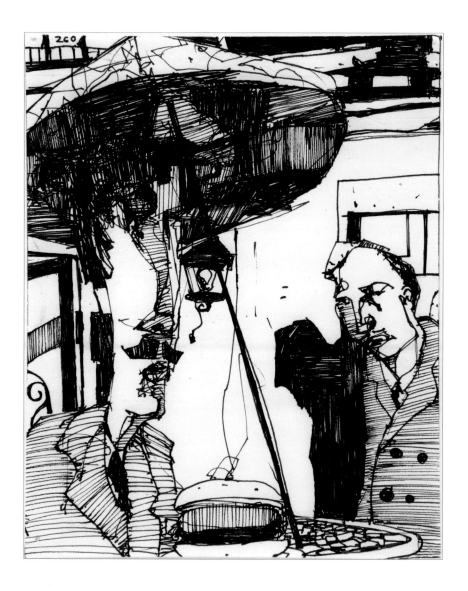

261

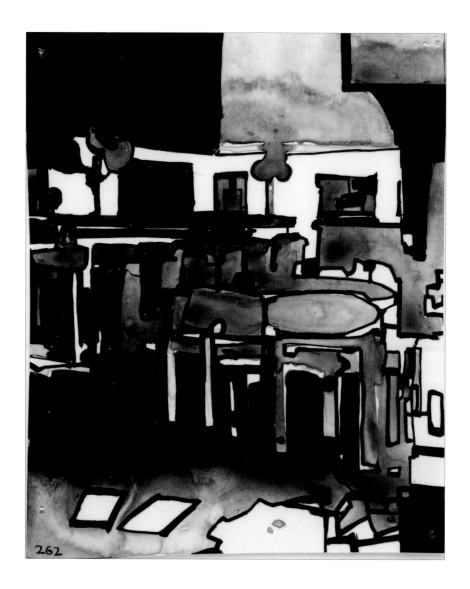

262

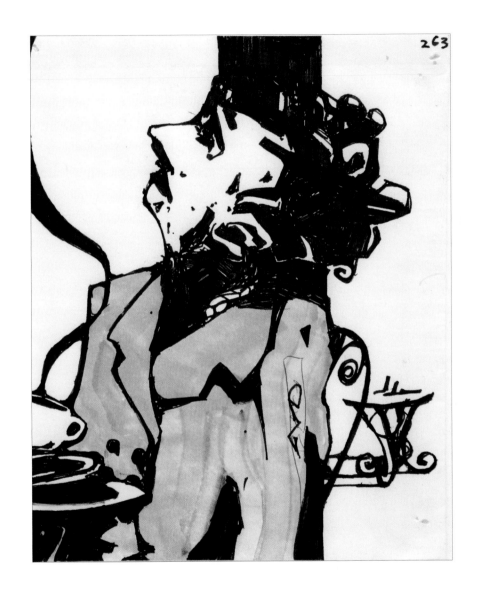

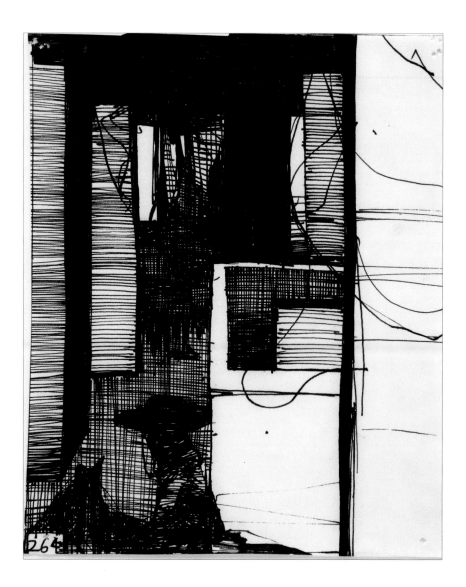

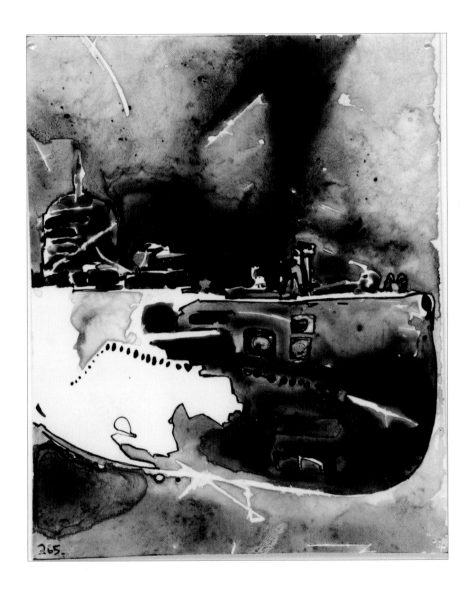

265.

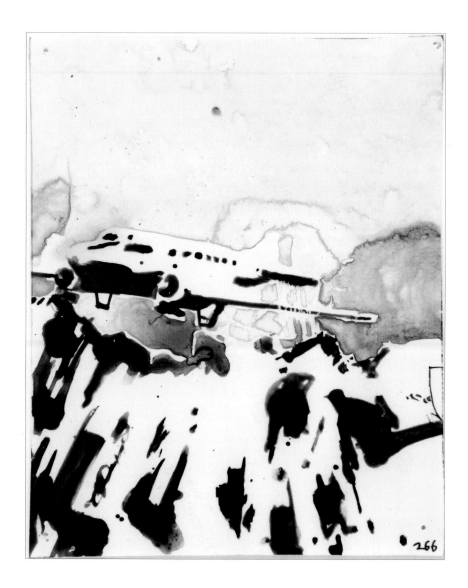

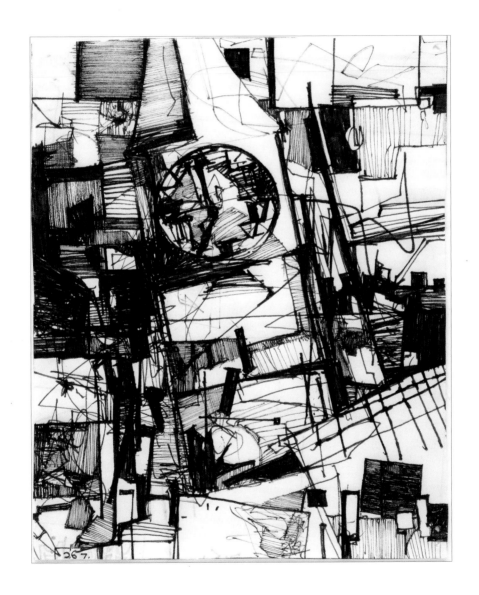

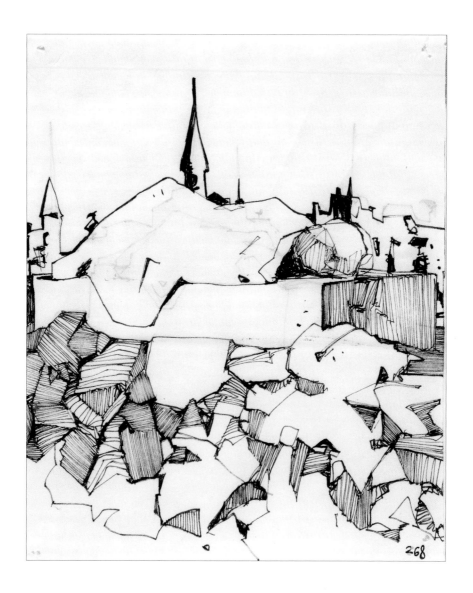

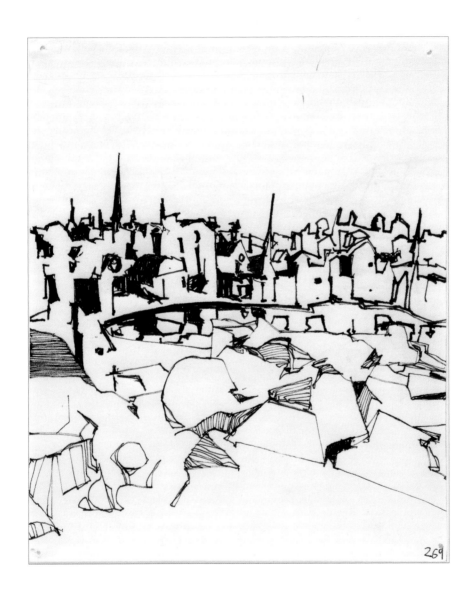

269

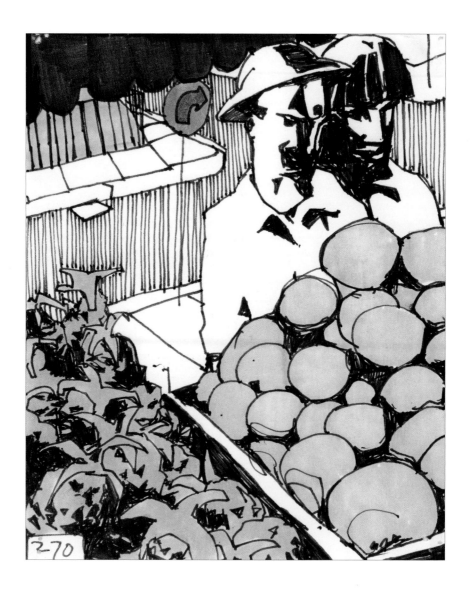

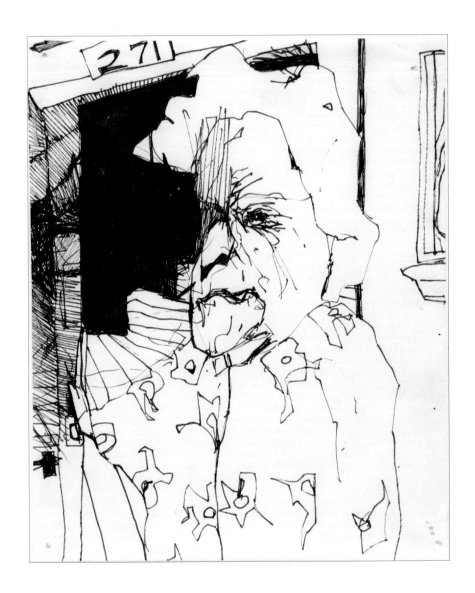

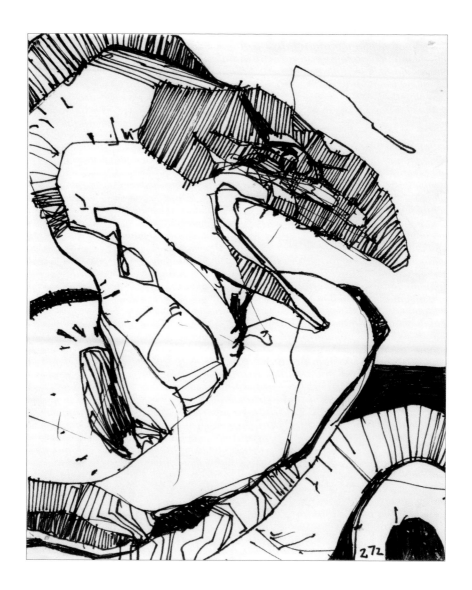

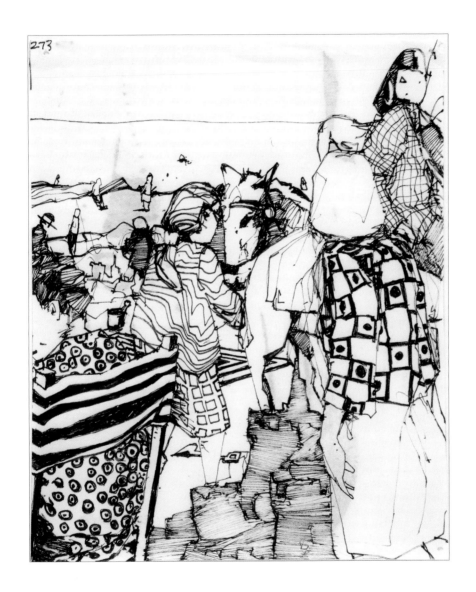

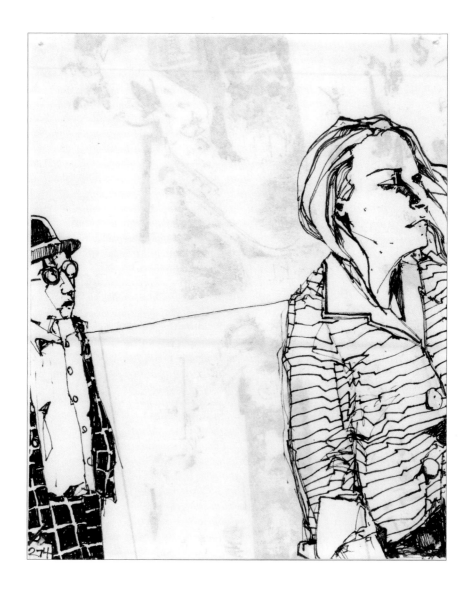

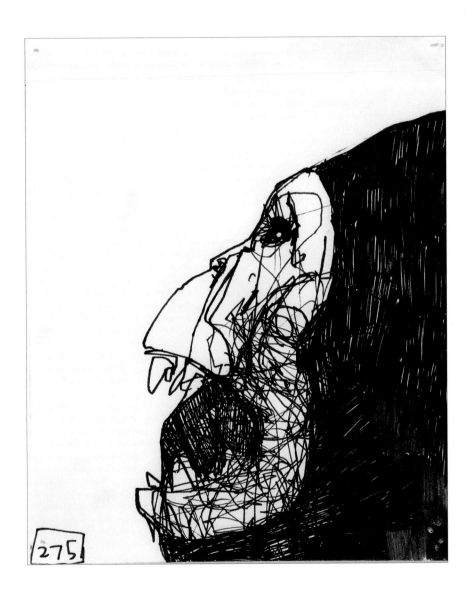

275

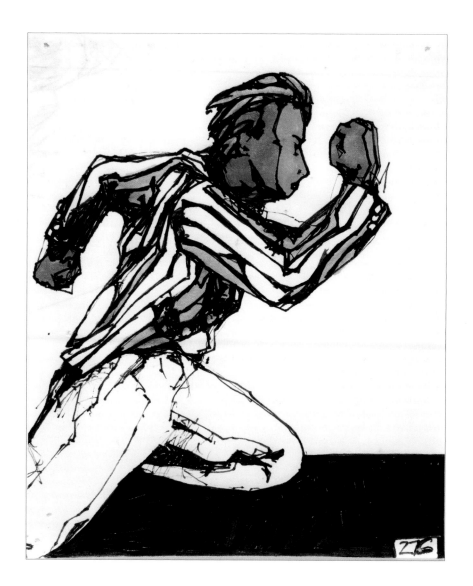

: 276 :

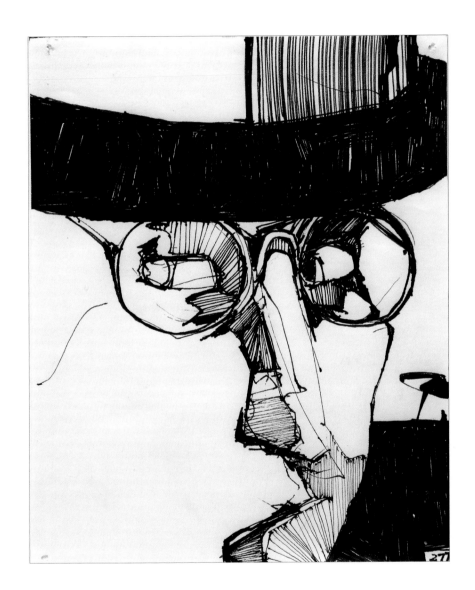

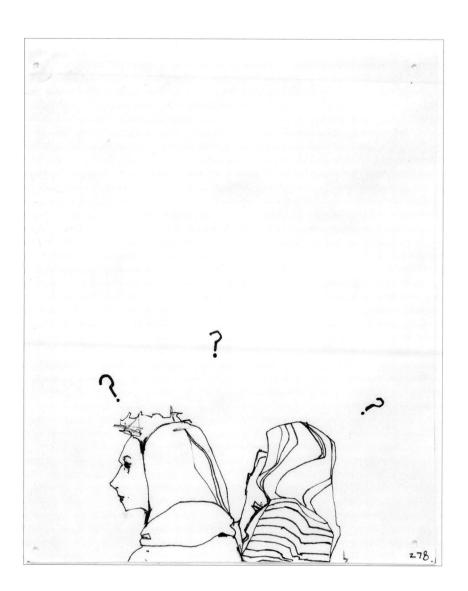

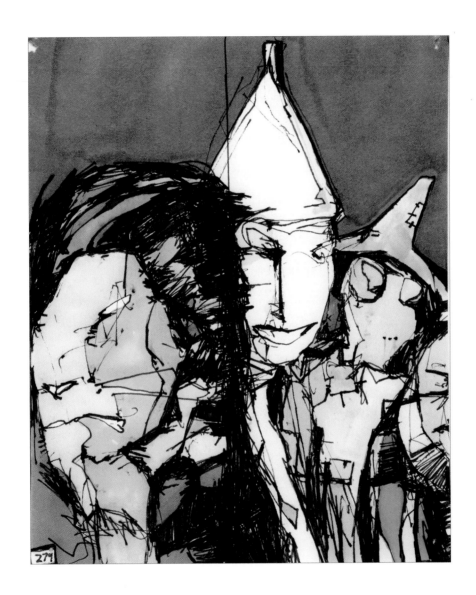

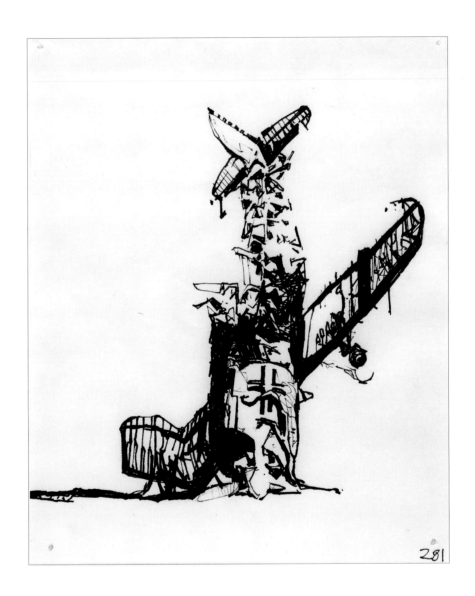

281

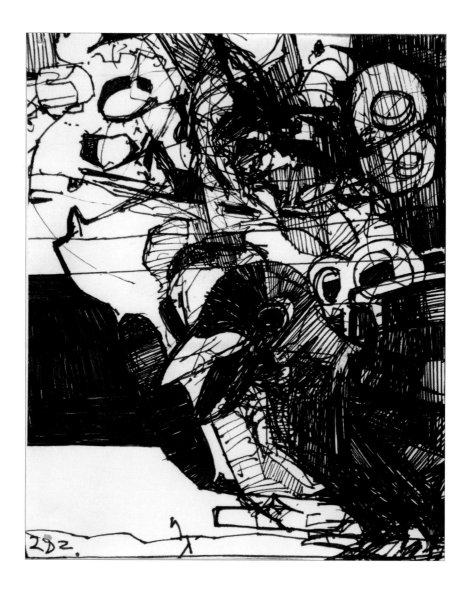

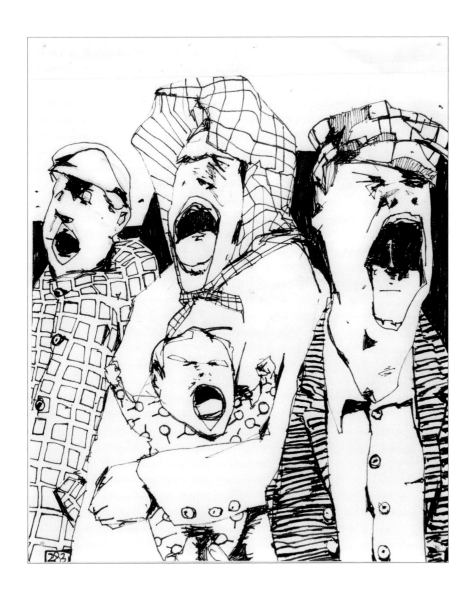

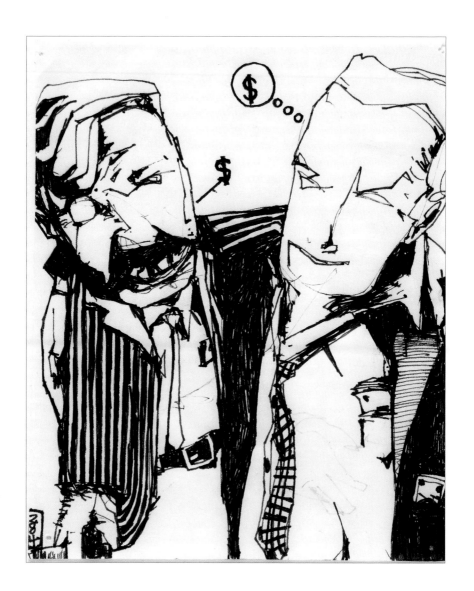

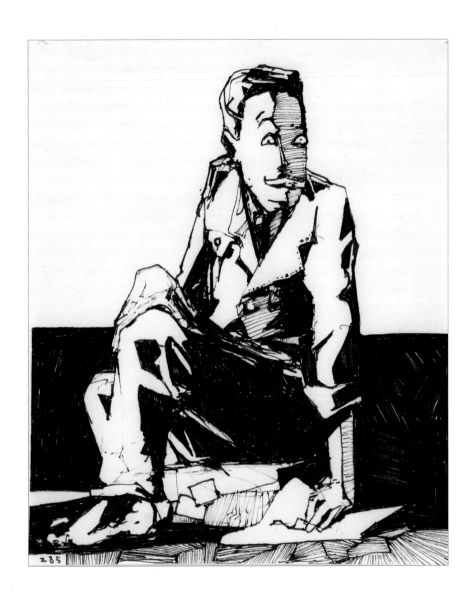

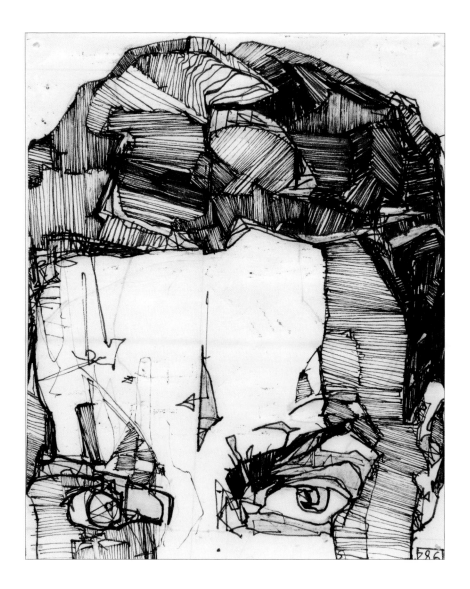

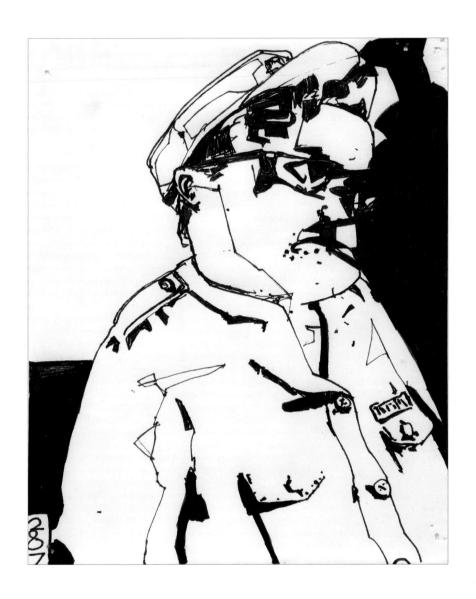

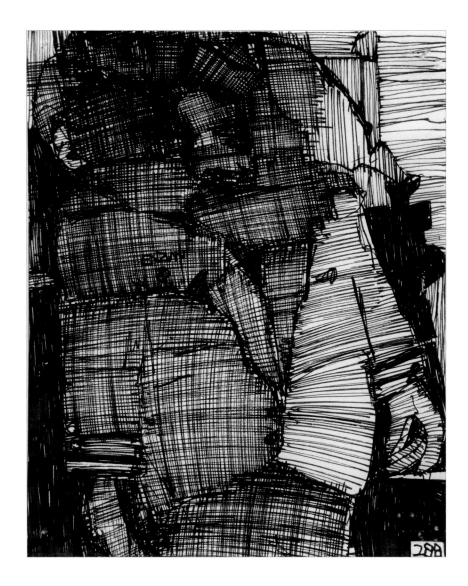

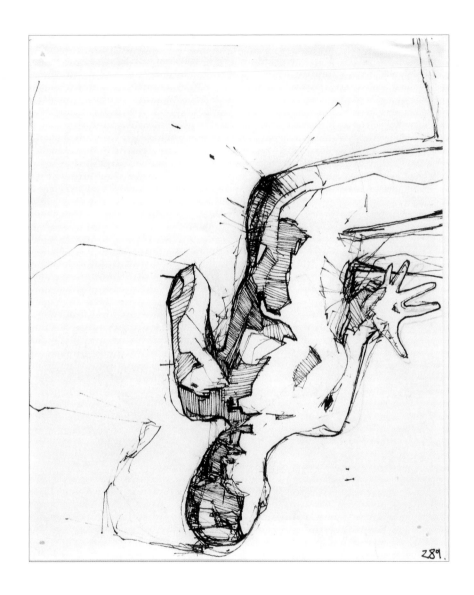

289.

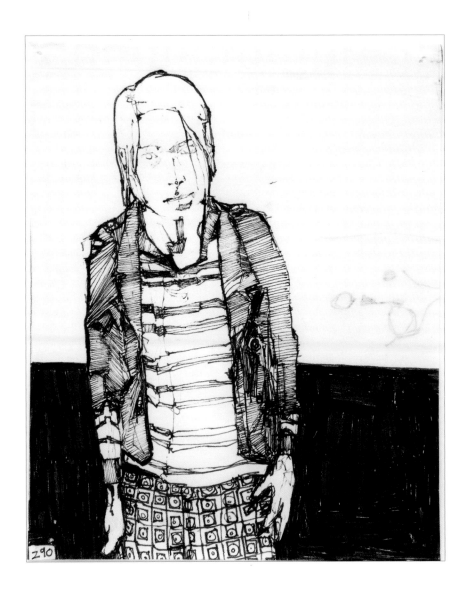

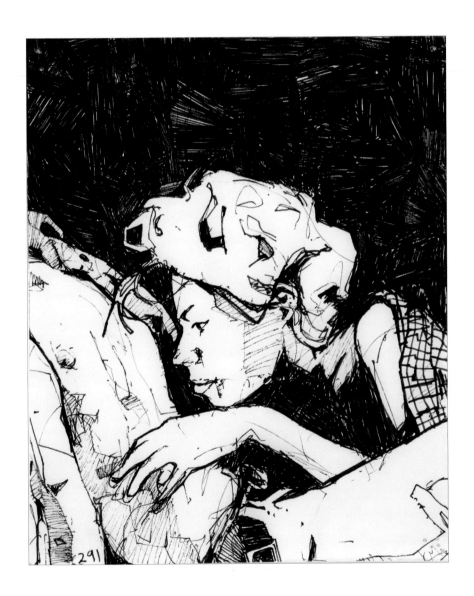

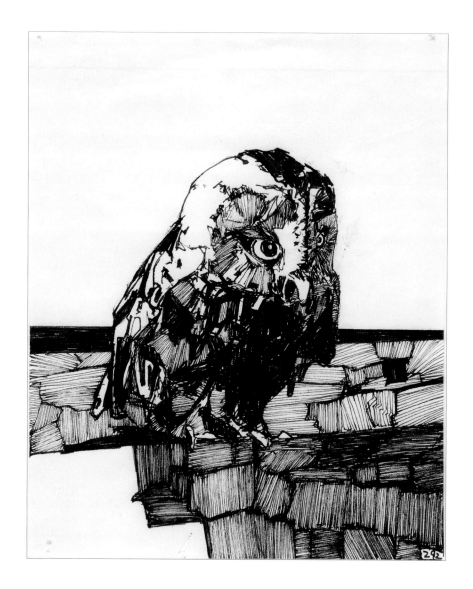

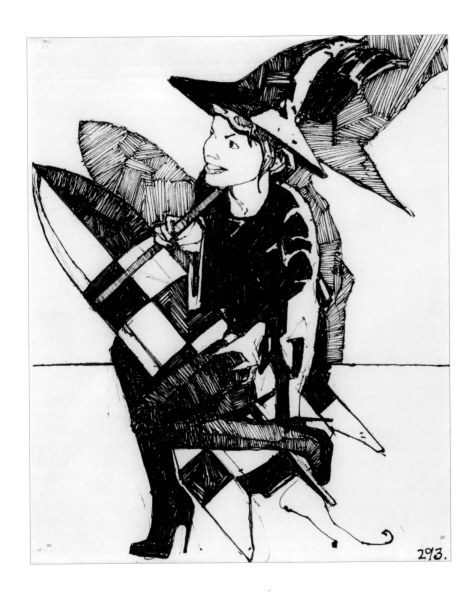

293.

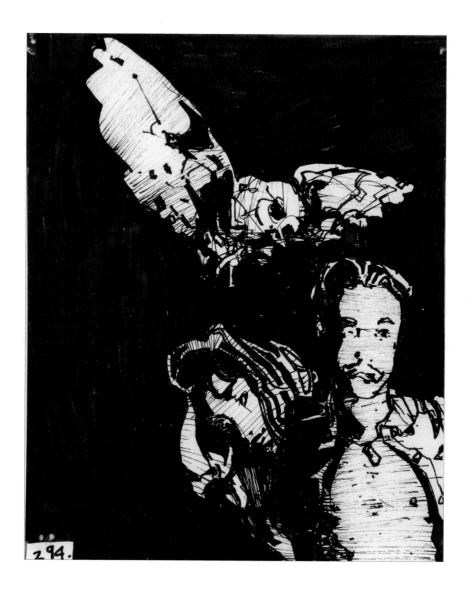

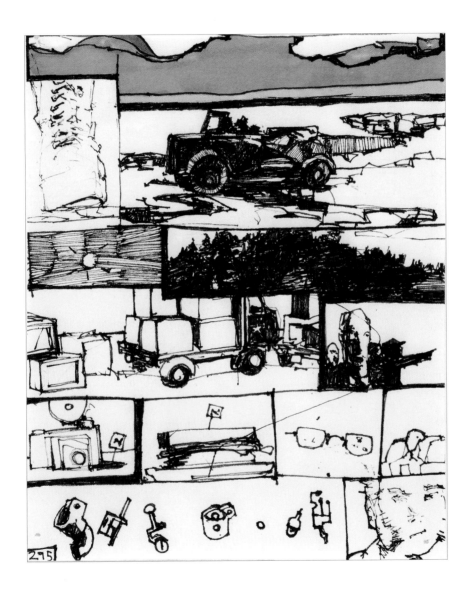

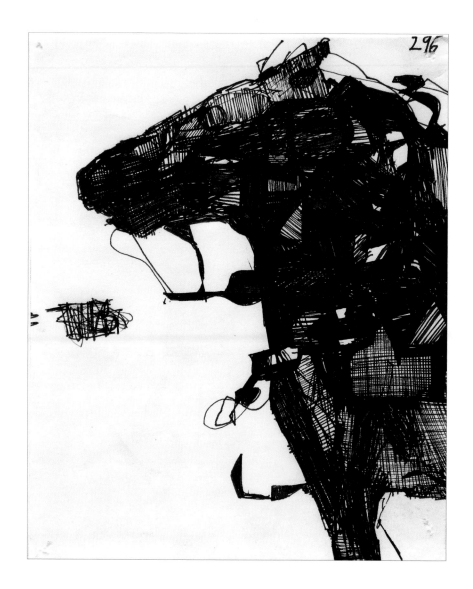

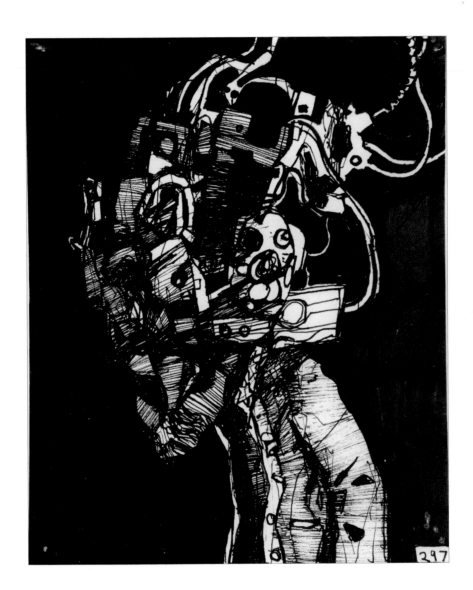

297

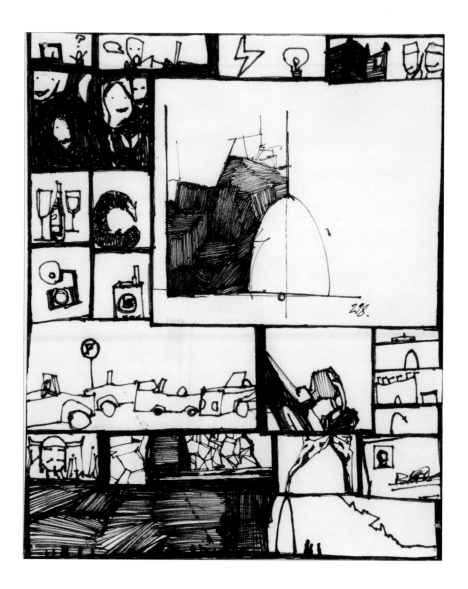

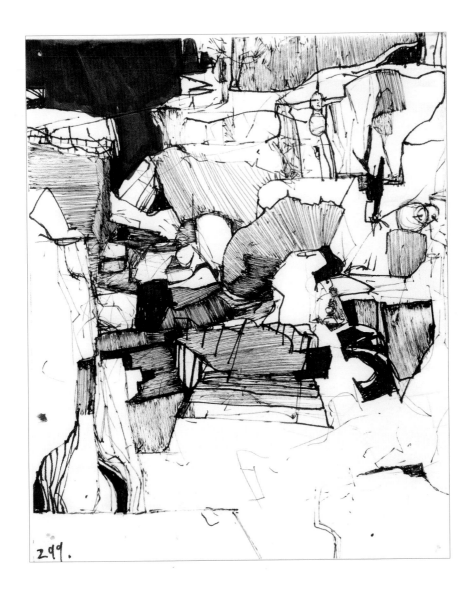

299.

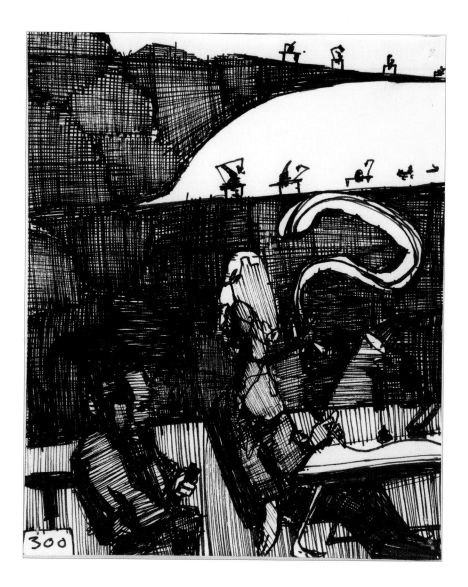

300

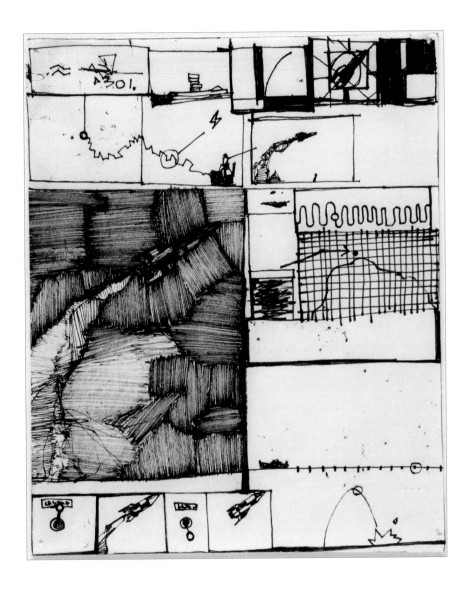

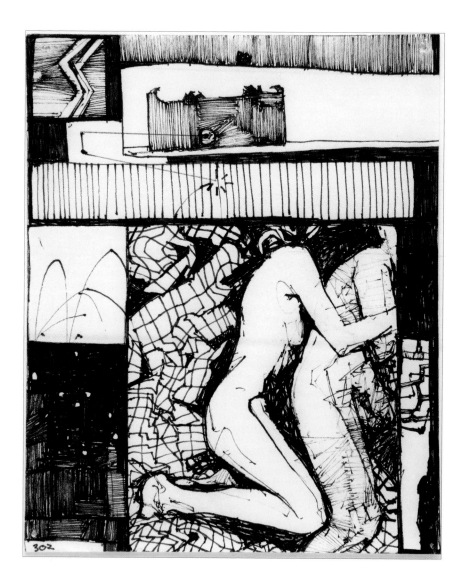

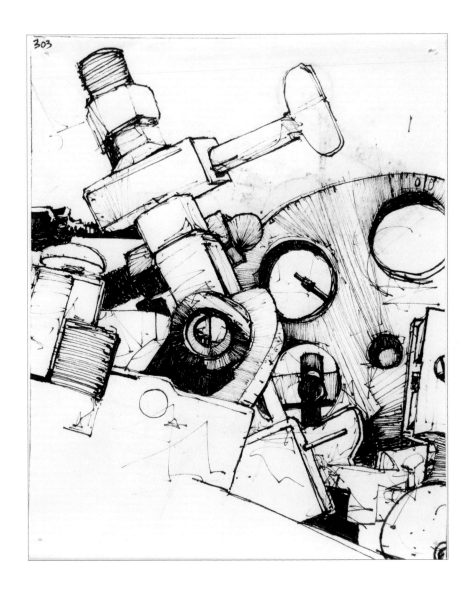

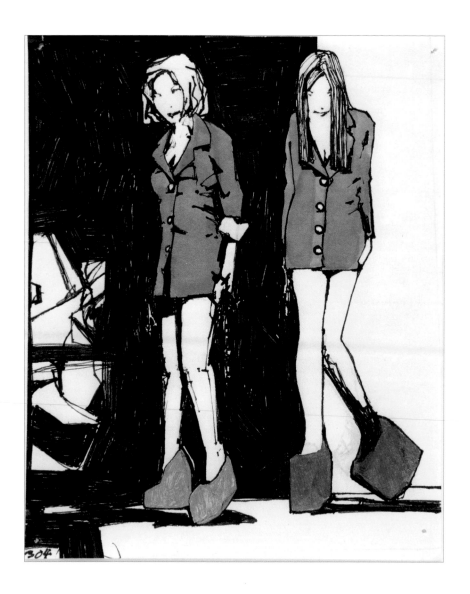

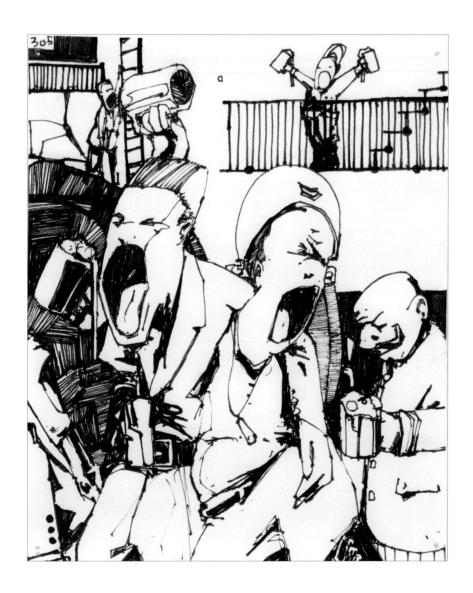

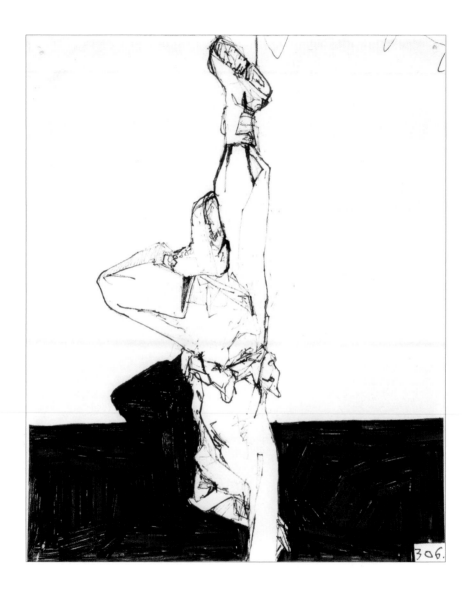

306.

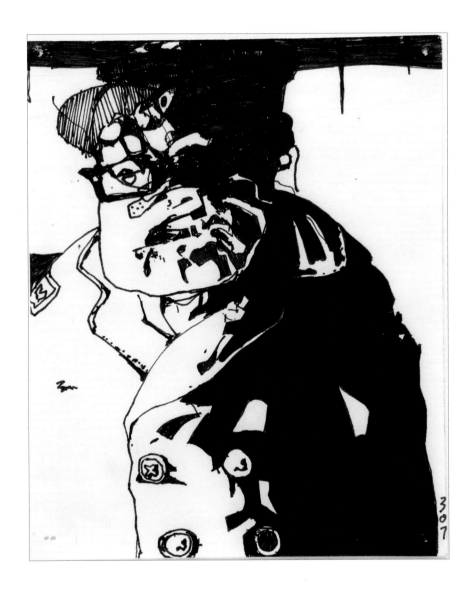

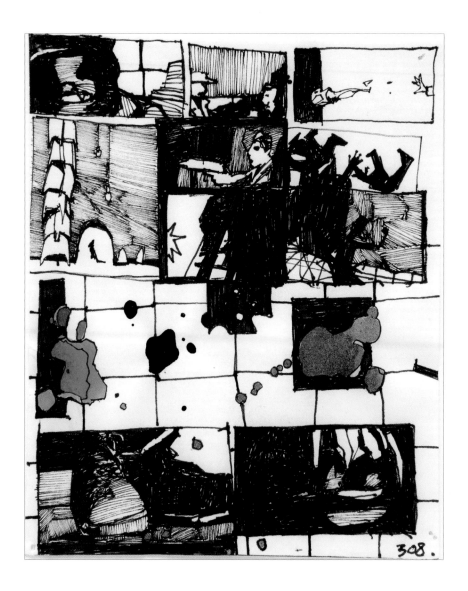

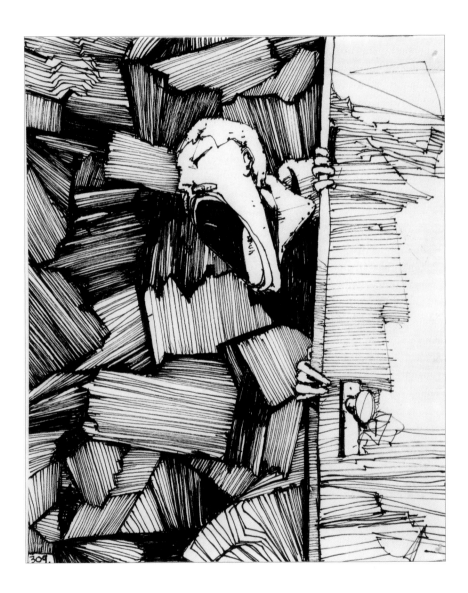

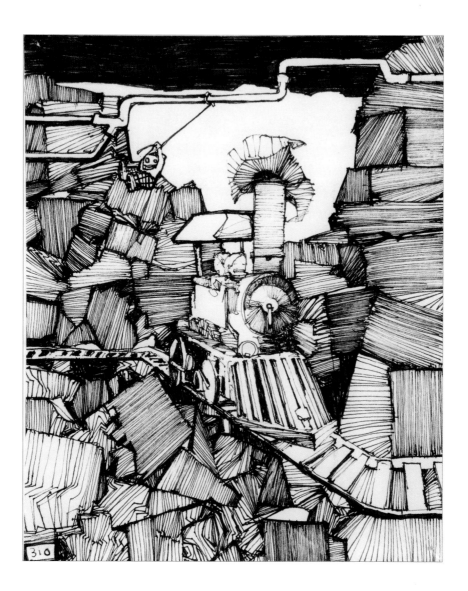

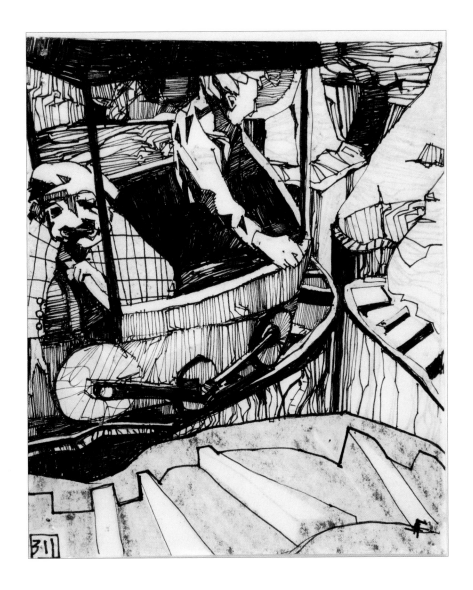

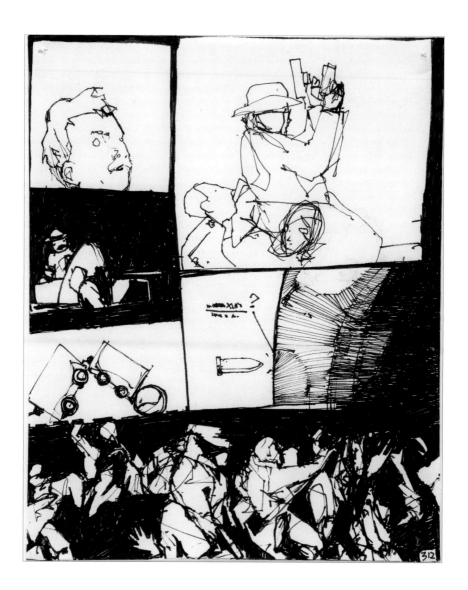

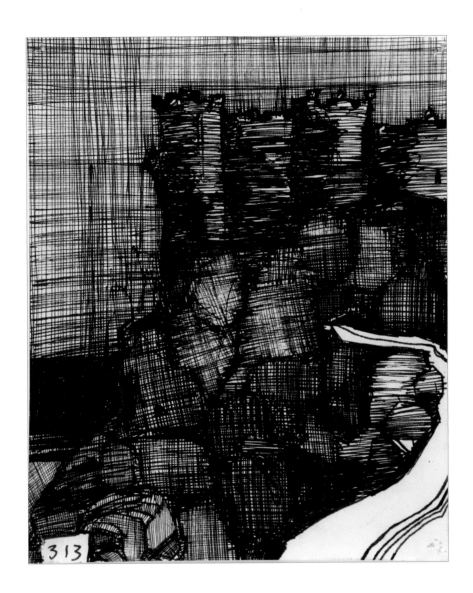

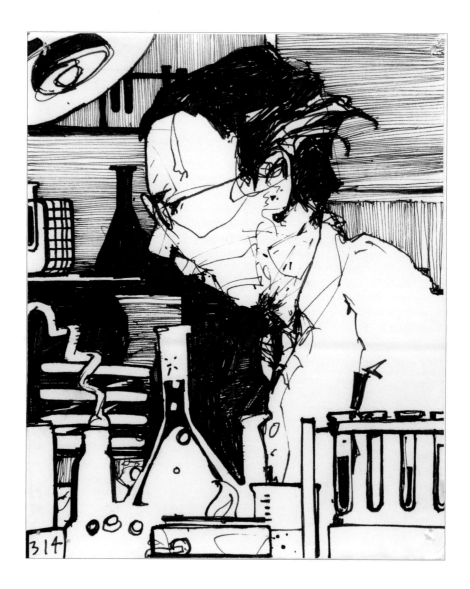

314

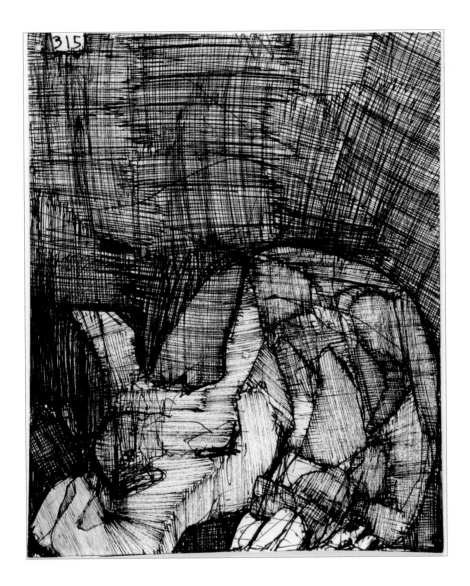

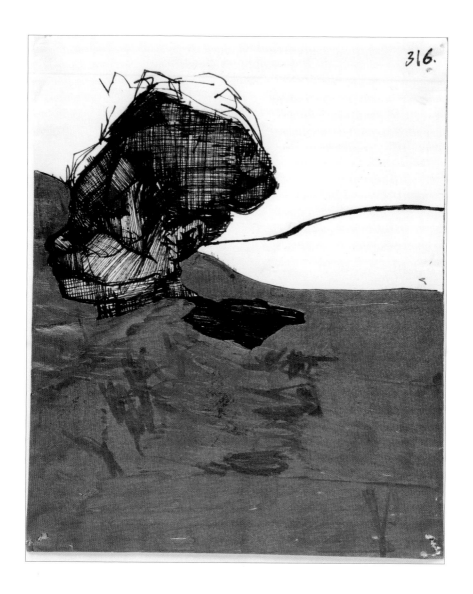

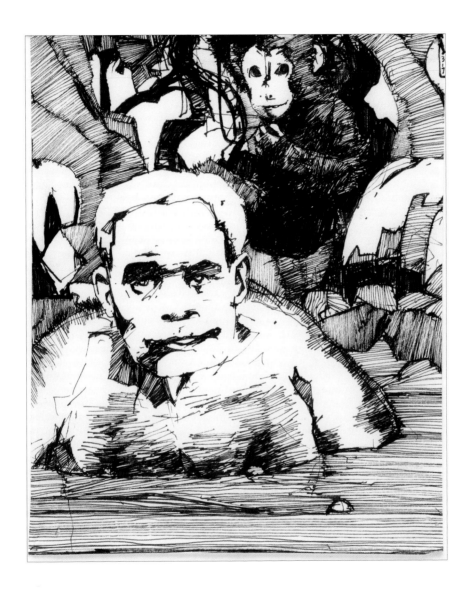

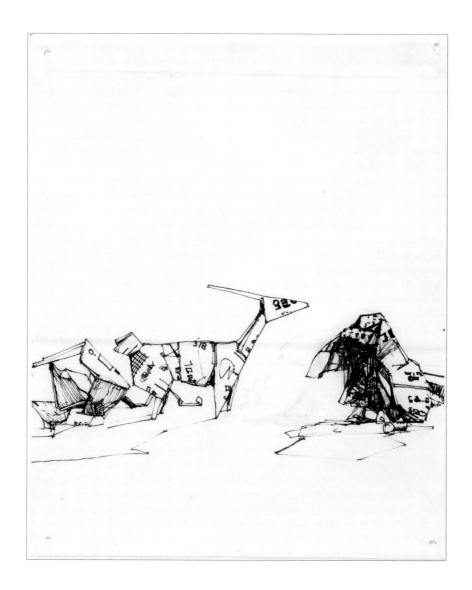

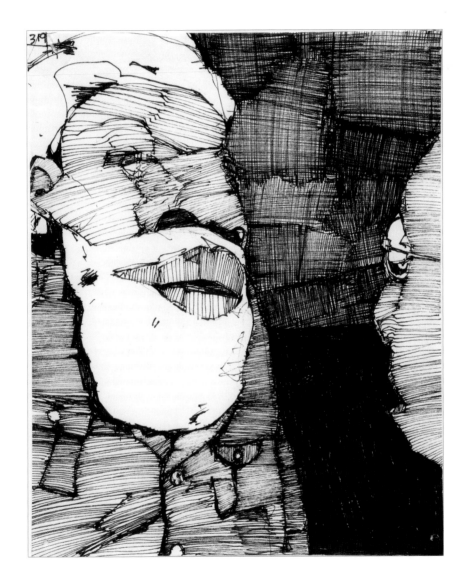

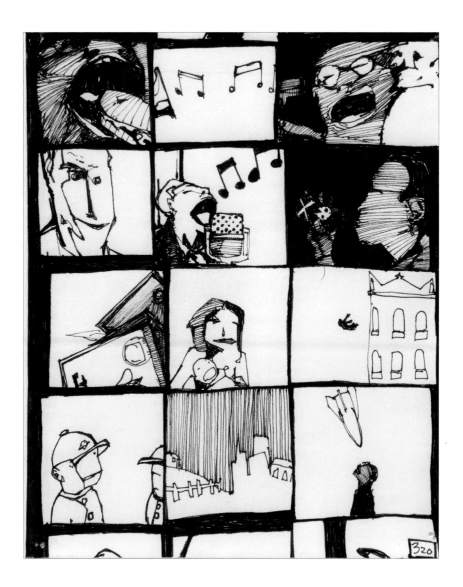

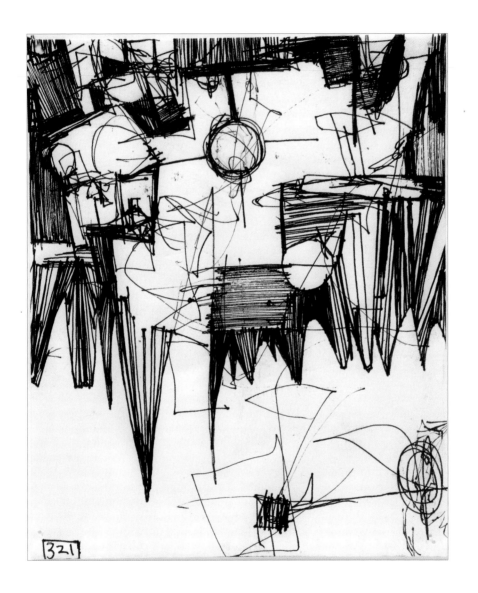

321

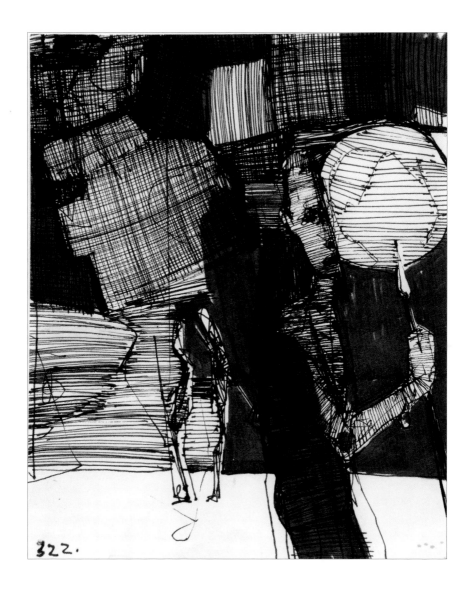

322.

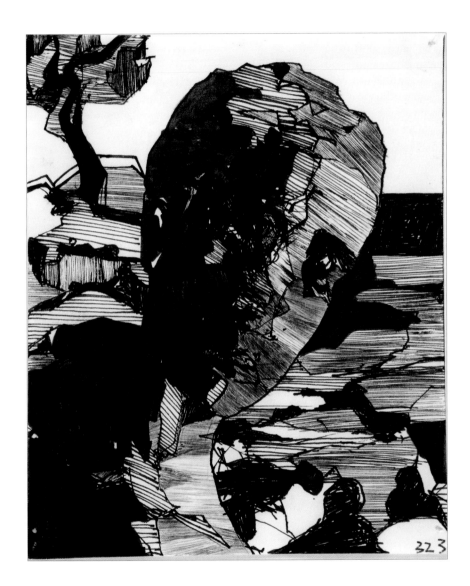

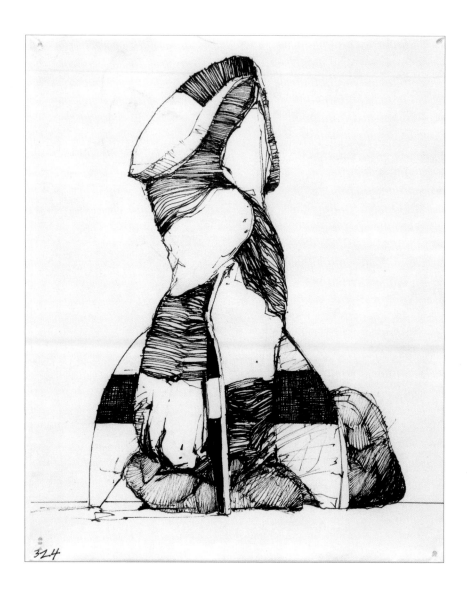

324

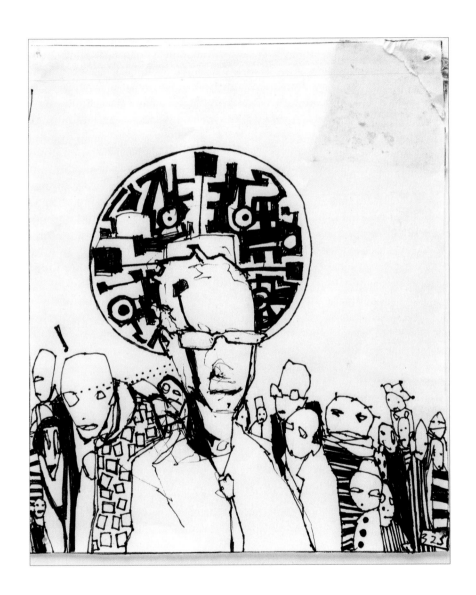

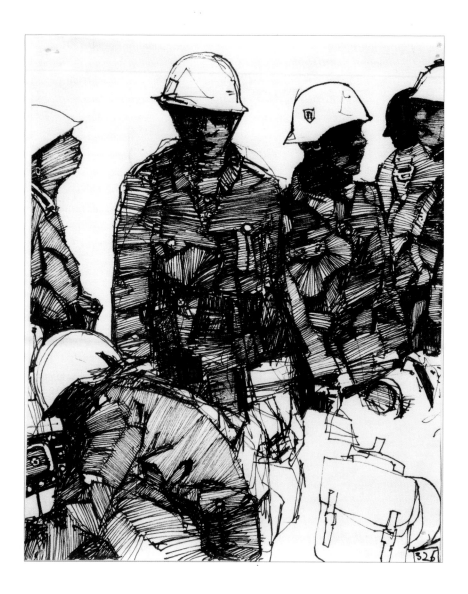

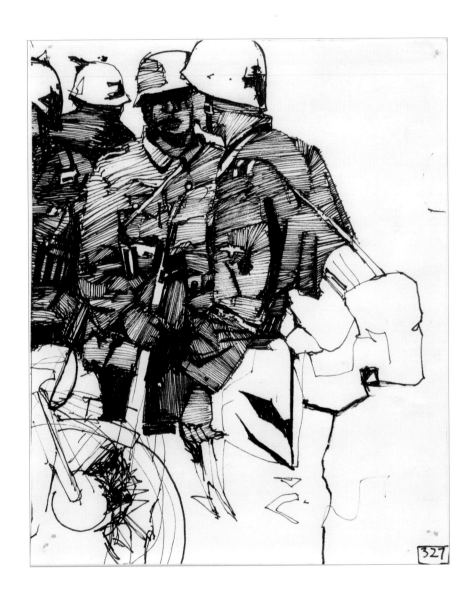

327

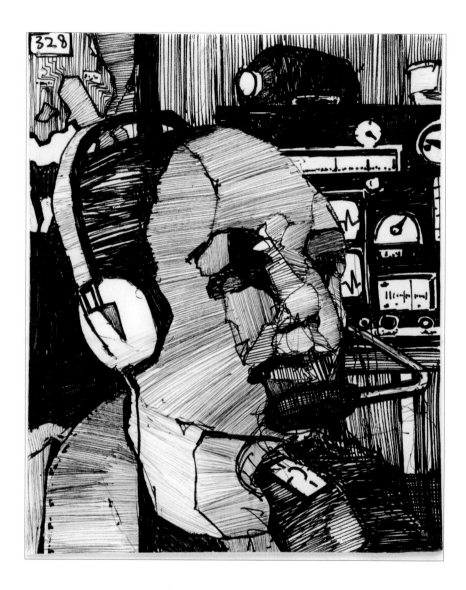

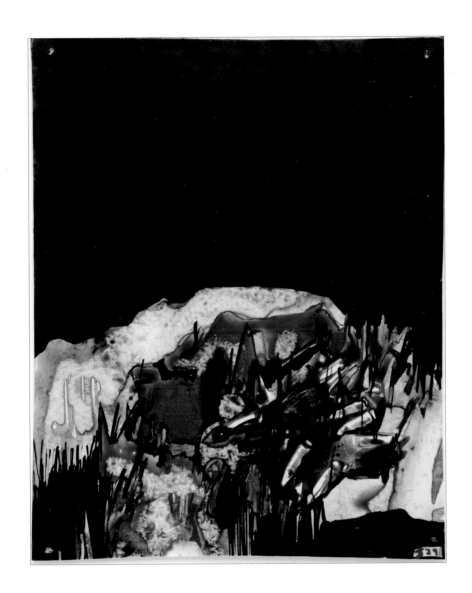

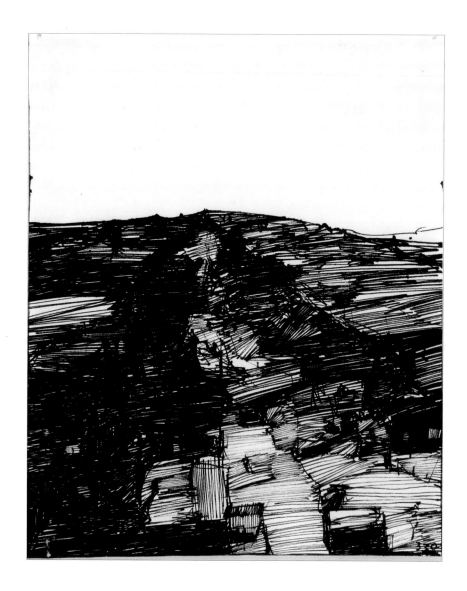

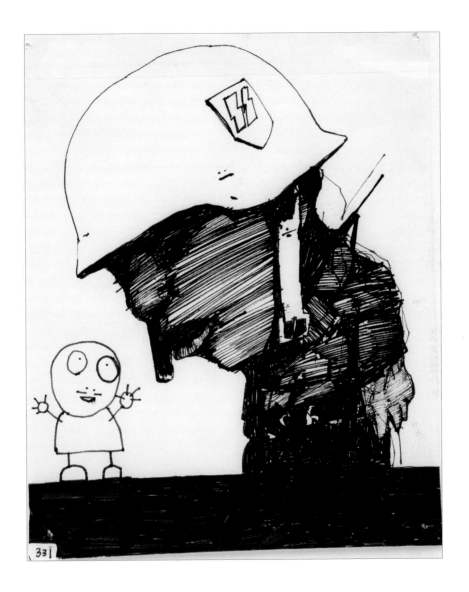

331

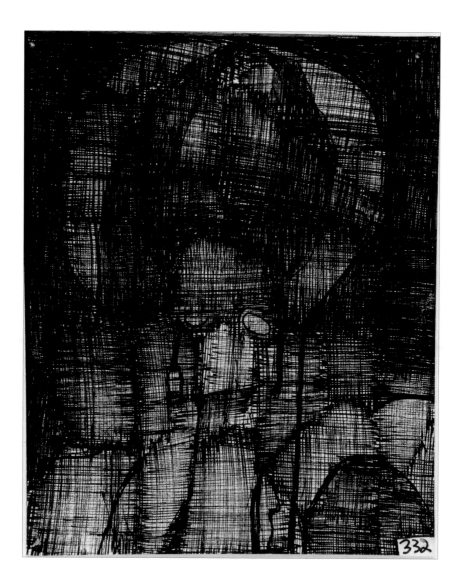

332

: 332 :

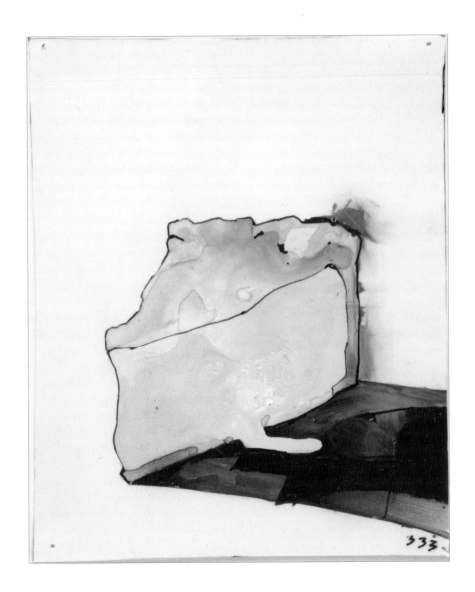

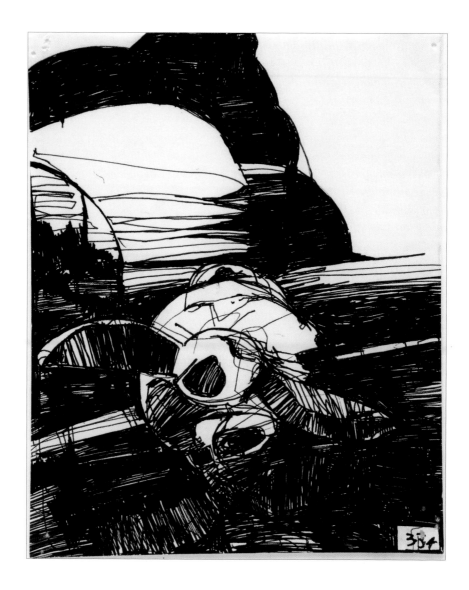

: 334 :

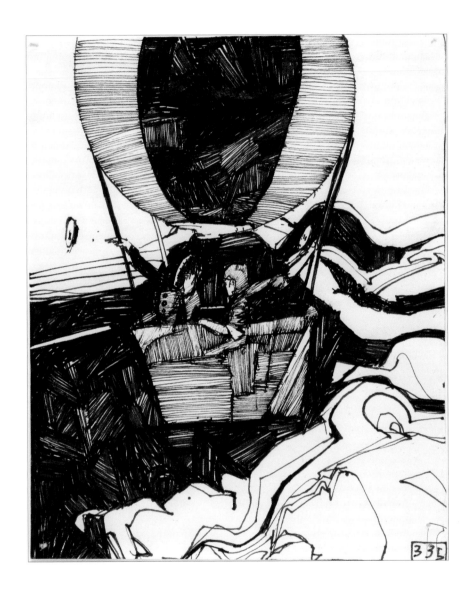

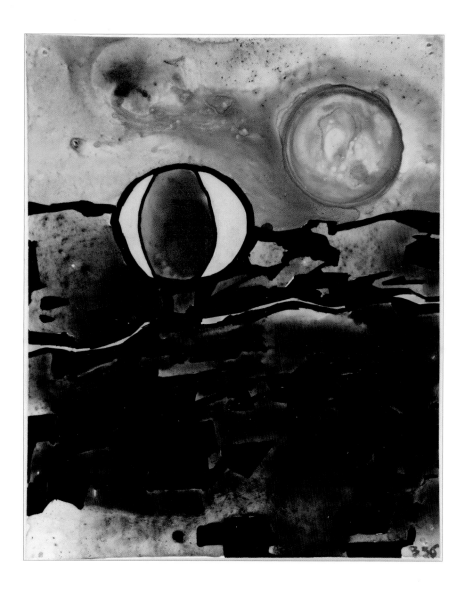

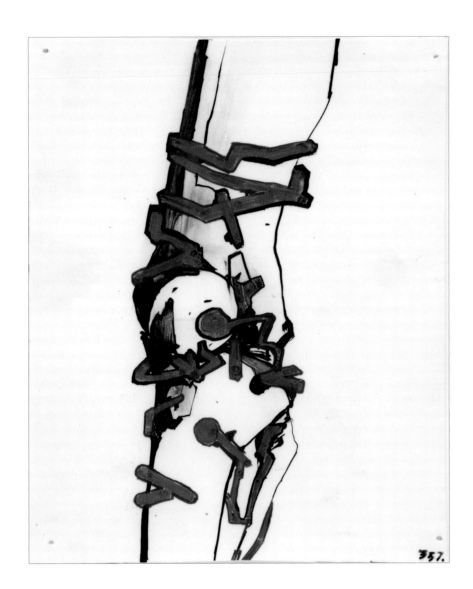

357.

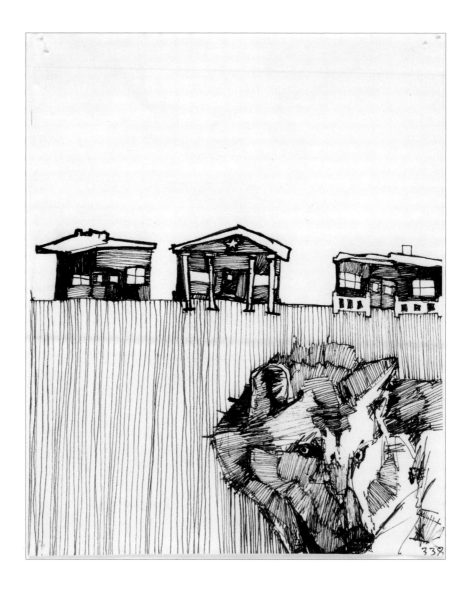

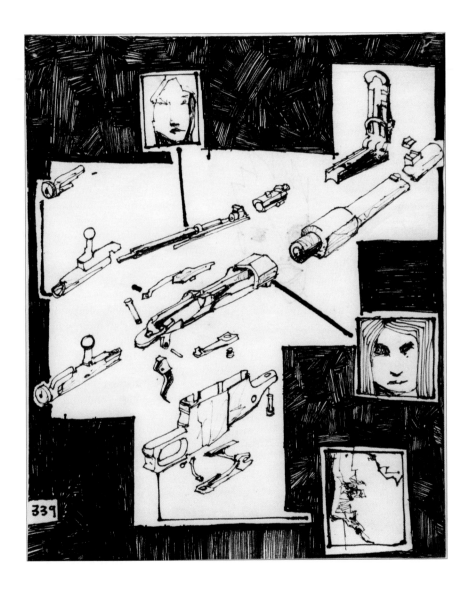

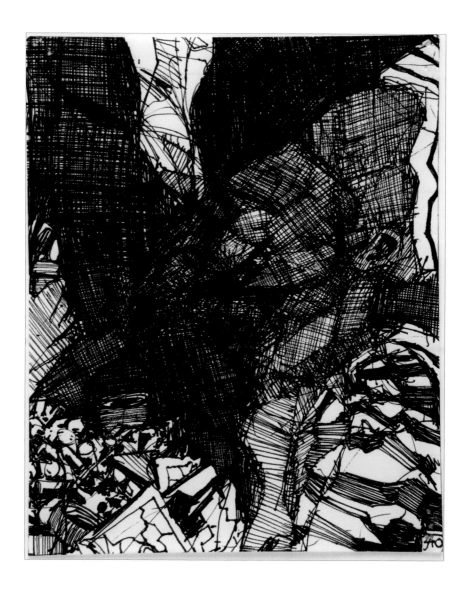

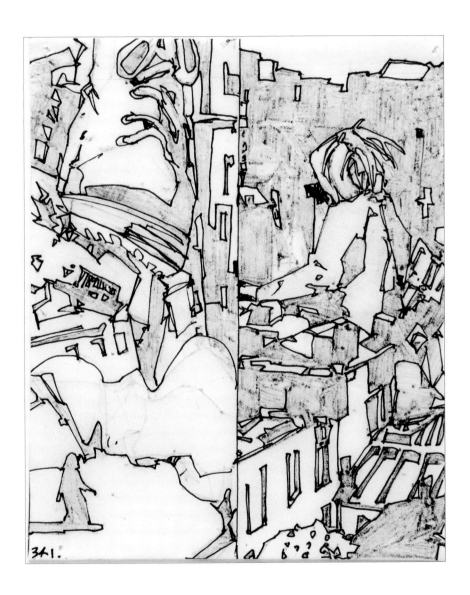

341.

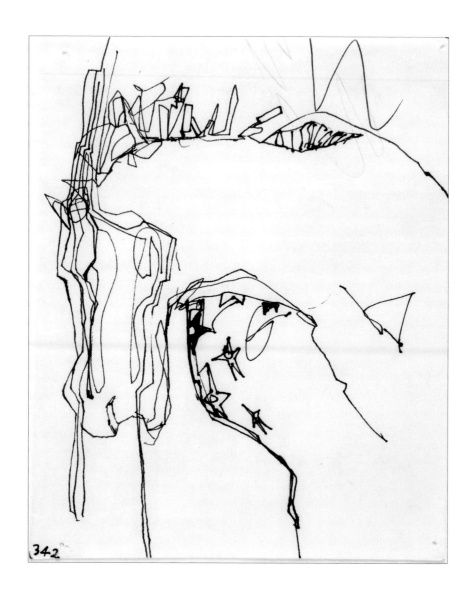

342

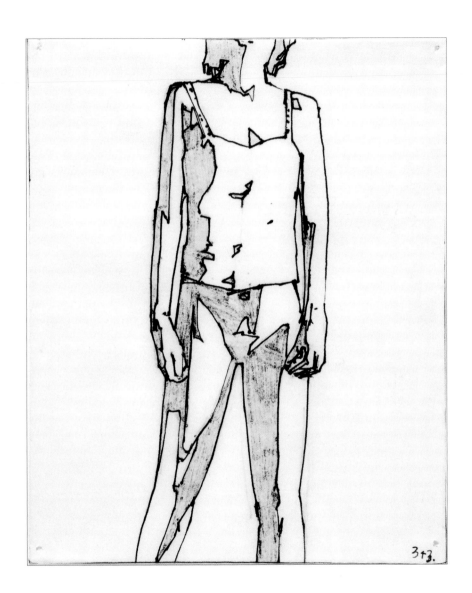

343.

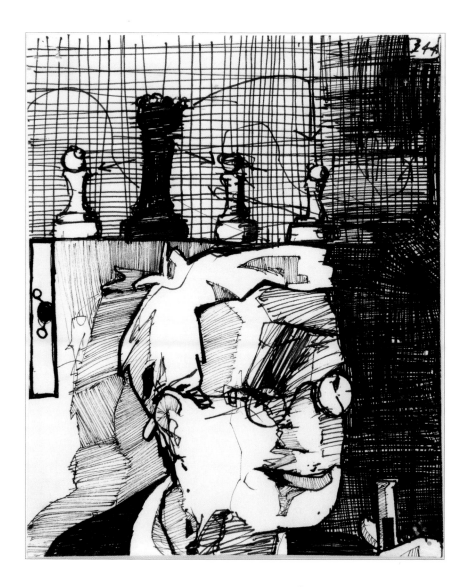

: 344 :

345

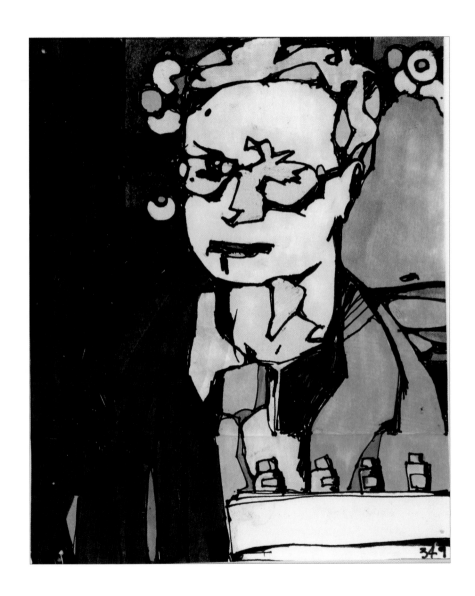

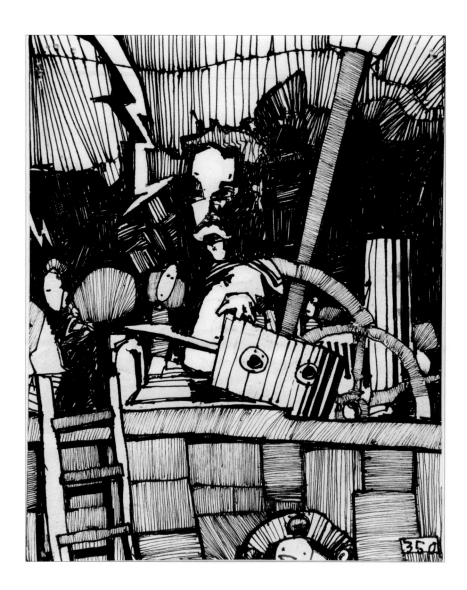

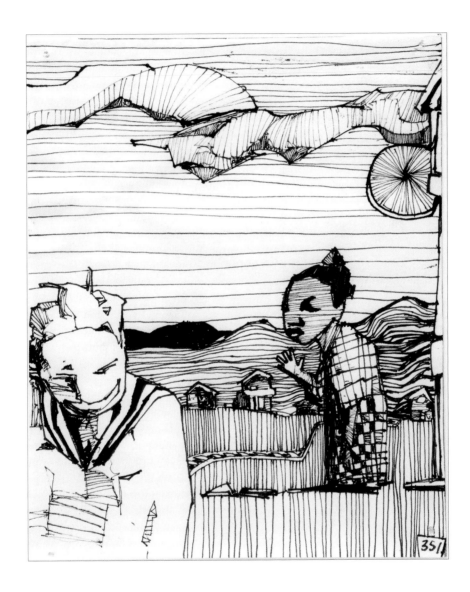

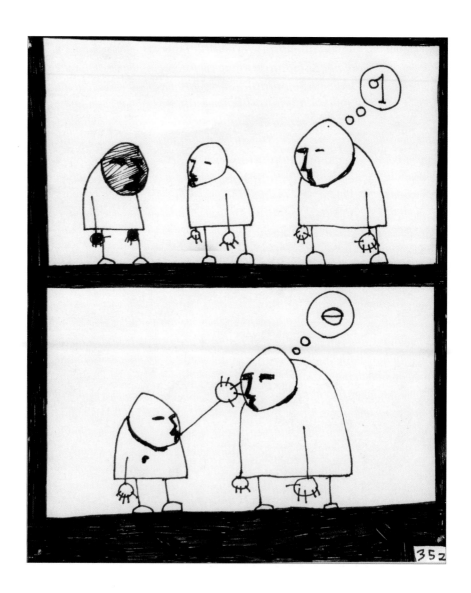

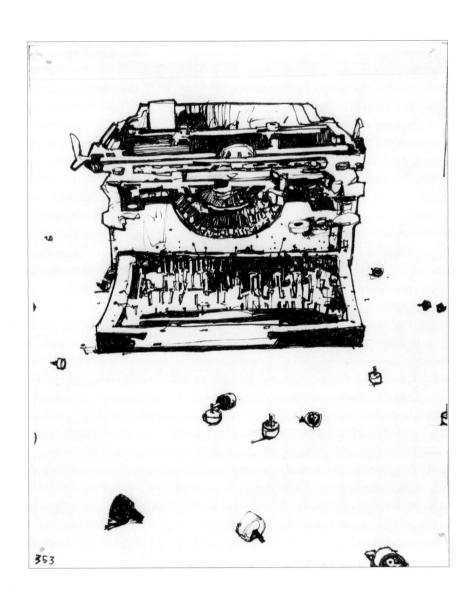

353

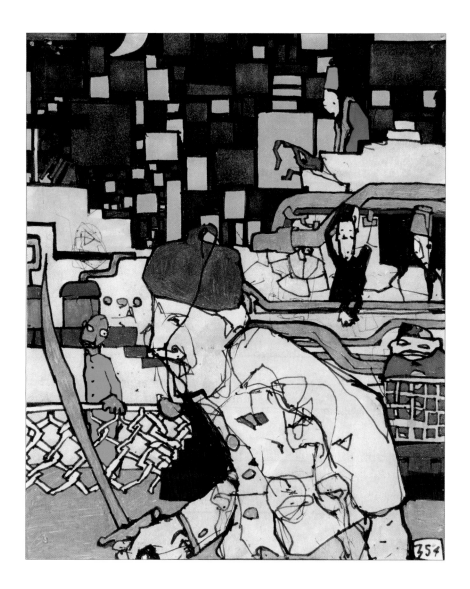

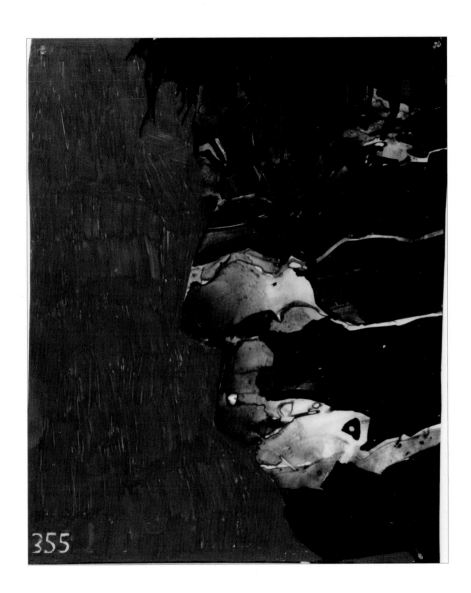

355

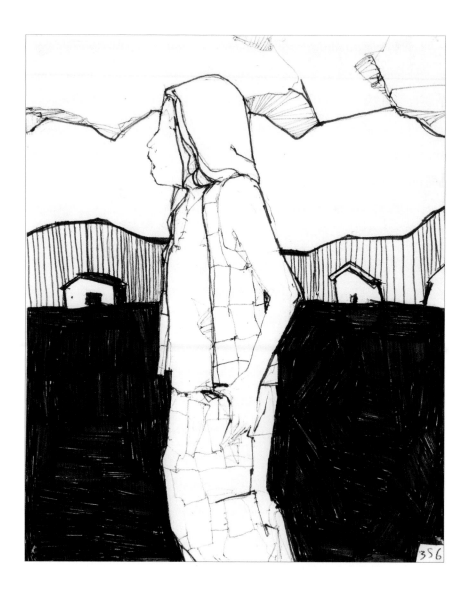

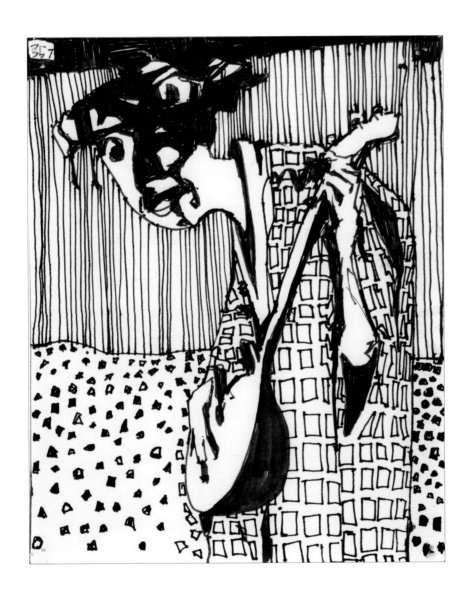

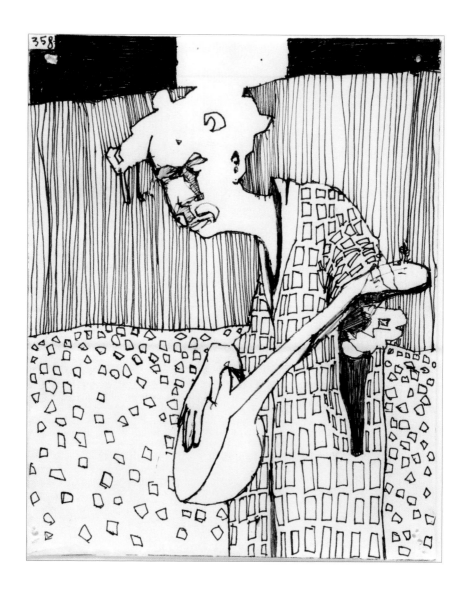

: 358 :

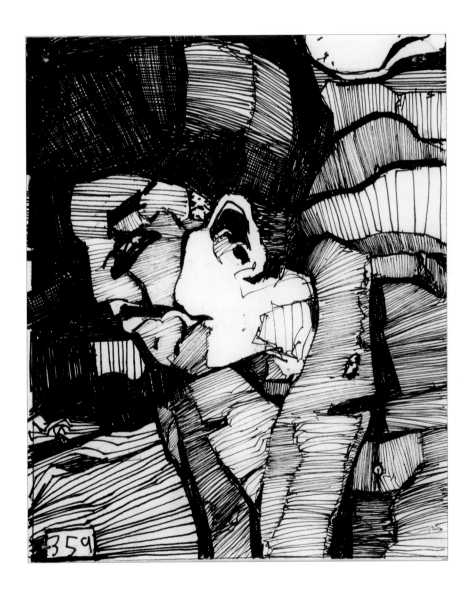

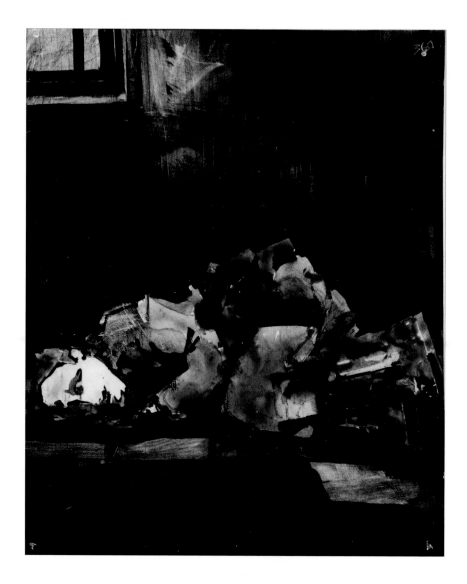

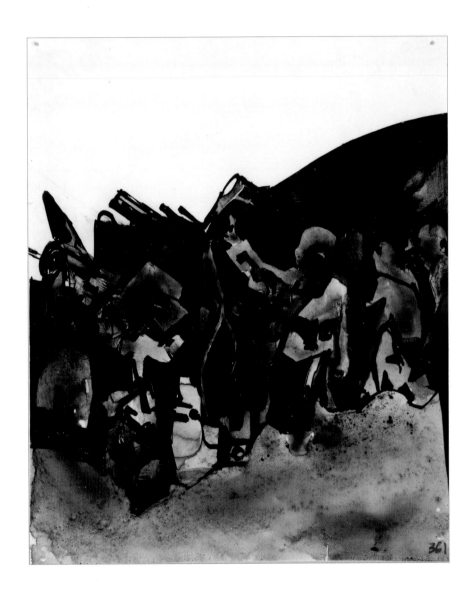

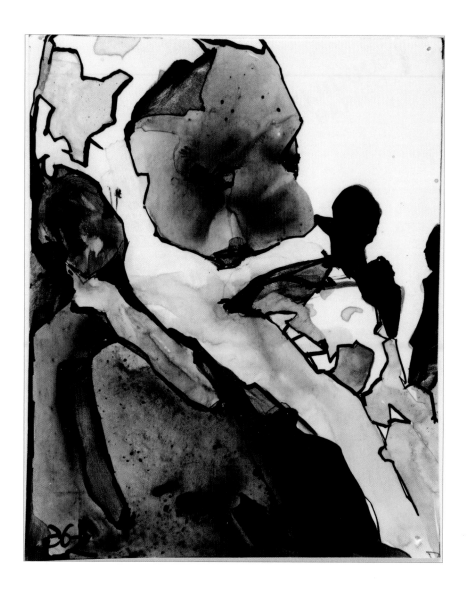

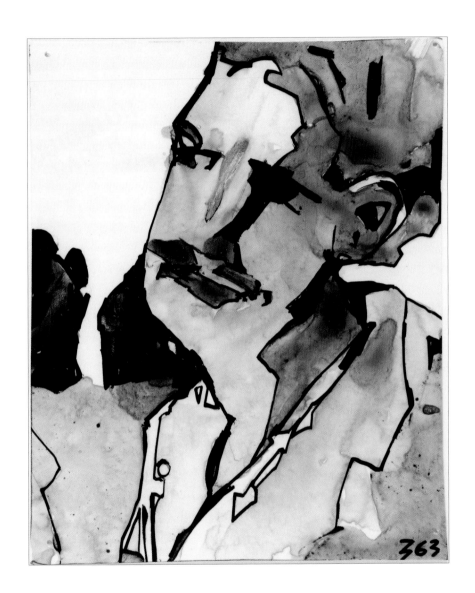

363

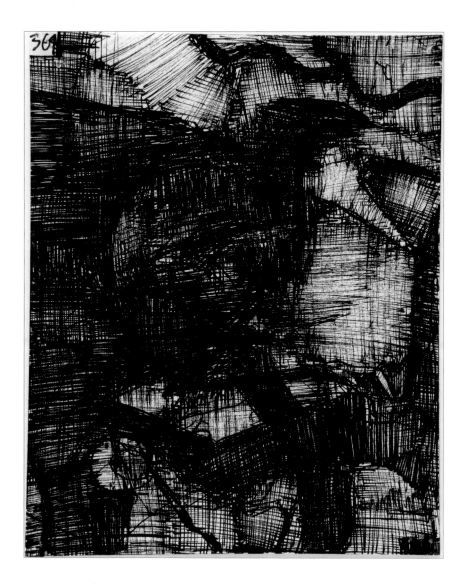

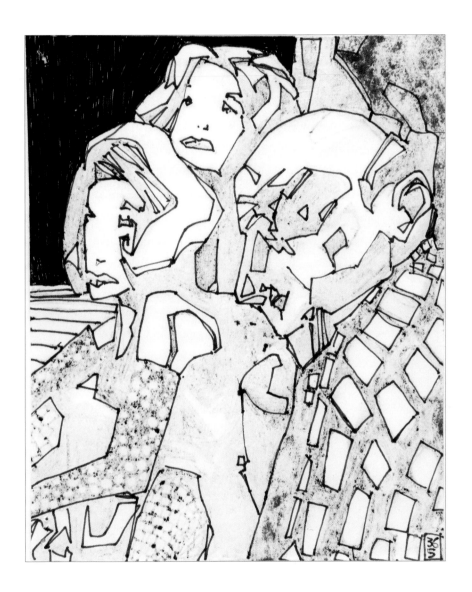

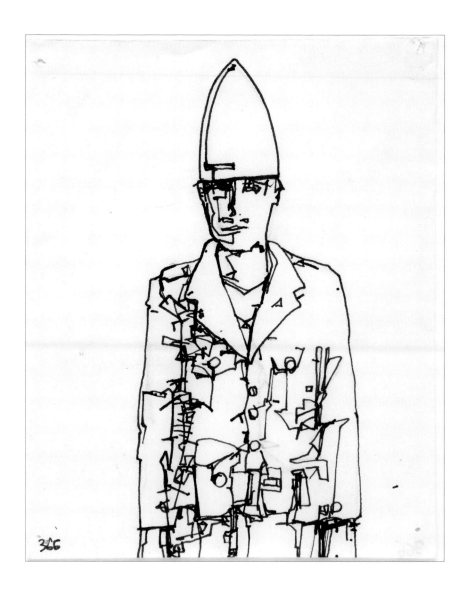

366

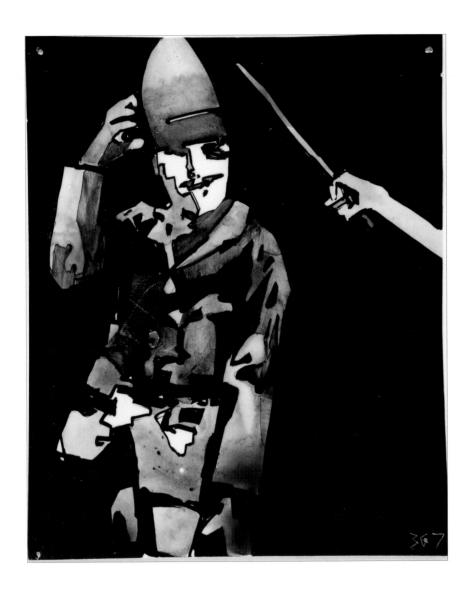

368

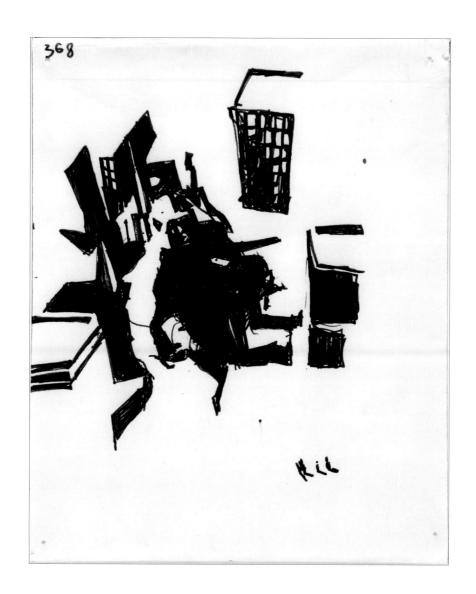

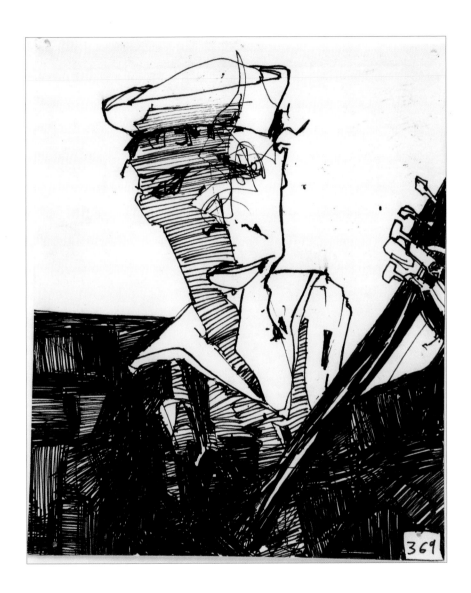

369

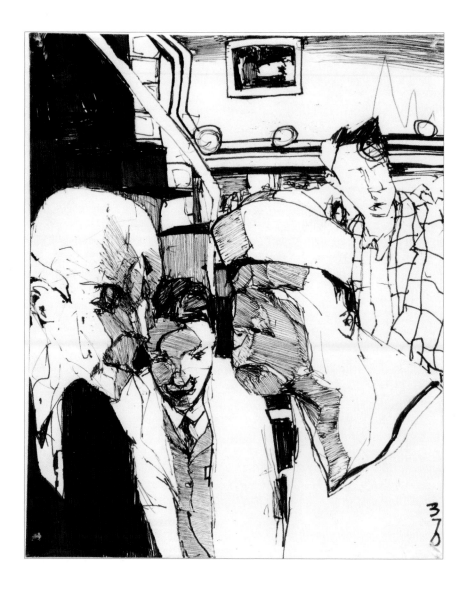

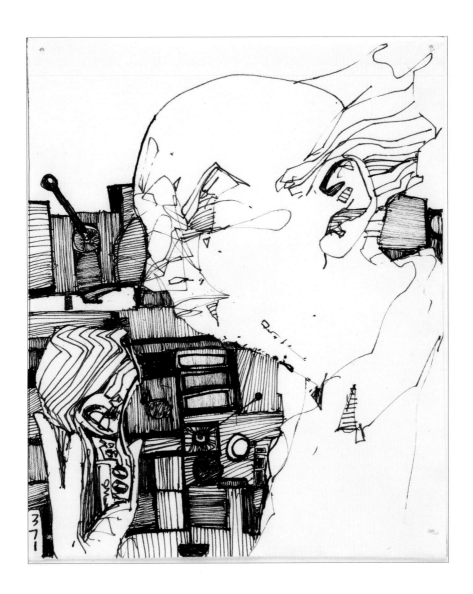

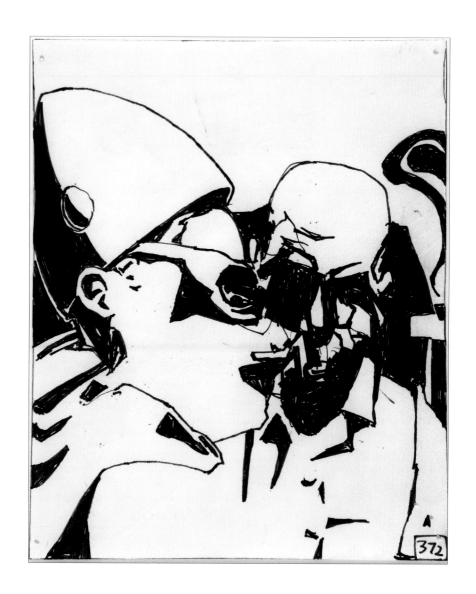

: 372 :

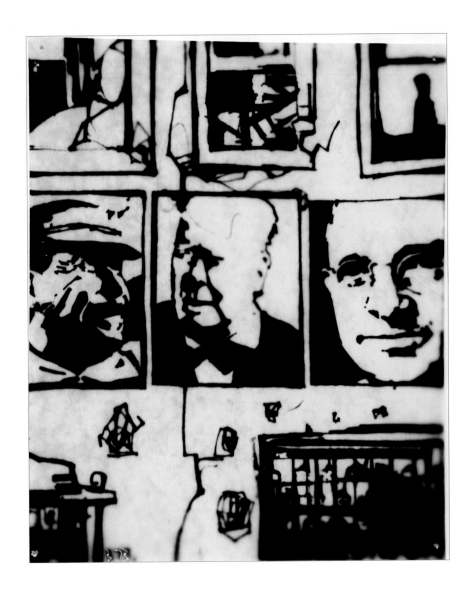

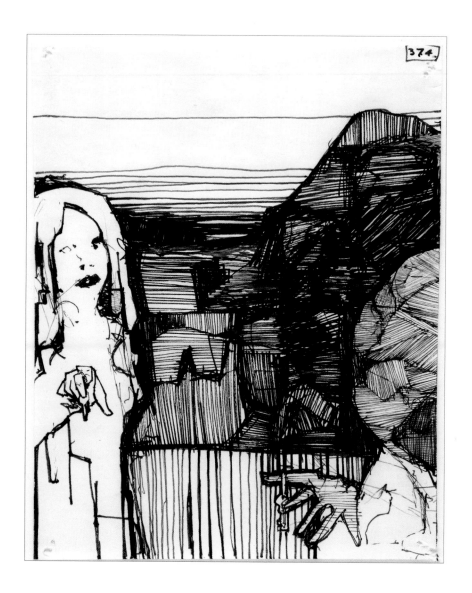

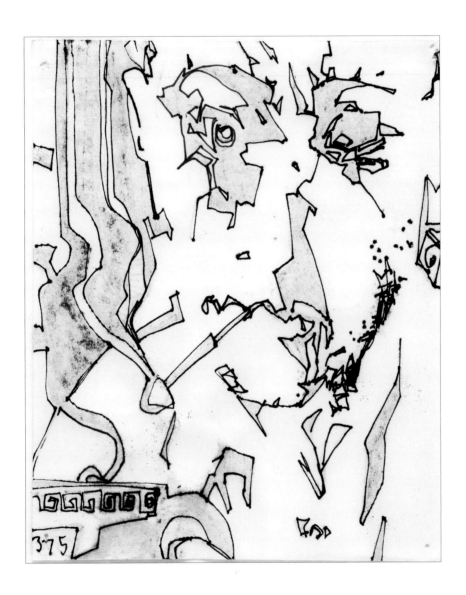

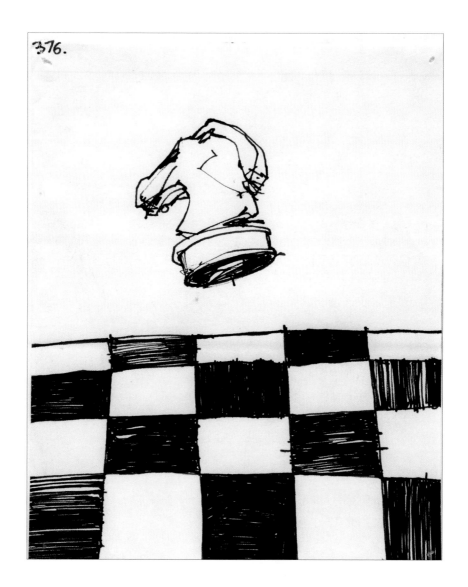

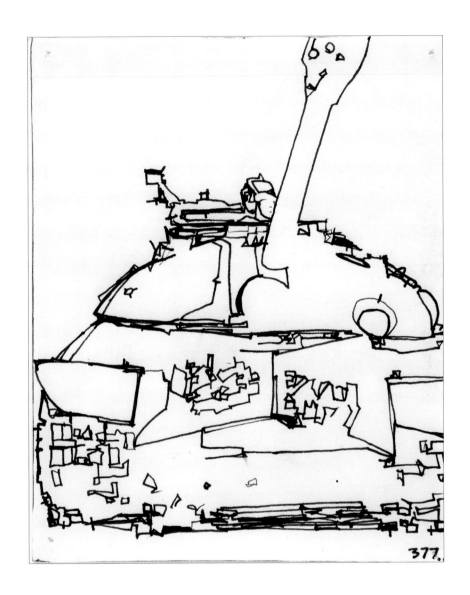

377.

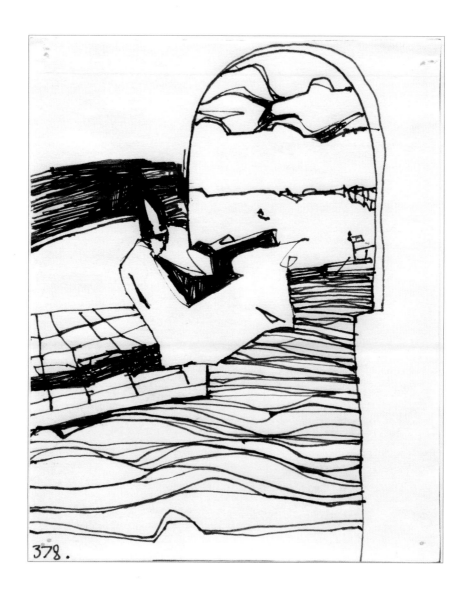

378.

379.

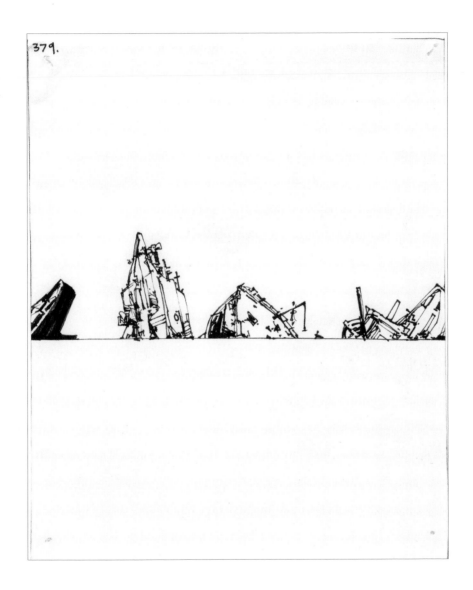

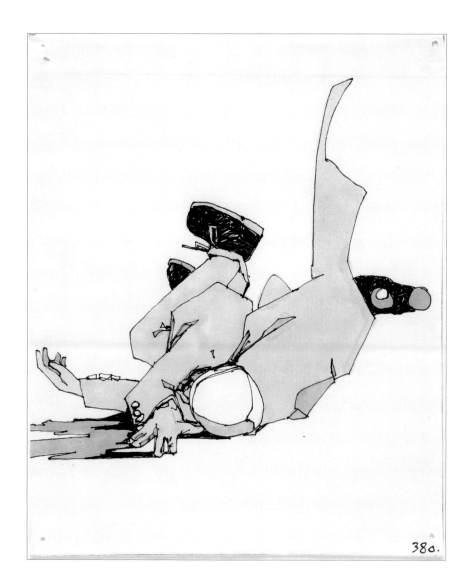

38a.

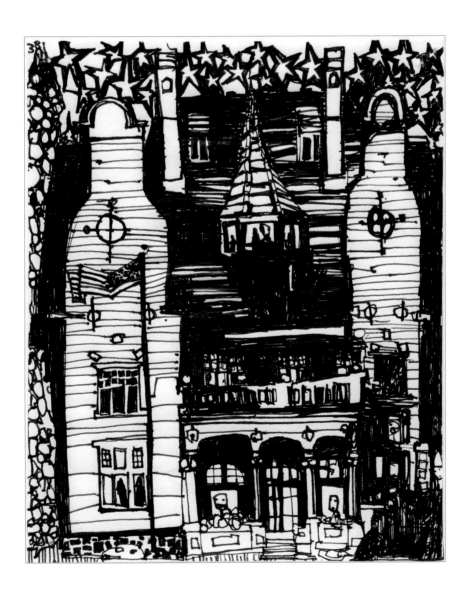

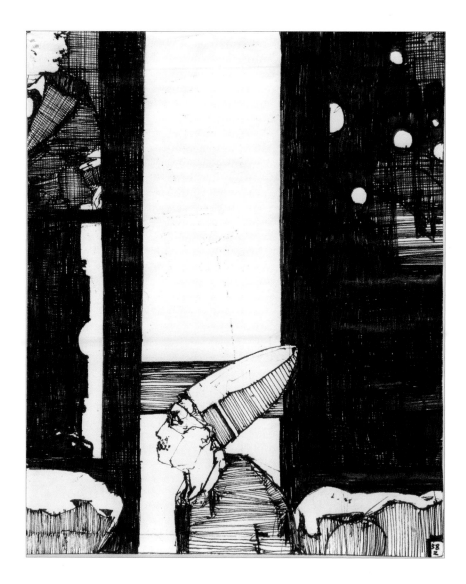

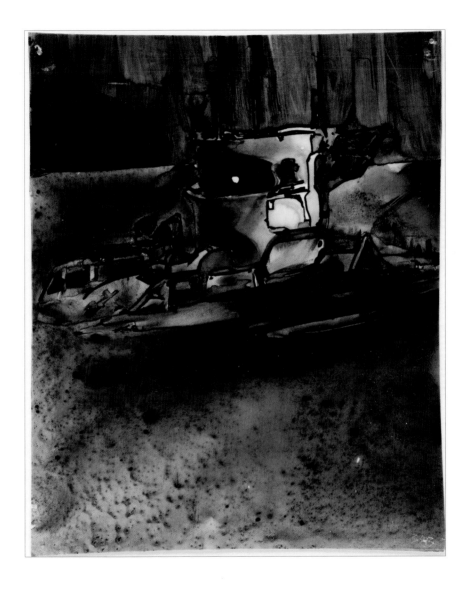

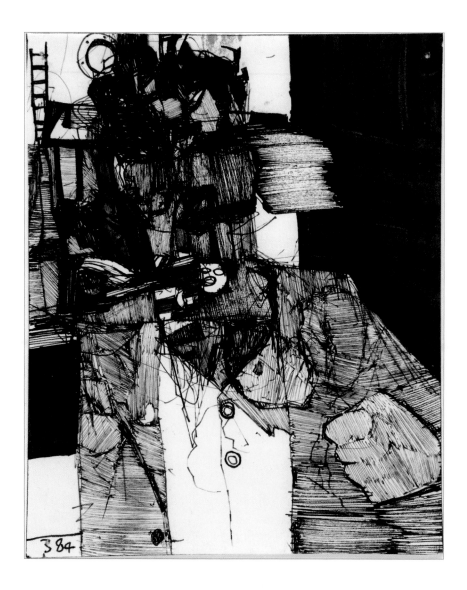

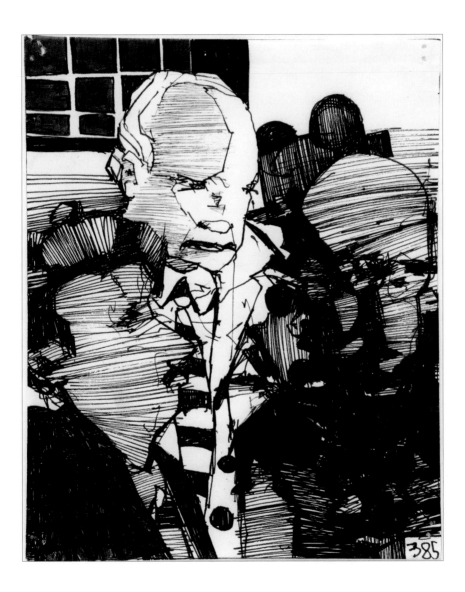

386

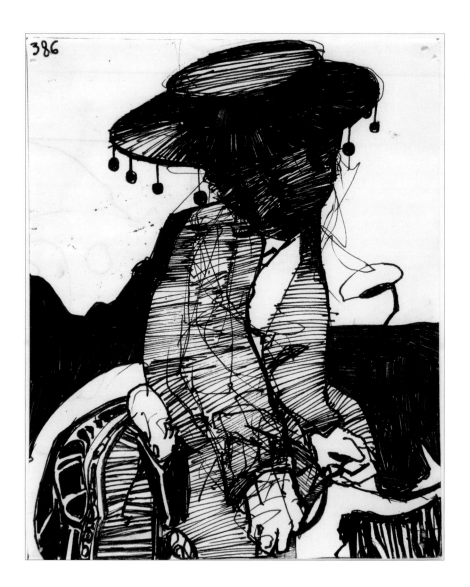

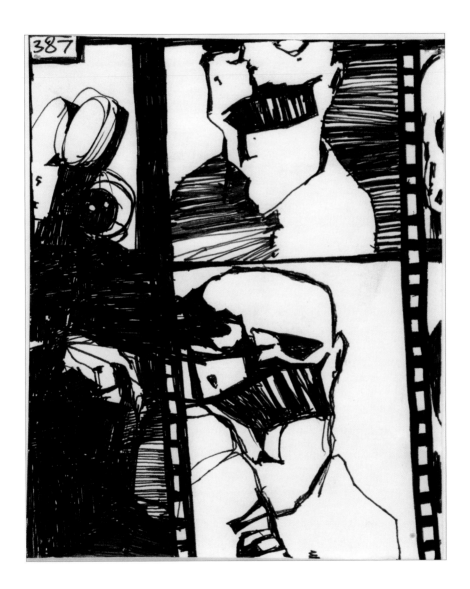

387

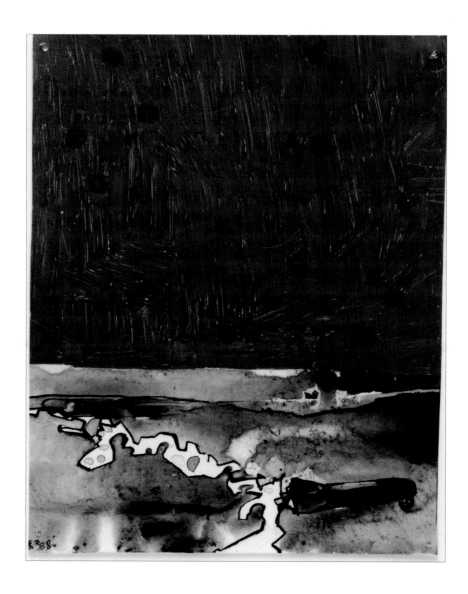

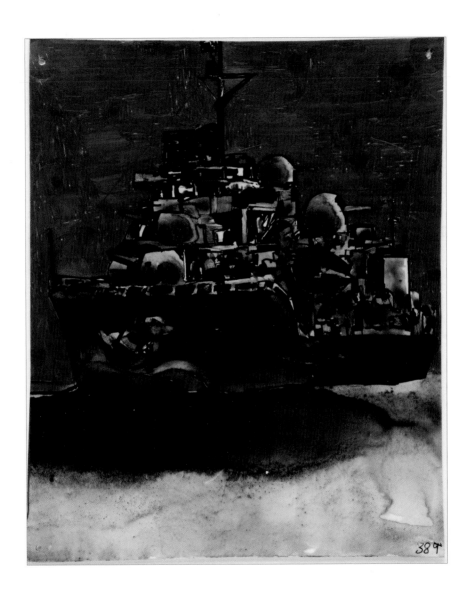

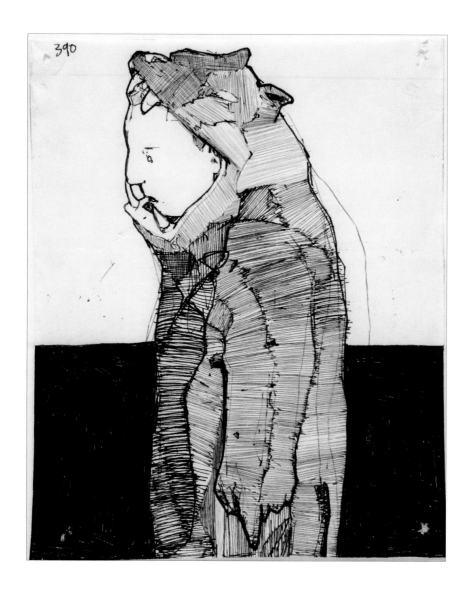

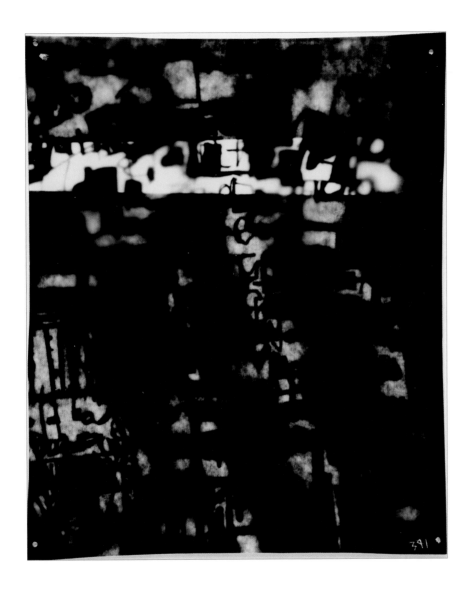

392.

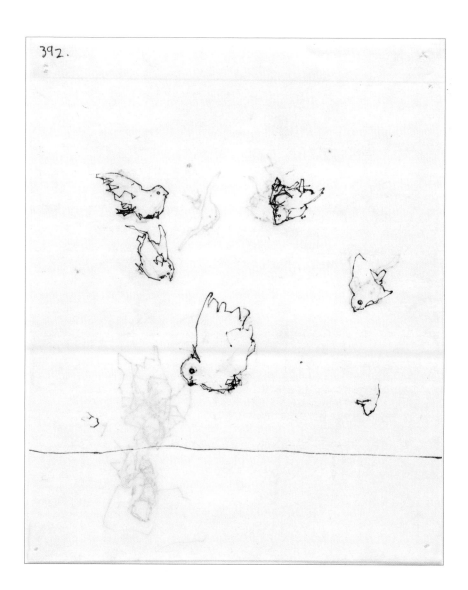

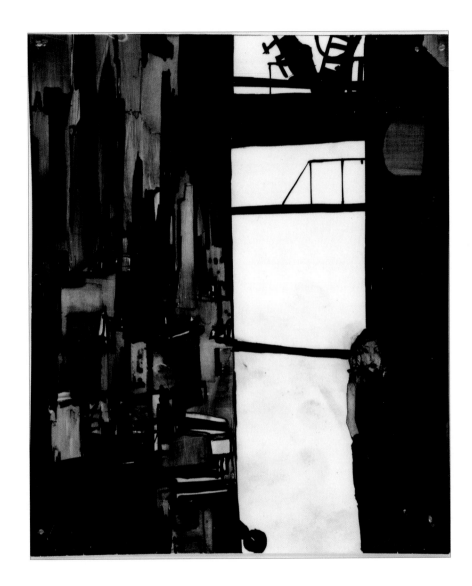

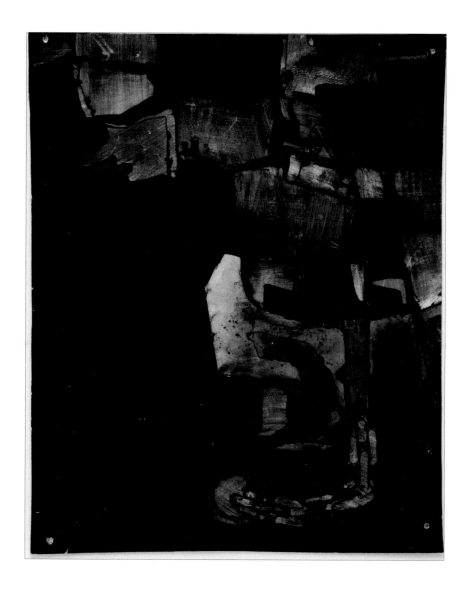

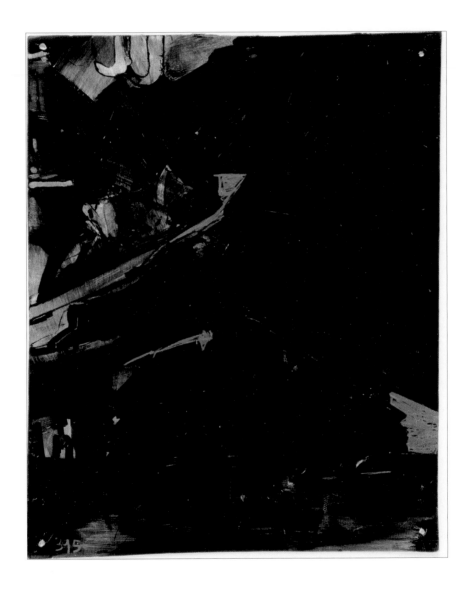

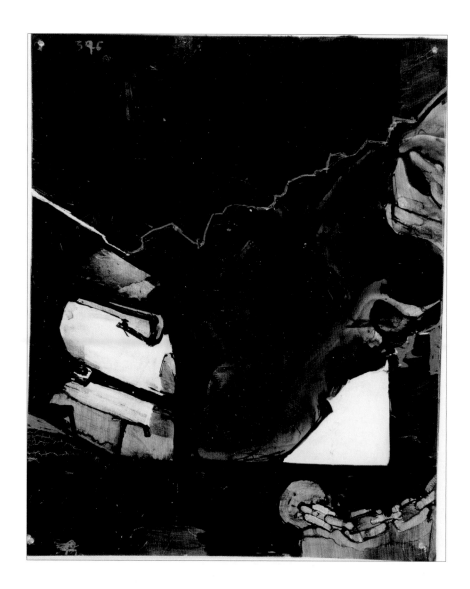

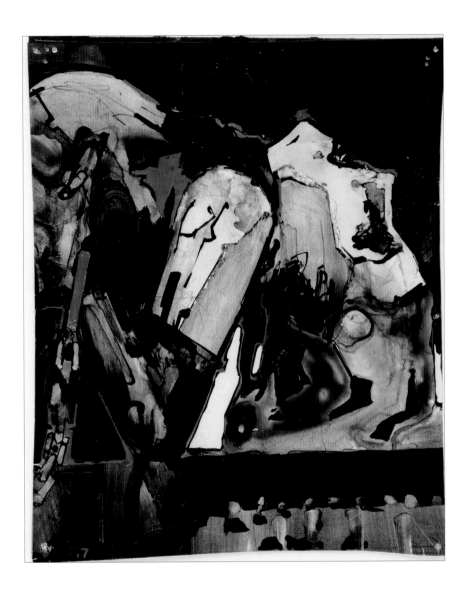

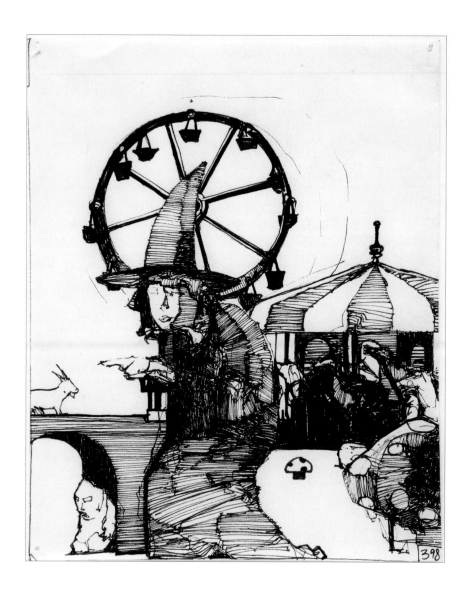

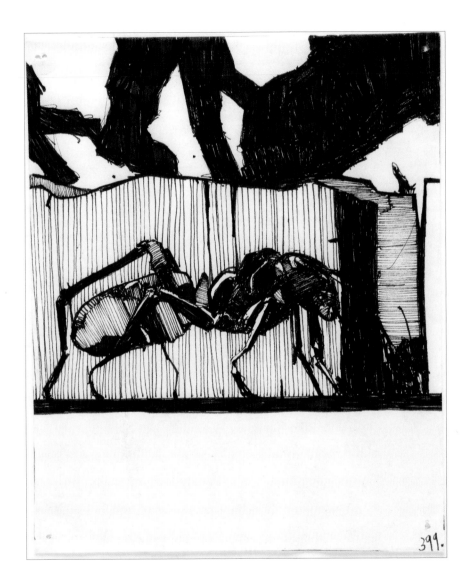

399.

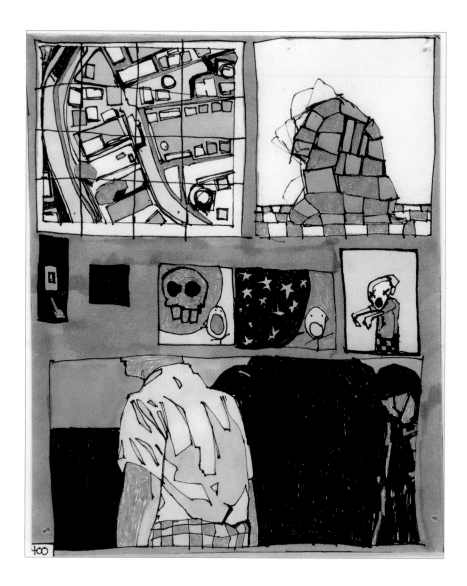

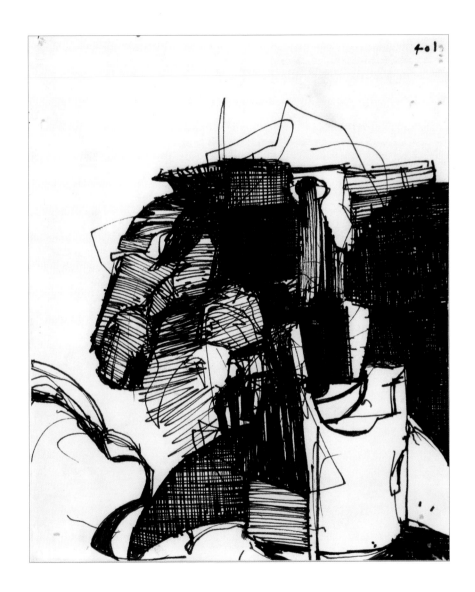

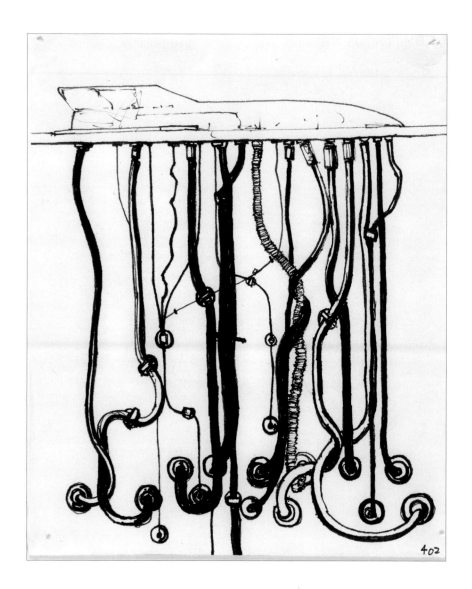

402

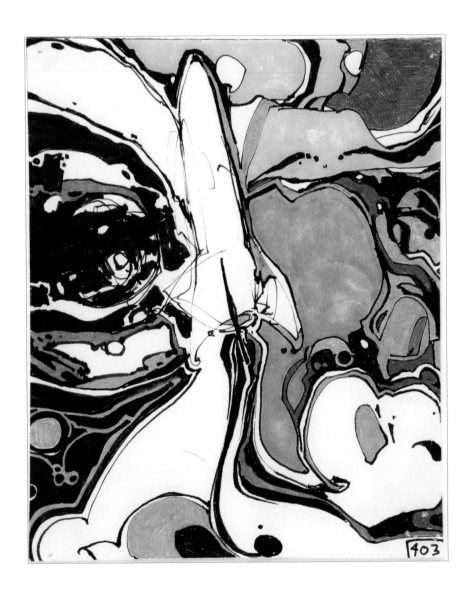

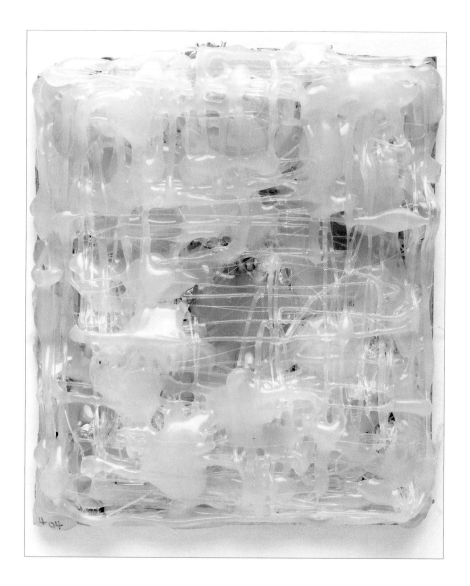

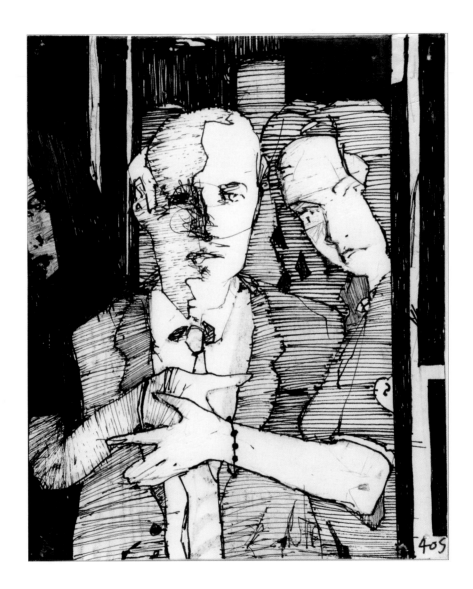

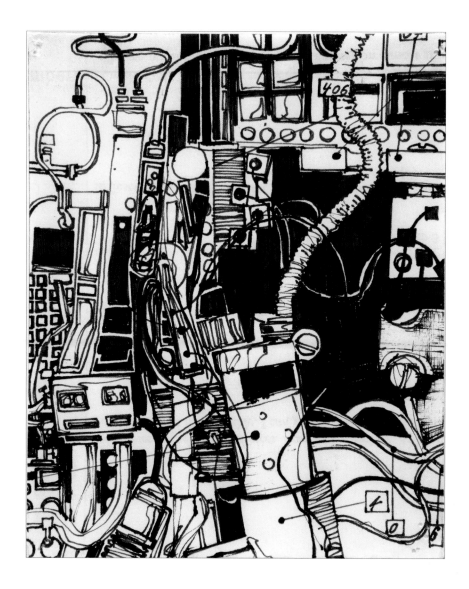

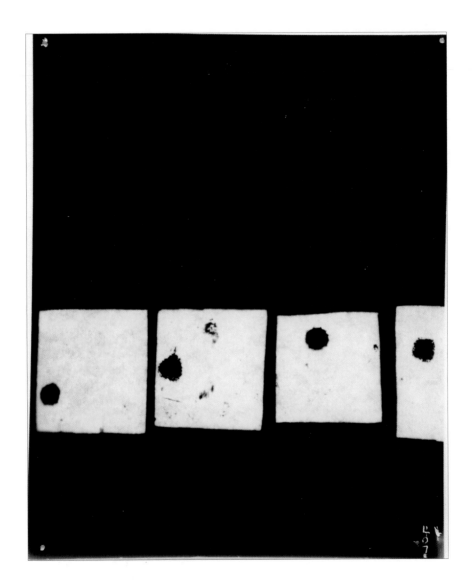

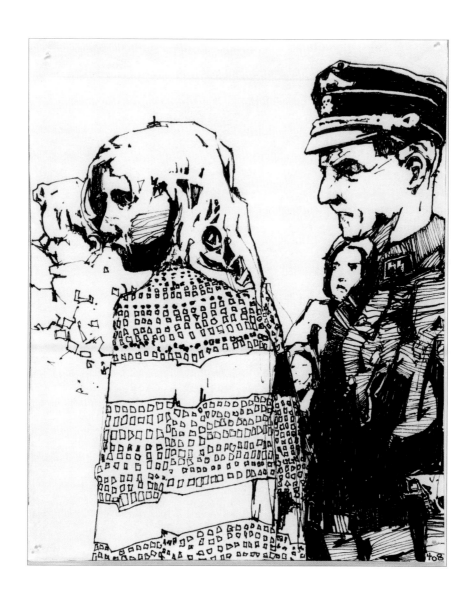

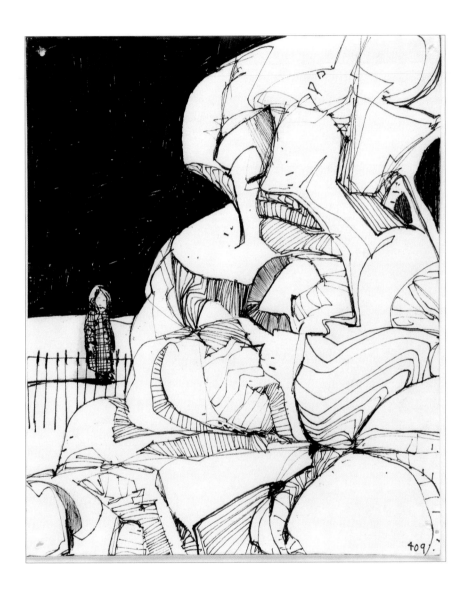

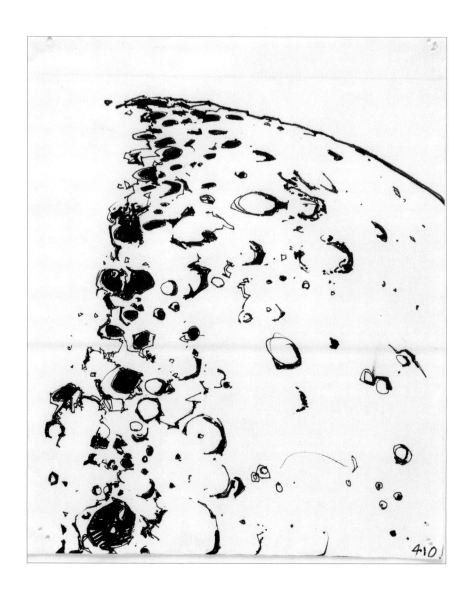

410

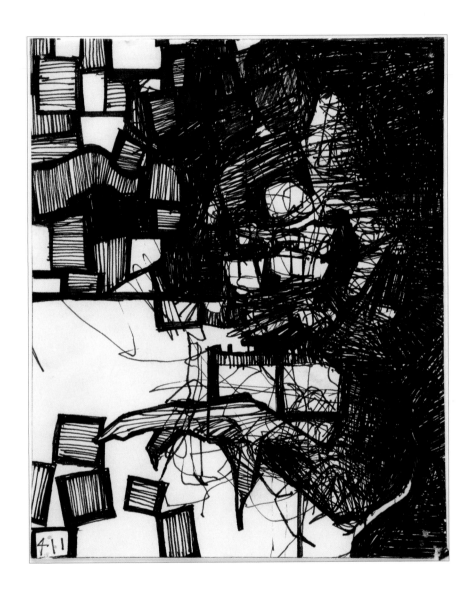

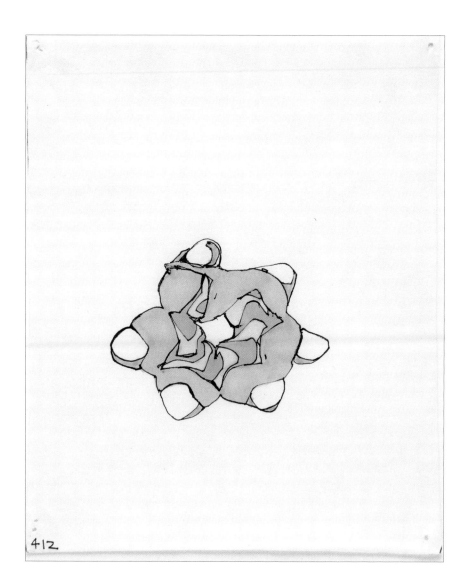

412

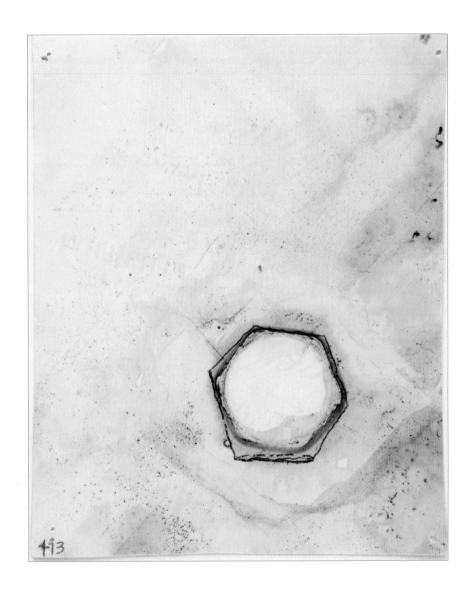

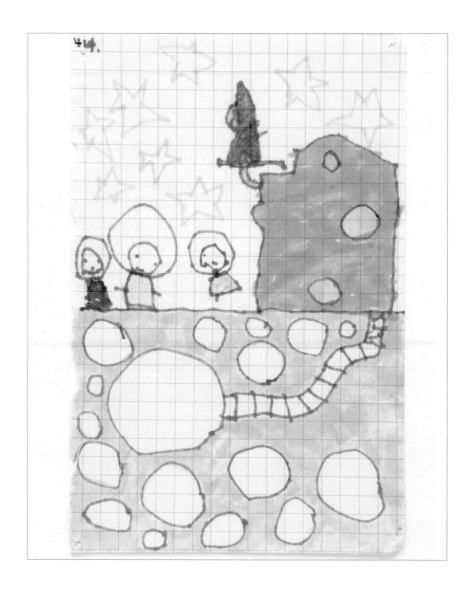

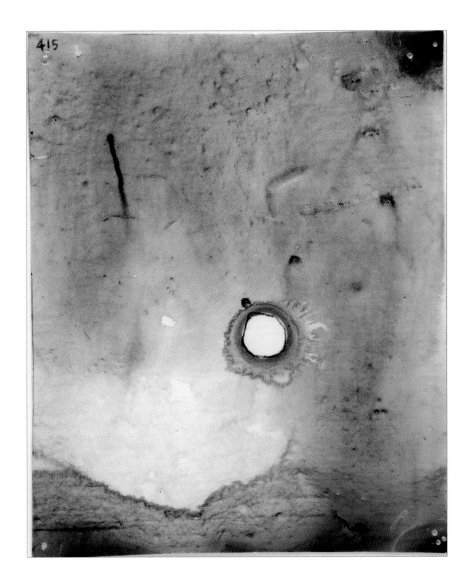

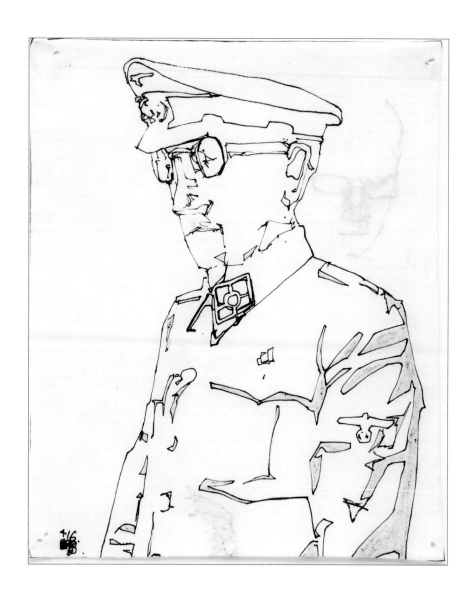

4·17.

418.

419.

420.

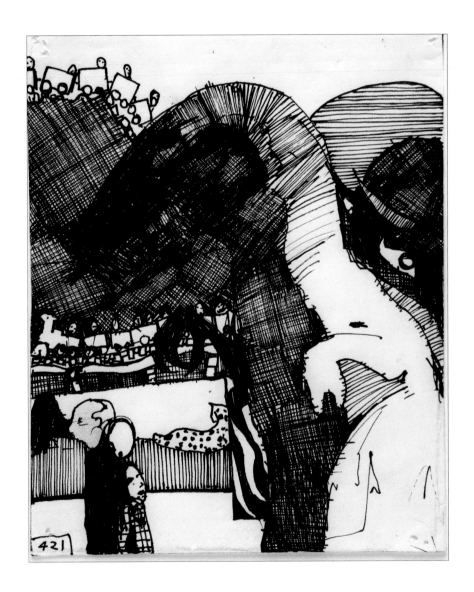

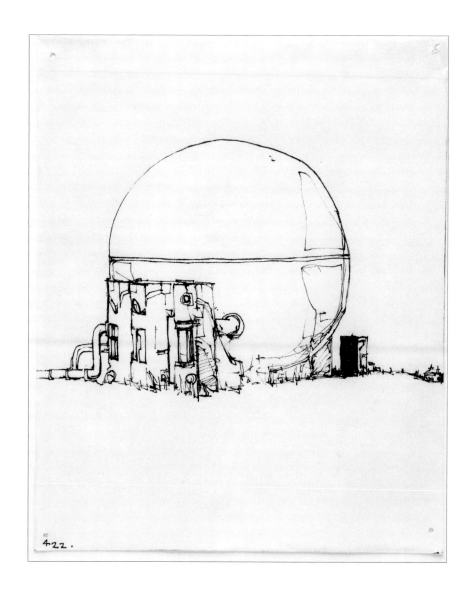

422.

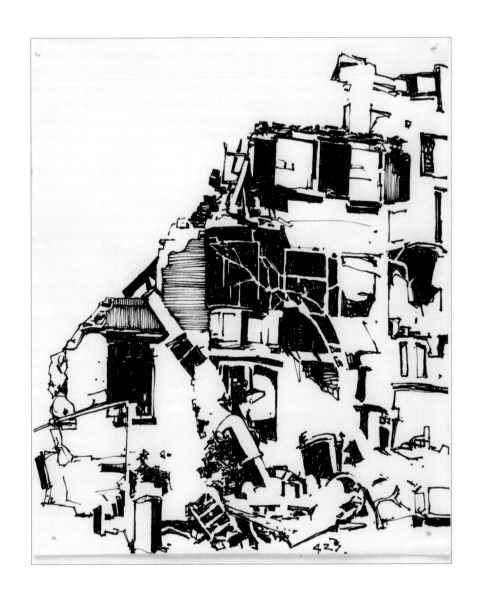

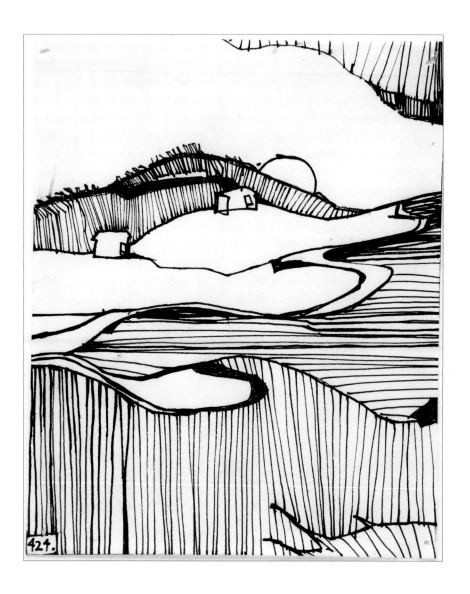

: 424 :

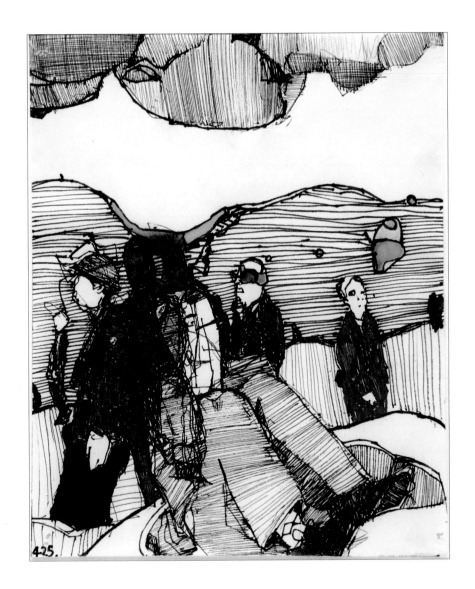

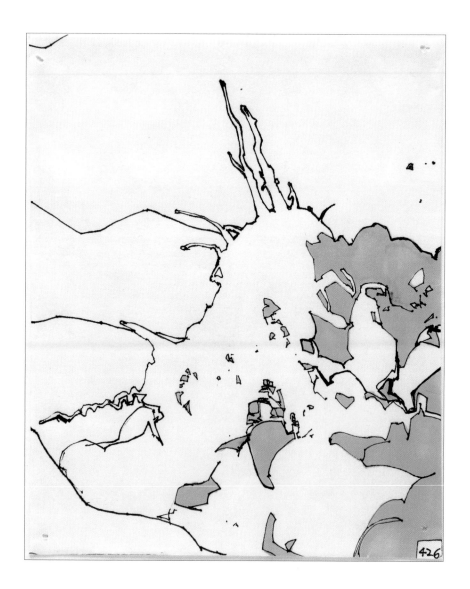

426

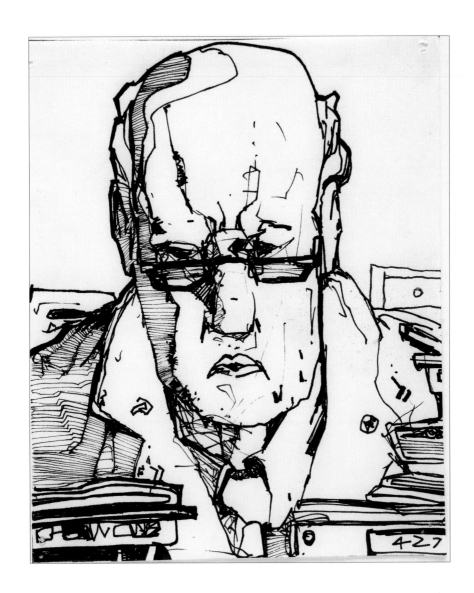

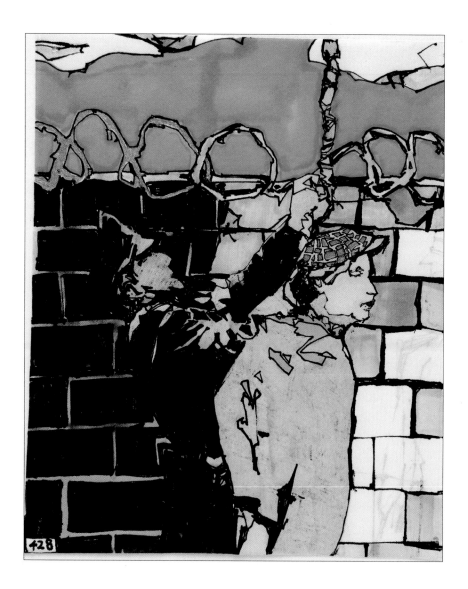

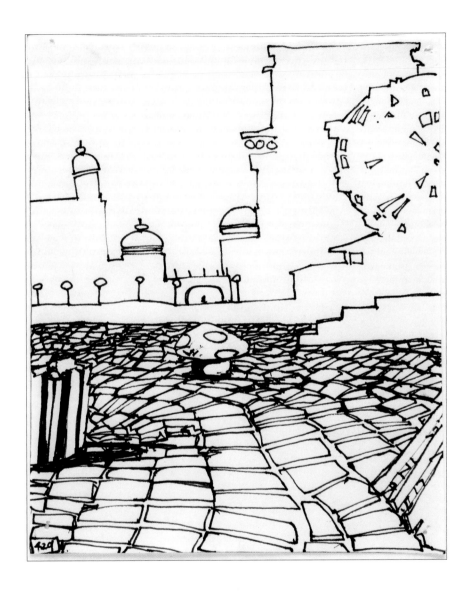

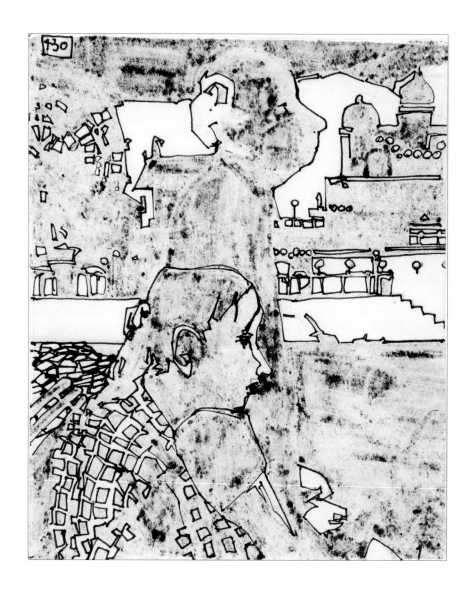

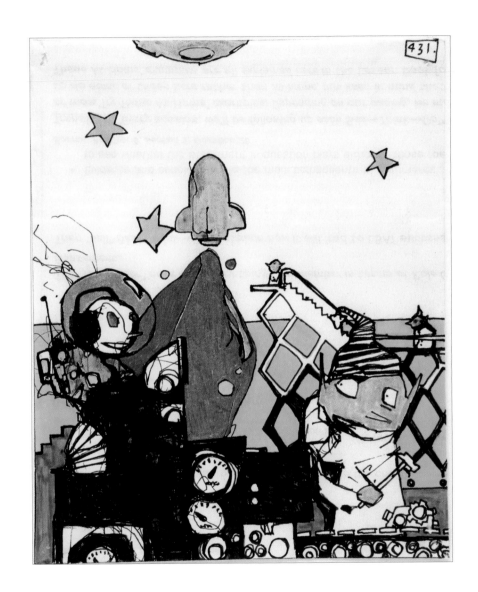

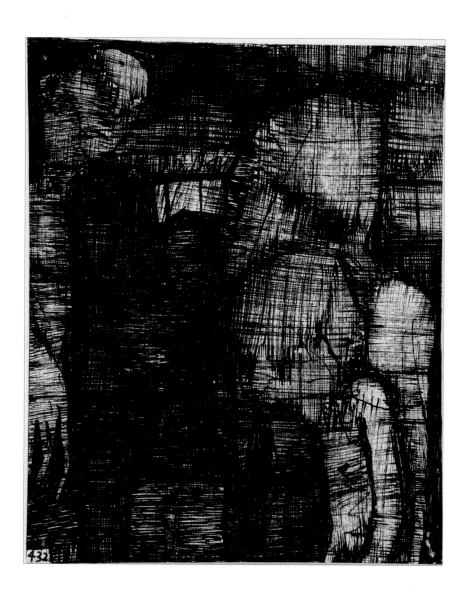

433.

434.

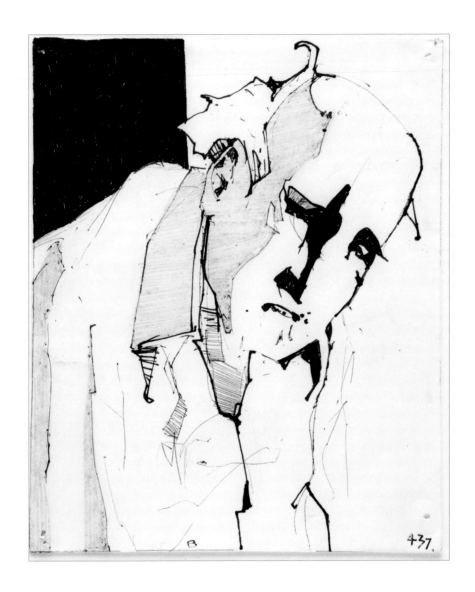

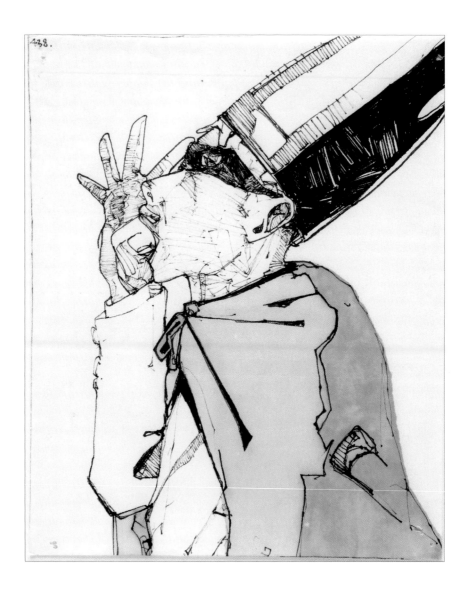

438.

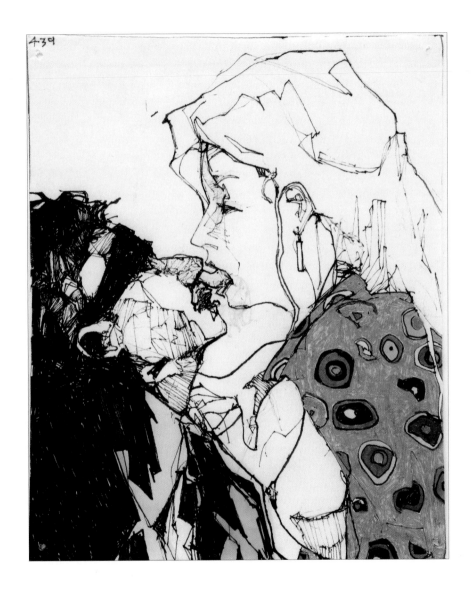

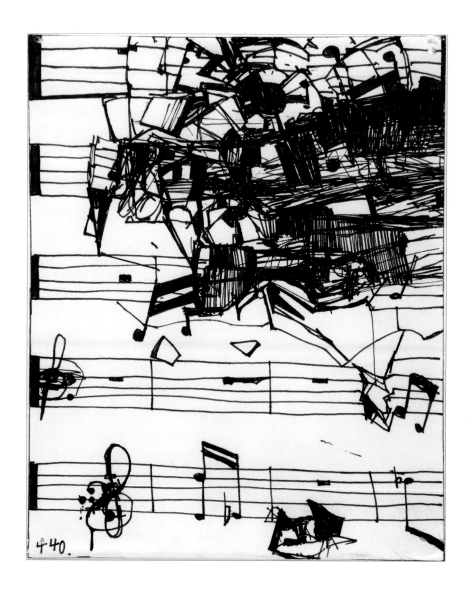

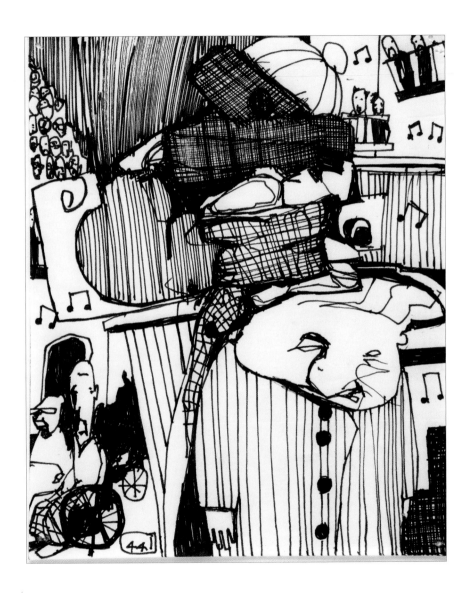

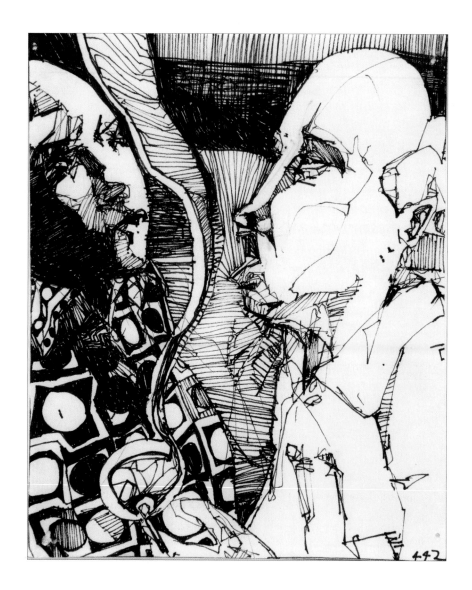

442

443.

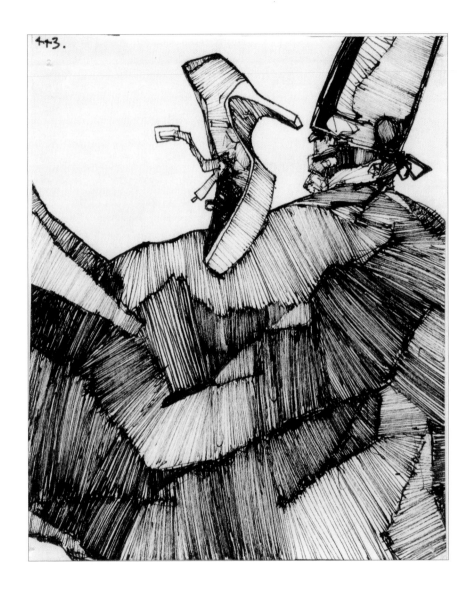

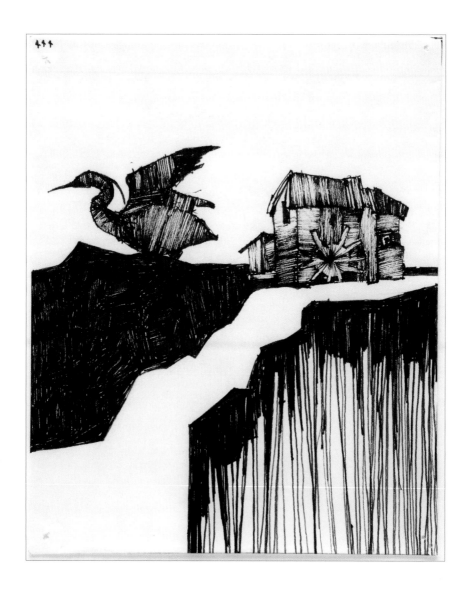

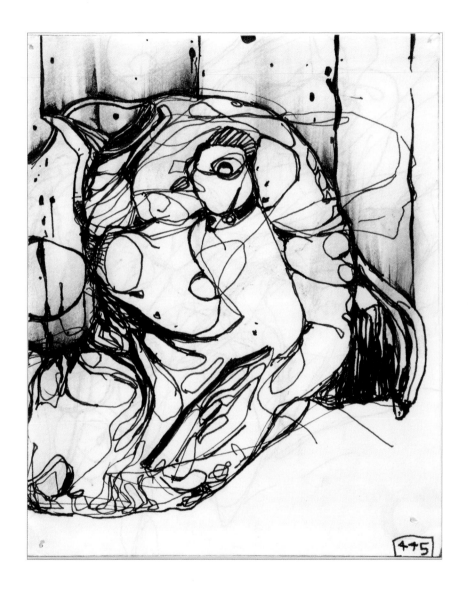

445

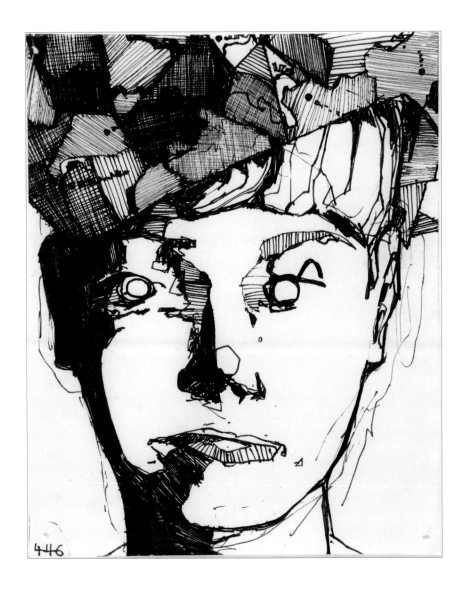

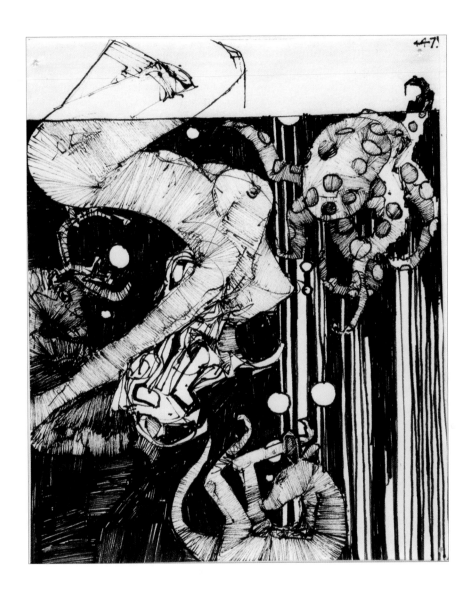

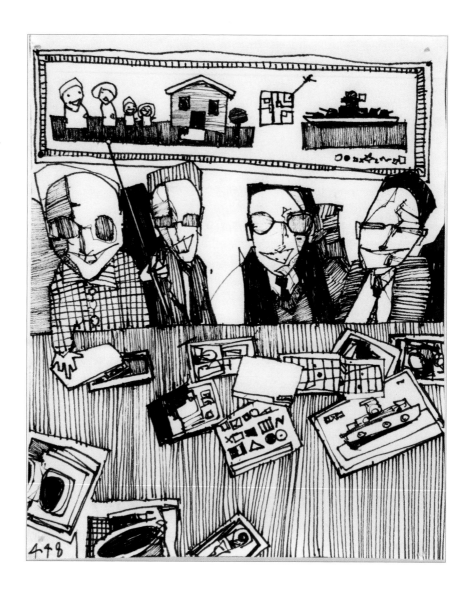

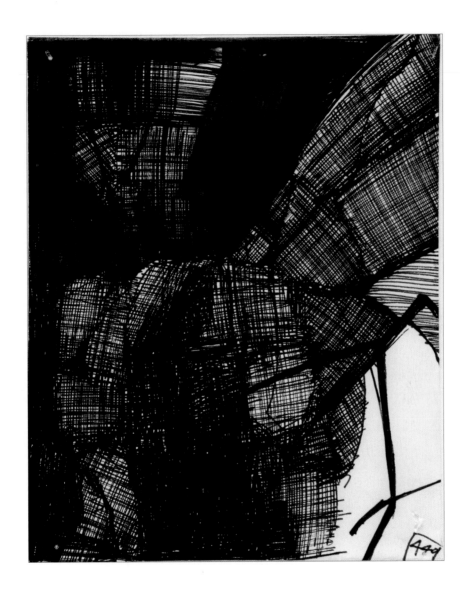

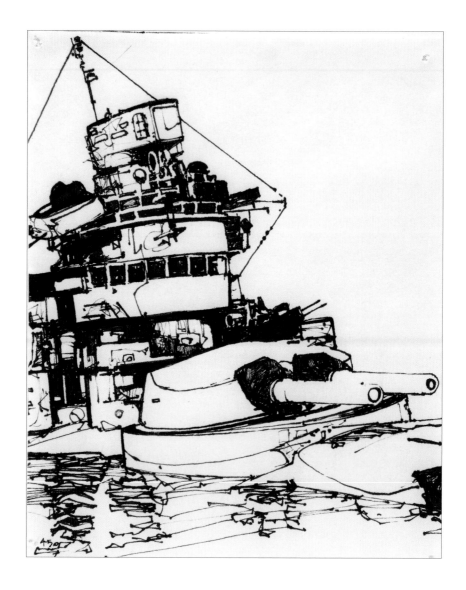

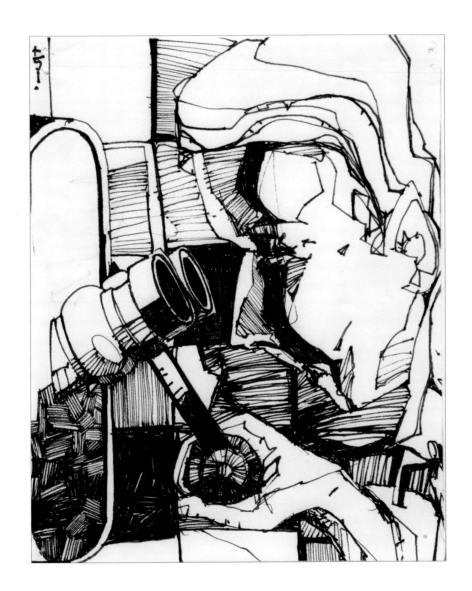

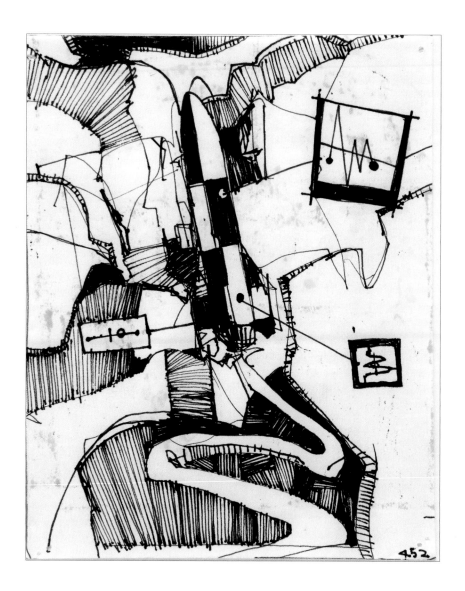

: 452 :

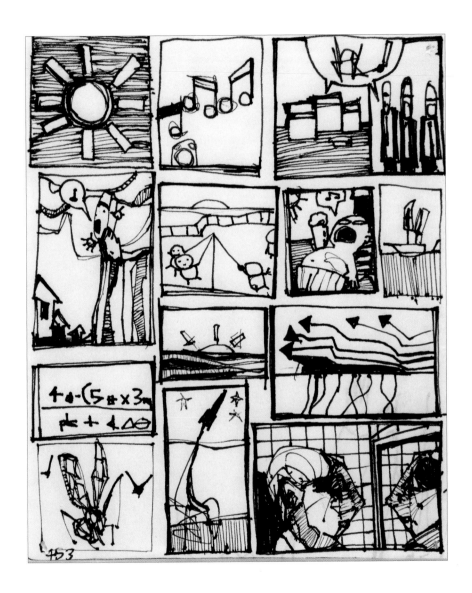

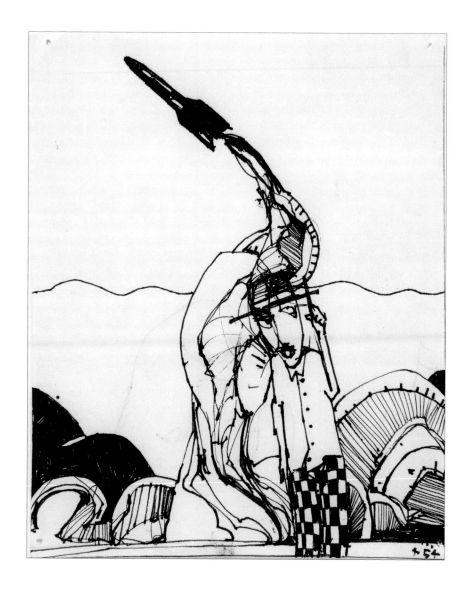

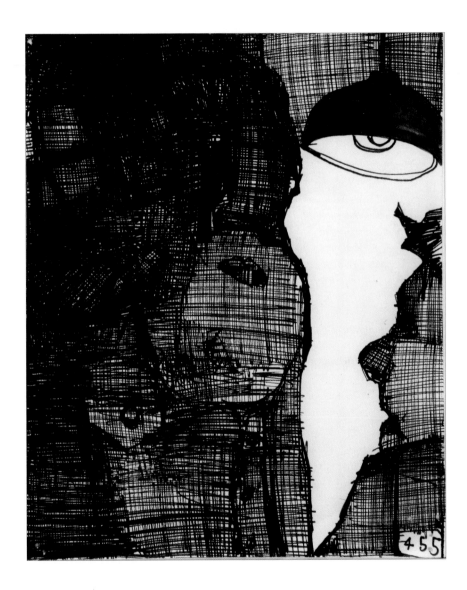

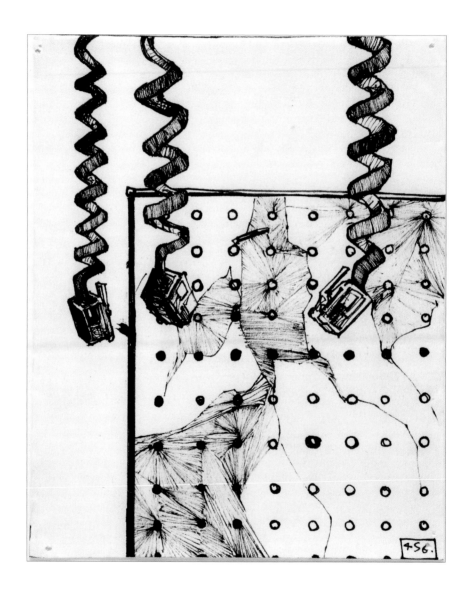

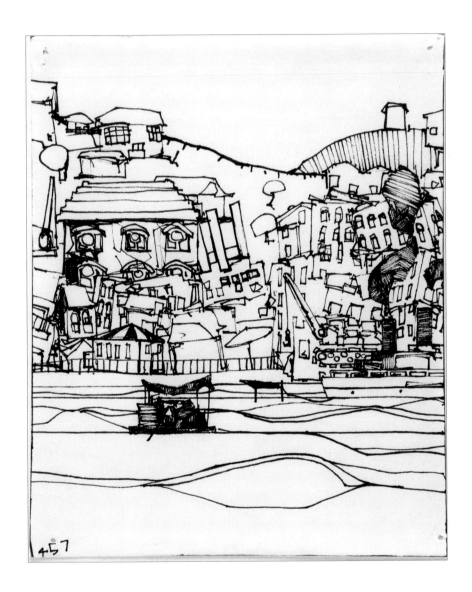

457

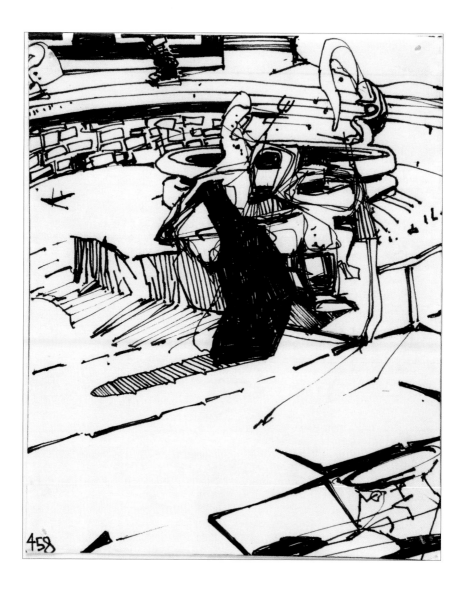

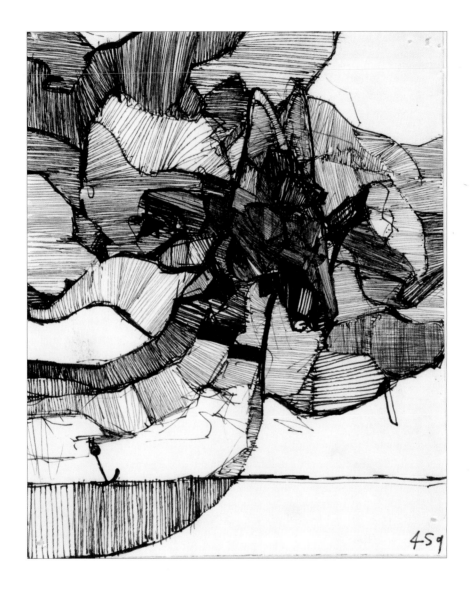

459

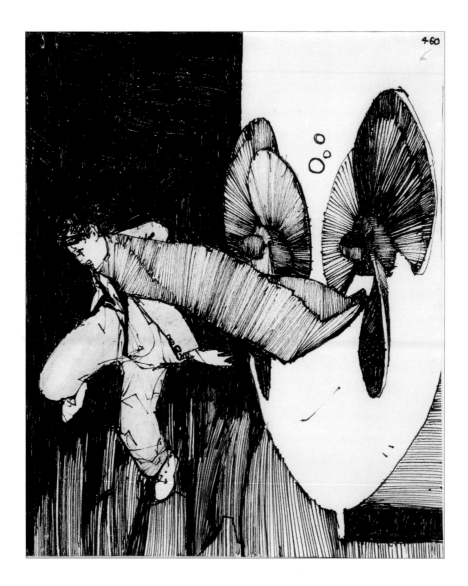

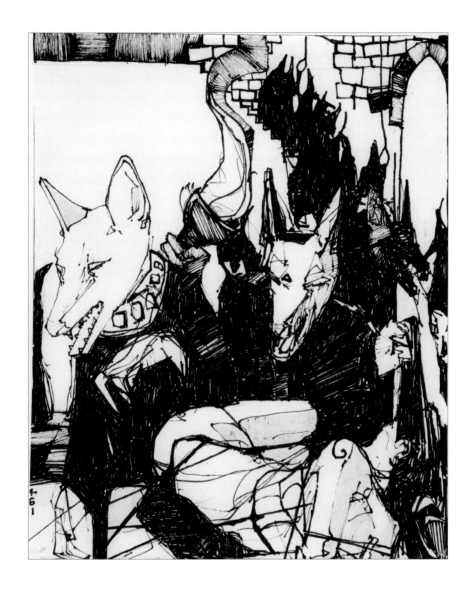

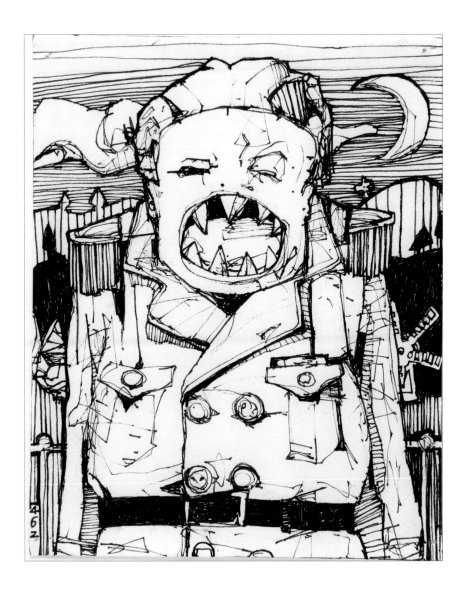

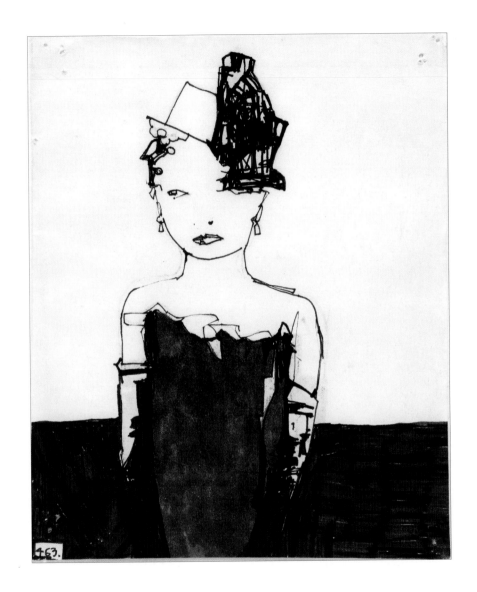

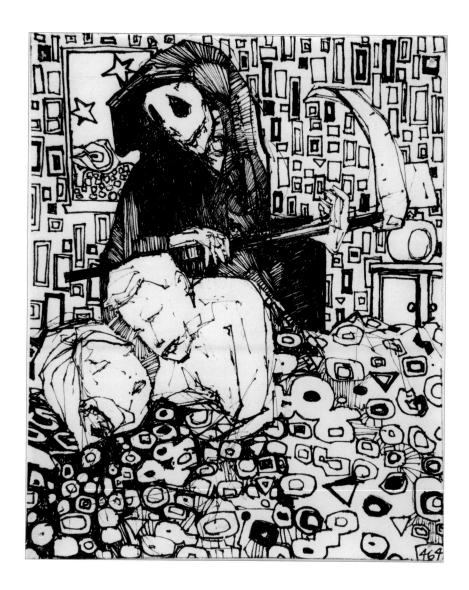

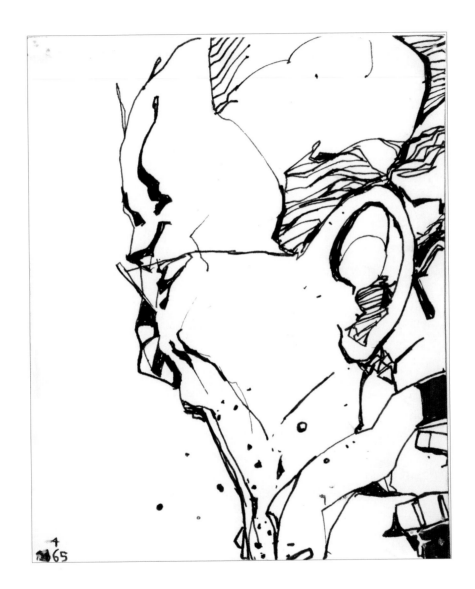

465

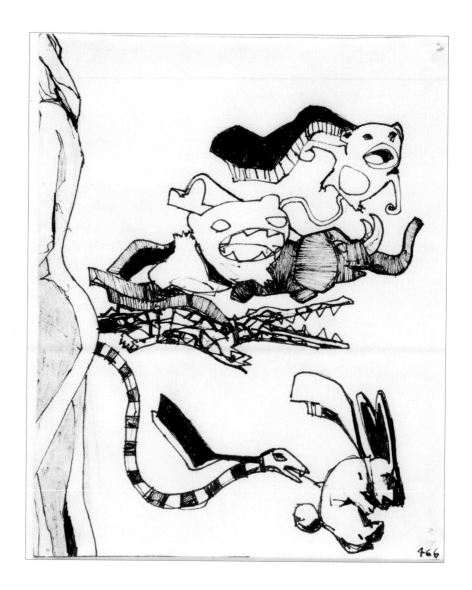

466

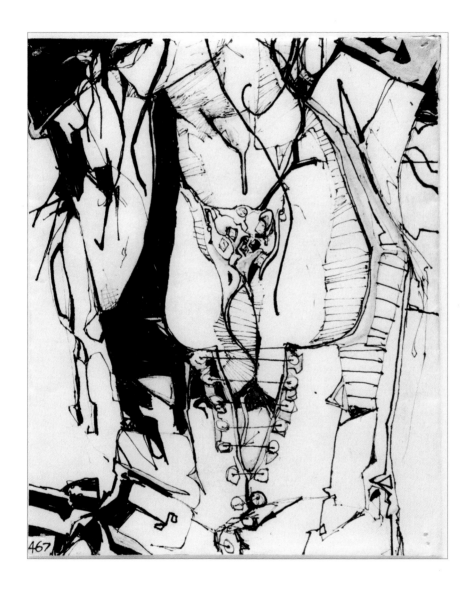

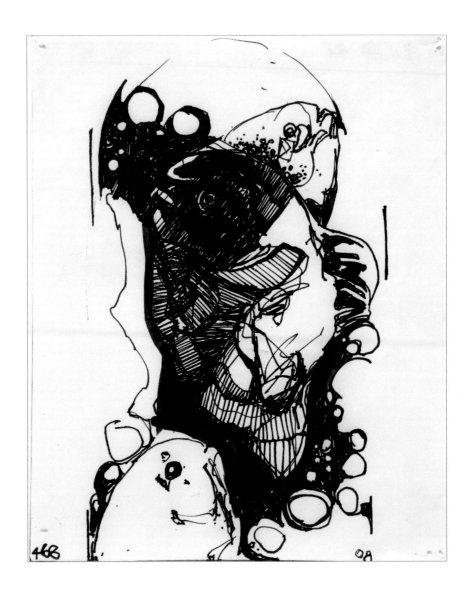

468

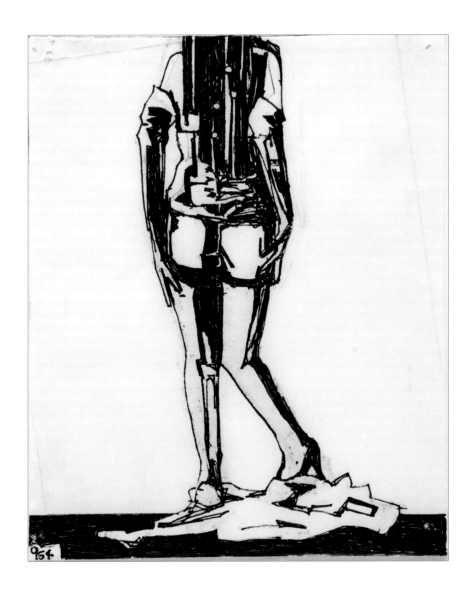

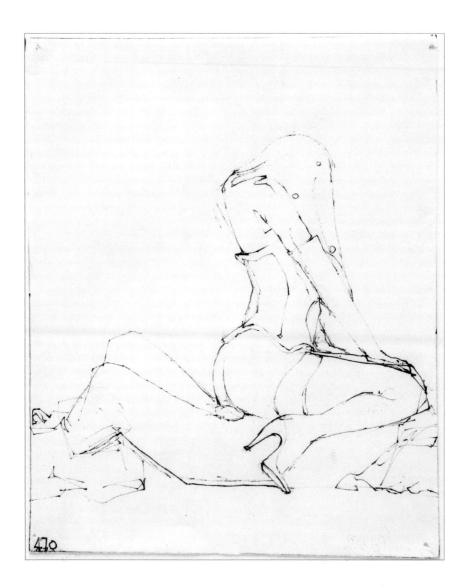

470

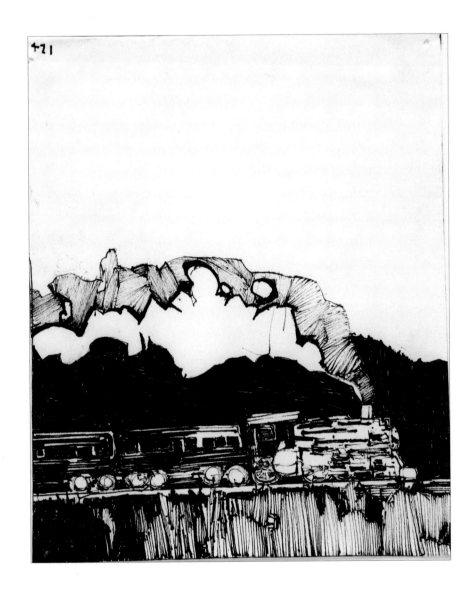

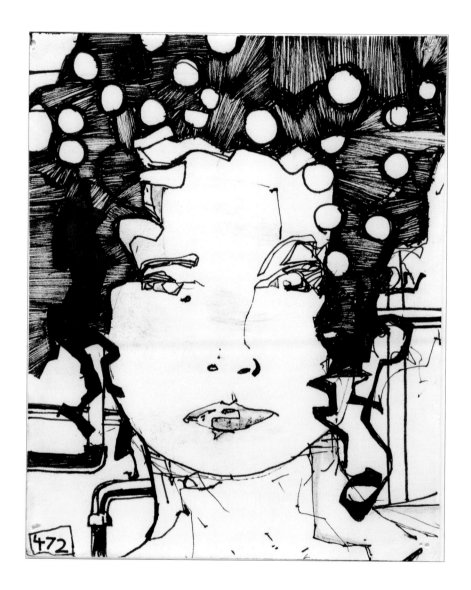

: 472 :

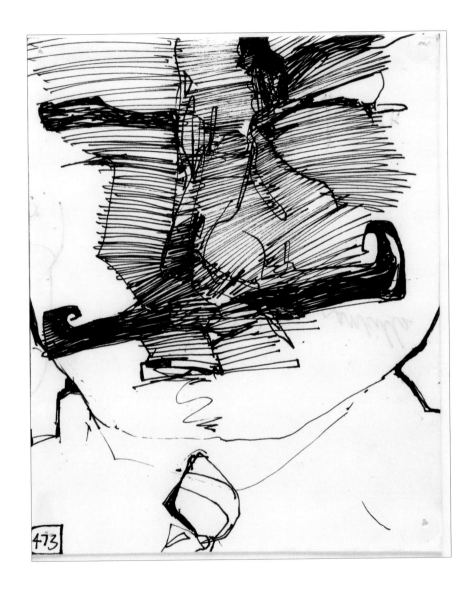

473

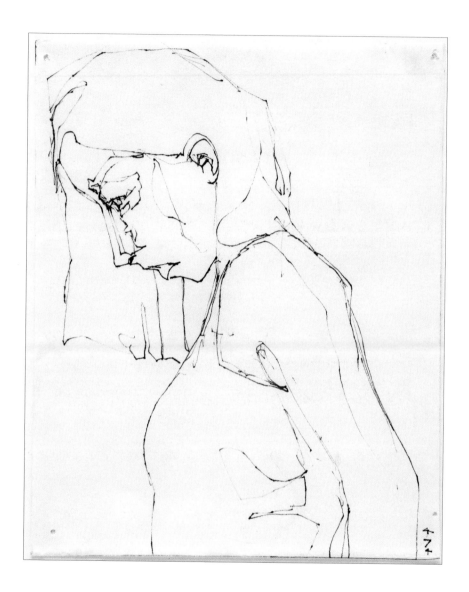

: 474 :

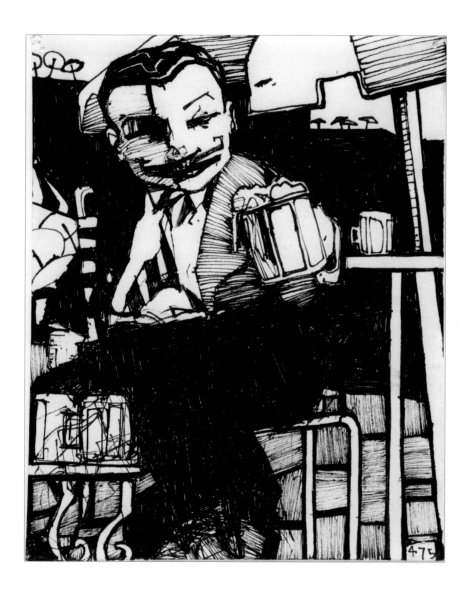

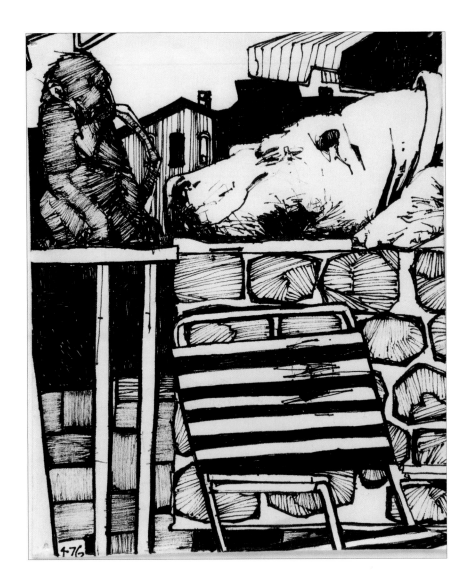

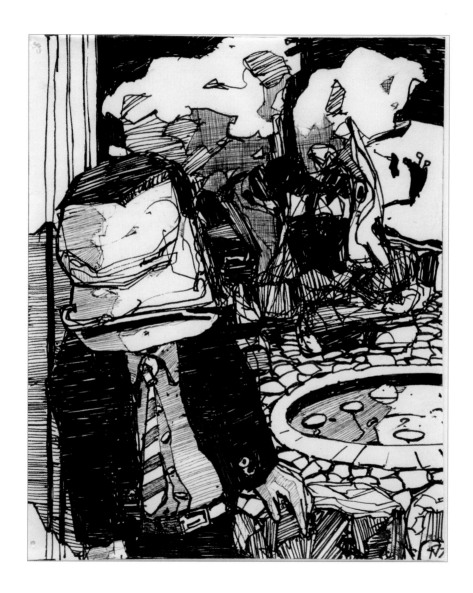

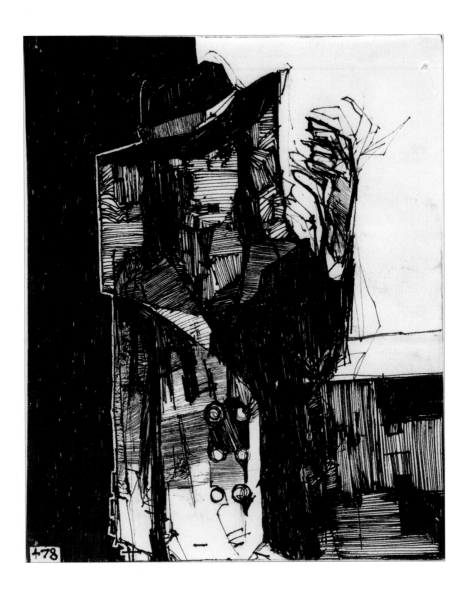

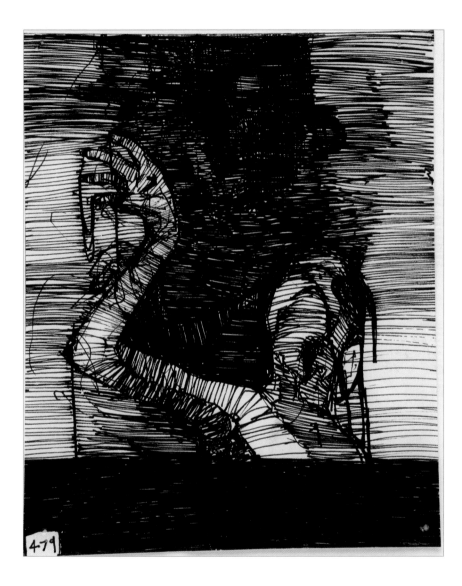

479

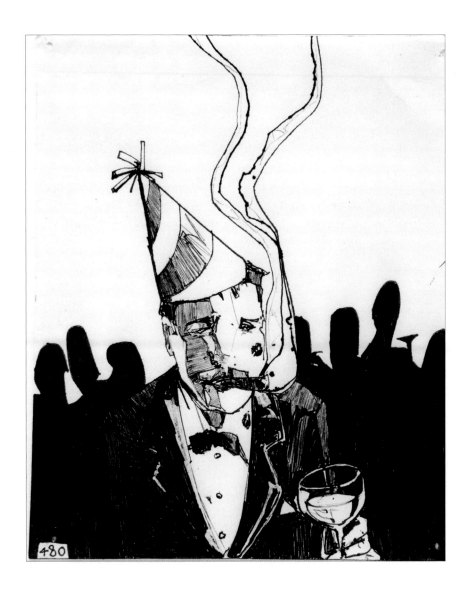

: 480 :

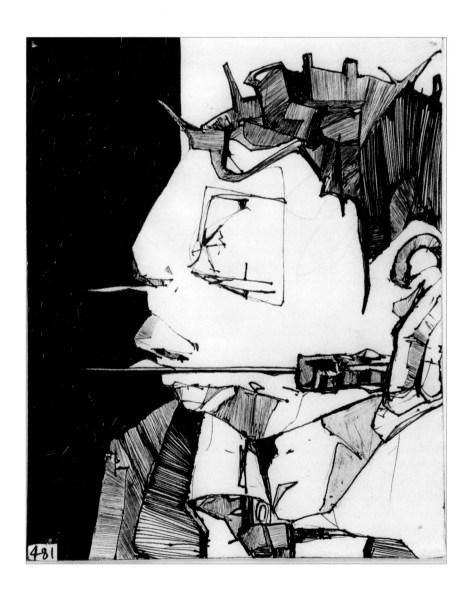

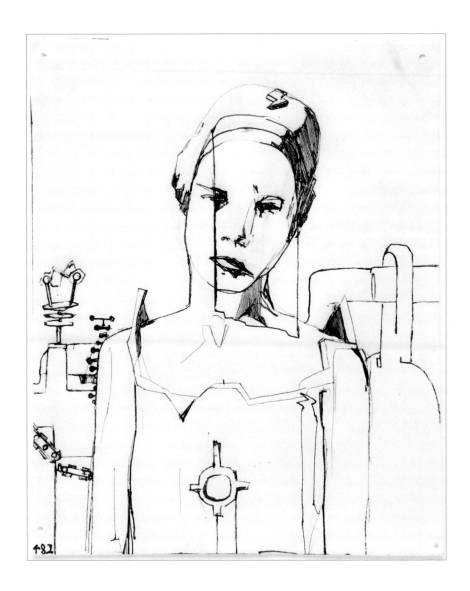

482

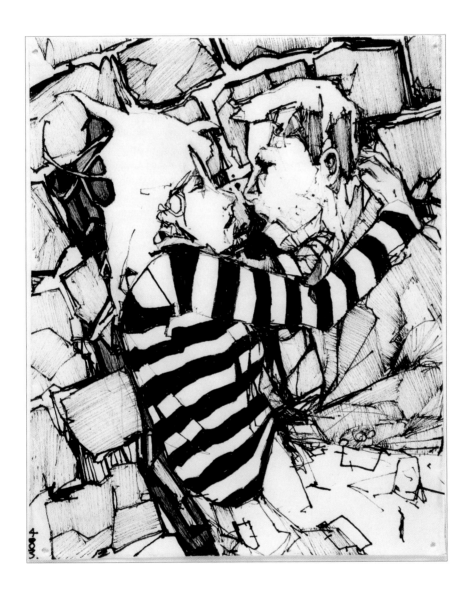

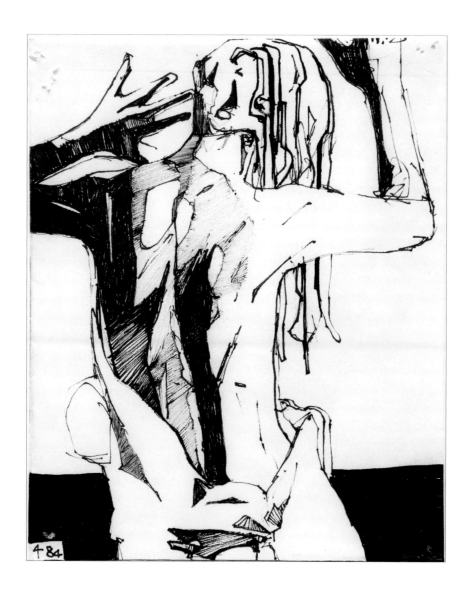

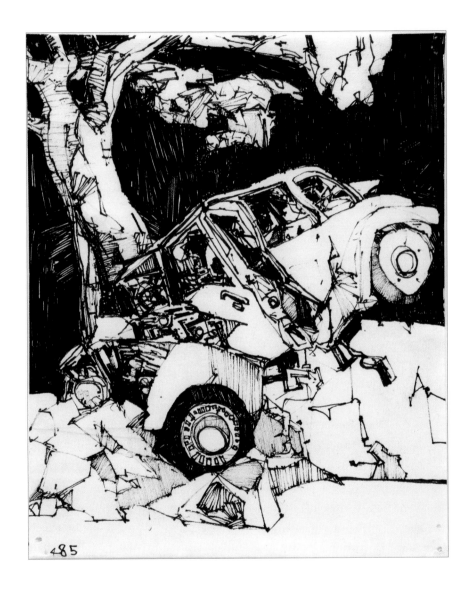

485

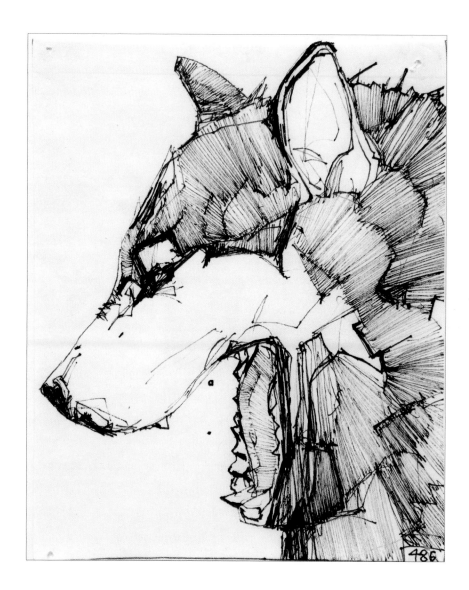

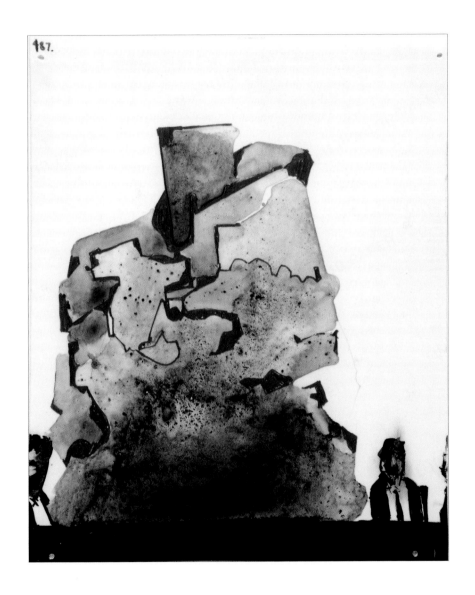

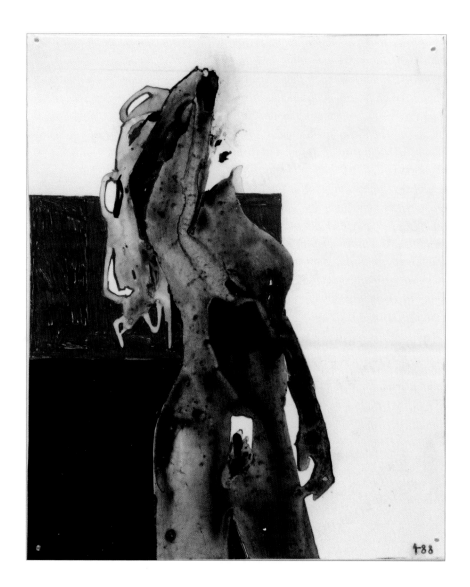

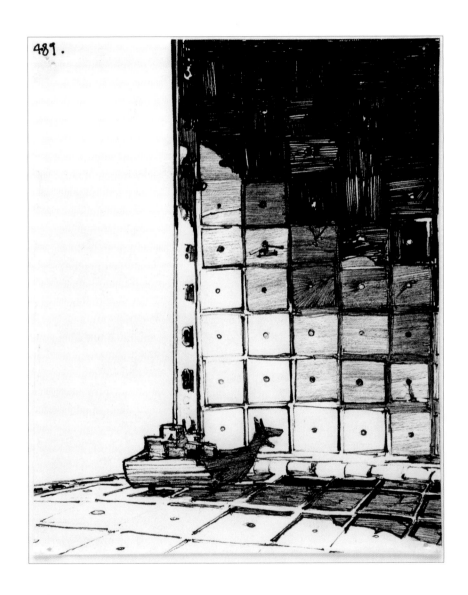

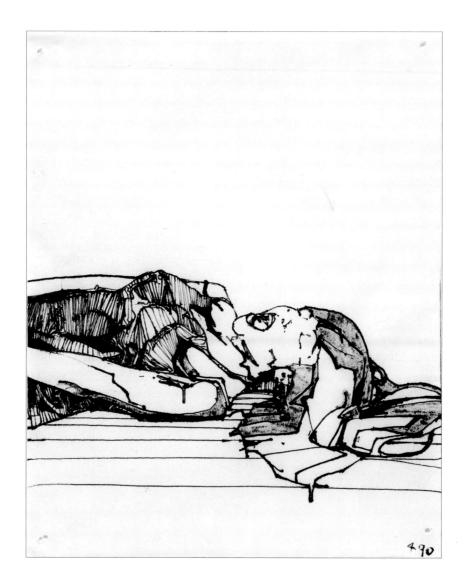

490

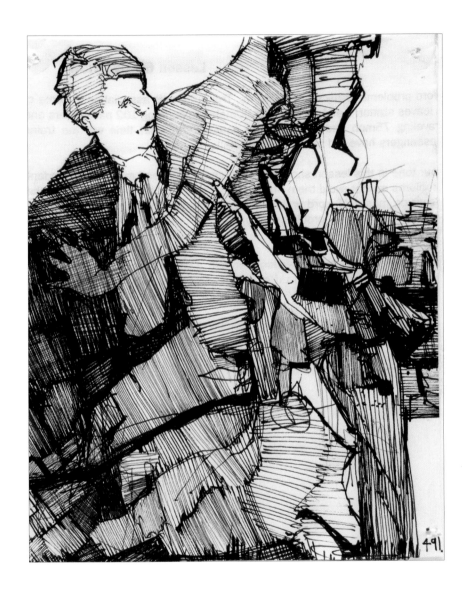

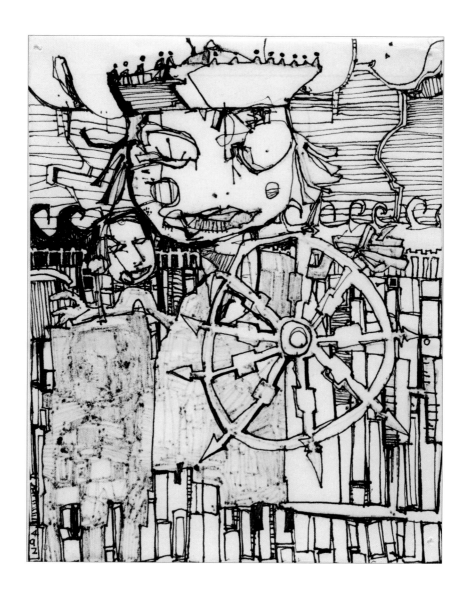

: 492 :

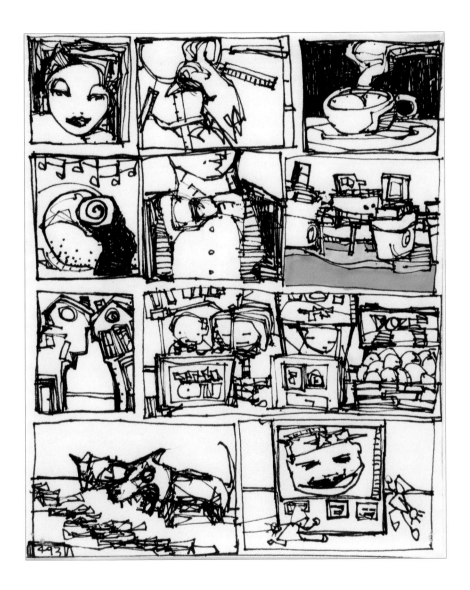

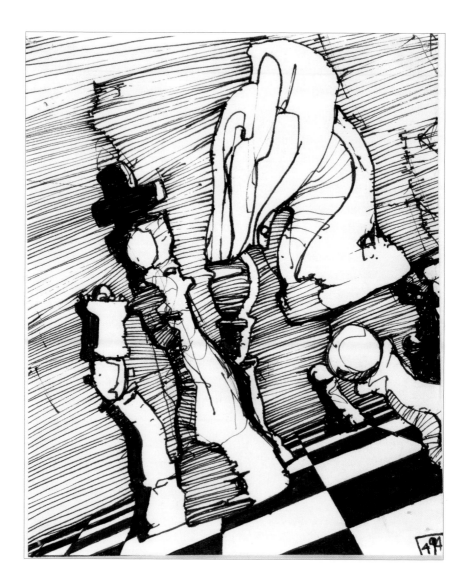

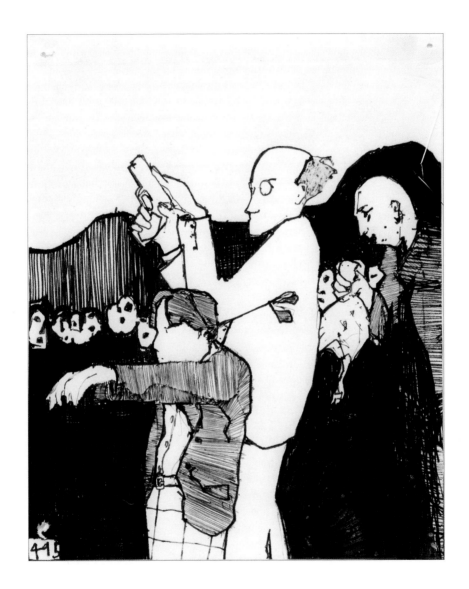

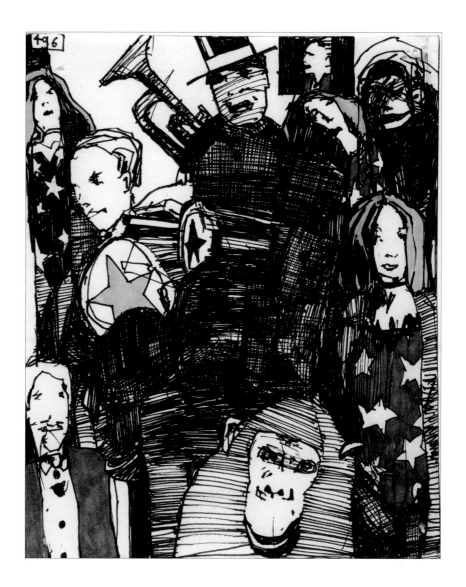

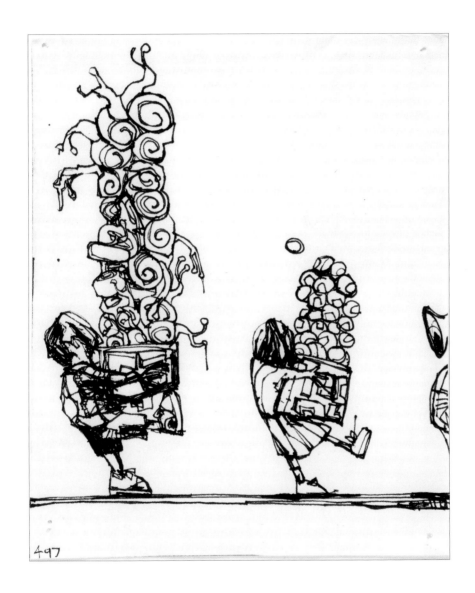

497

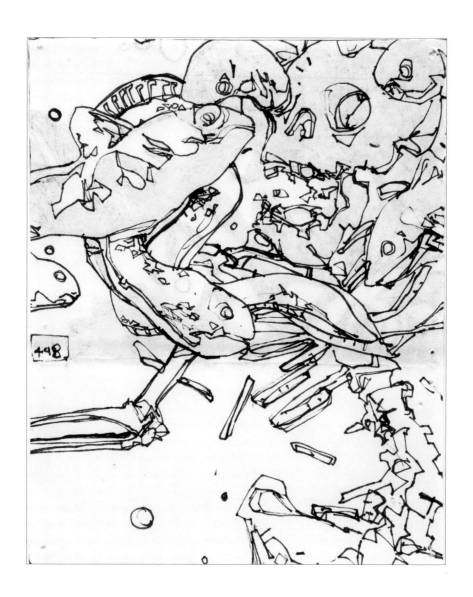

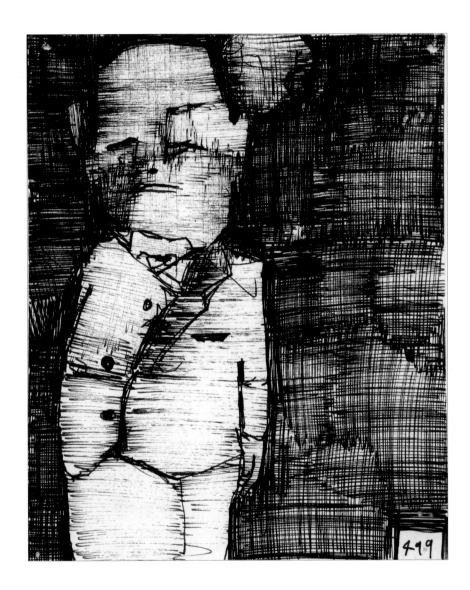

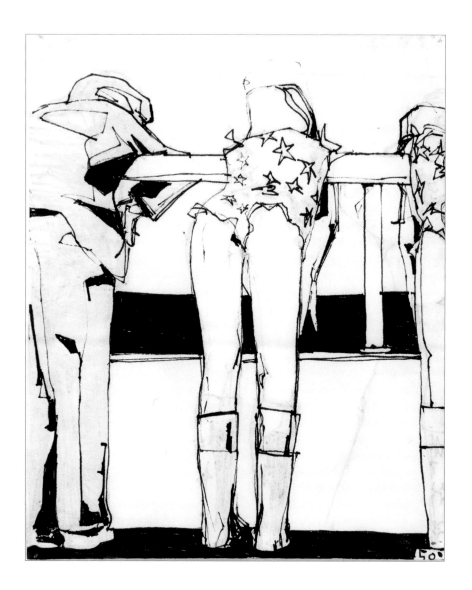

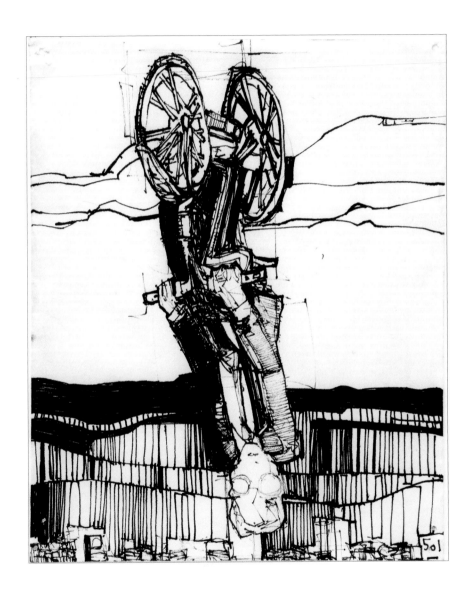

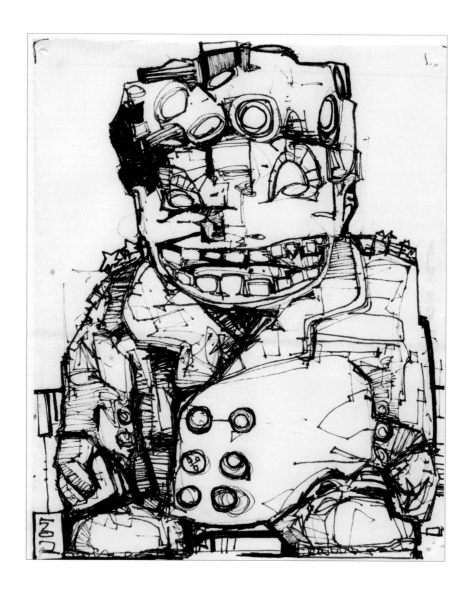

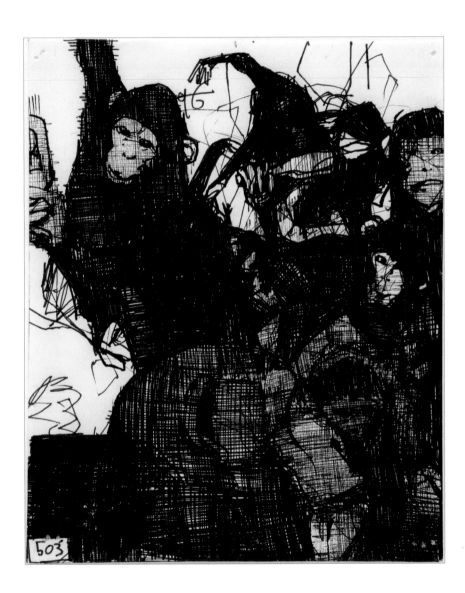

503

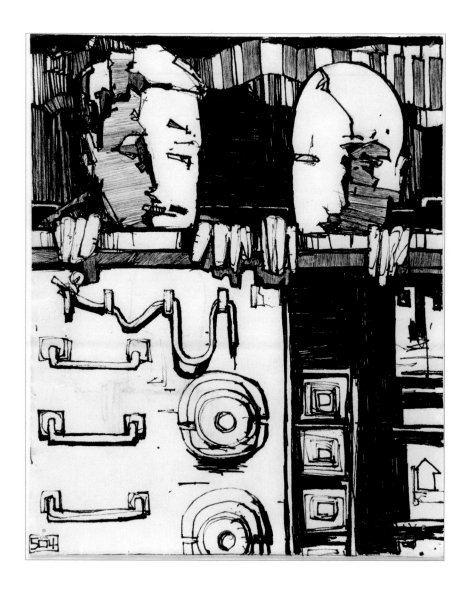

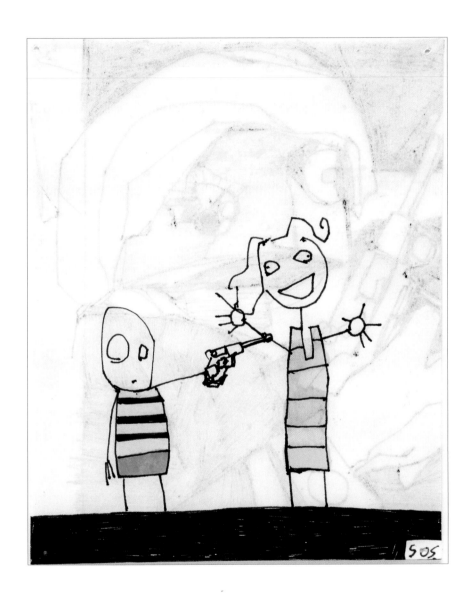

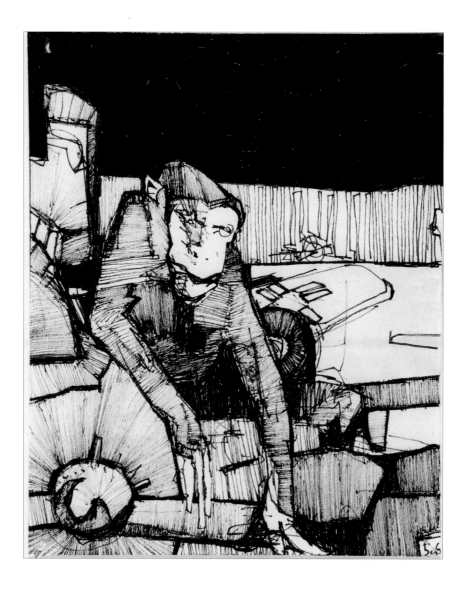

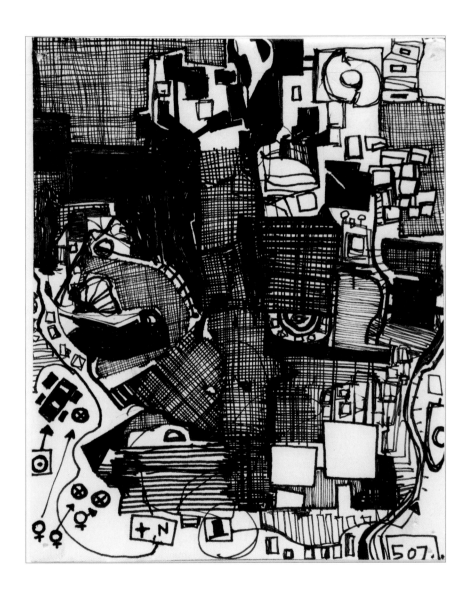

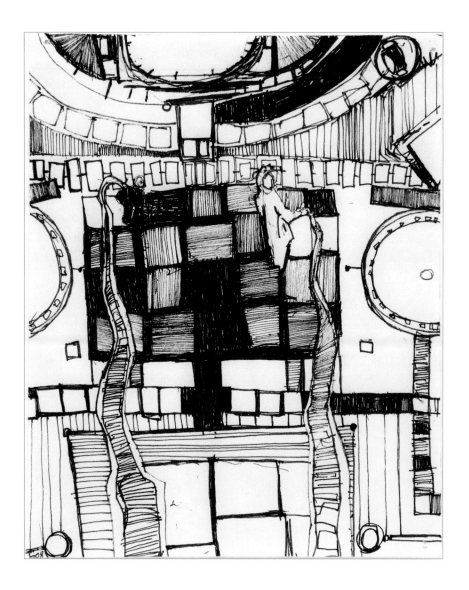

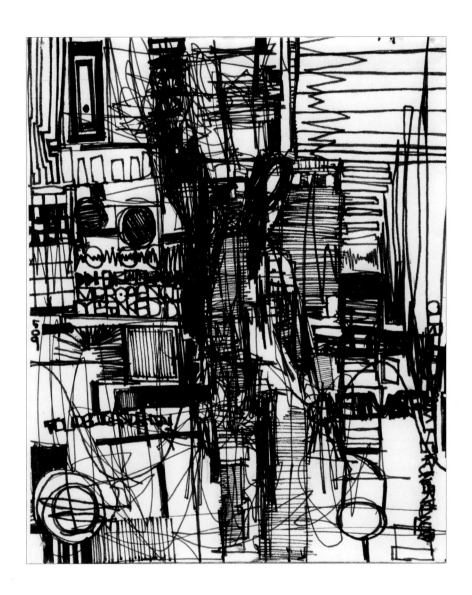

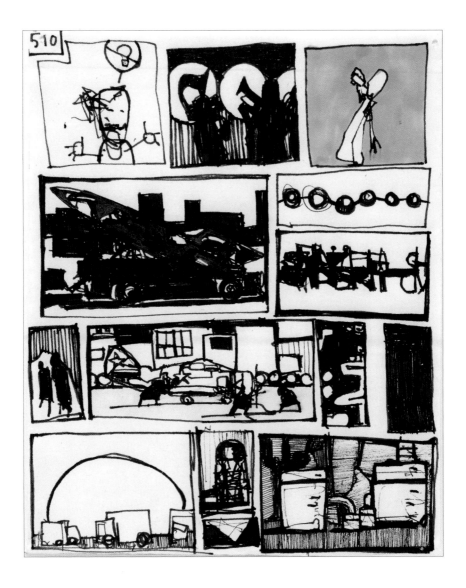

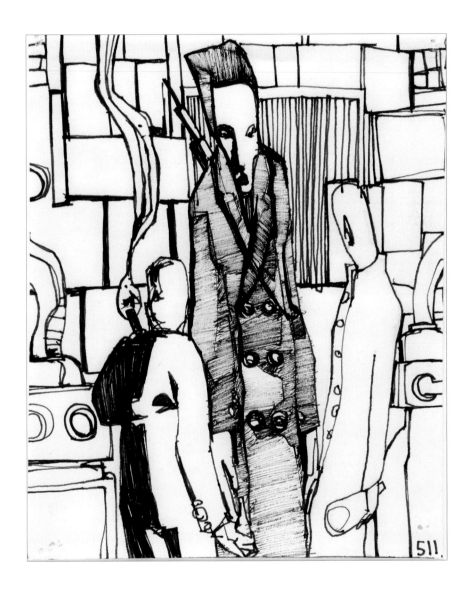

511.

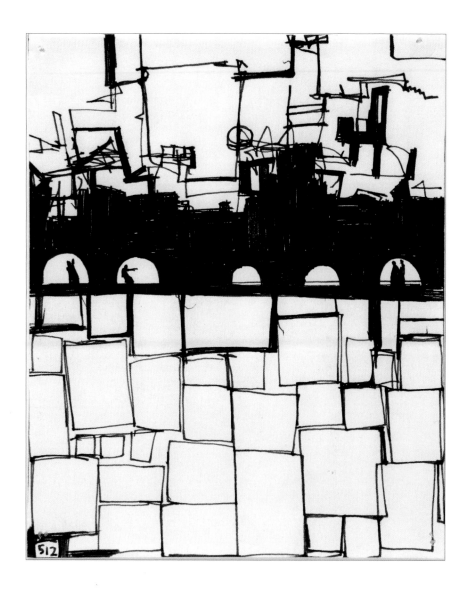

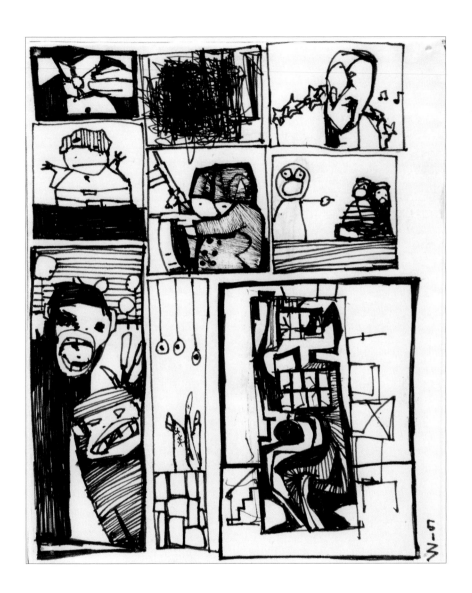

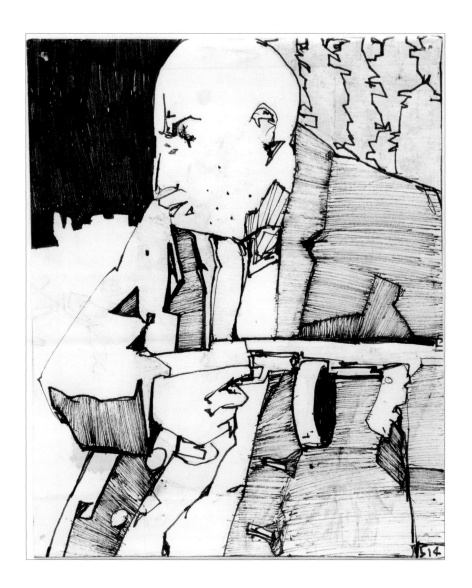

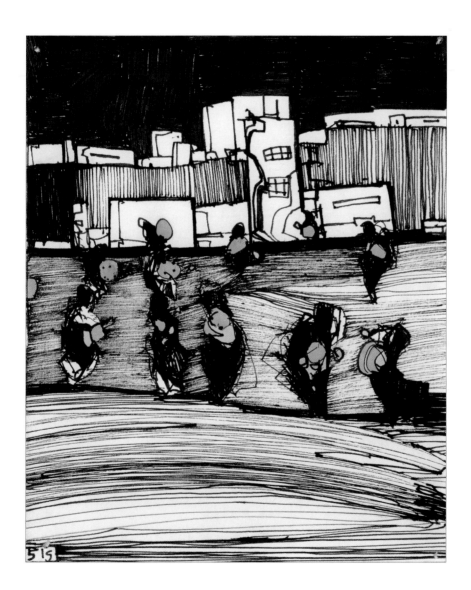

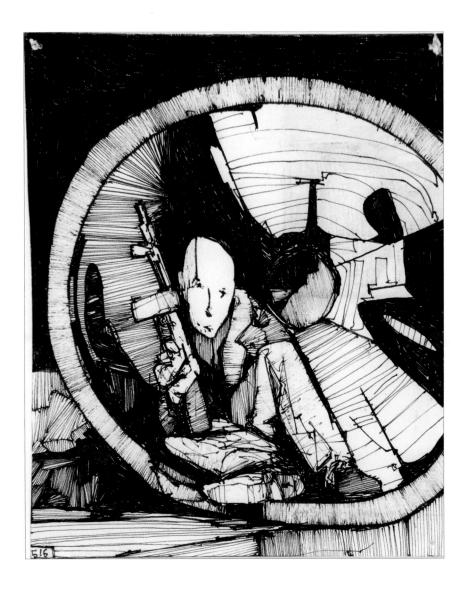

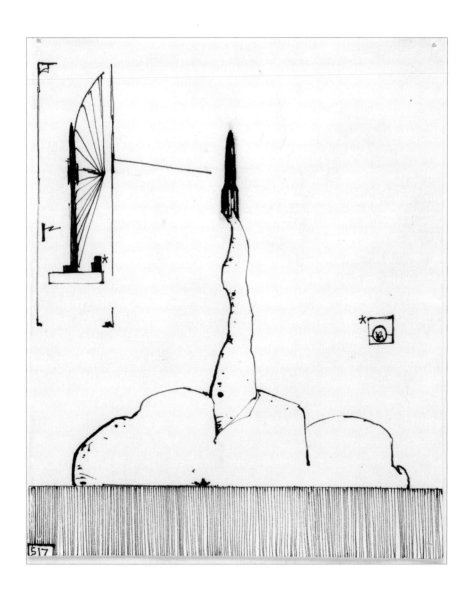

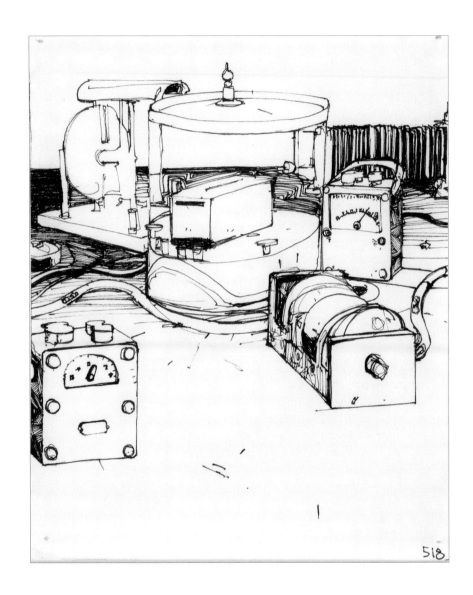

518

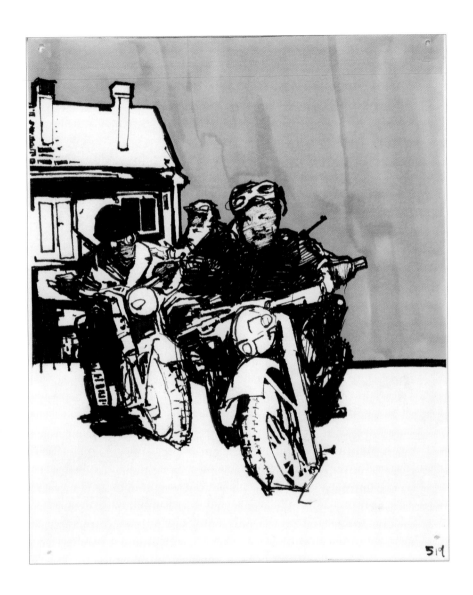

519

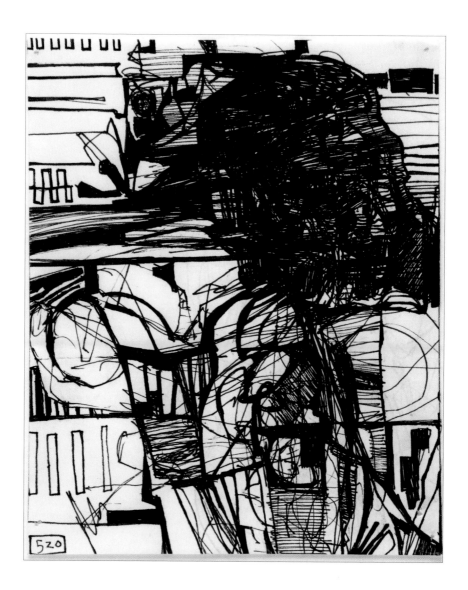

: 520 :

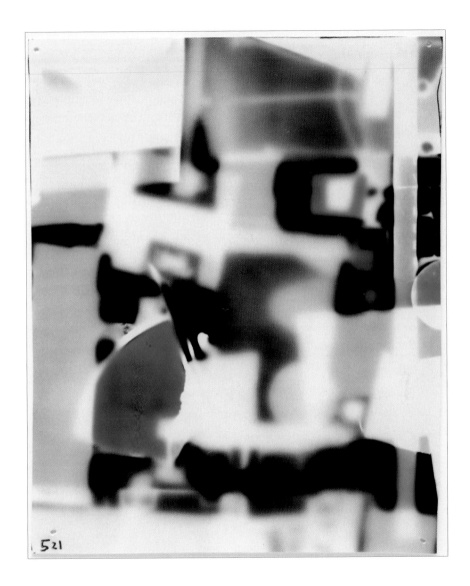

521

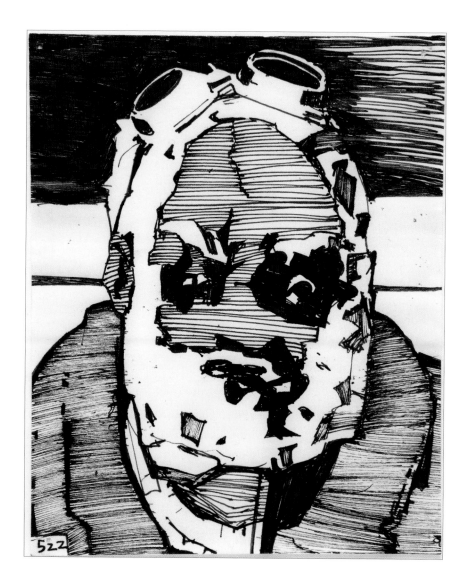

: 522 :

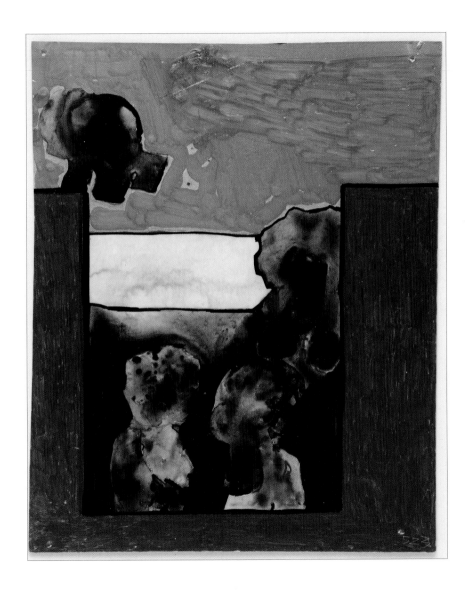

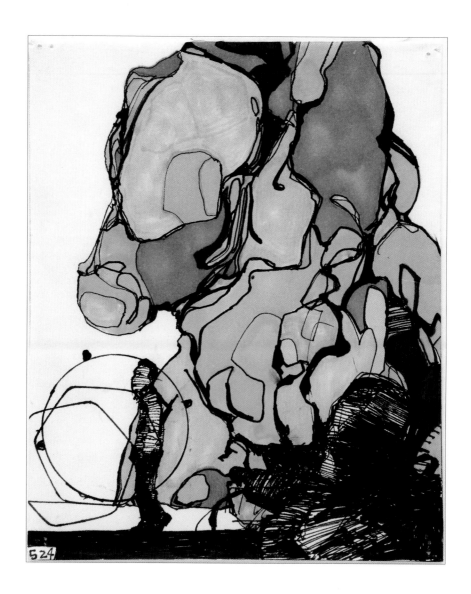

: 524 :

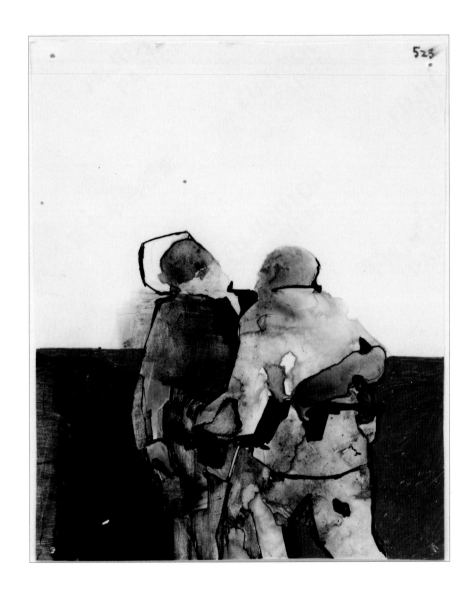

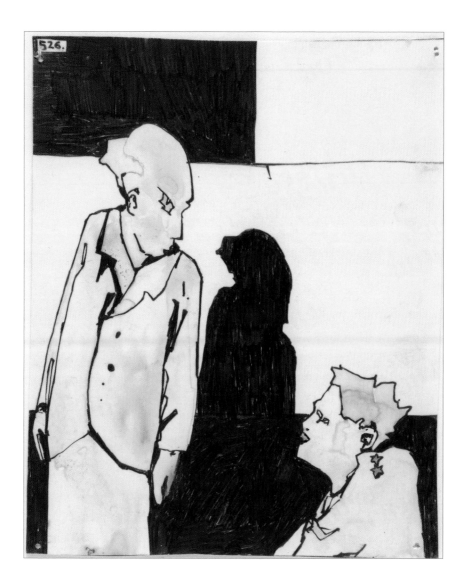

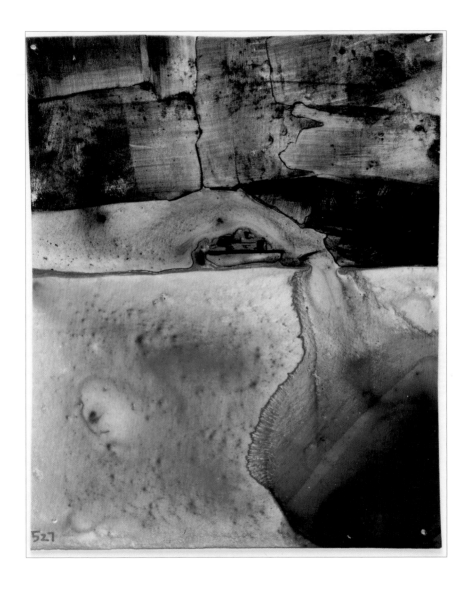

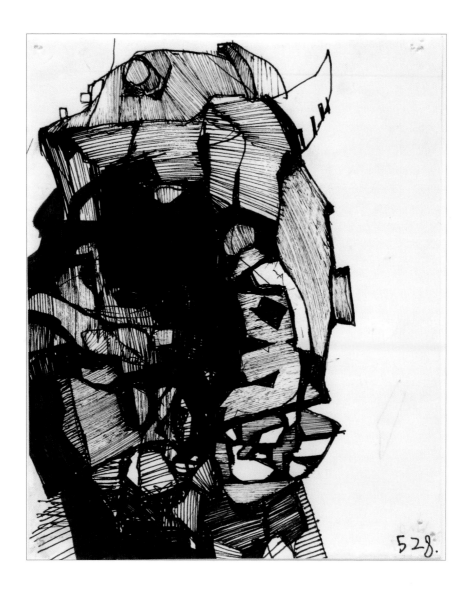

528.

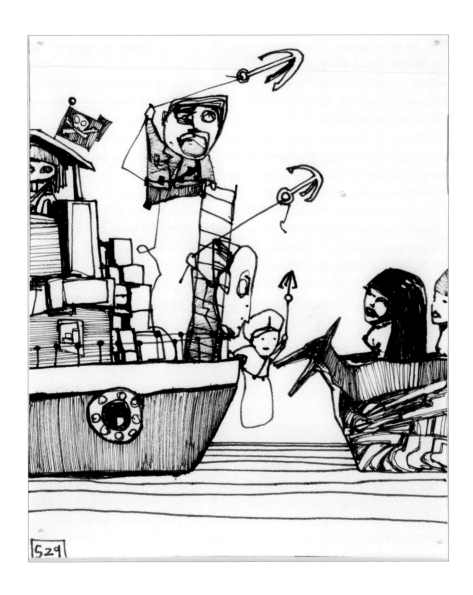

529

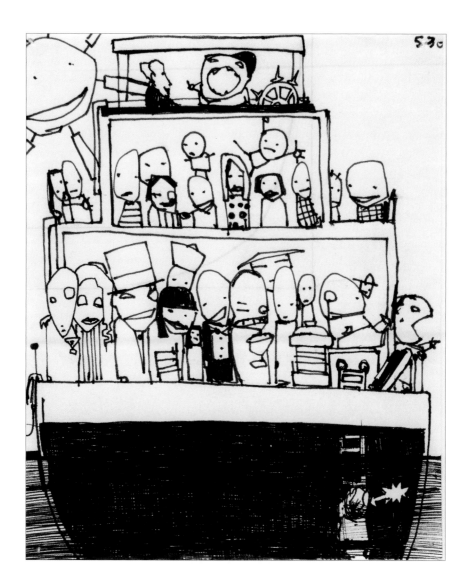

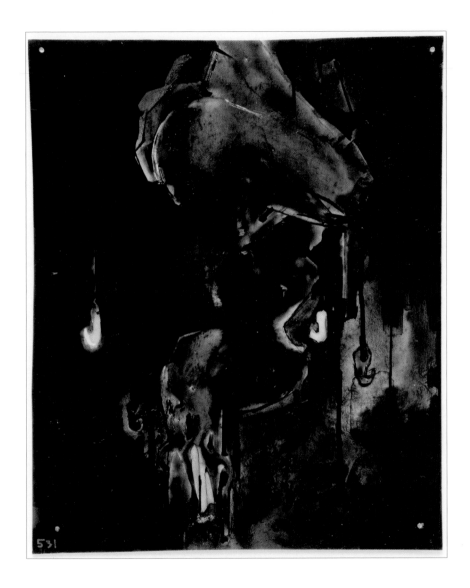

531

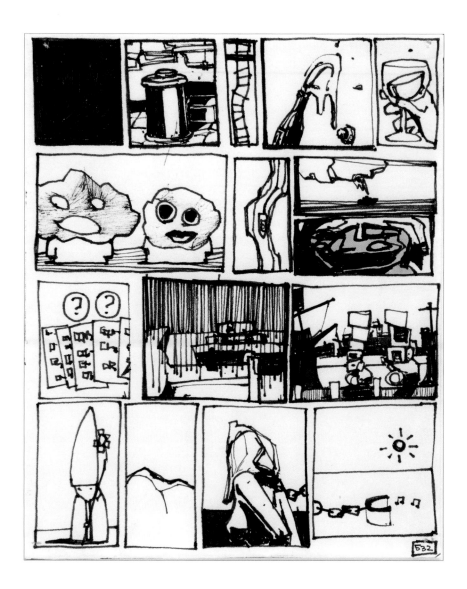

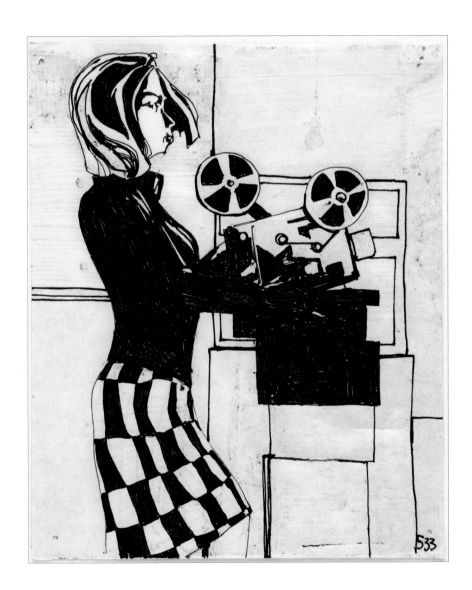

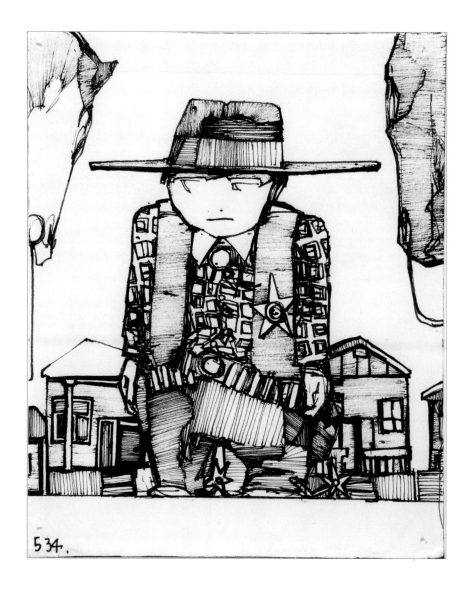

534.

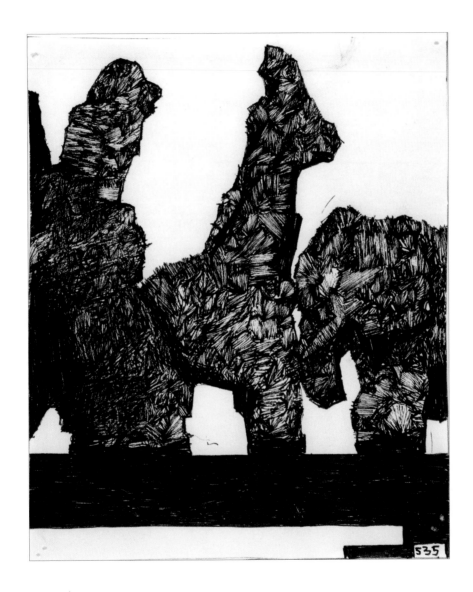

535

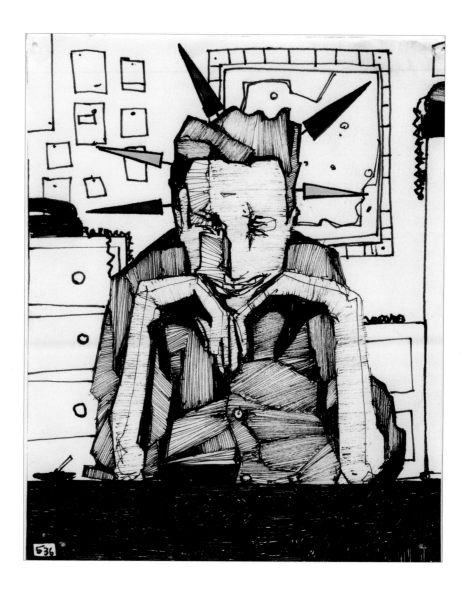

: 536 :

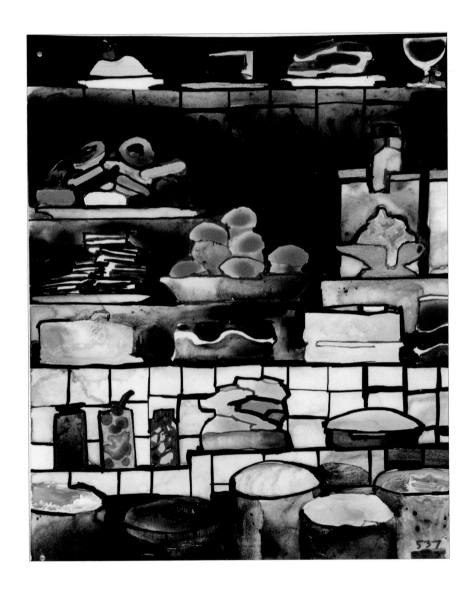

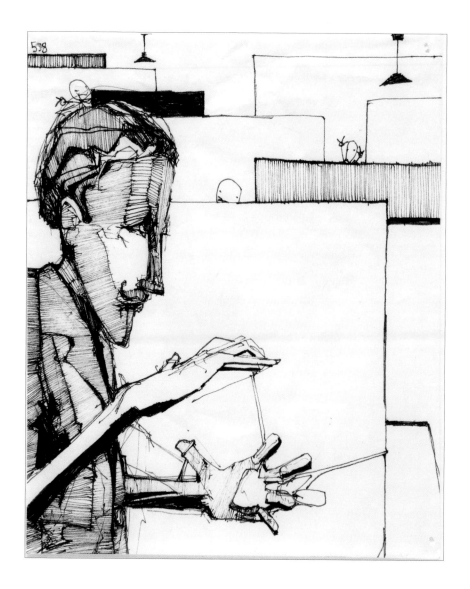

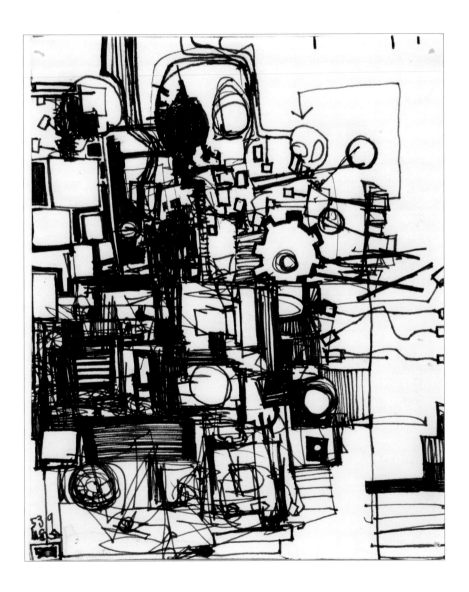

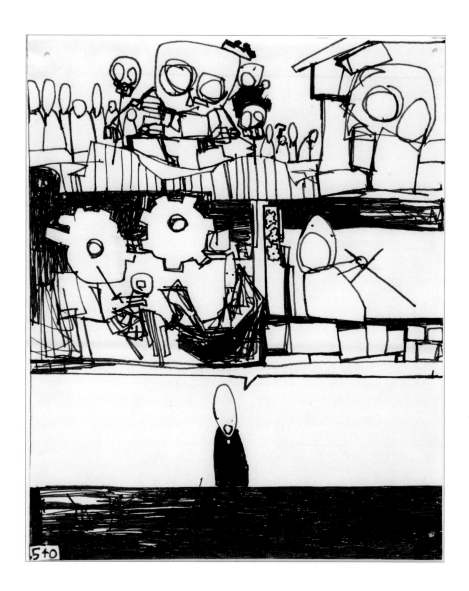

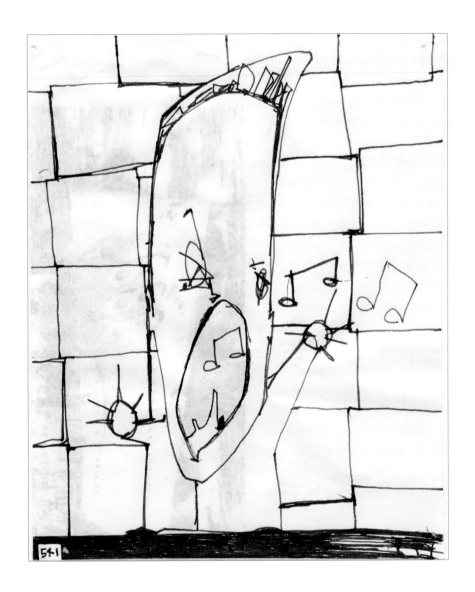

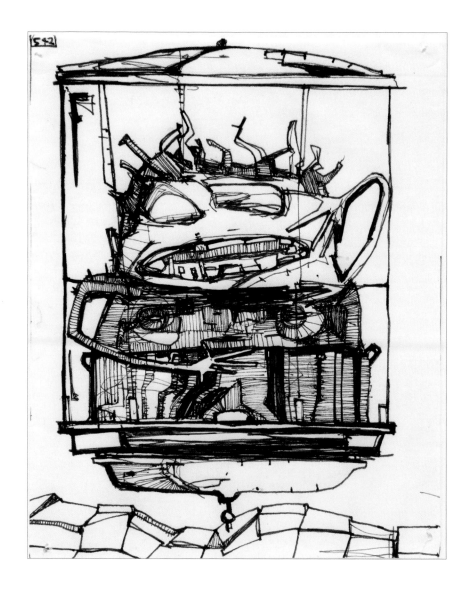

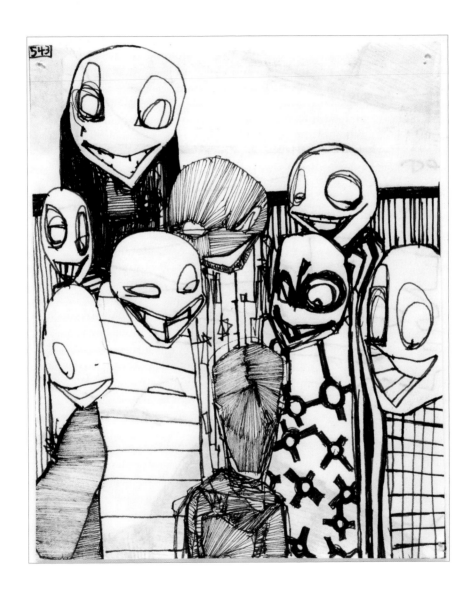

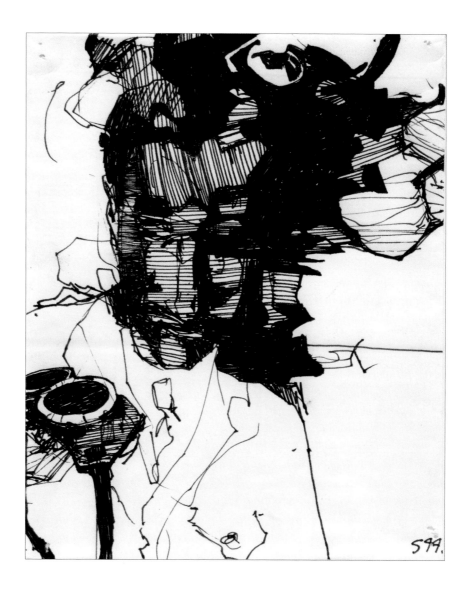

594.

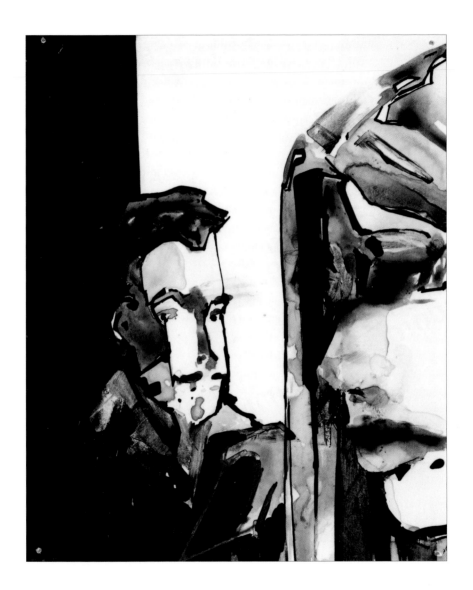

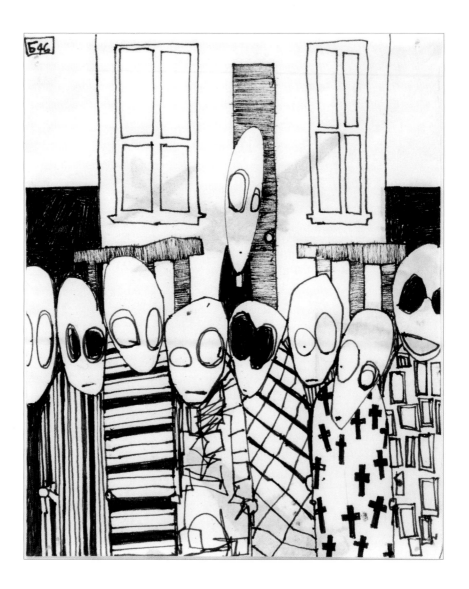

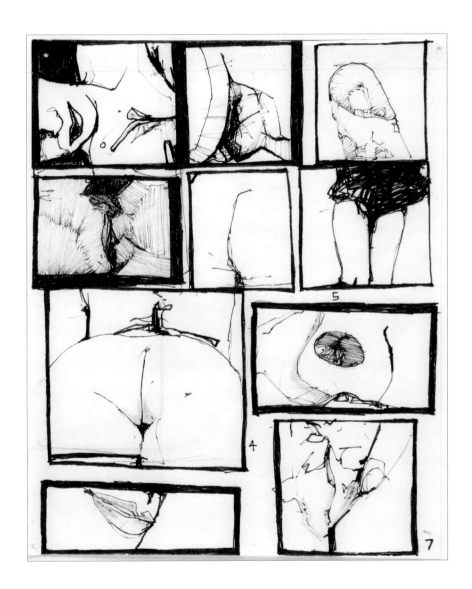

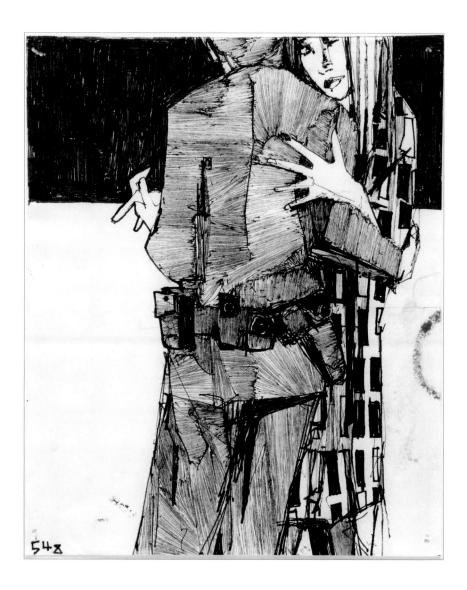

548

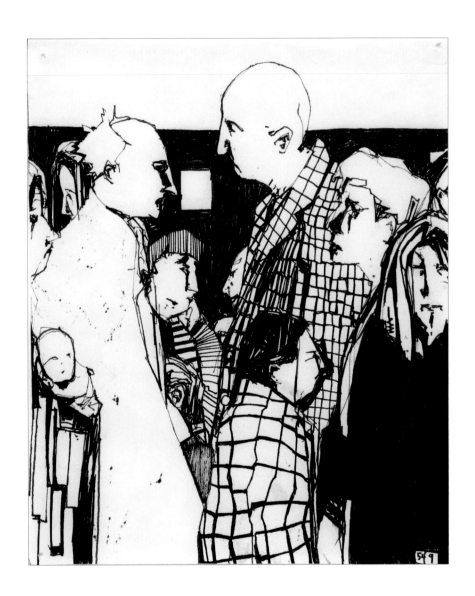

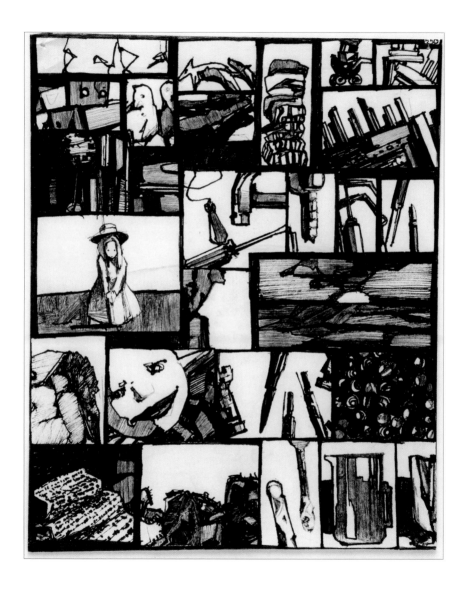

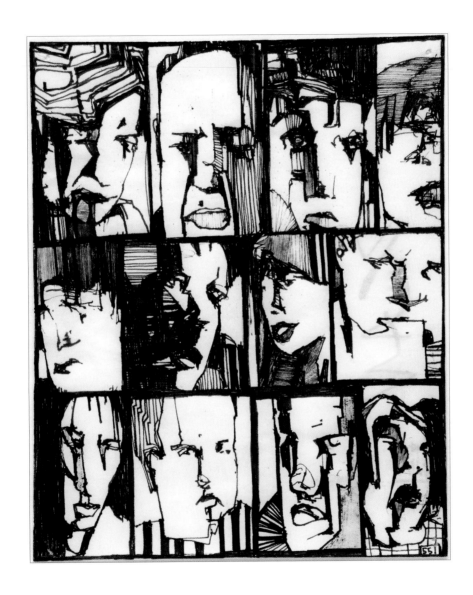

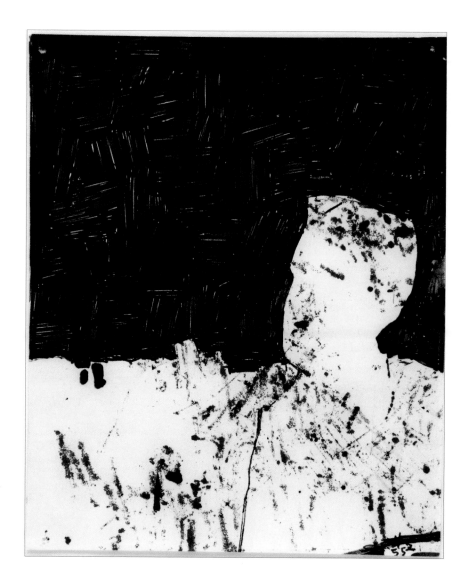

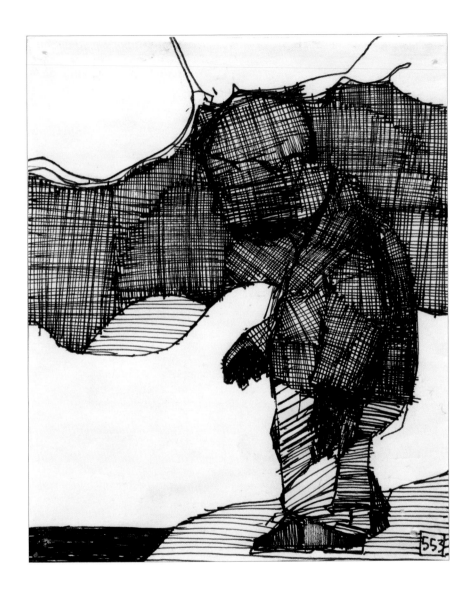

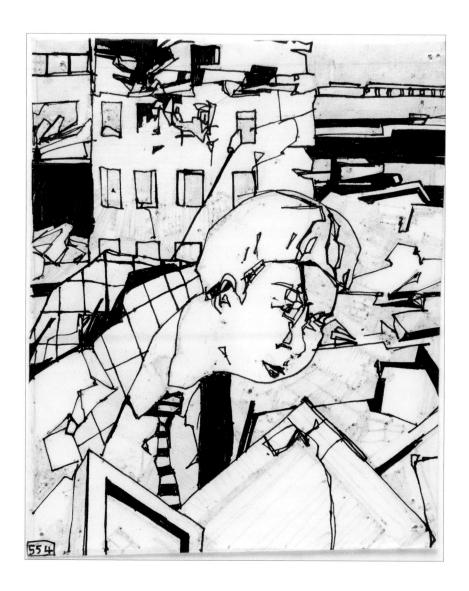

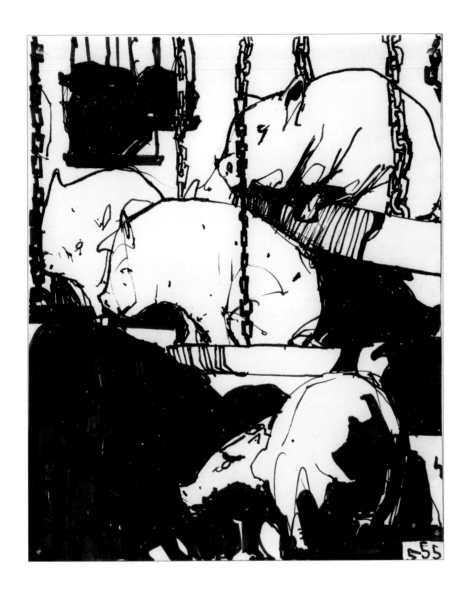

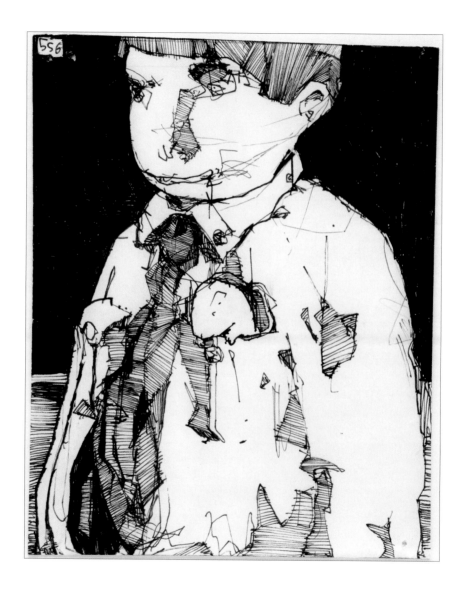

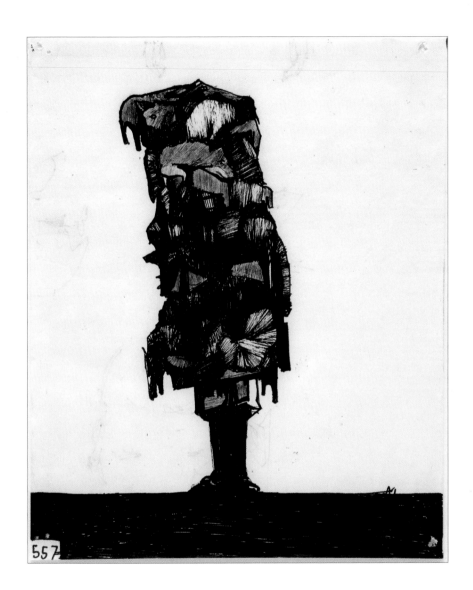

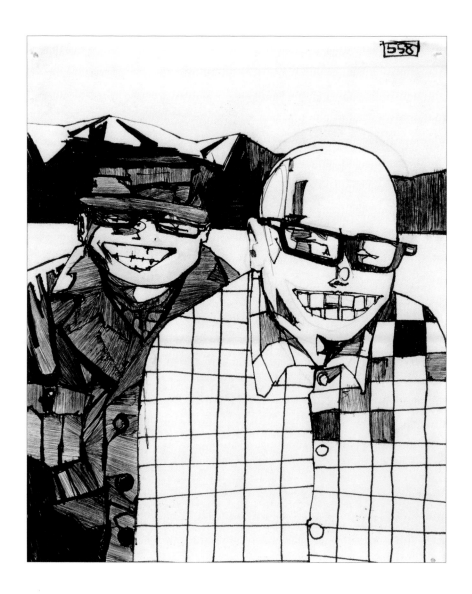

559.

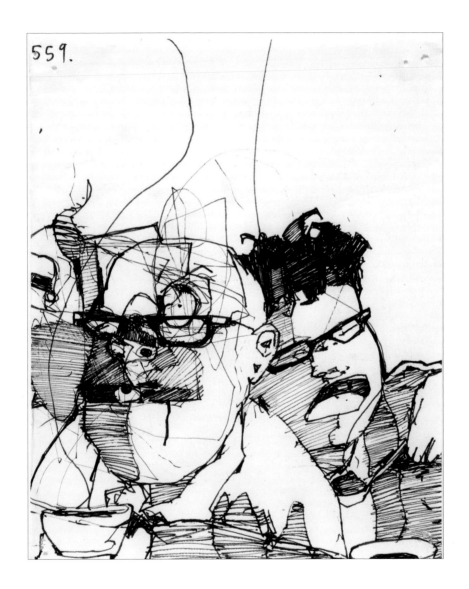

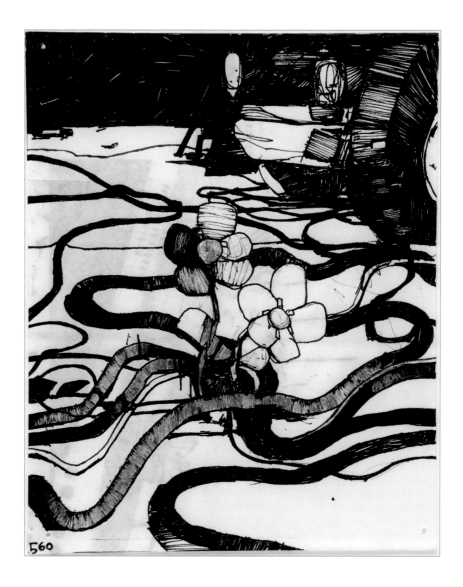

560

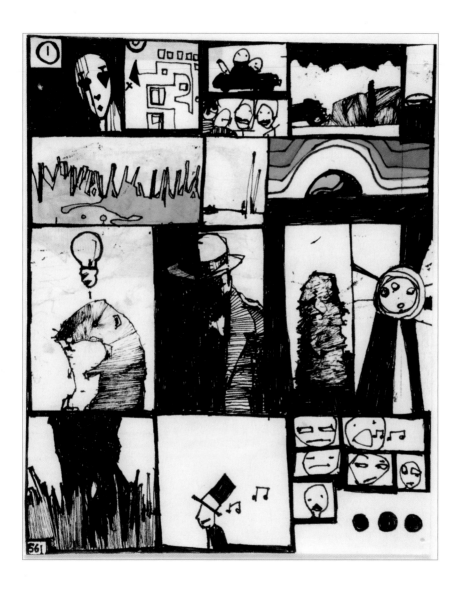

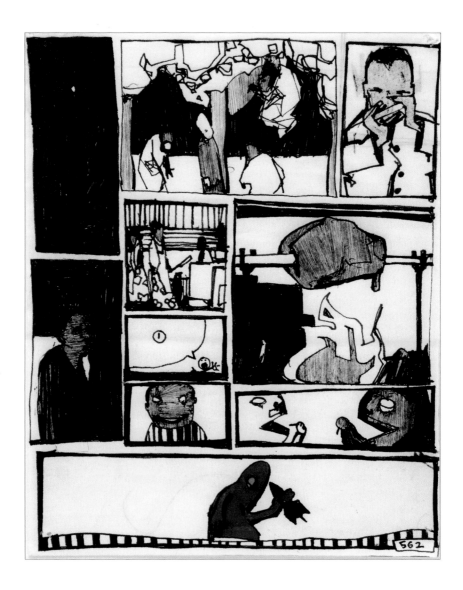

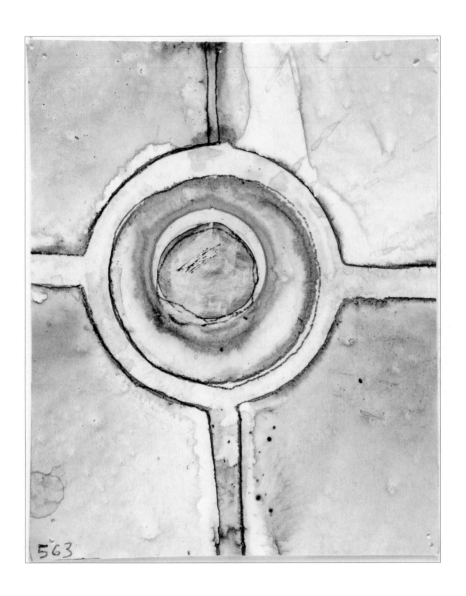

563

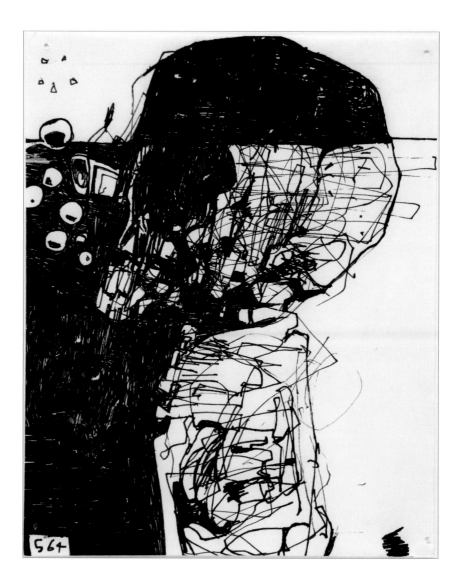

564

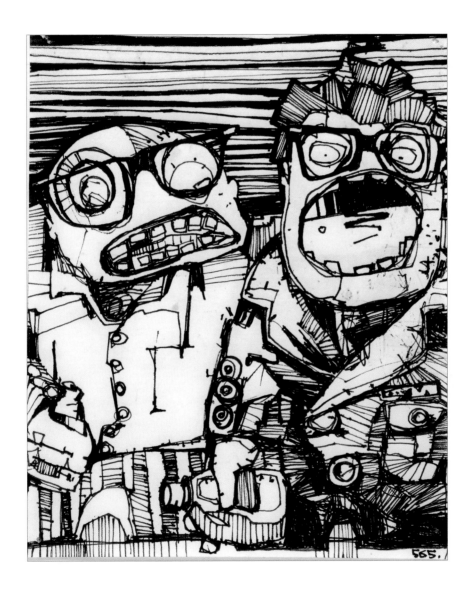

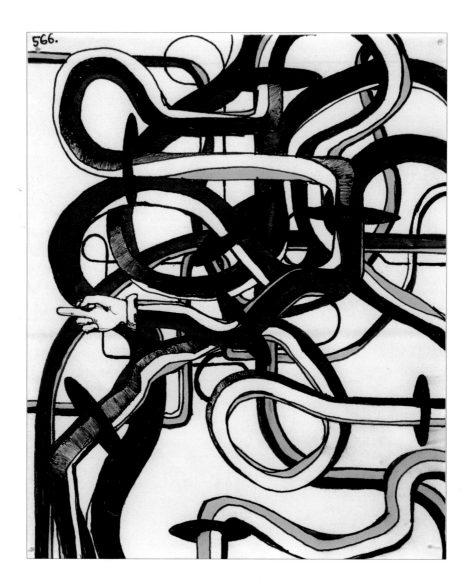

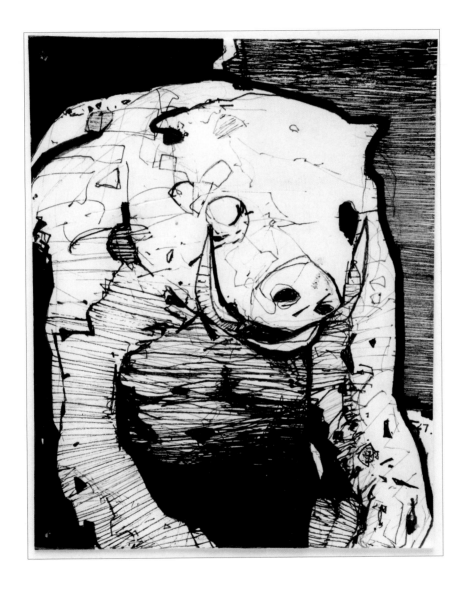

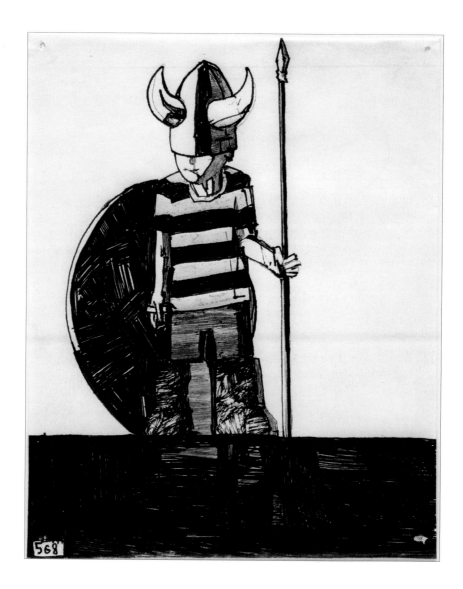

: 568 :

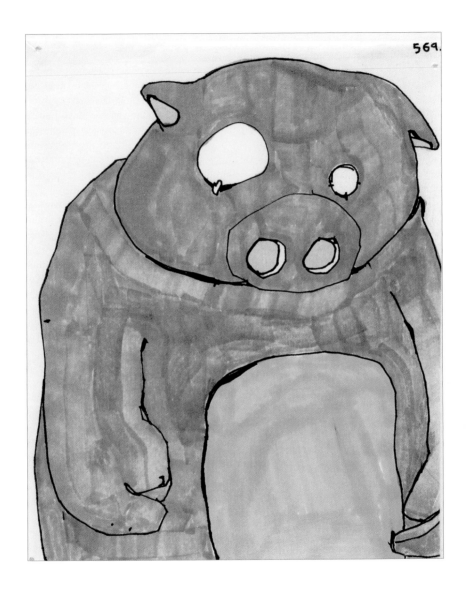

570.

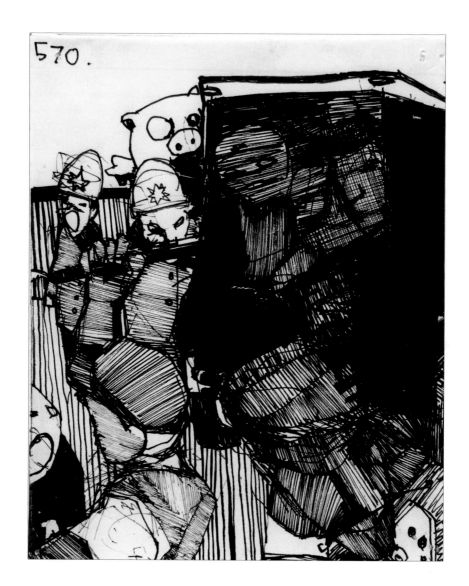

: 570 :

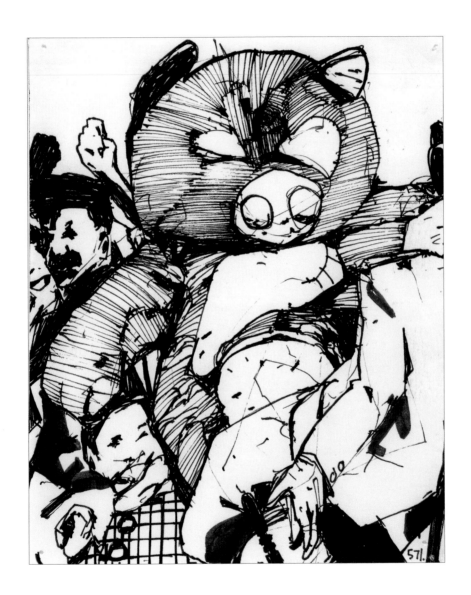

571.

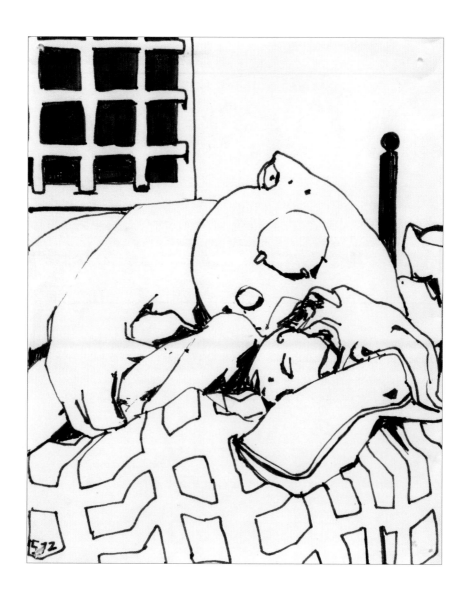

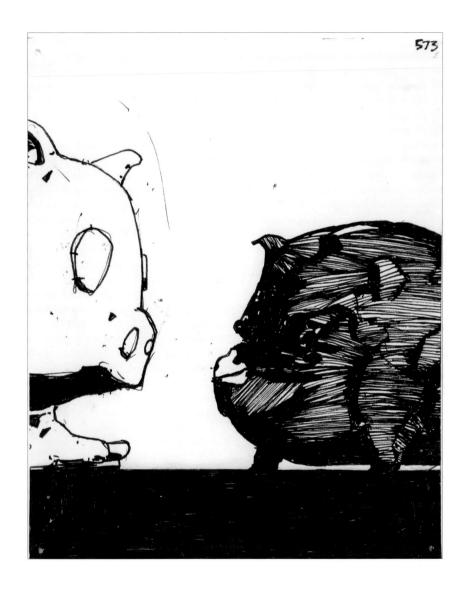

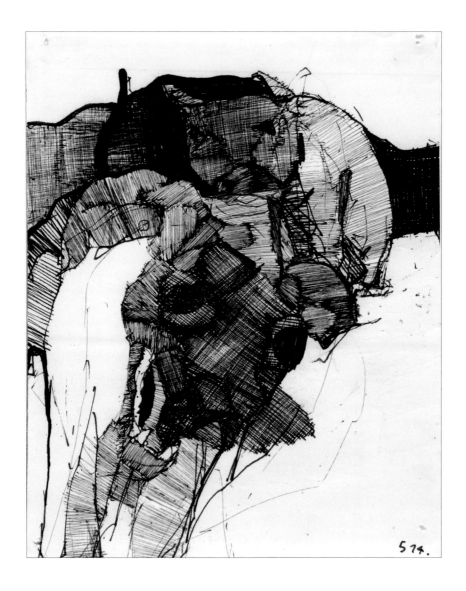

574.

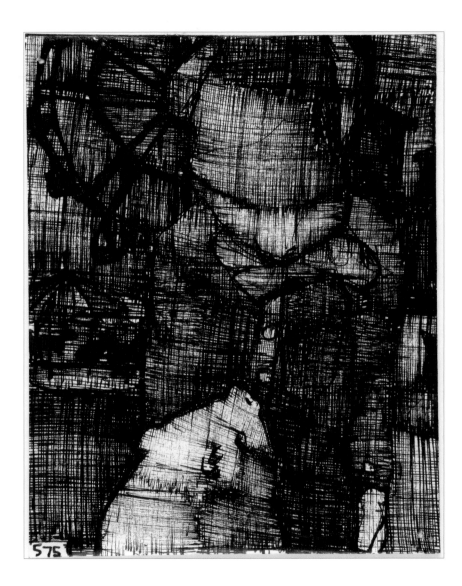

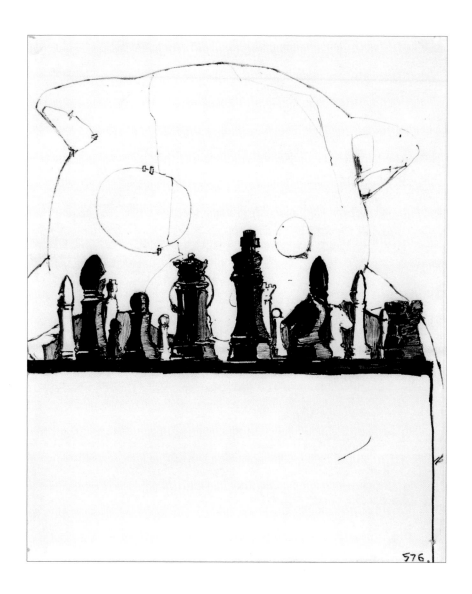

576.

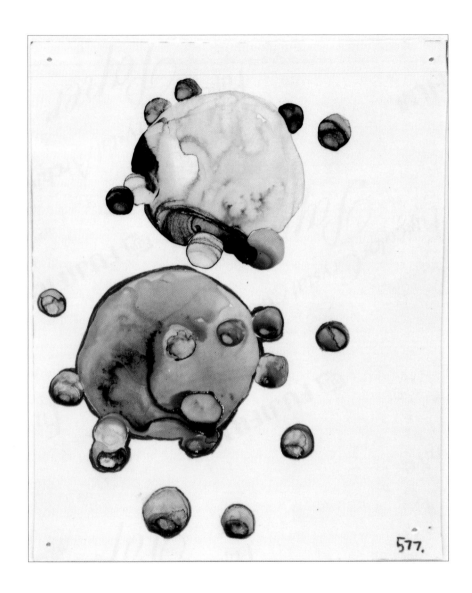

577.

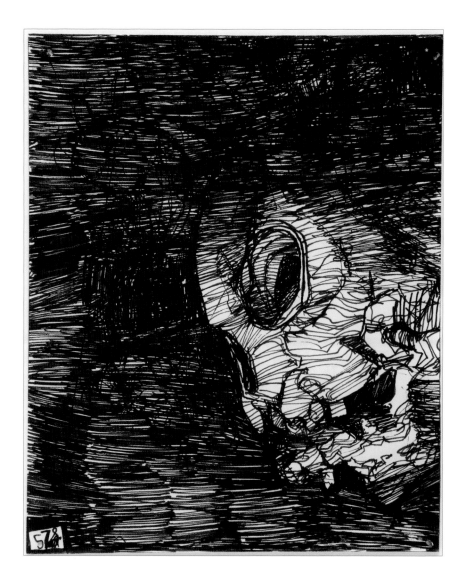

579.

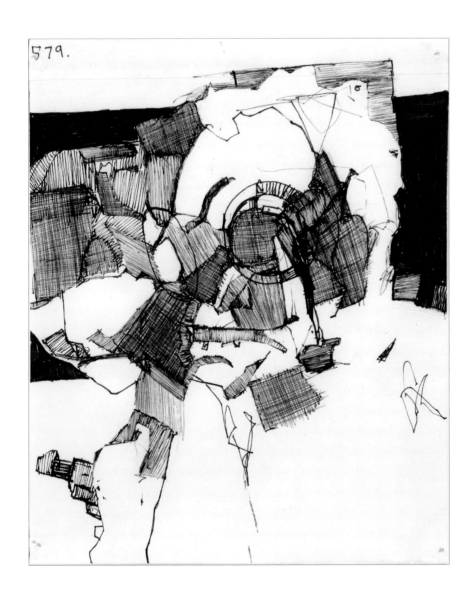

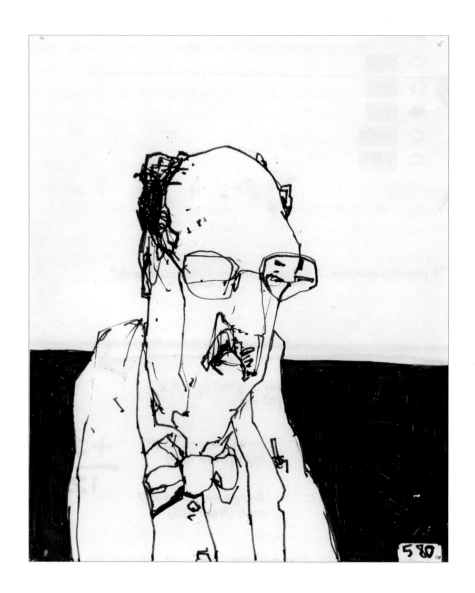

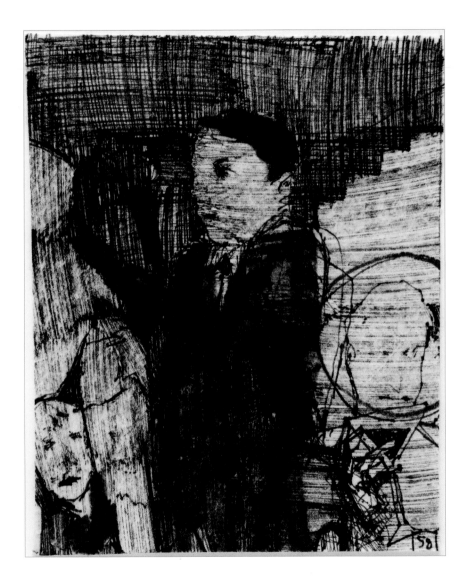

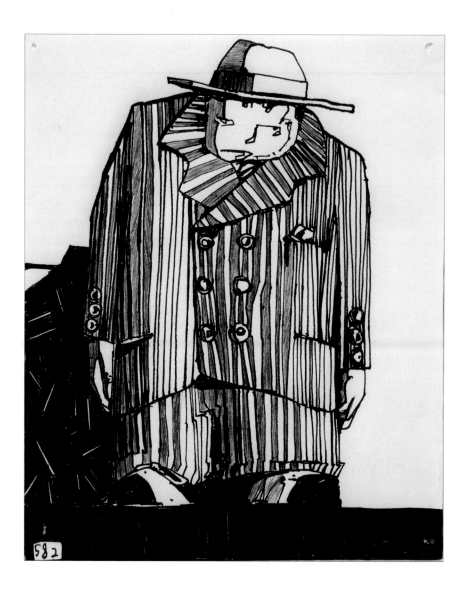

582

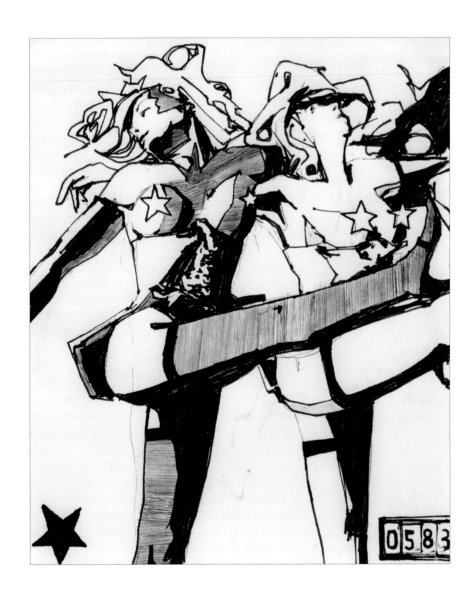

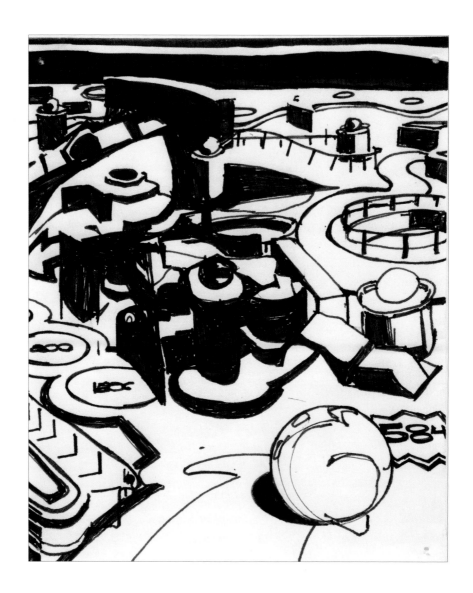

584

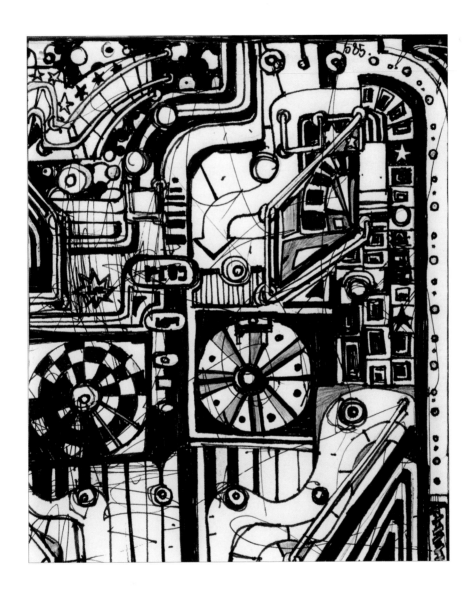

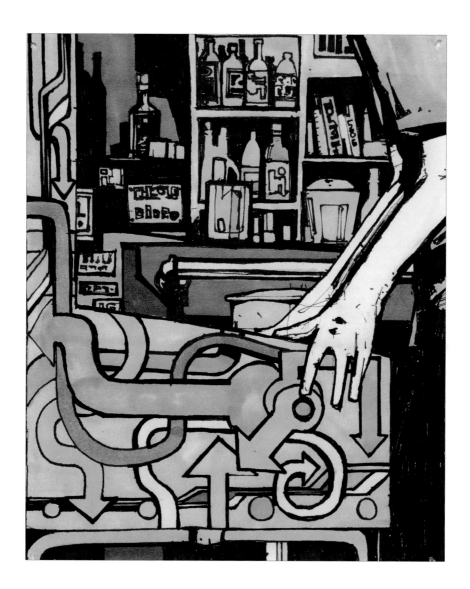

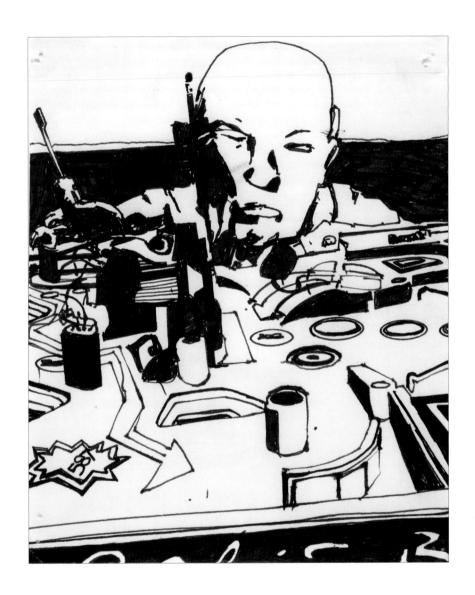

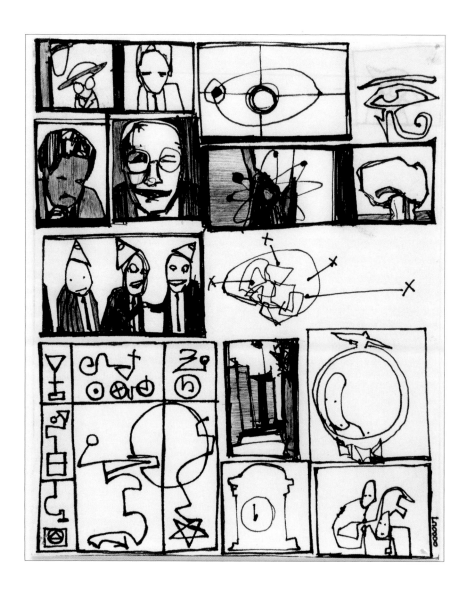

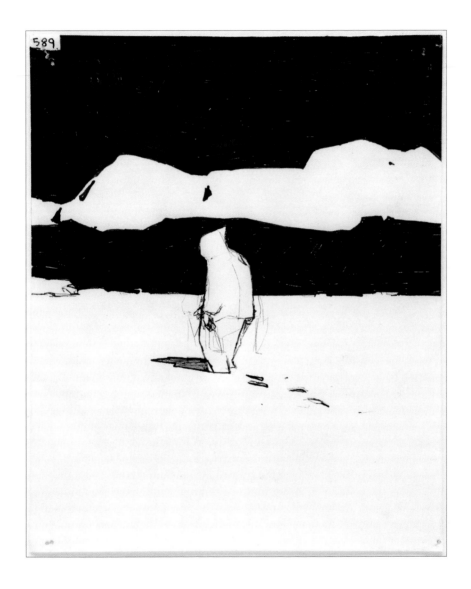

589

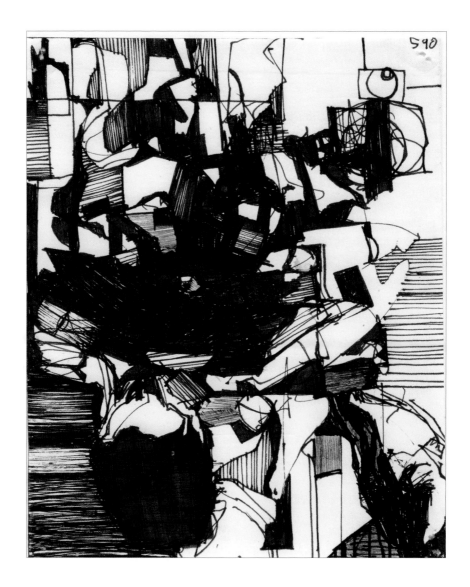

590

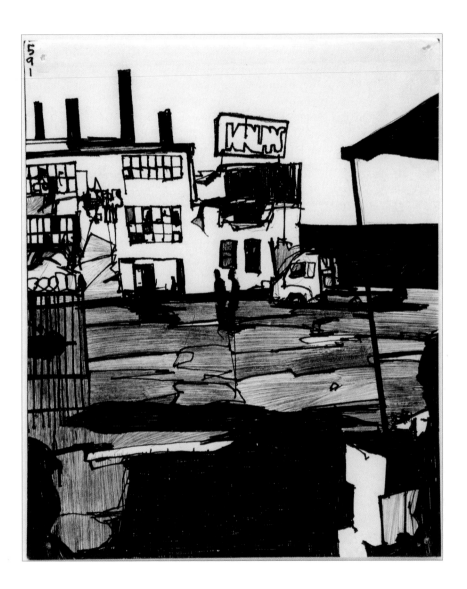

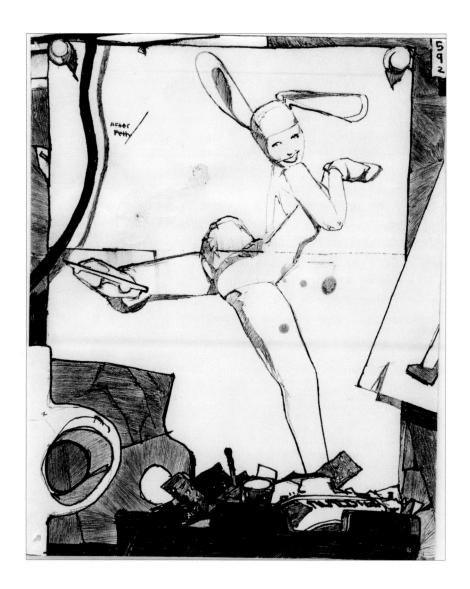

: 592 :

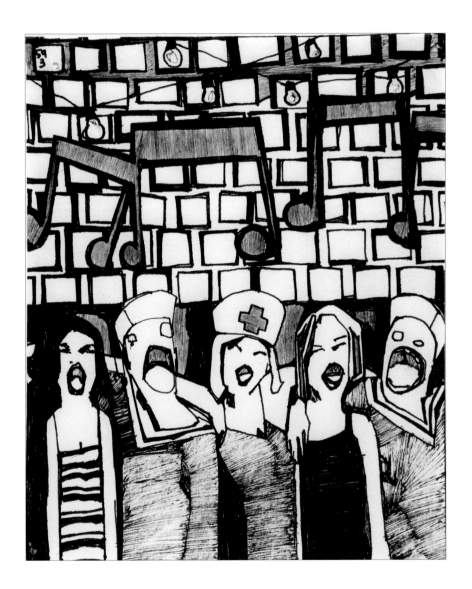

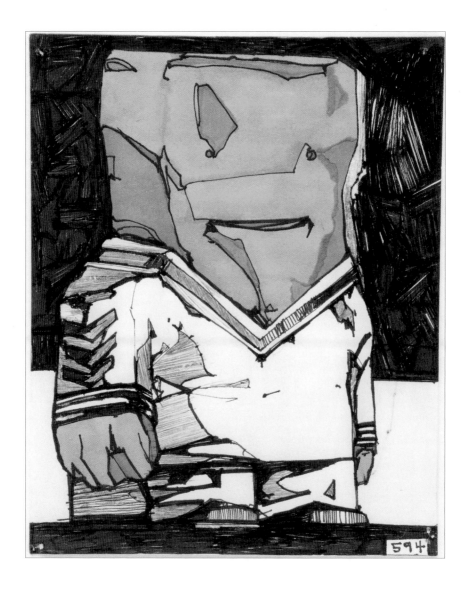

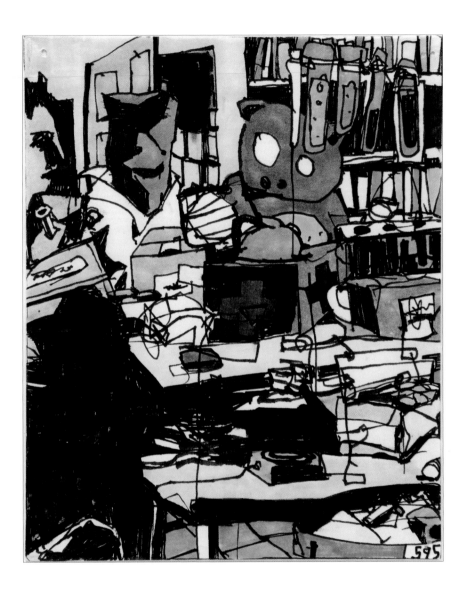

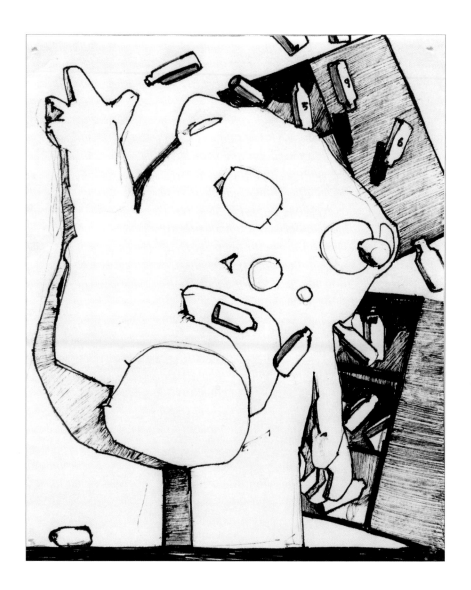

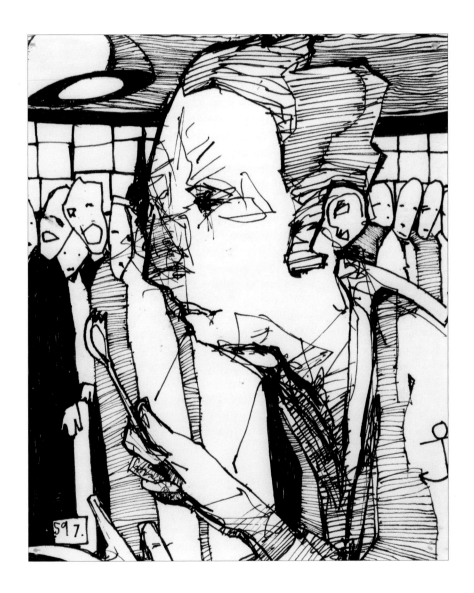

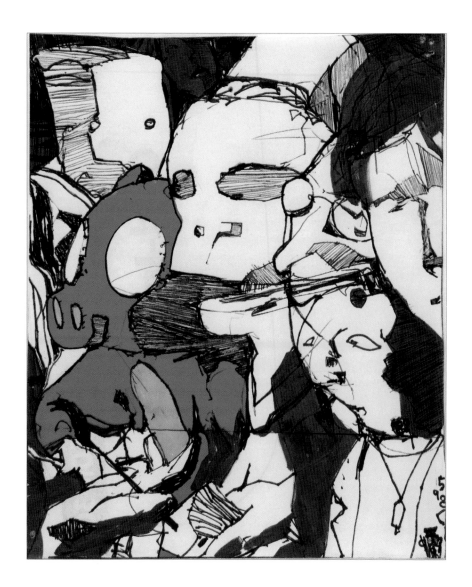

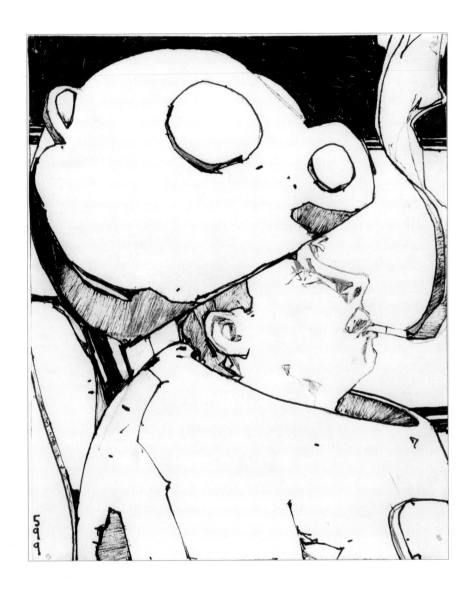

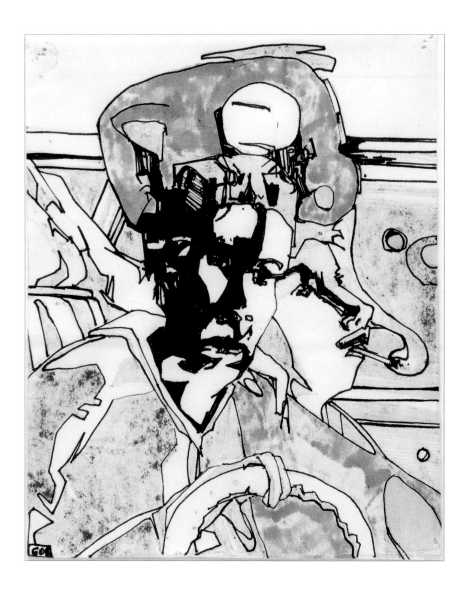

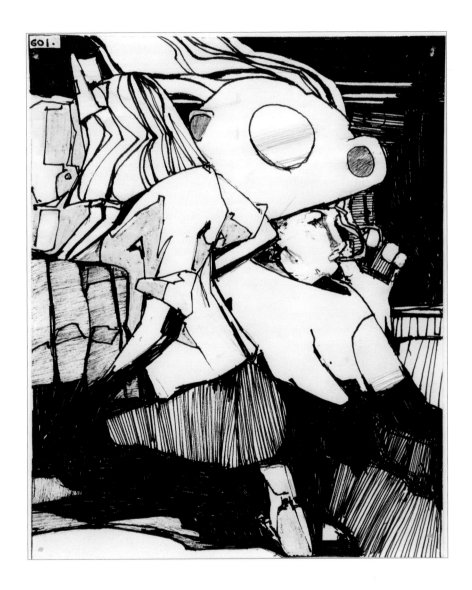

601.

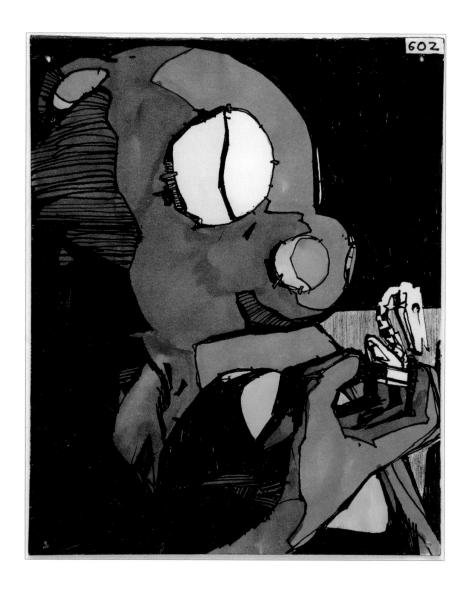

602

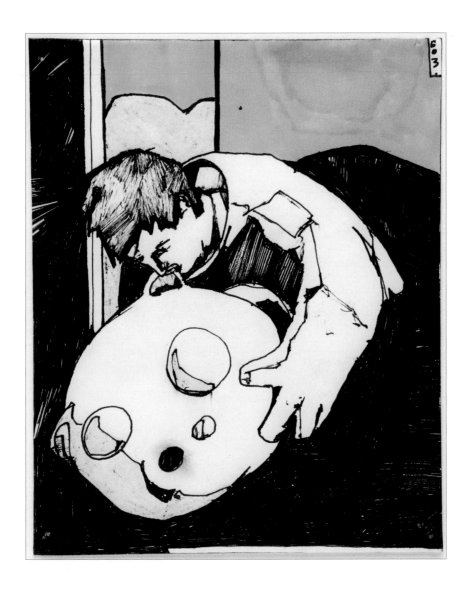

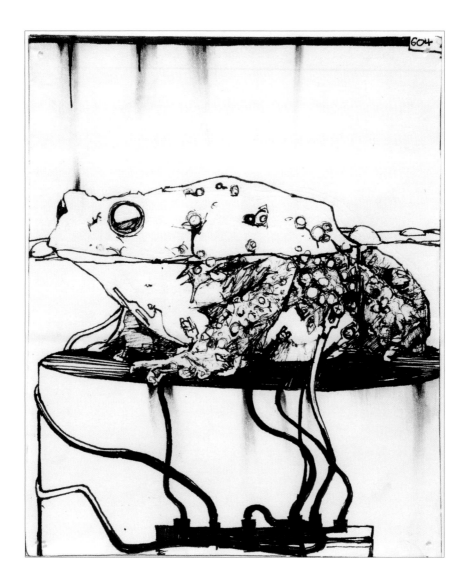

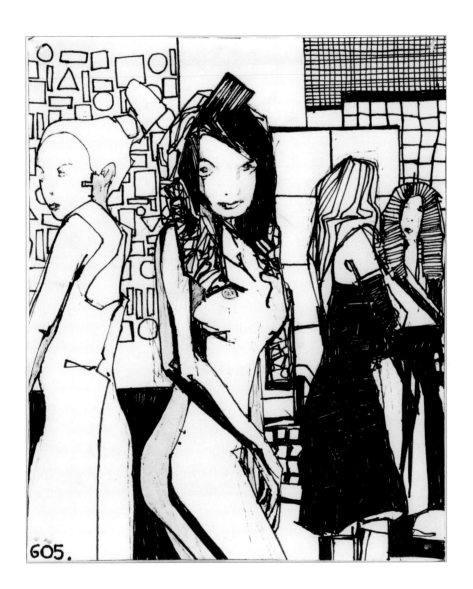

605.

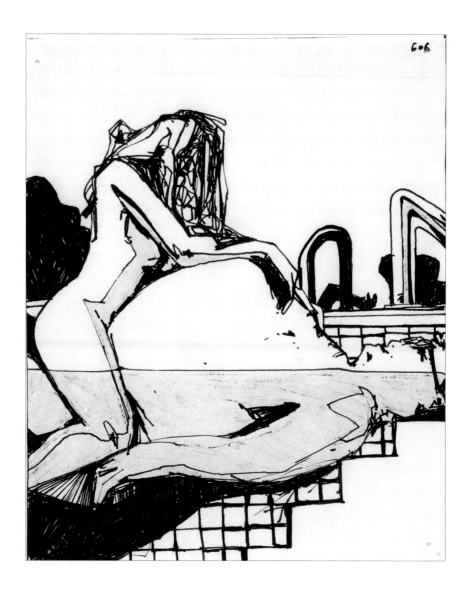

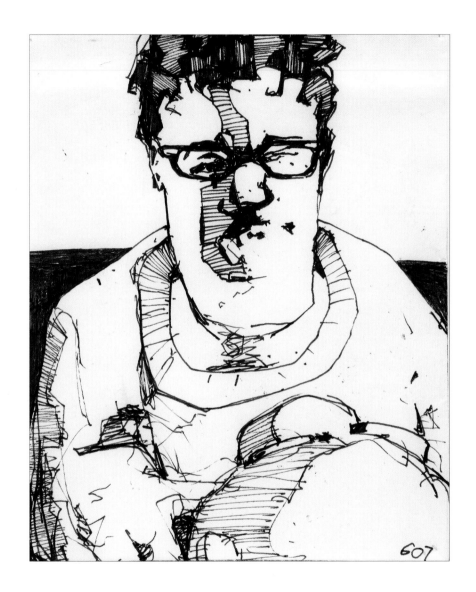

607

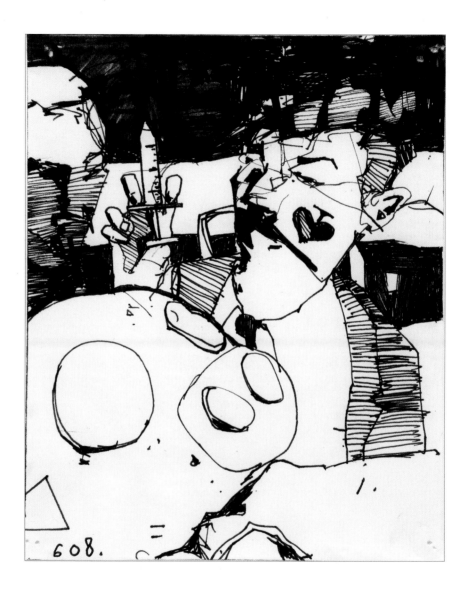

608.

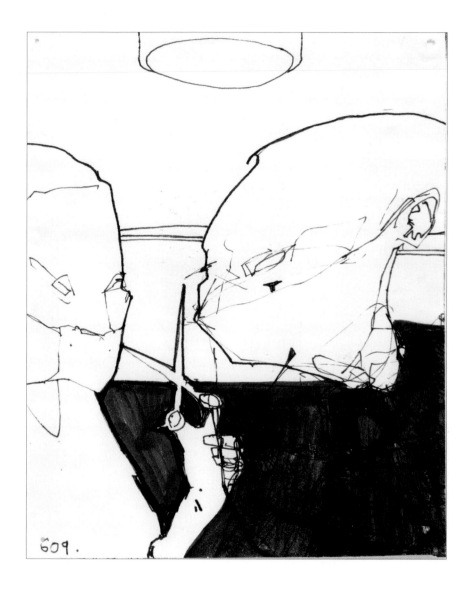

609.

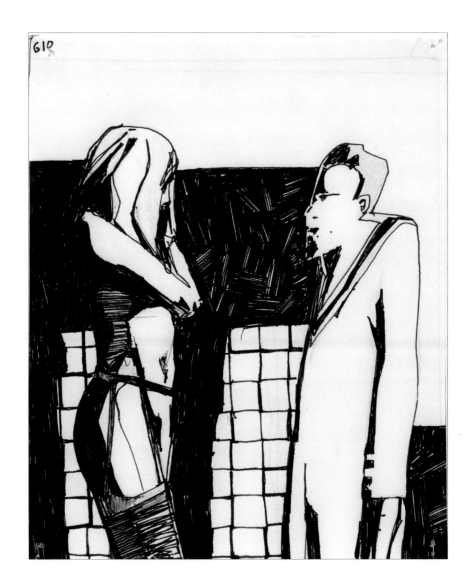

610

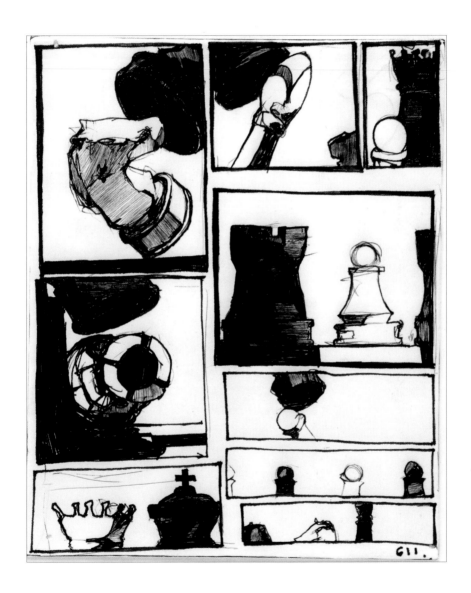

612.

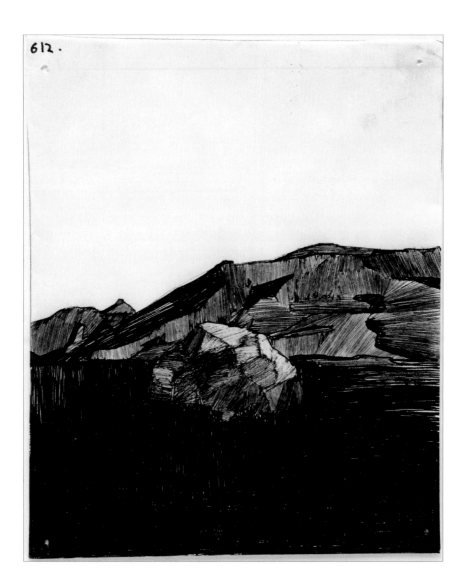

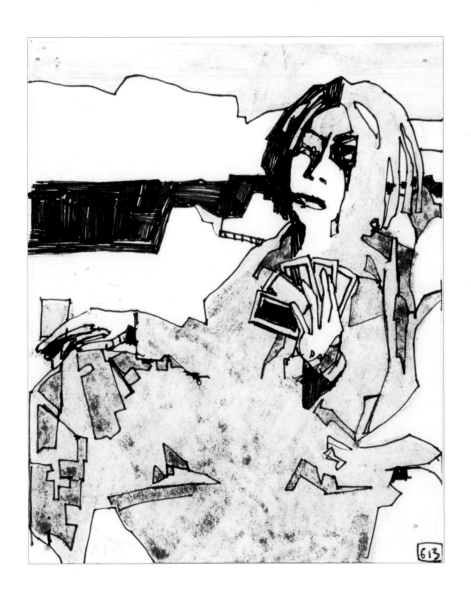

613

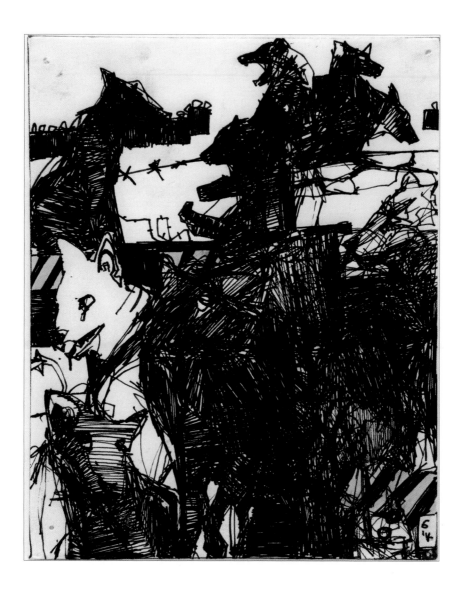

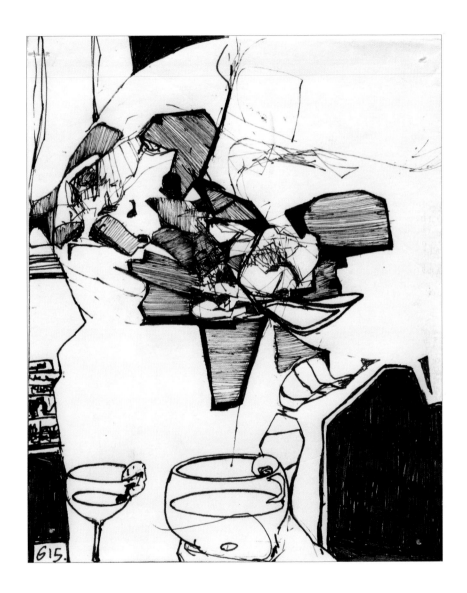

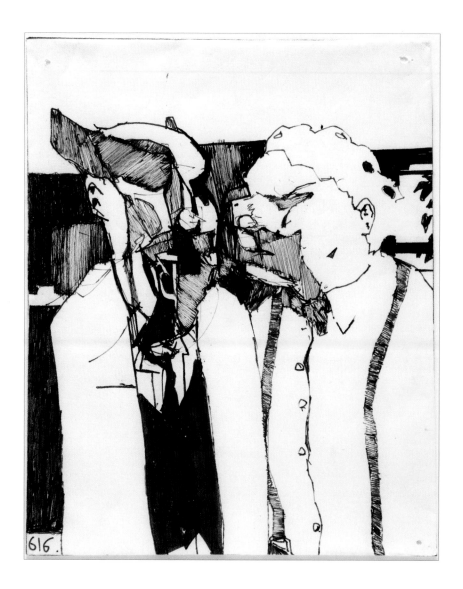

616.

: 616 :

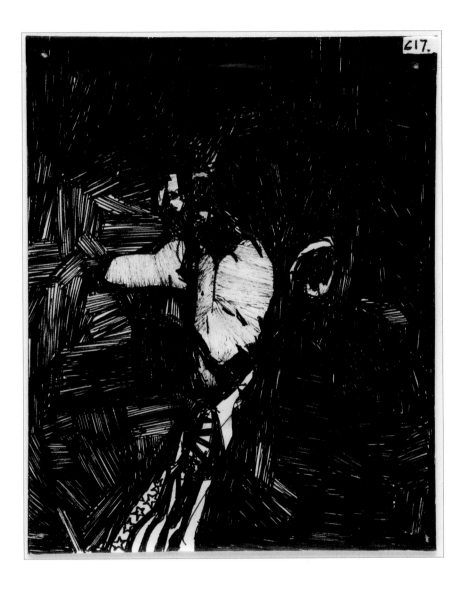

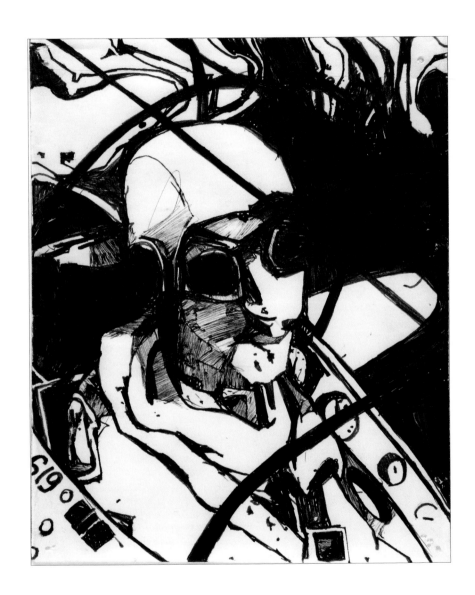

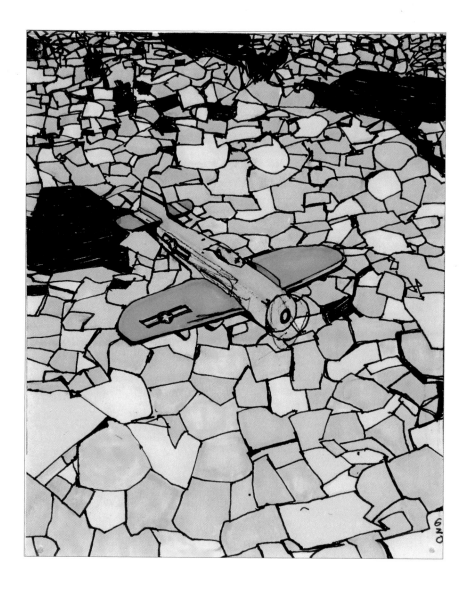

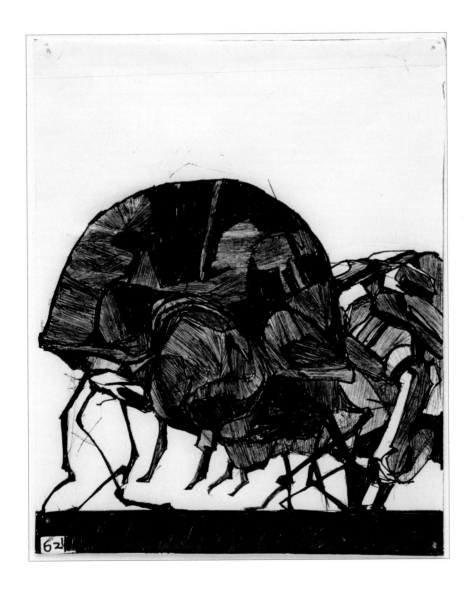

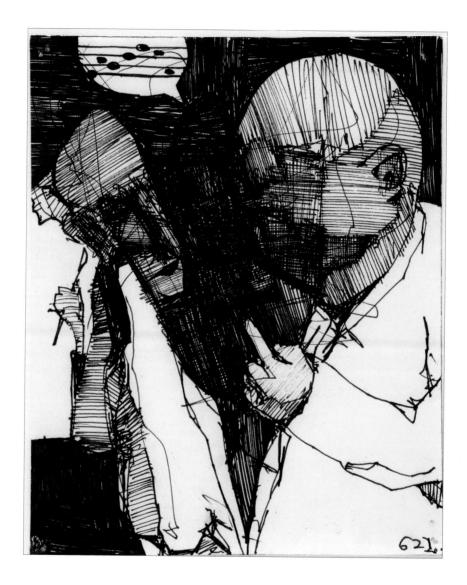

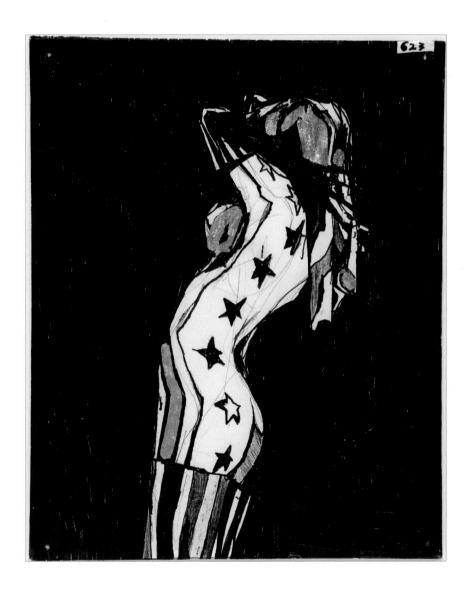

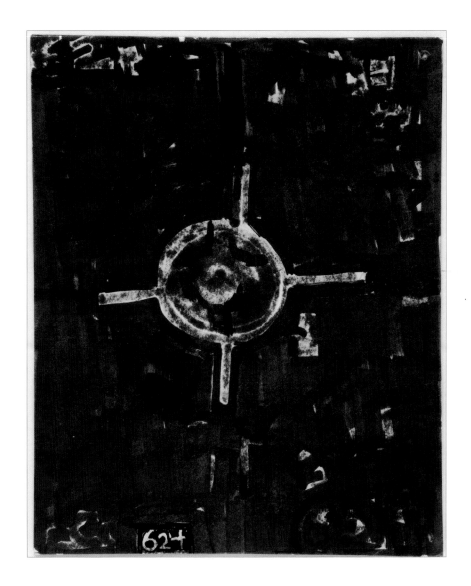

: 624 :

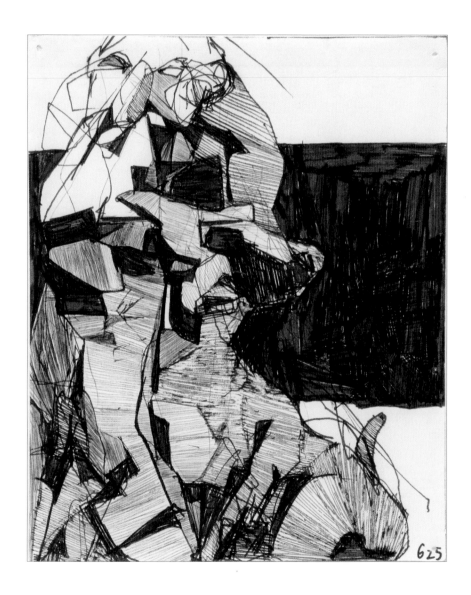

625

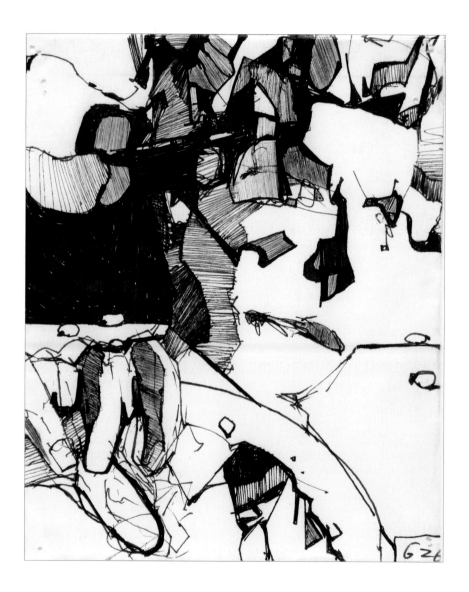

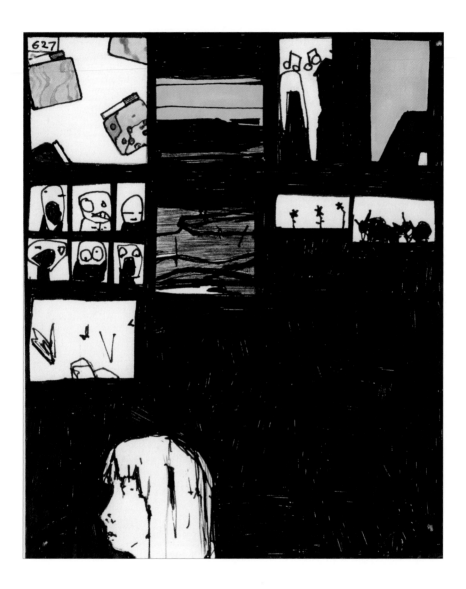

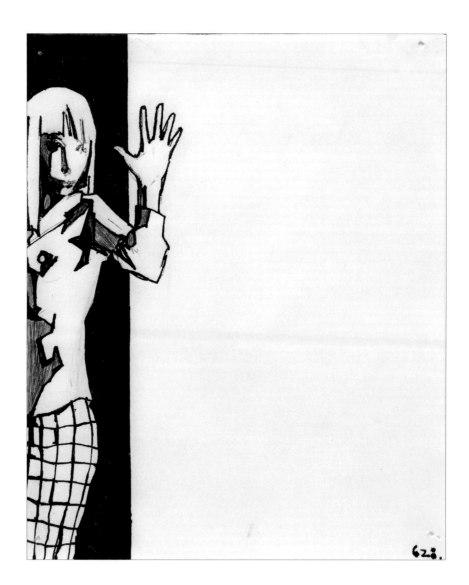

628.

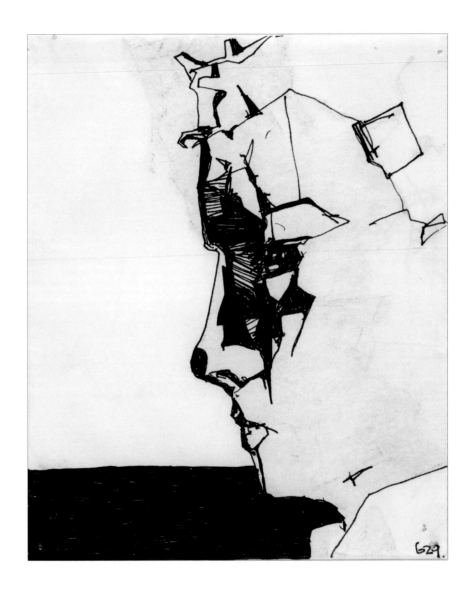

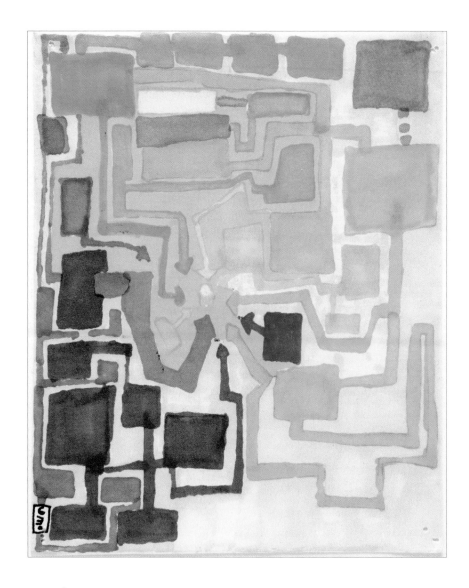

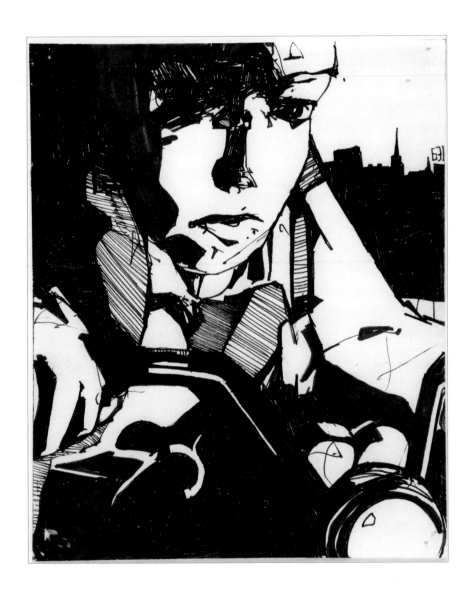

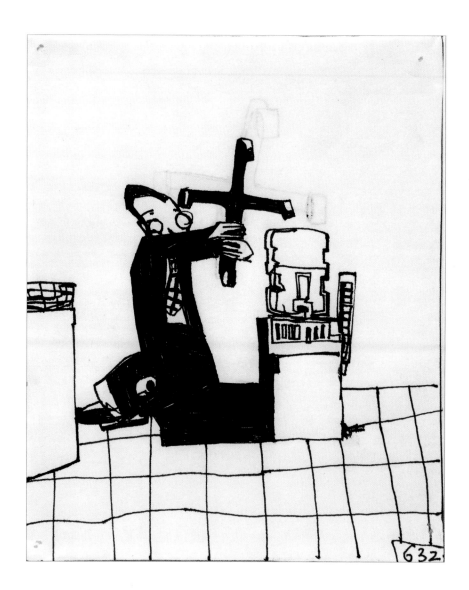

632

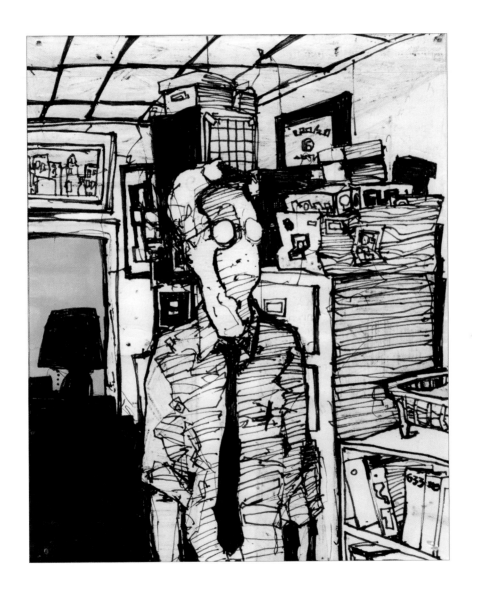

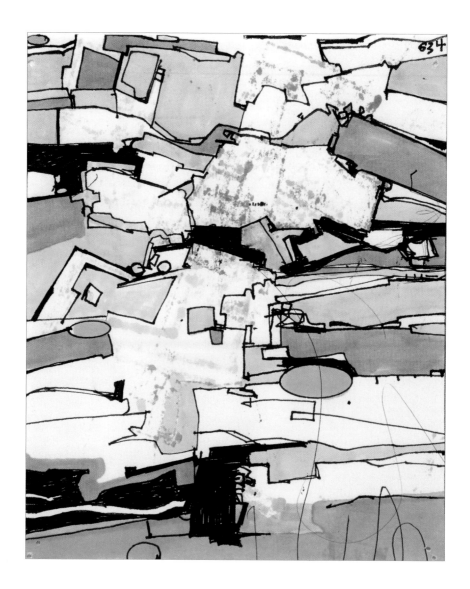

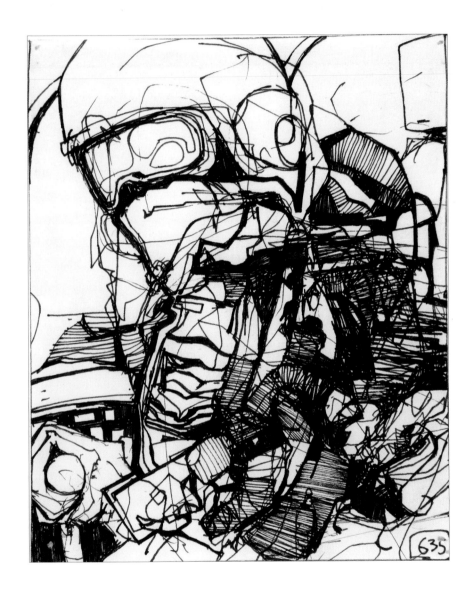

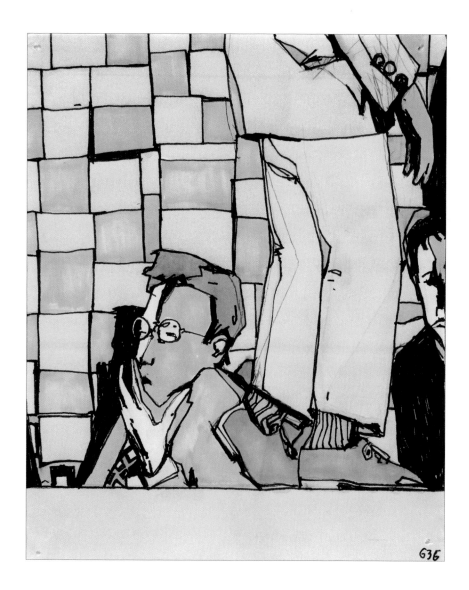

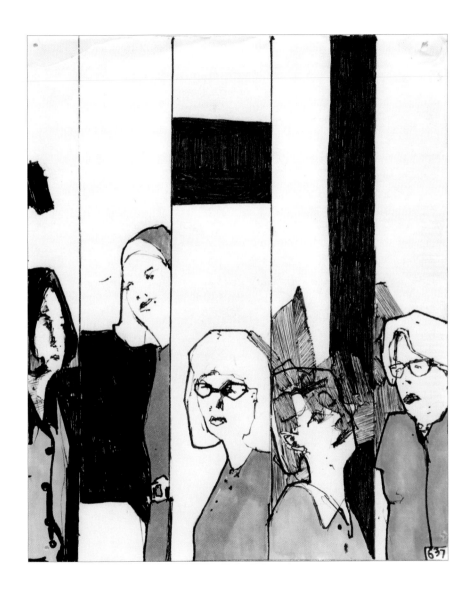

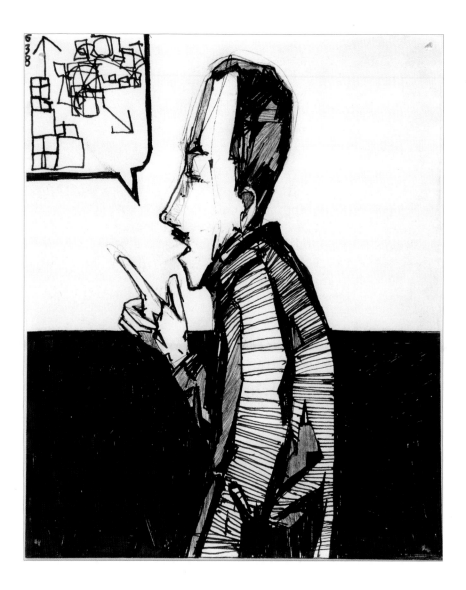

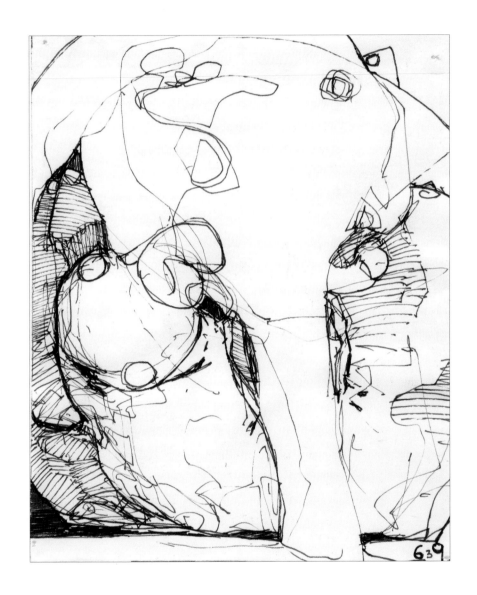

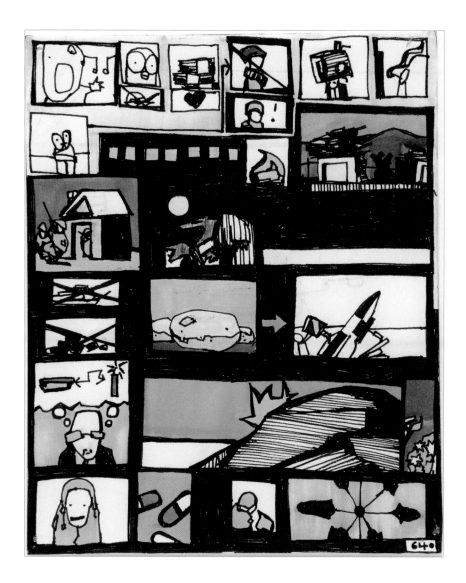

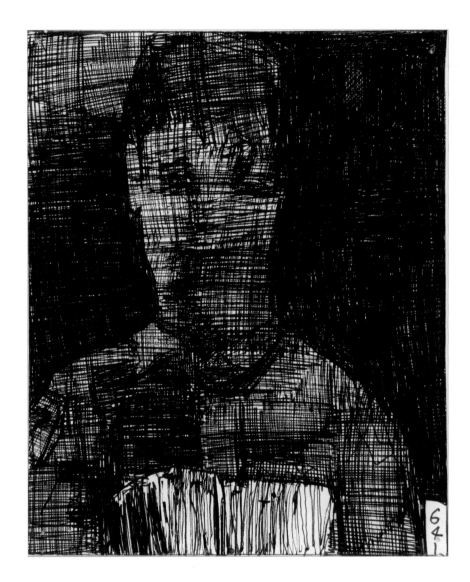

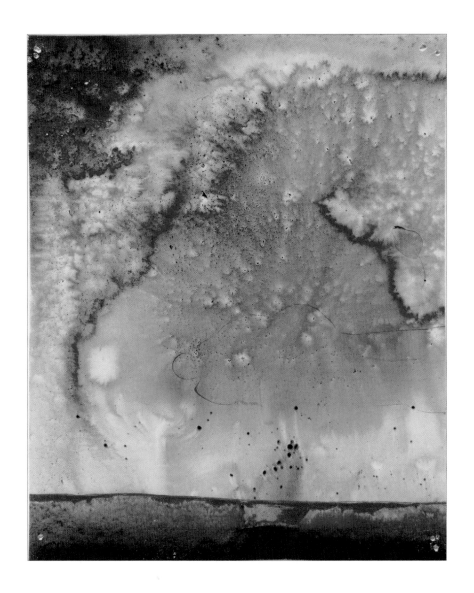

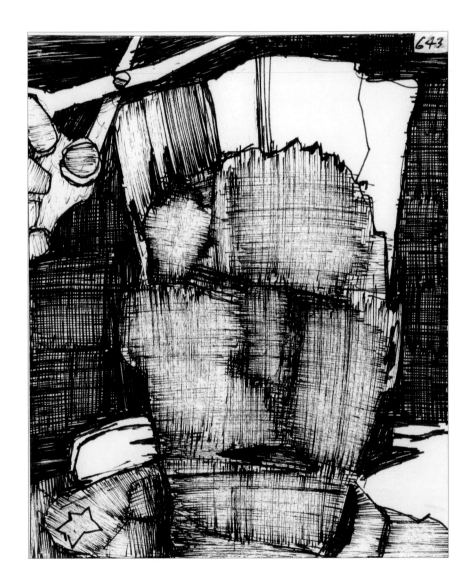

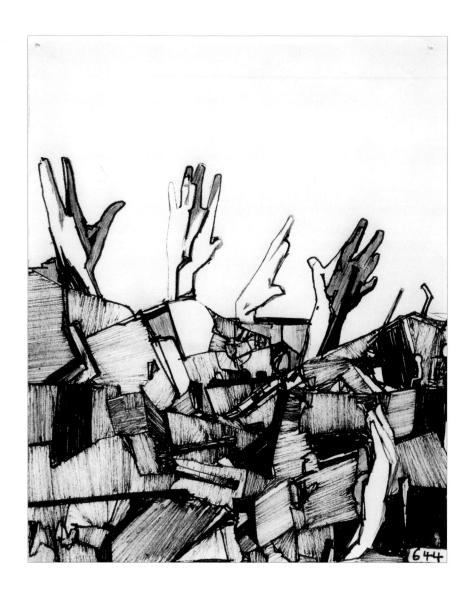

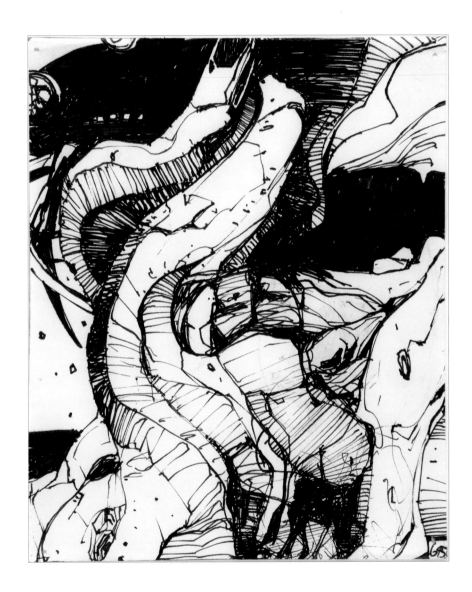

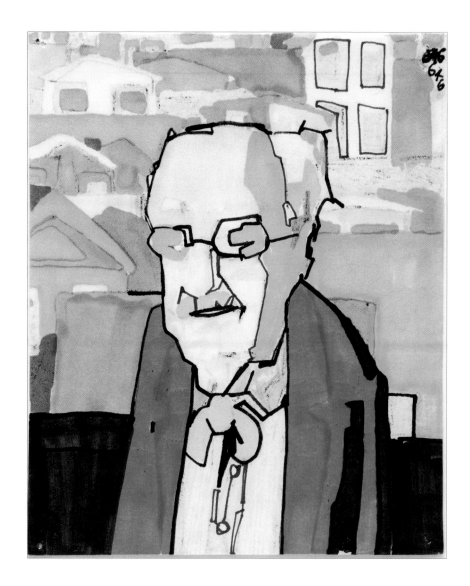

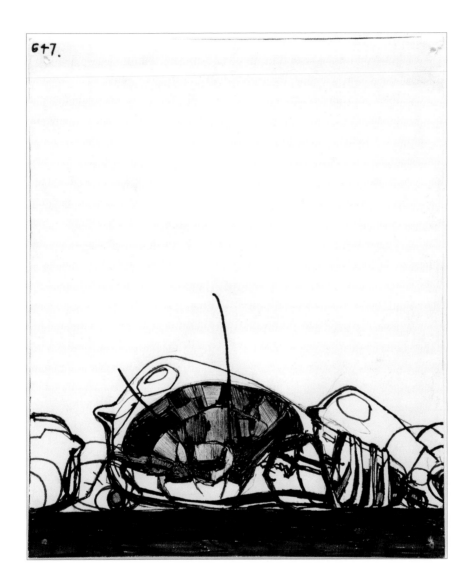

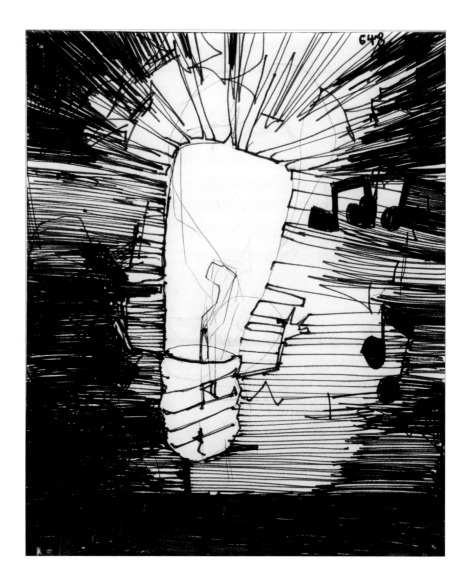

: 648 :

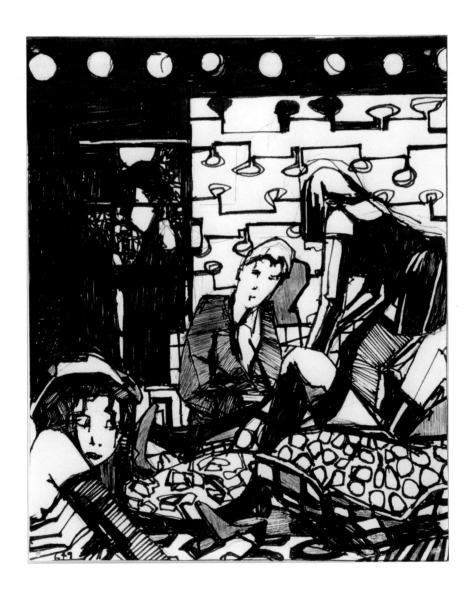

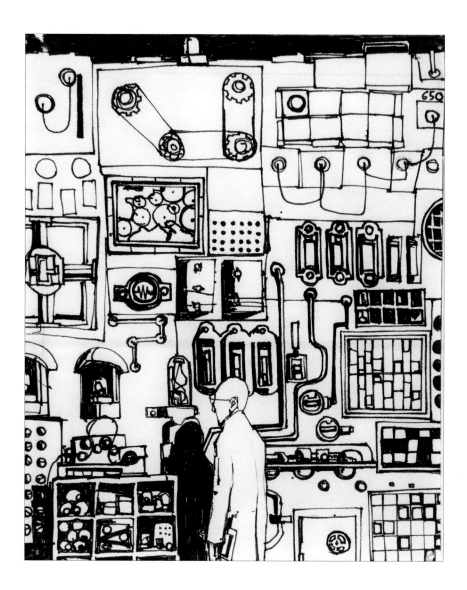

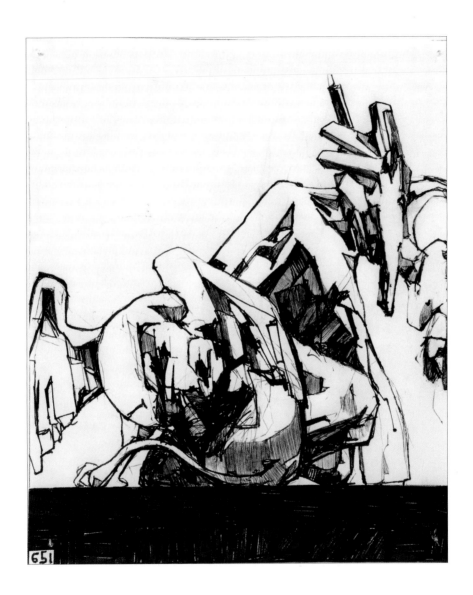

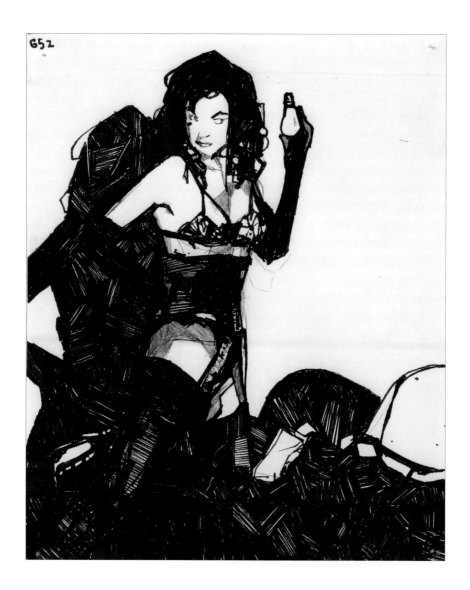

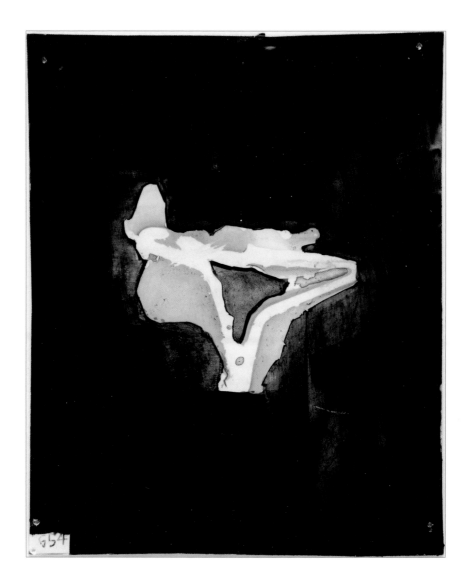

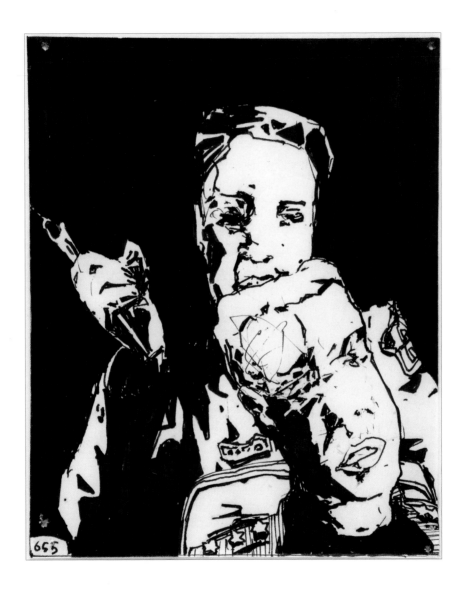

655

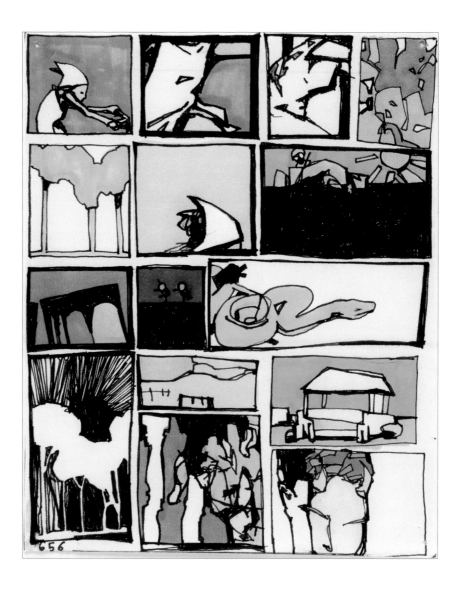

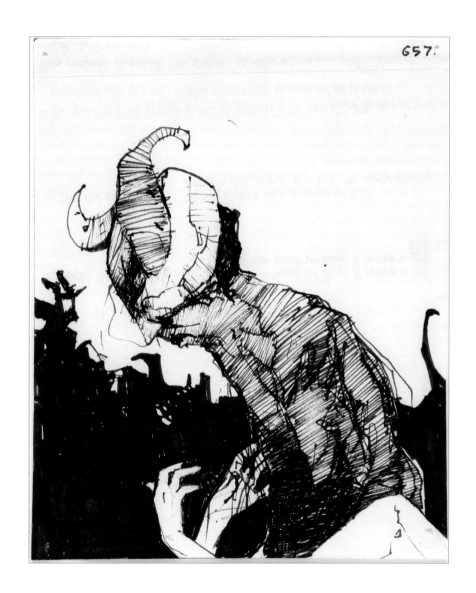

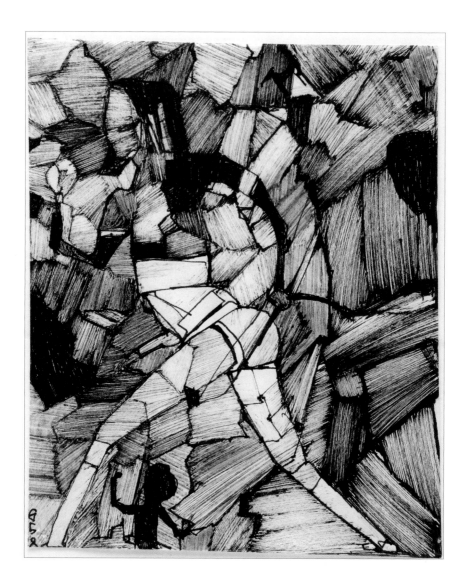

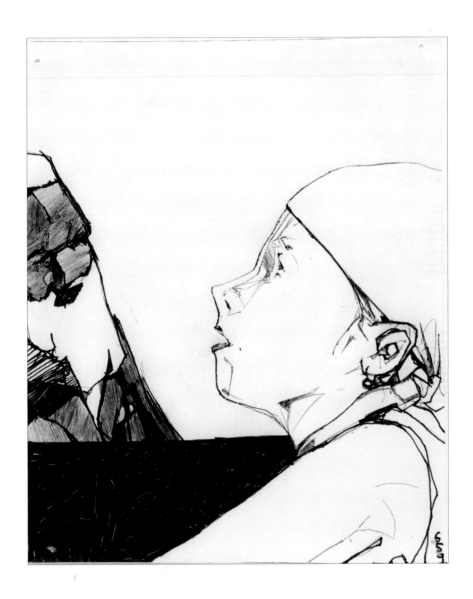

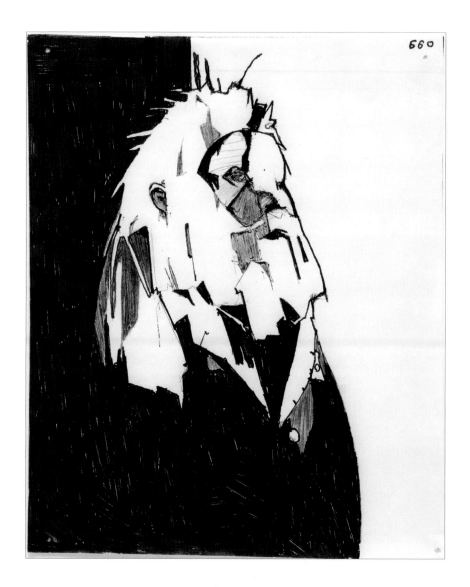

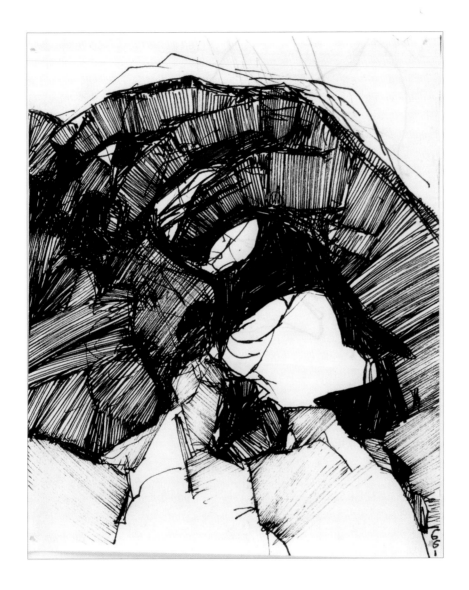

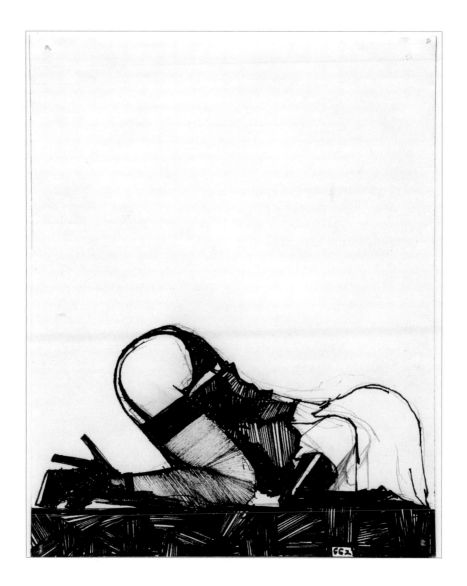

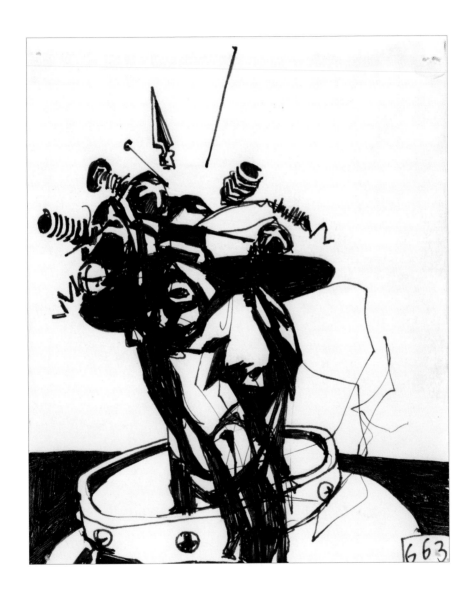

663

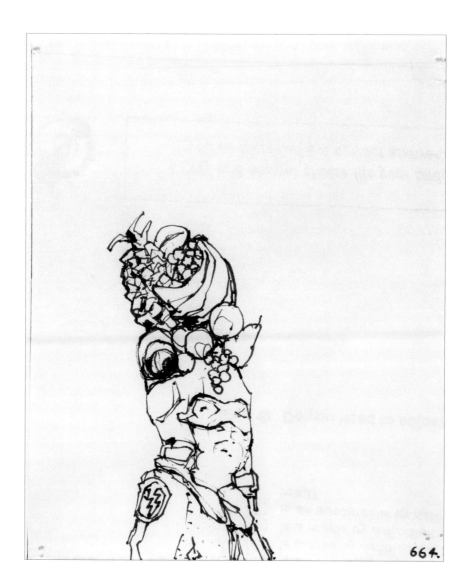

664.

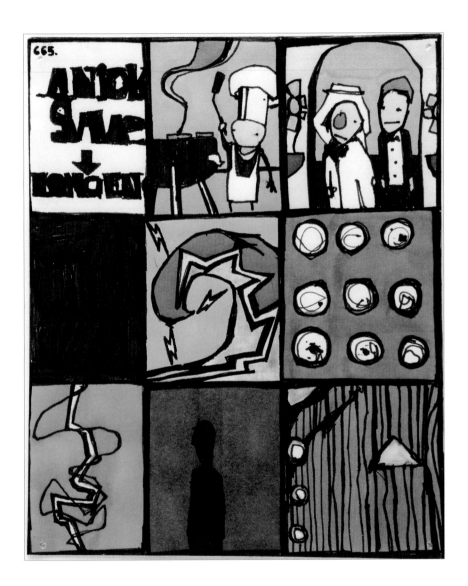

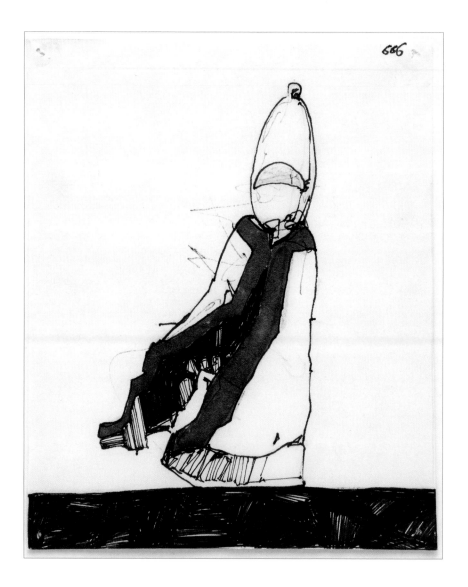

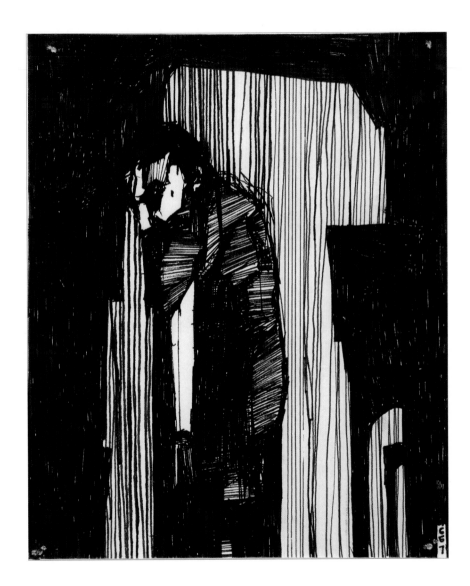

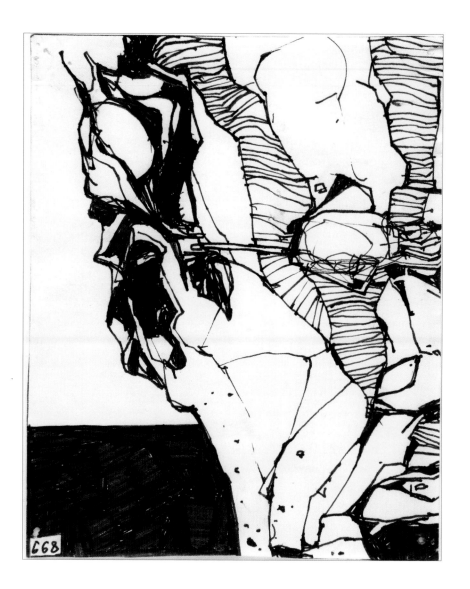

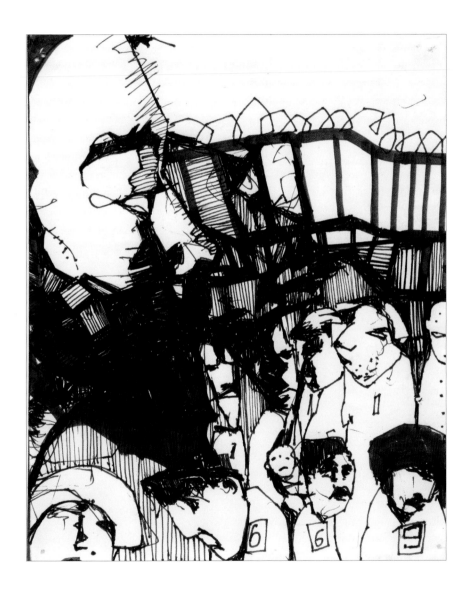

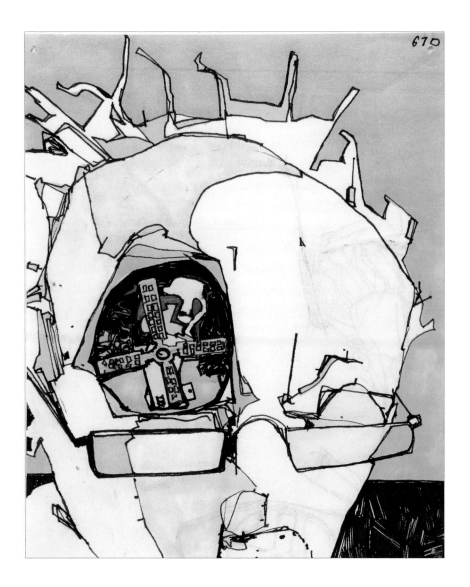

: 670 :

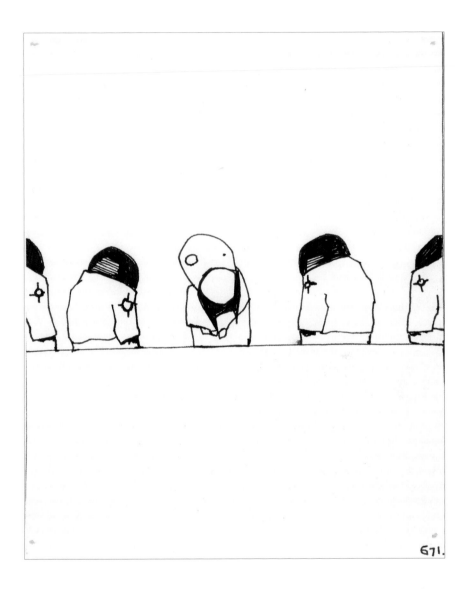

671.

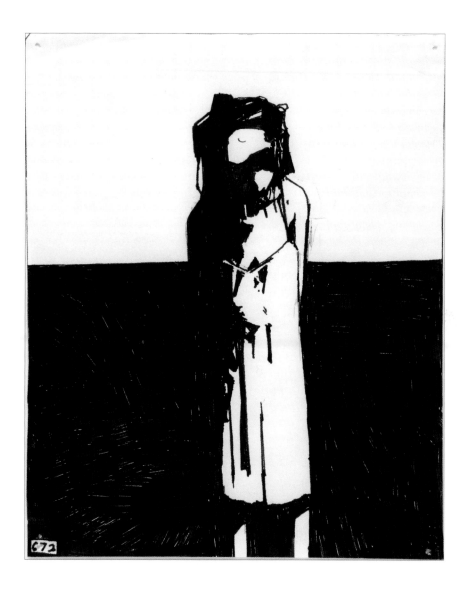

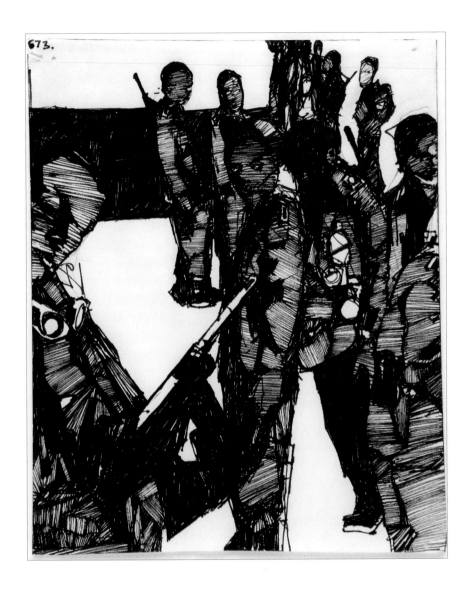

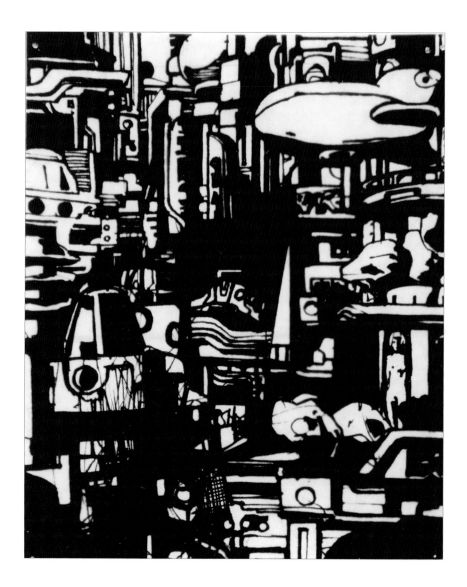

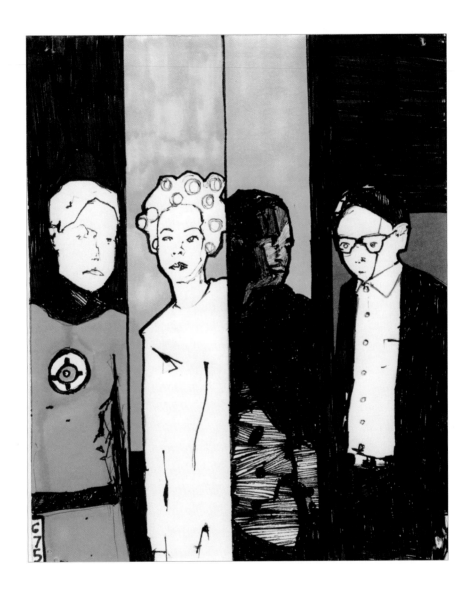

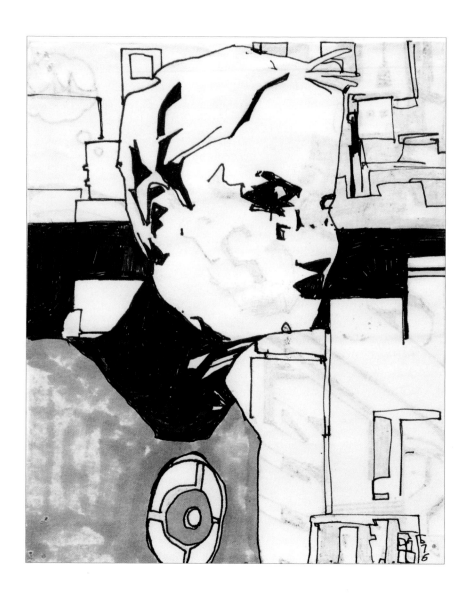

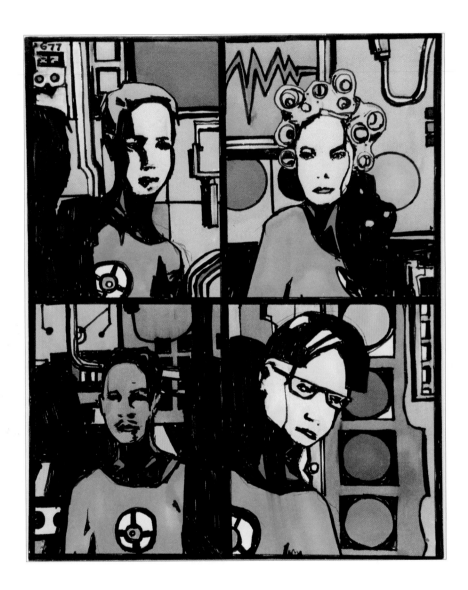

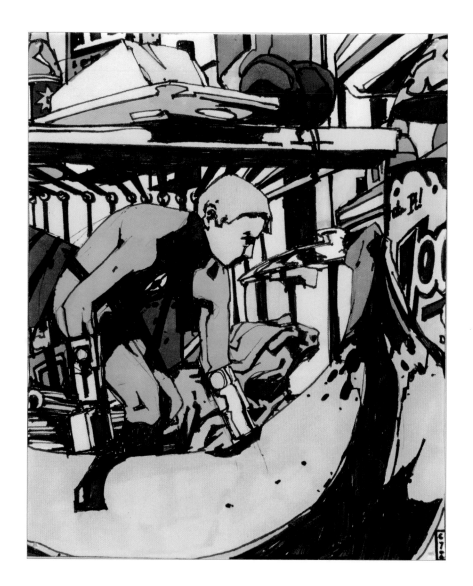

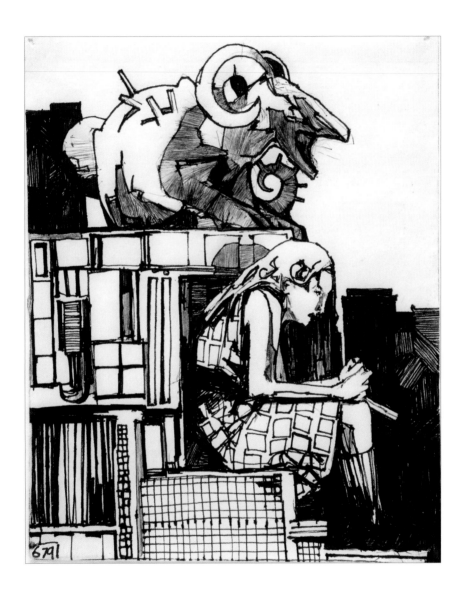

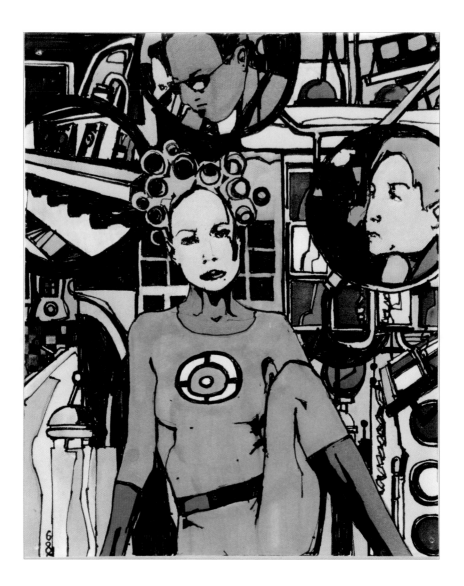

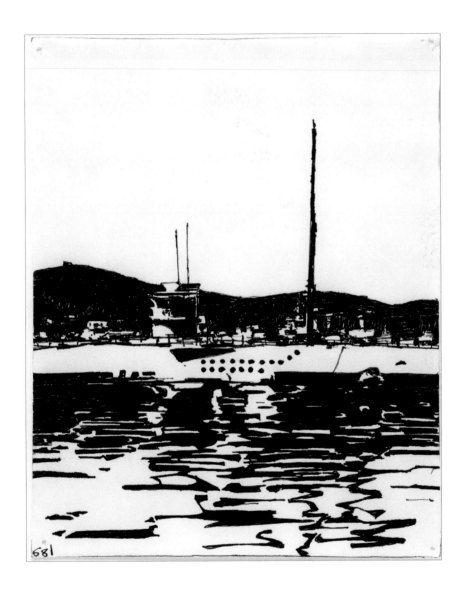

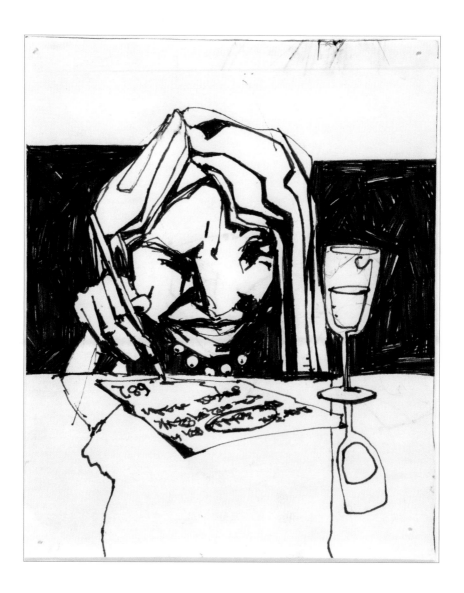

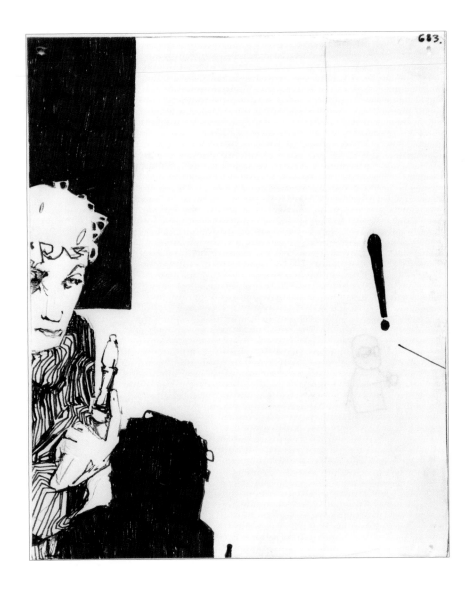

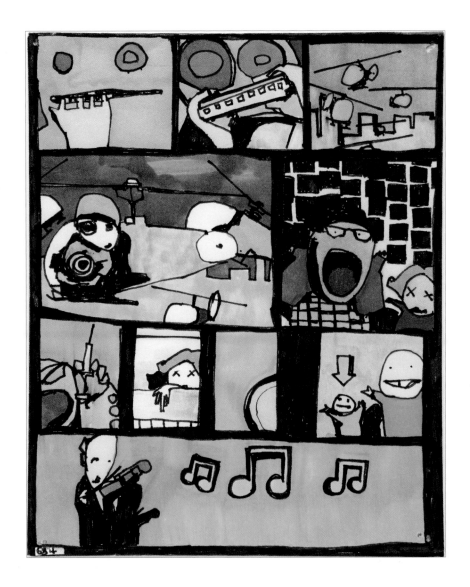

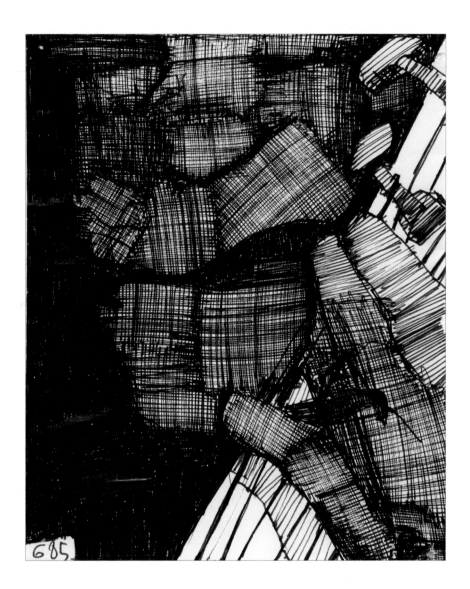

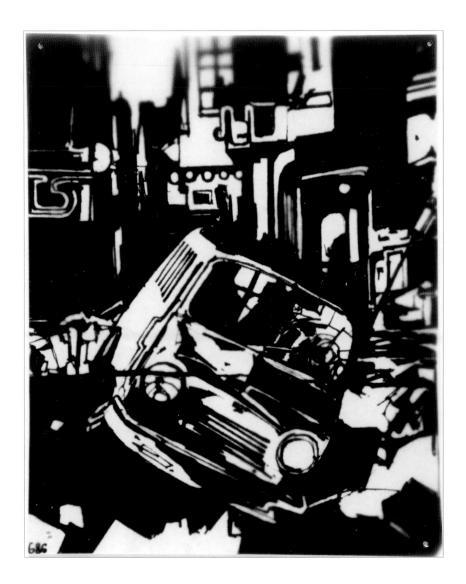

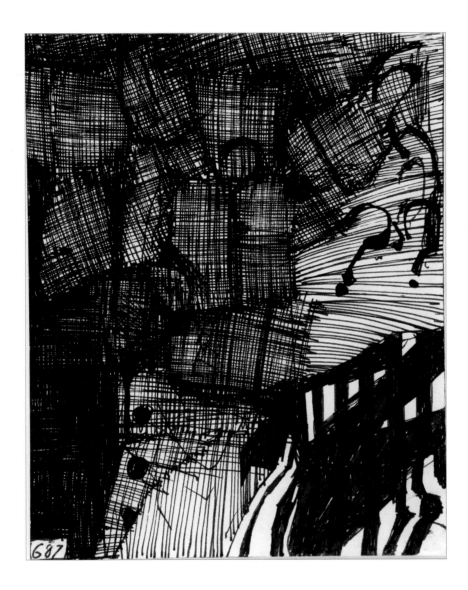

687

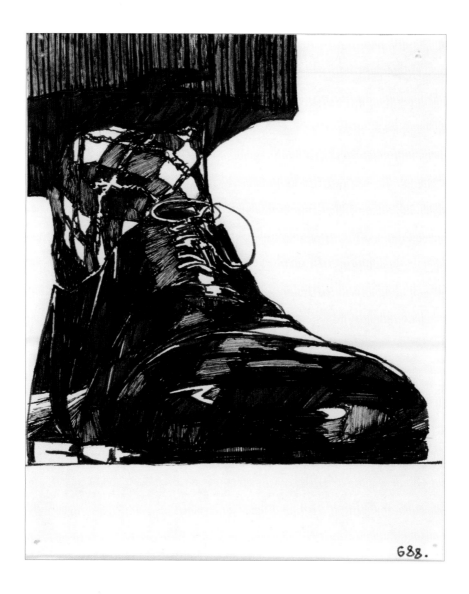

688.

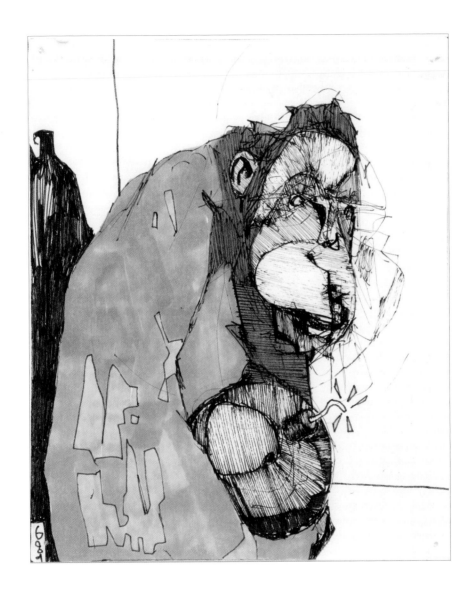

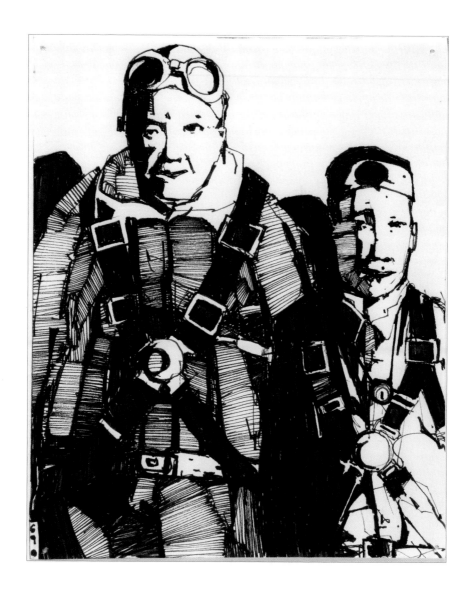

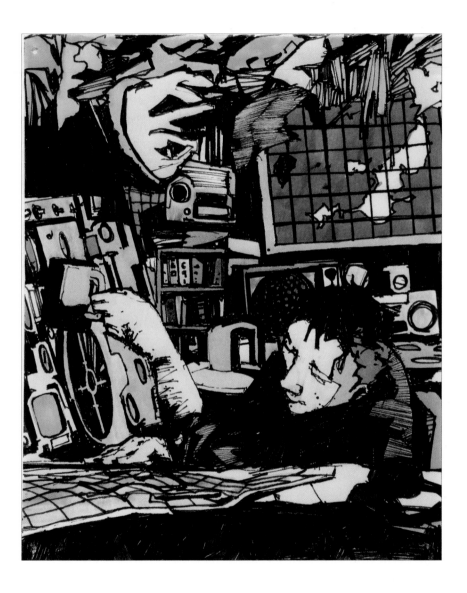

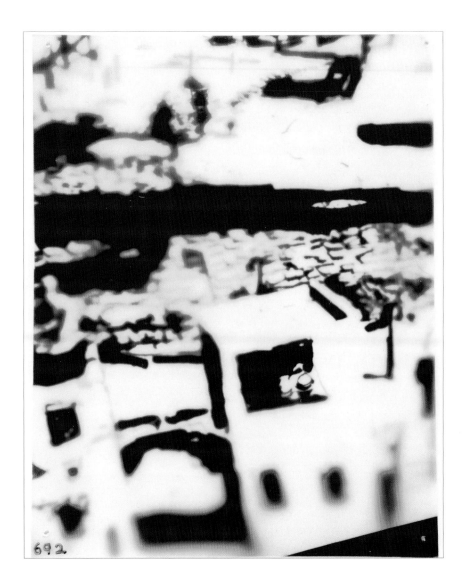

692

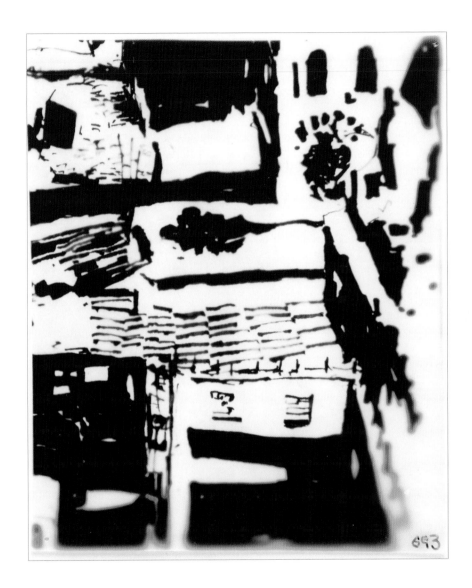

693

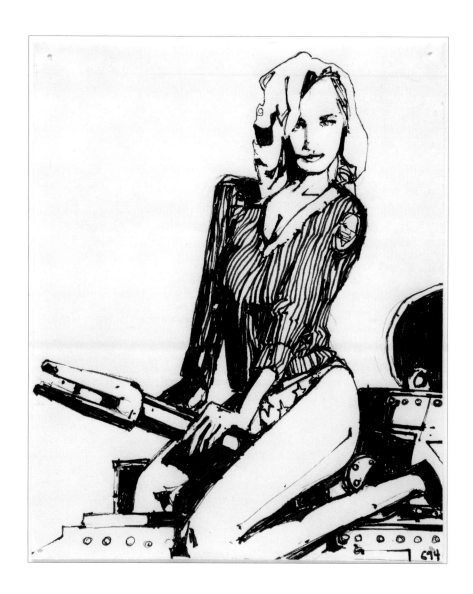

: 694 :

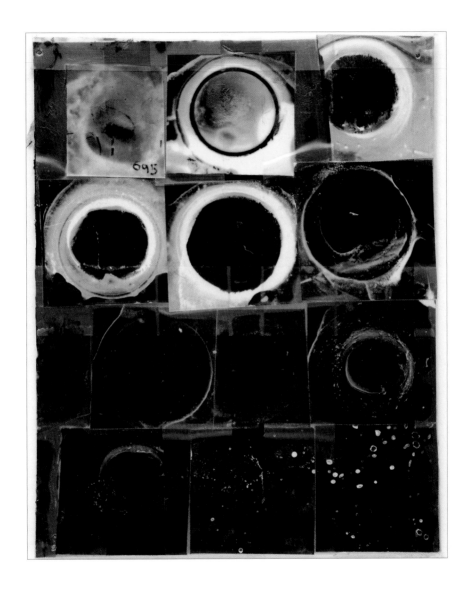

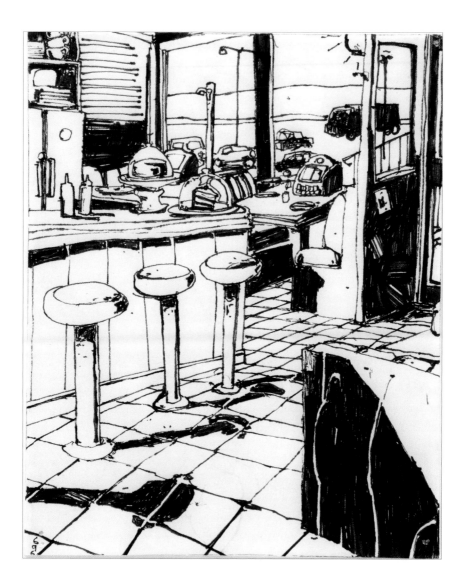

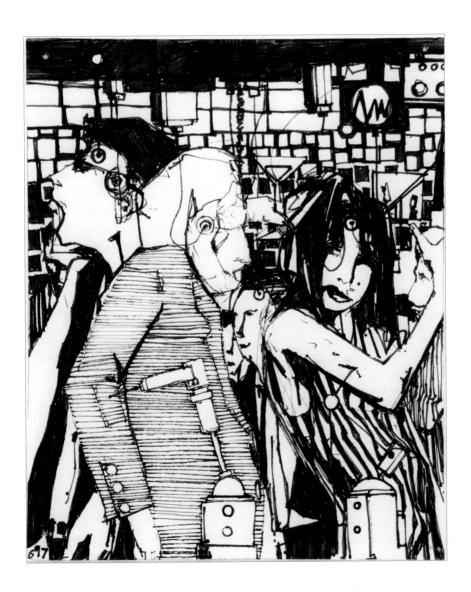

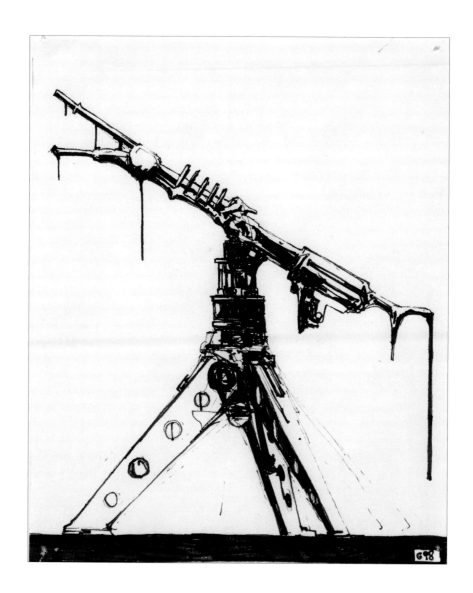

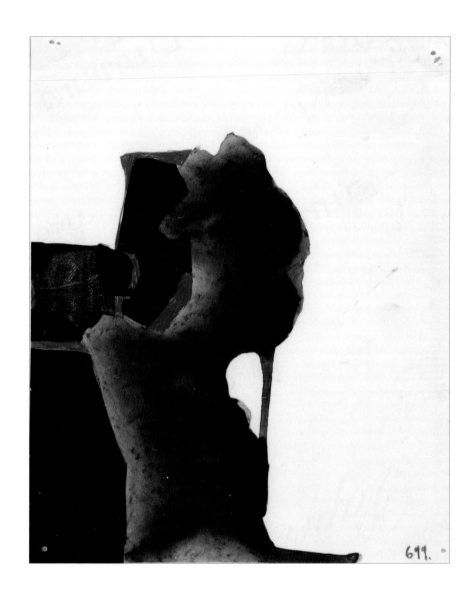

699.

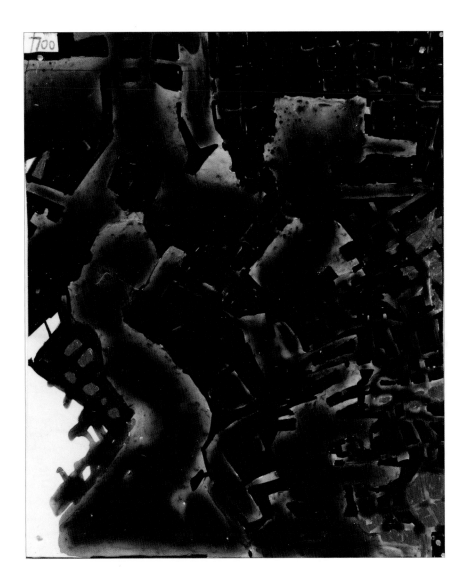

: 700 :

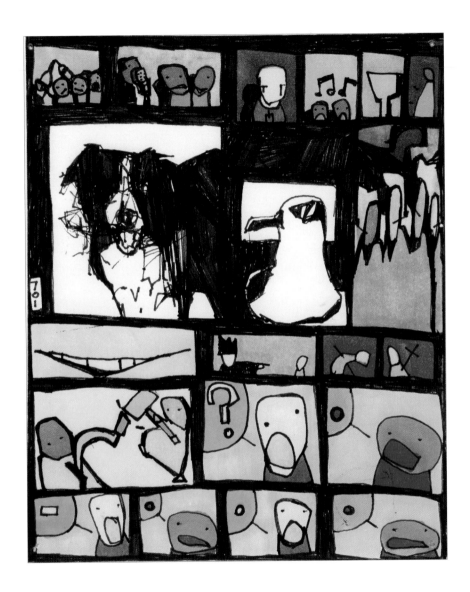

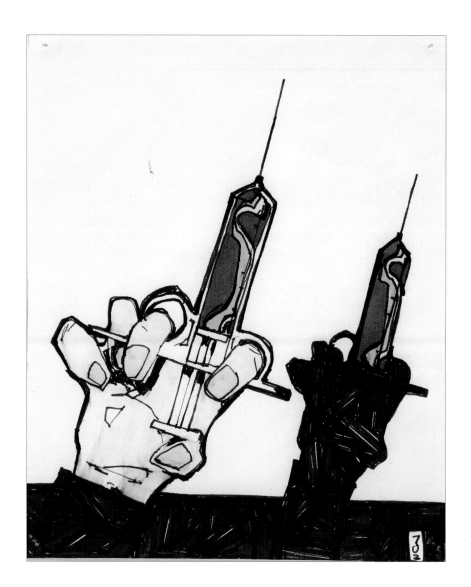

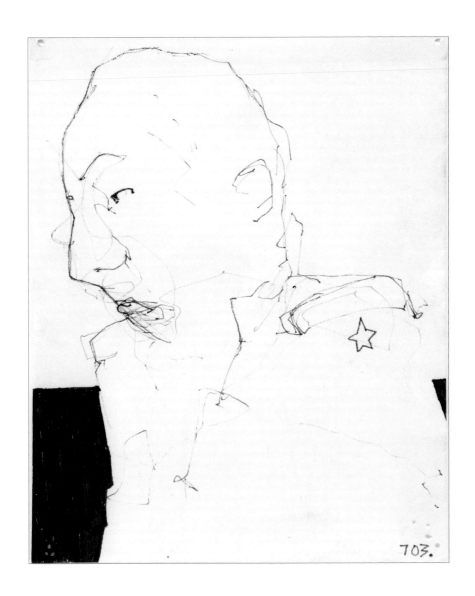

703.

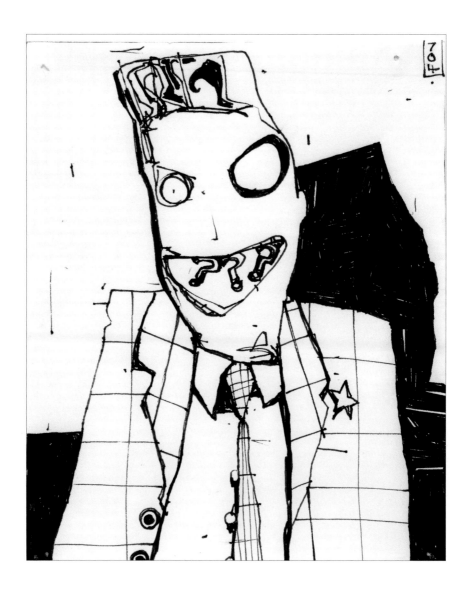

: 704 :

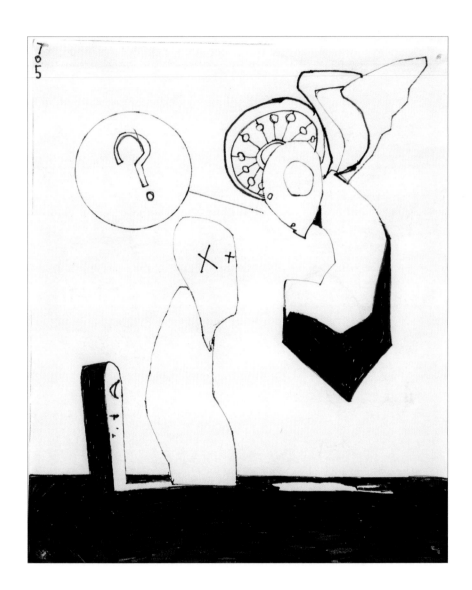

705

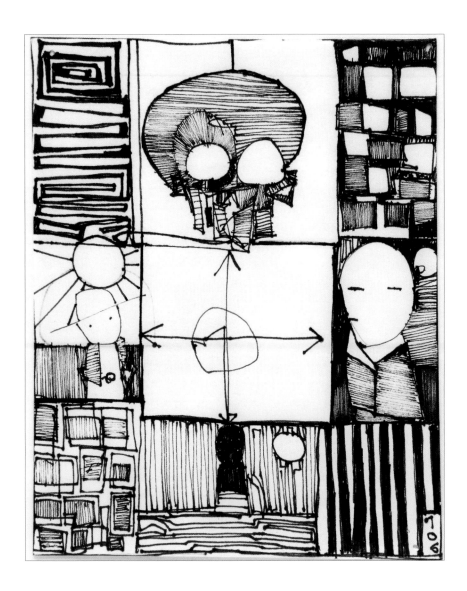

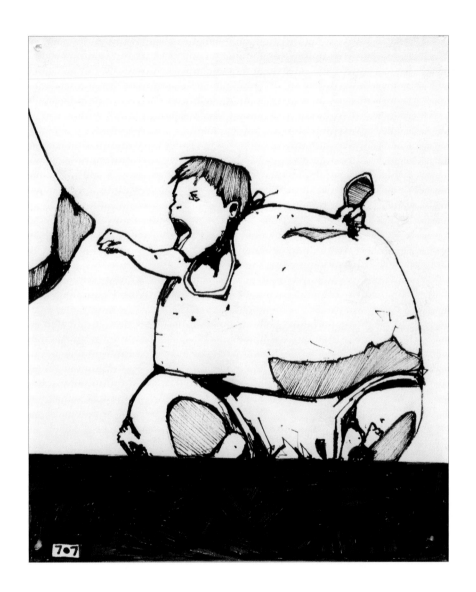

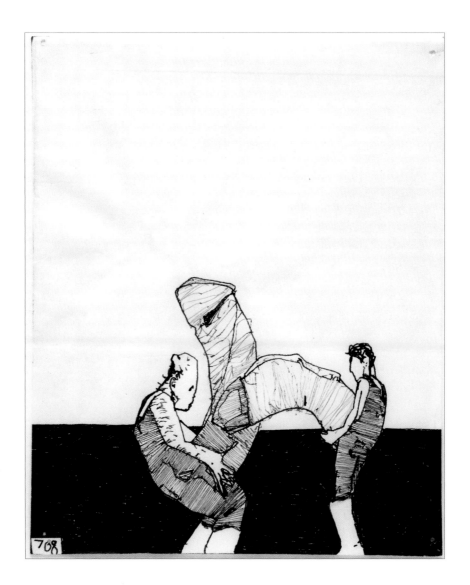

: 708 :

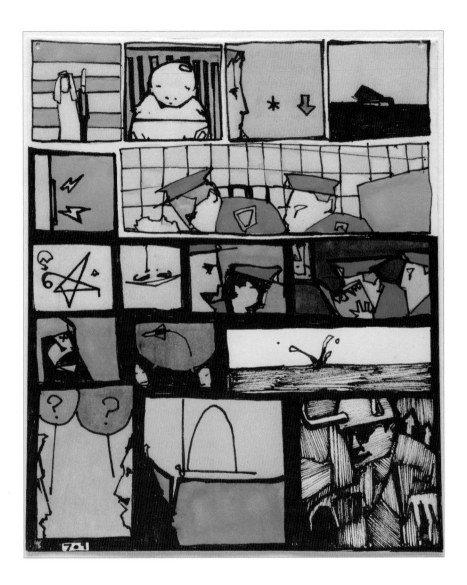

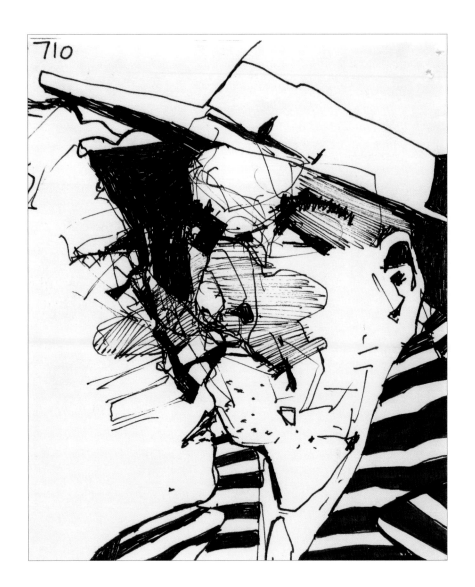

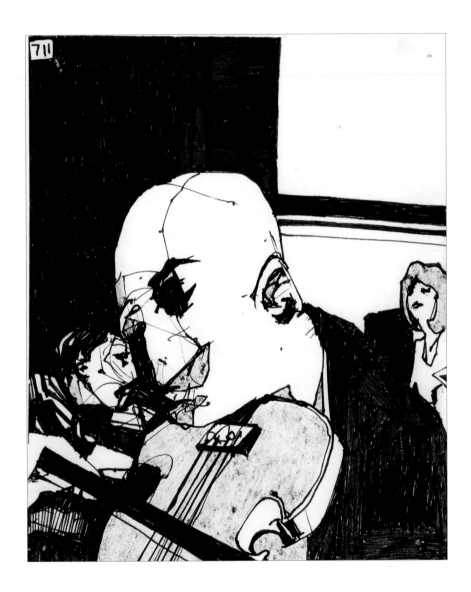

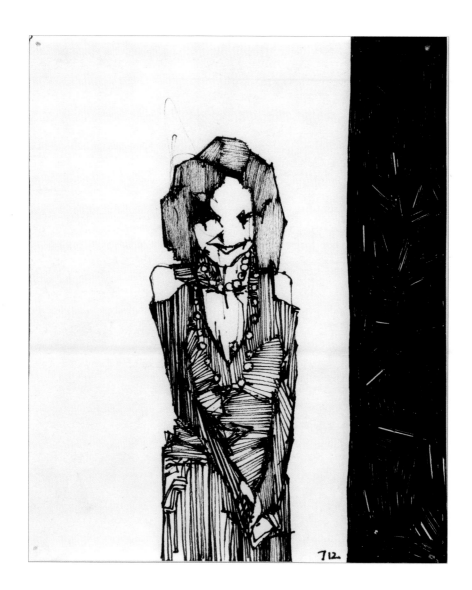

: 712 :

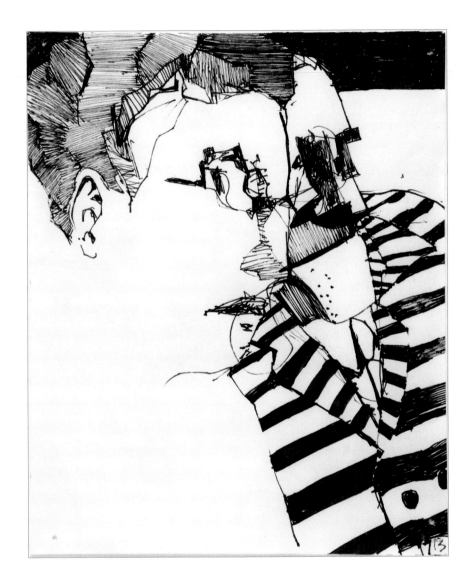

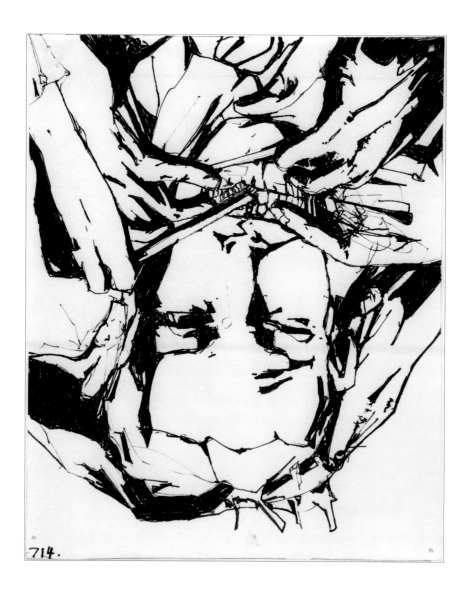

714.

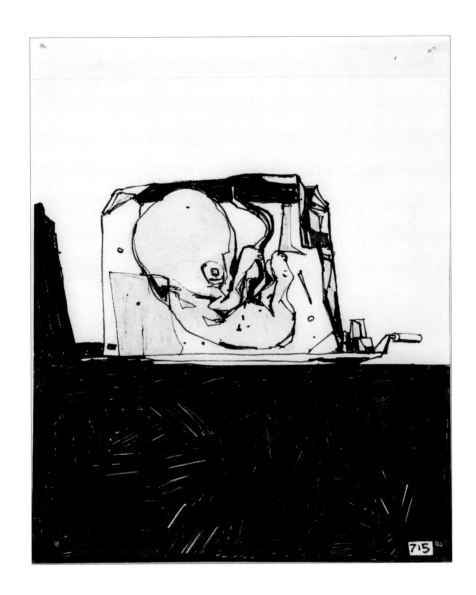

715

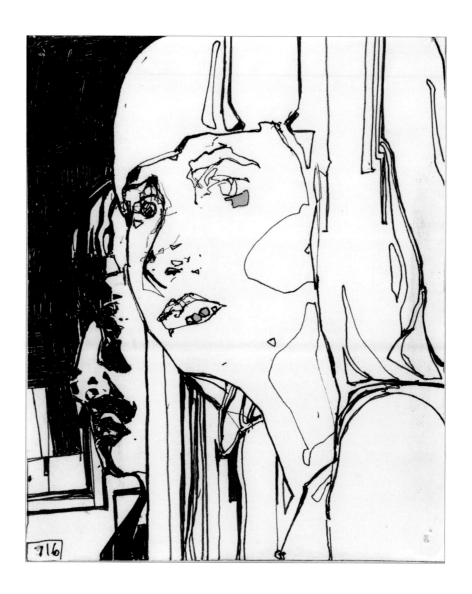

716

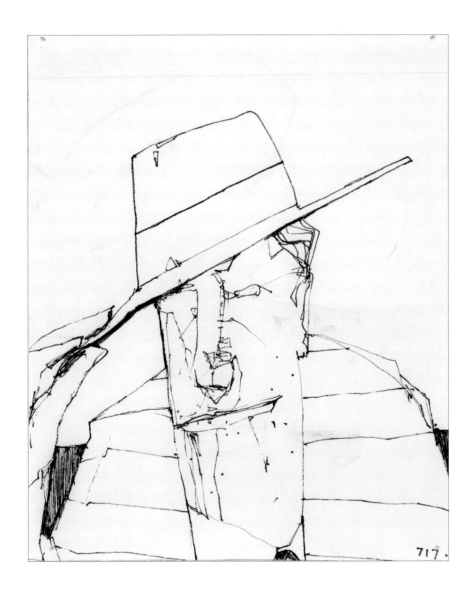

717.

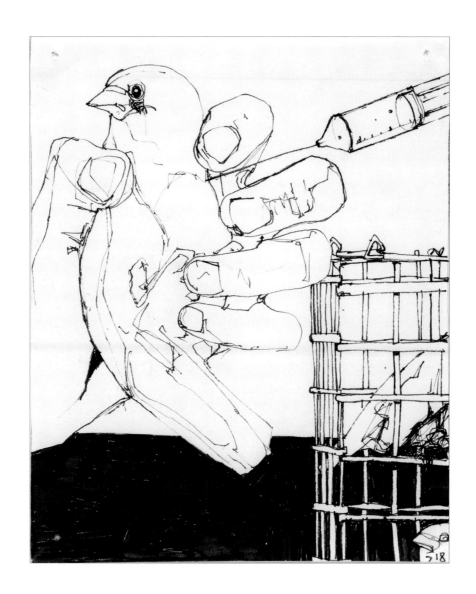

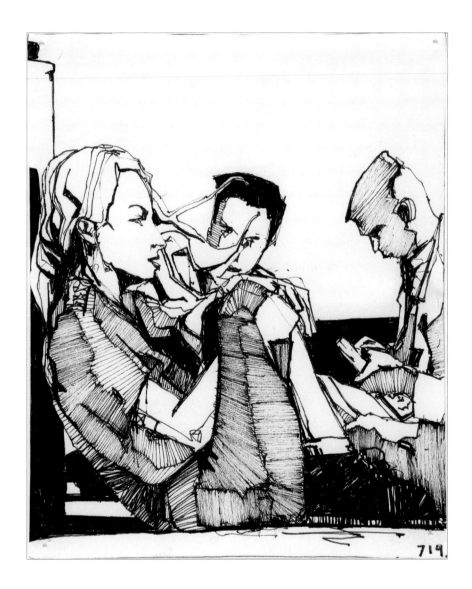

719.

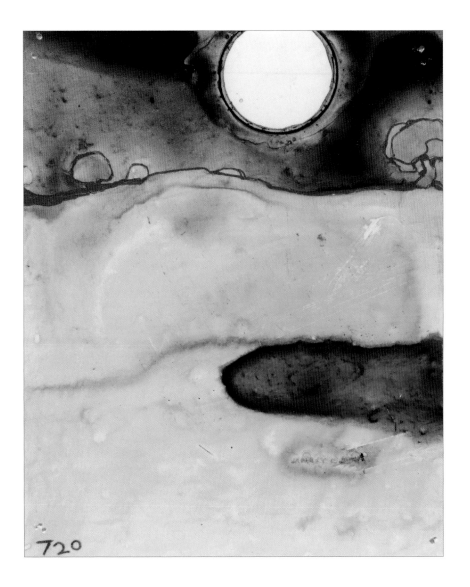

720

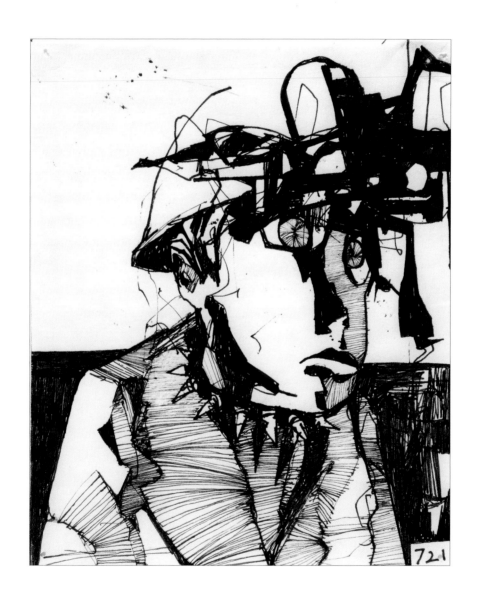

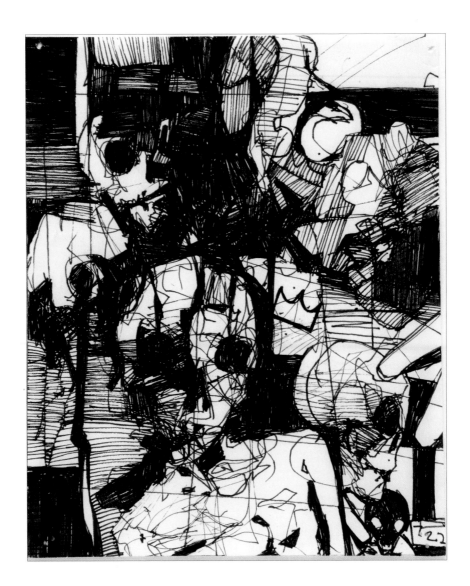

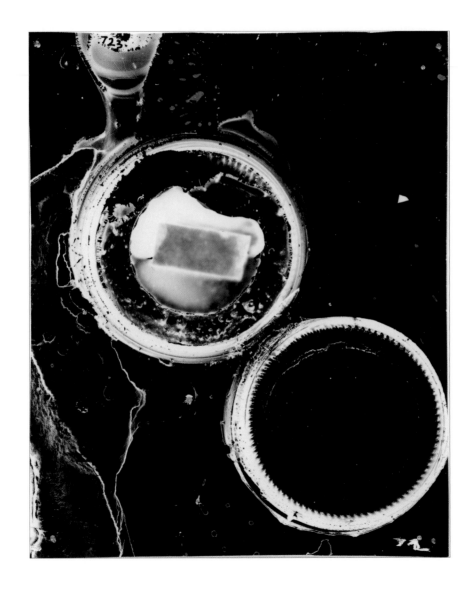

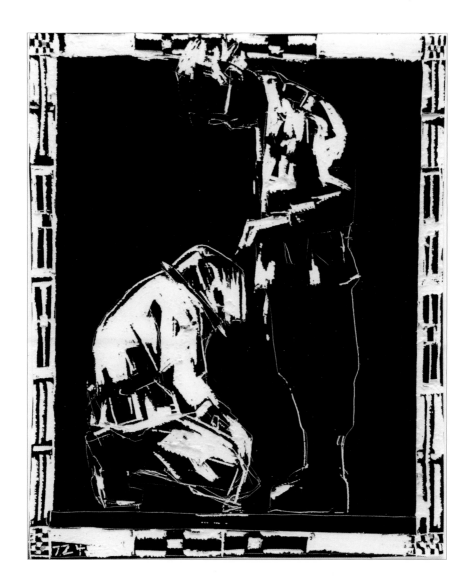

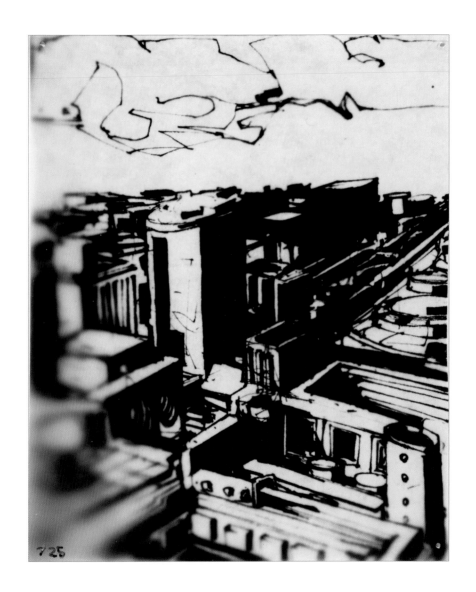

725

: 726 :

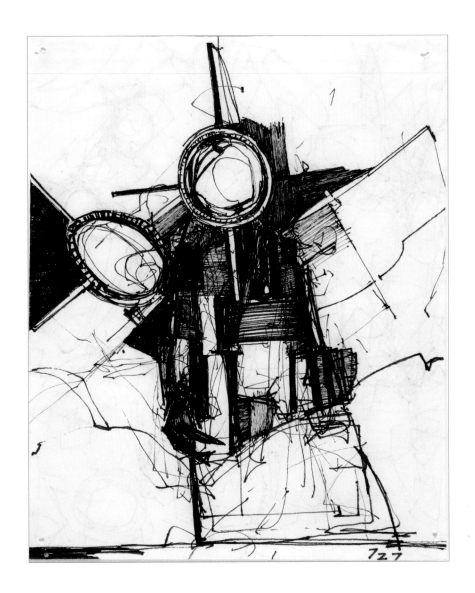

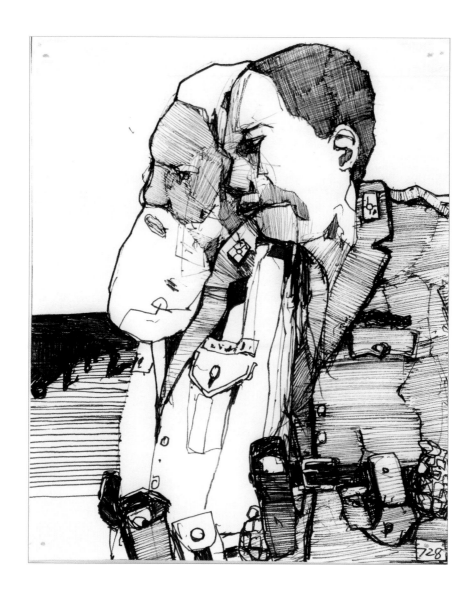

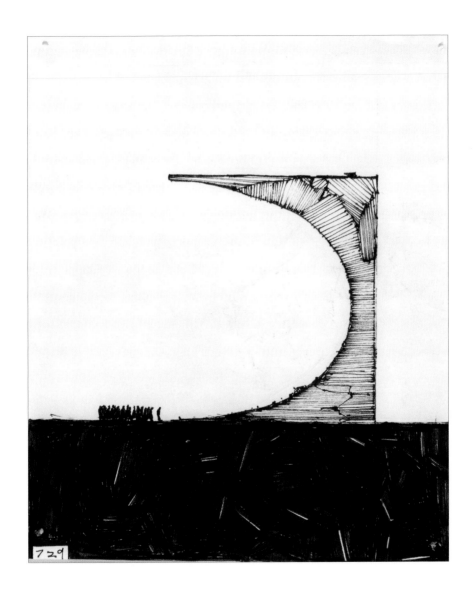

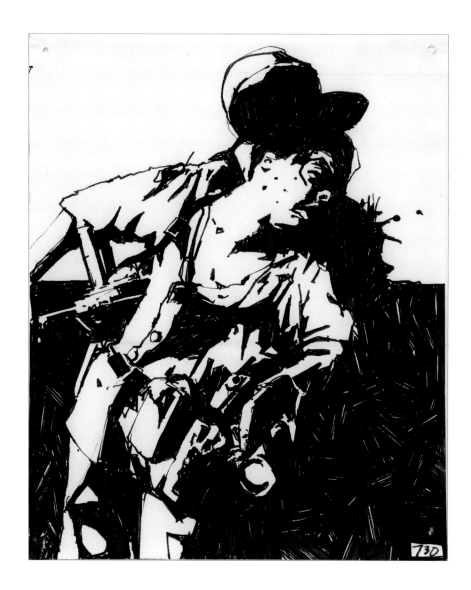

: 730 :

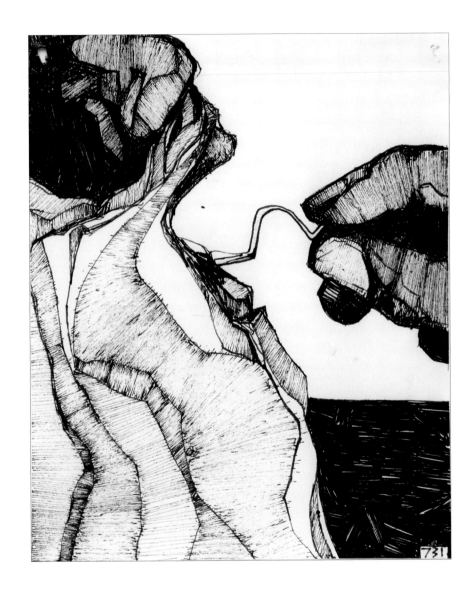

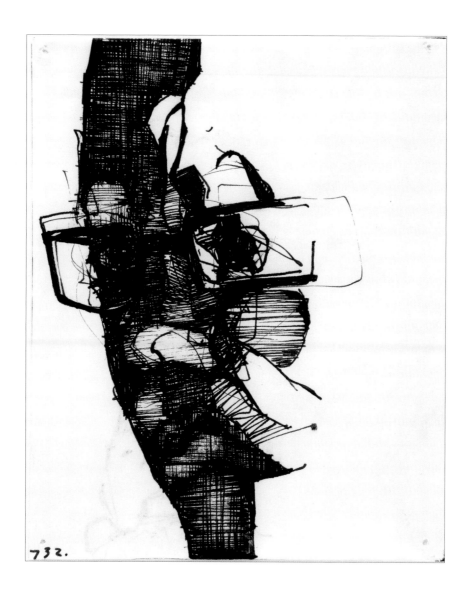

732.

: 734 :

736

: 736 :

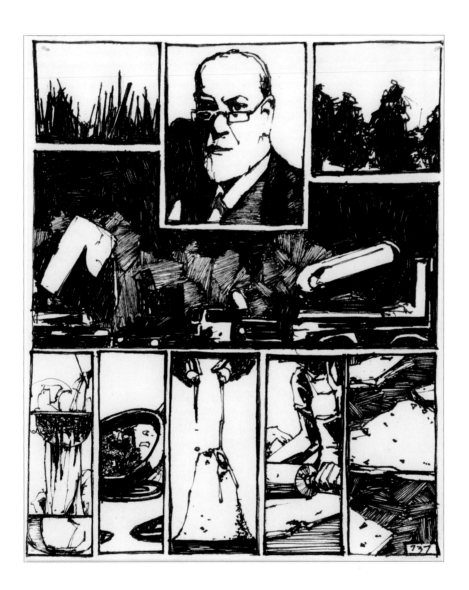

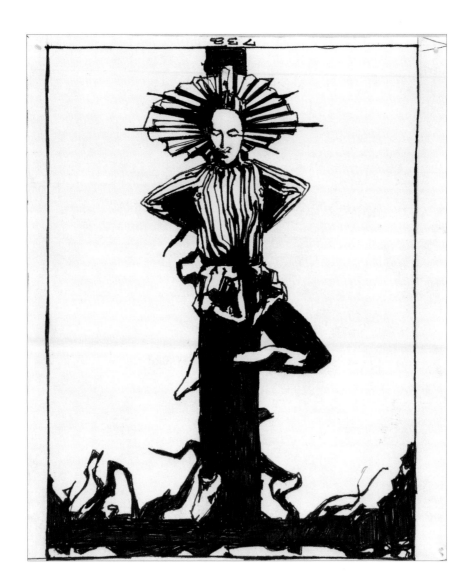

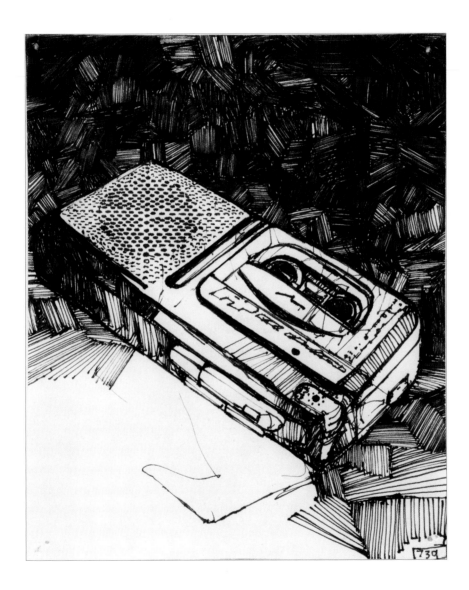

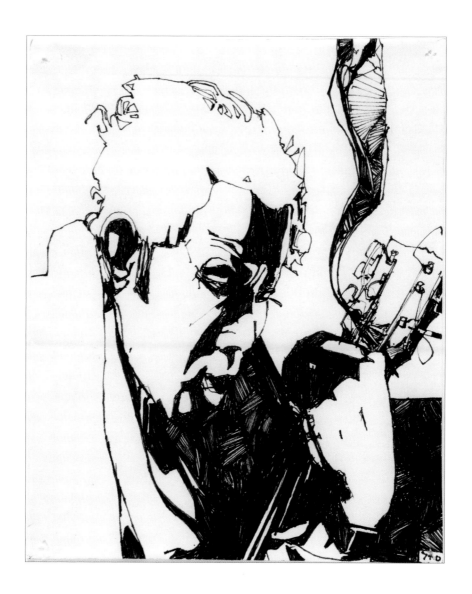

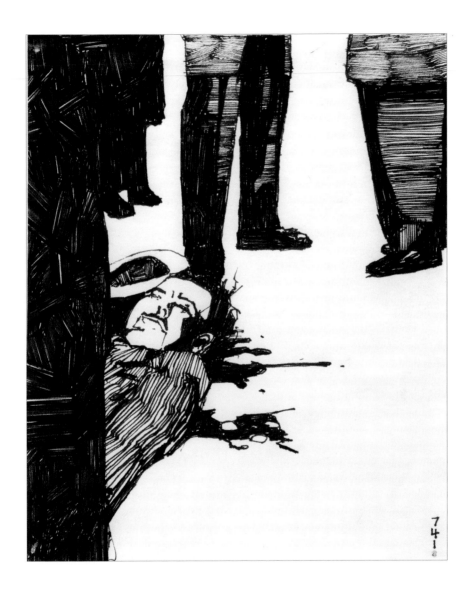

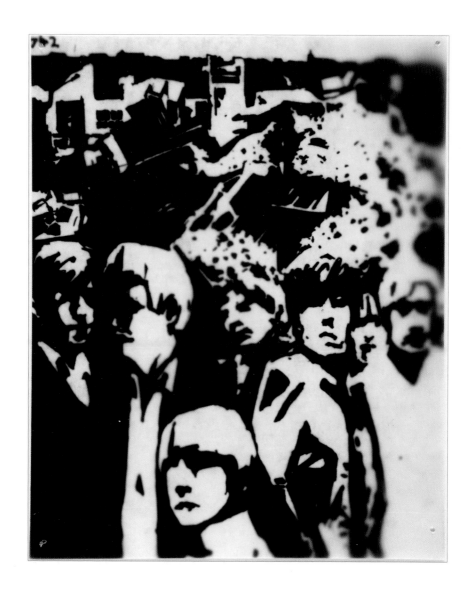

: 742 :

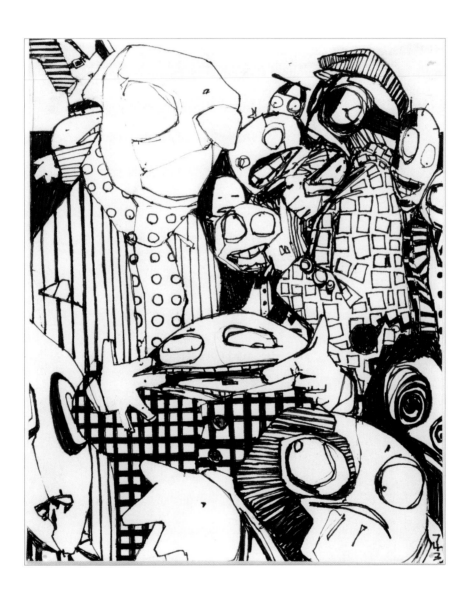

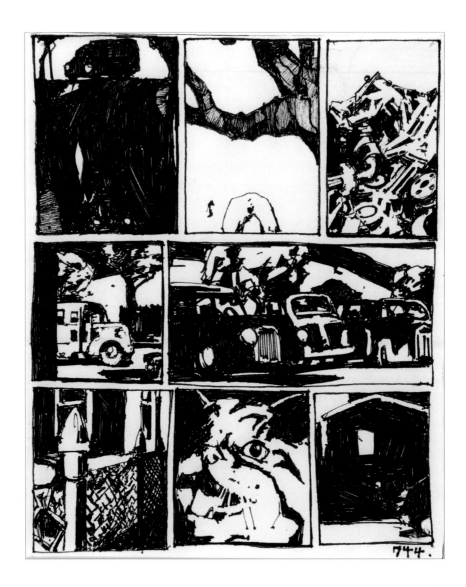

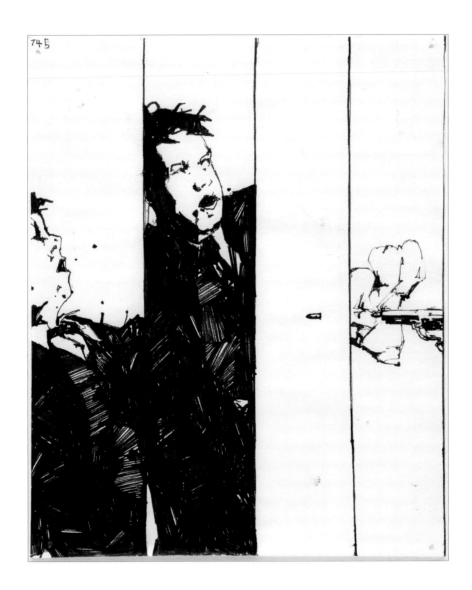

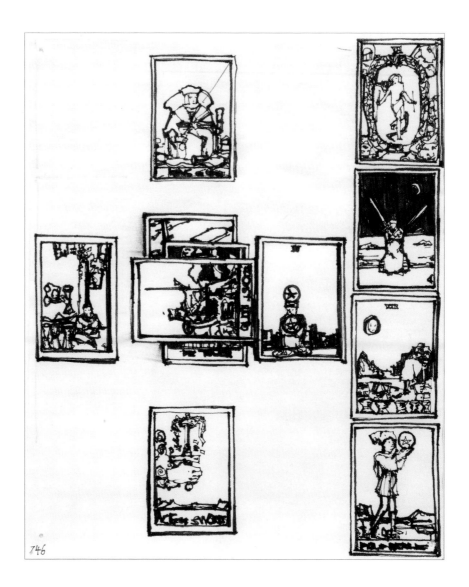

746

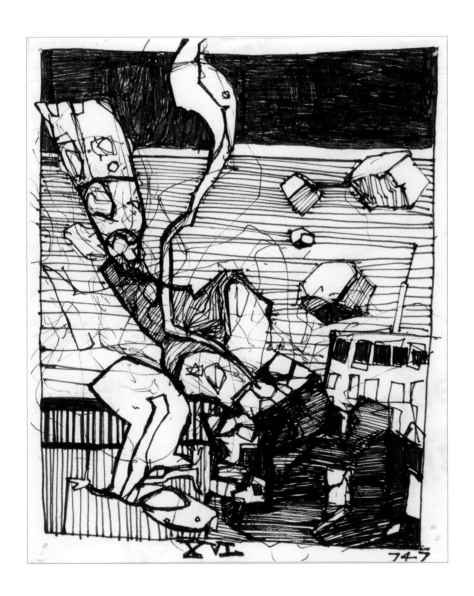

XVI.

747

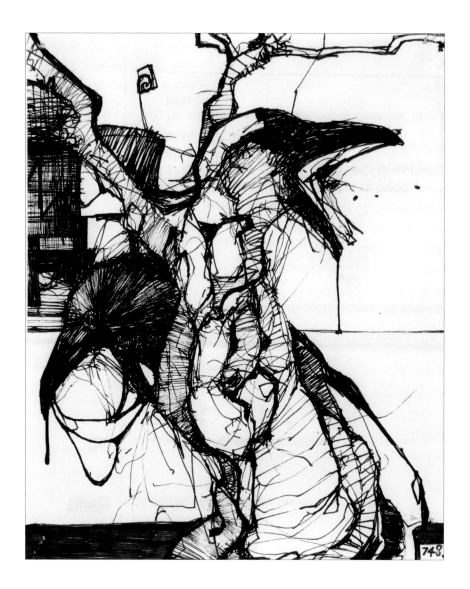

: 748 :

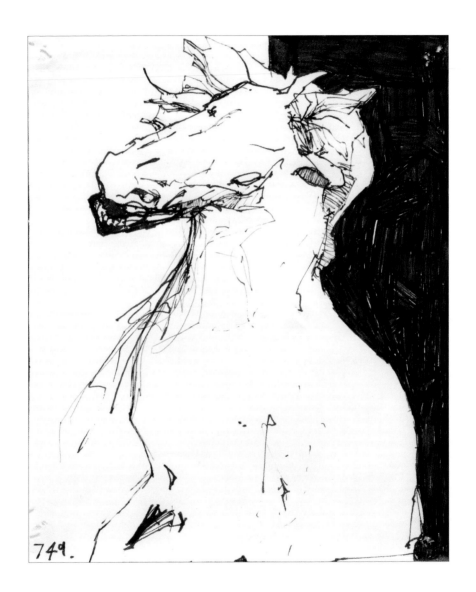

749.

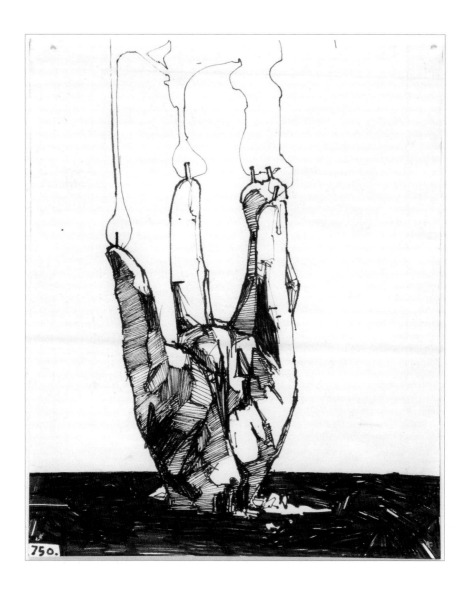

750.

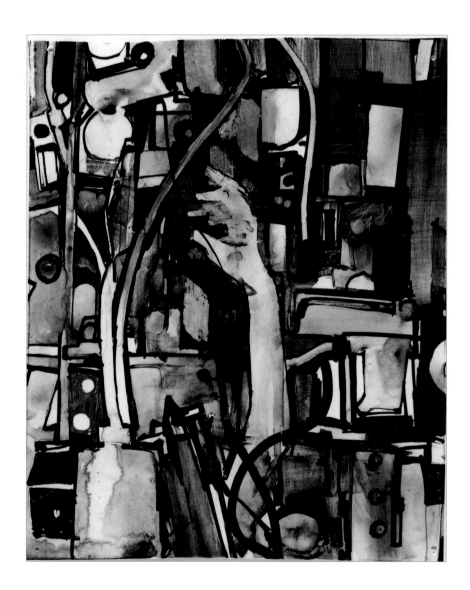

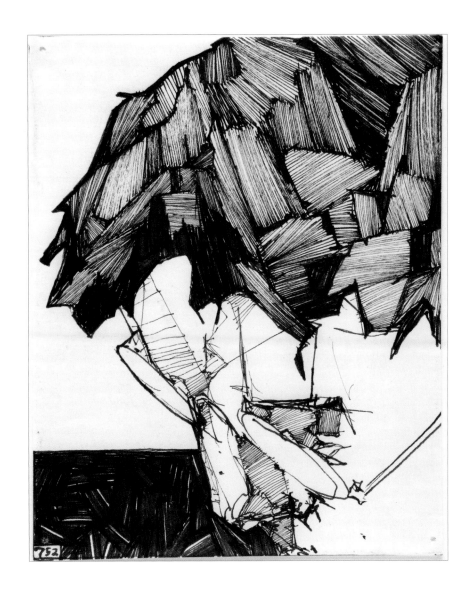

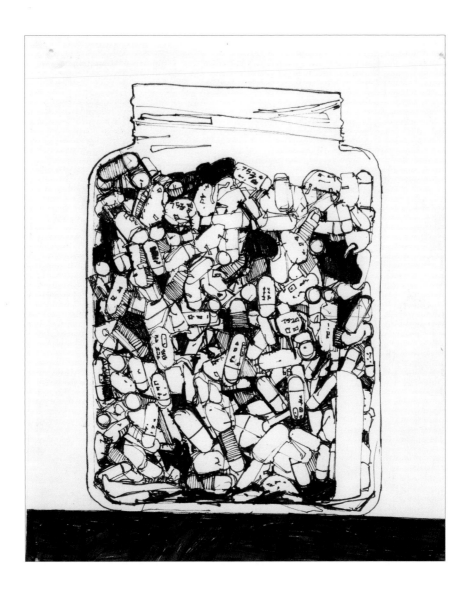

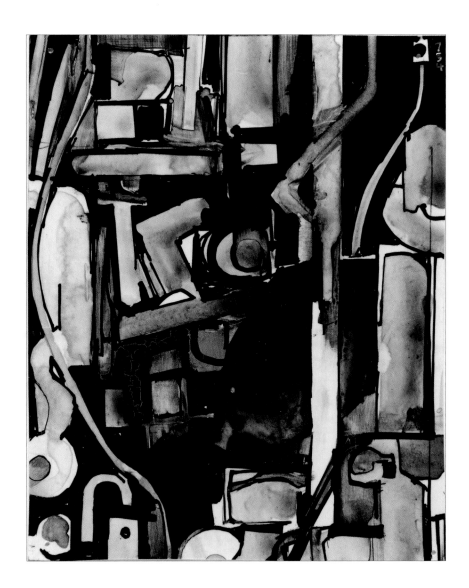

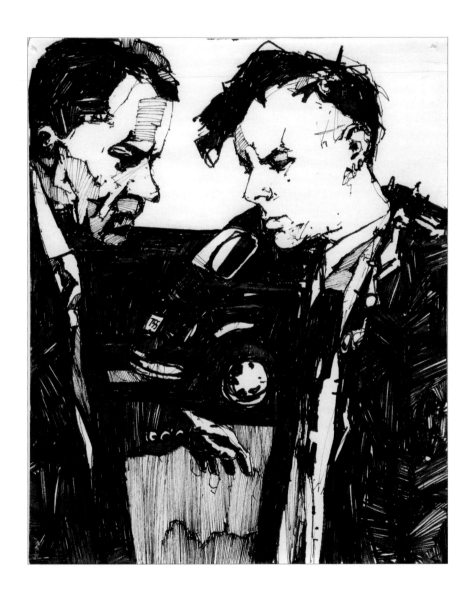

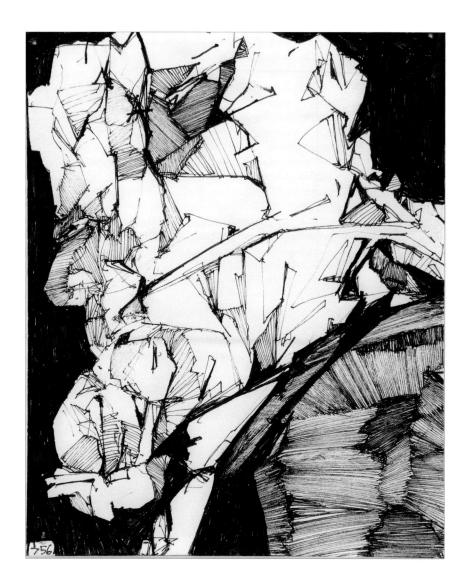

: 756 :

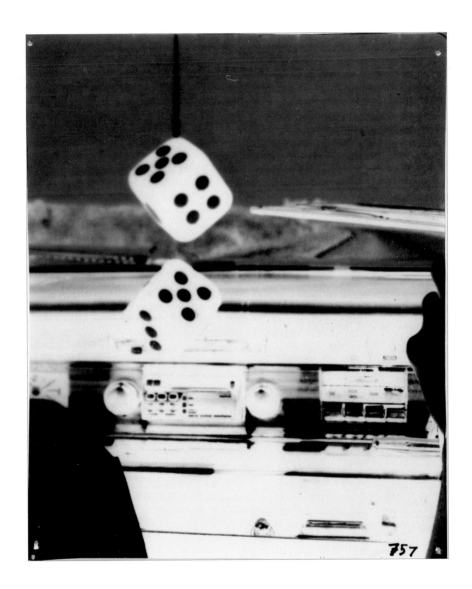

757

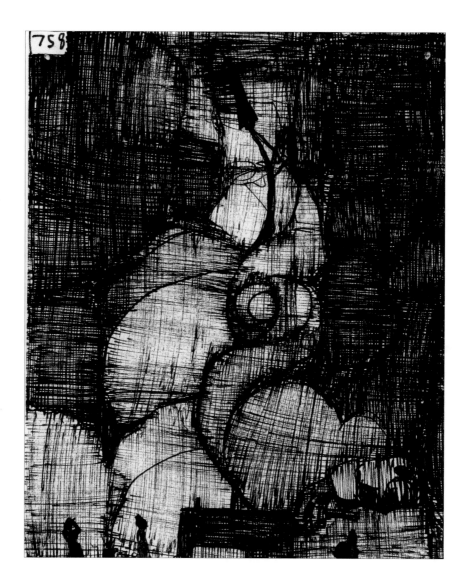

: 758 :

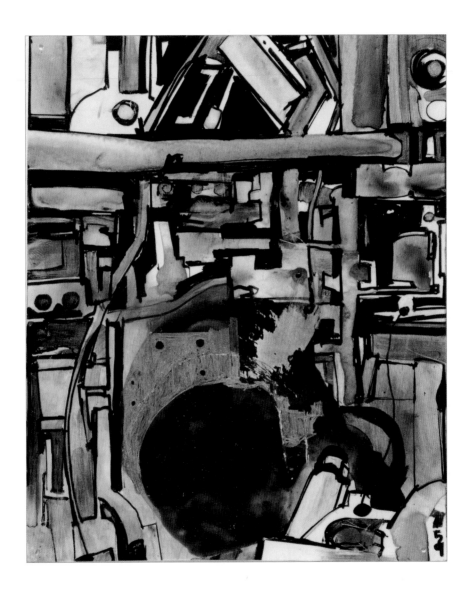

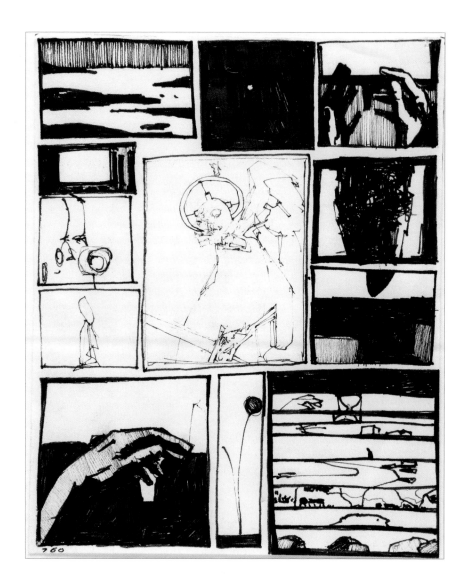

: 760 :

ACKNOWLEDGEMENTS

The artist would like to thank Sean McCarthy, Mandy Morbid, Adrienne Anderson, Sarah Lookofsky, Quinna Diana, Francesca Maniace, everyone at Tin House and The Modern Word, Joe King at the Walker, Steve Erickson, Tim Peterson, Jeff I. Ross, Andrew Freiser, Jessica Fredericks, Shamim Momin, Monica Ramos, Lizzie Stein, Benny Profane, Creon Upton, Beatrice Schleyer, and any friends who recognize their arm, leg, head, or shoe in any of the pictures.

I used all sorts of reference books in order to figure out what Pynchon was talking about and what it looked like, but in particular I'd like to thank Chris Bishop and Chris McNab for their *The Campaigns of World War II Day by Day*, the people over at the HyperArts online index to *Gravity's Rainbow*, and Steven Weisenburger for his *A "Gravity's Rainbow" Companion: Sources and Contexts for Pynchon's Novel*.

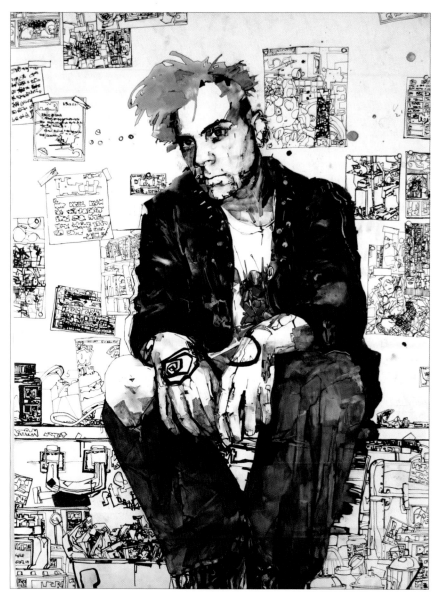

Most Accurate Self-Portrait To Date, 2004. Acrylic and ink on paper. 32.5 x 27.5 inches.
Collection of Ninah and Michael Lynne.

ABOUT THE ARTIST

ZAK SMITH was born in Syracuse, New York, in 1976. In addition to the illustrations based on Thomas Pynchon's *Gravity's Rainbow*, which were shown in the 2004 Whitney Biennial and are now in the collection of the Walker Art Center in Minneapolis, Smith's recent projects include the multipanel painting *100 Girls and 100 Octopuses* and an ongoing series of portraits of friends and acquaintances in the sex industry entitled *Girls in the Naked Girl Business*, as well as a number of stand-alone paintings and drawings, abstract and otherwise. His work has appeared in numerous publications worldwide and is held in many public and private collections, including the Museum of Modern Art and the Whitney Museum. He is a frequent contributor to several independent comics and zines, including *Paping* and *See How Pretty, See How Smart*. His first monograph, *Zak Smith: Pictures of Girls*, was published in 2005.

He lives and works in Brooklyn, where he is currently working on new paintings as well as an autobiographical series entitled *Drawings from Around the Time I Became a Porn Star*. He is represented by Fredericks & Freiser Gallery in New York.

STEVE ERICKSON is the author of nine books, including the novels *Our Ecstatic Days* (just released in paperback by Simon and Schuster), *The Sea Came in at Midnight*, *Days Between Stations*, and *Tours of the Black Clock*. He teaches writing at the California Institute of the Arts (CalArts), where he also edits the national literary magazine *Black Clock*. He has written about film for *Los Angeles* magazine since 2001.